CHASING LIGHT

"My photography career has spanned five decades so far, and in
Stefan Forster's work I see a bit of myself when I was a younger
photographer. His landscape work is full of sweep and ambition, technical
proficiency, and very hard work. I sense a kindred spirit behind the camera;
a photographer who times the light and carefully crafts compositions of our
natural world. The key to any great photo is being in the right place at the right
moment, and getting up earlier and staying out later than everyone else.
Mr. Forster excels at this and takes great joy in inclement weather, which
can bring the most dazzling displays of earthly illumination.
In *Chasing Light* he takes us on a global trek, hunting, if you
will, the most beautiful landscapes in the world."

— Art Wolfe, photographer, conservationist, and TV host.

1

FORESTS AND TREES //
WÄLDER UND BÄUME // LES FORÊTS ET LES ARBRES //

With its innumerable animals and organisms, the forest habitat has fascinated me from the beginning. Practically everywhere on earth—despite, of course, glaciers or arctic and Antarctic pack ice—trees will grow, accomplishing miracles. Trees have played an important role throughout my journeys. I toured what are probably the least-known forests on earth, the stands of giant lobelia in the Rwenzori Mountains in Uganda, to photograph those plants and trees, which occur nowhere else. I had the same thing in mind in the taxodium forests of pond and bald cypress in the swamps of the southeastern United States.

It was immensely impressive to be floating alone in a kayak next to one of the oldest trees on earth and see that it still puts forth dazzling green shoots after a thousand years or more. Even in the Namibian desert, trees once subsisted on periodic rainfall. The dwindling and disappearance of rain over several decades brought about the Deadvlei, a basin of lonely ancient, desiccated trees surrounded by Namibia's highest sand dunes that bears witness to these events.

Der Lebensraum Wald mit seinen unzähligen Tieren und Organismen fasziniert mich schon seit jeher. Praktisch überall auf dieser Erde (ausgenommen Gletscher oder Packeis der Arktis und Antarktis) vollbringen Bäume das Wunder und wachsen. Bei all meinen Reisen spielten Bäume immer eine wichtige Rolle. Meine Tour zu den wohl am wenigsten bekannten Wäldern dieser Erde, den Riesenlobelienwäldern des Ruwenzori-Gebirges in Uganda, unternahm ich, um die ausschließlich dort vorkommenden Pflanzen und Bäume zu fotografieren; das gleiche Ziel verfolgte ich in den Sumpfzypressenwäldern der Südstaatenswamps der USA.

Alleine im Kayak neben einem der ältesten Bäume der Erde zu schwimmen und zu beobachten, wie der Baum, trotz seines Alters von über 1000 Jahren, in grellem Grün ausschießt, beeindruckte mich sehr. Sogar in der Wüste Namibias wuchsen einst Bäume, die von regelmäßigem Regen lebten, der dann über Jahrzehnte ausblieb und das Deadvlei entstehen ließ. Davon zeugt dort heute noch ein Tal einsamer alter und morscher Bäumen, die umringt von den höchsten Sanddünen Namibias sind.

La forêt comme espace vital avec ses myriades d'espèces animales et d'organismes vivants me fascine de tout temps. Presque partout sur notre planète (hormis sur les glaciers et sur la banquise de l'Arctique et de l'Antarctique), les arbres sont capables de miracles pour grandir. Dans tous mes voyages, les arbres ont joué un rôle primordial. Ainsi mon expédition dans les forêts parmi les moins connues de la Terre, dans les monts Rwenzori en Ouganda avec ses lobélias gigantesques, avait pour seul but de photographier des plantes et des arbres endémiques. C'est pour la même raison que je me suis rendu dans les marais de Louisiane à la rencontre des plus anciens cyprès.

Seul à bord d'un kayak, j'ai pu approcher l'un des plus anciens arbres de la Terre, et j'ai été particulièrement impressionné par cet arbre millénaire qui continue à bourgeonner comme au premier jour de printemps. Et même dans le désert du Namib, en Namibie, il y a des arbres que la pluie arrosait régulièrement jusqu'à ce qu'elle se fasse rare et que la région se transforme en marais mort, appelé le Deadvlei. En témoignent ces vieux arbres presque secs encore debout dans cette vallée entourée des plus hautes dunes de sable de Namibie.

// OPPOSITE PAGE

What looks like moss is really a cushion plant that has grown for thousands of years into the largest member of its species in the world. Its home is hidden at the foot of Mount Anne in the mountains of Tasmania. This natural wonder is surrounded by a fabulous giant grass tree, *R. pandanifolia*, a large tree endemic to Tasmania.

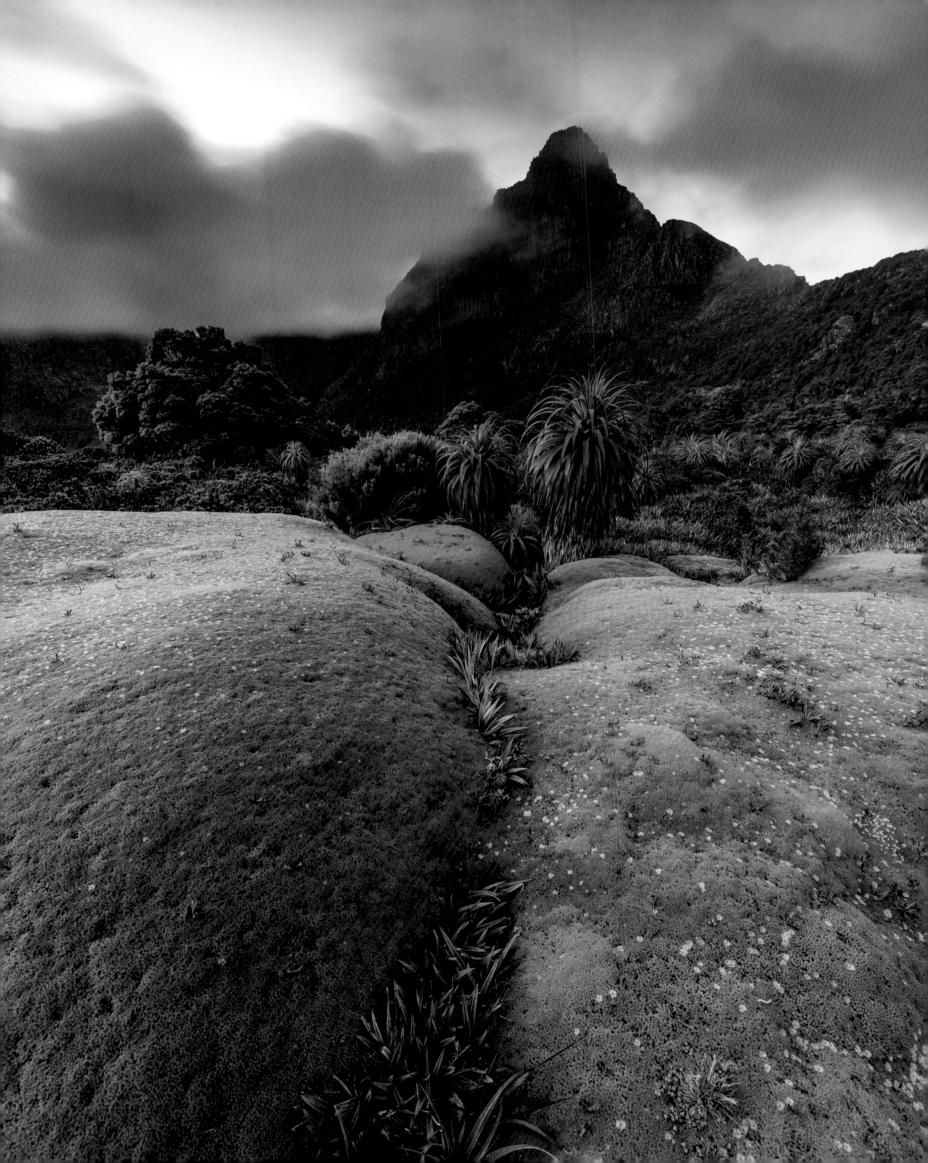

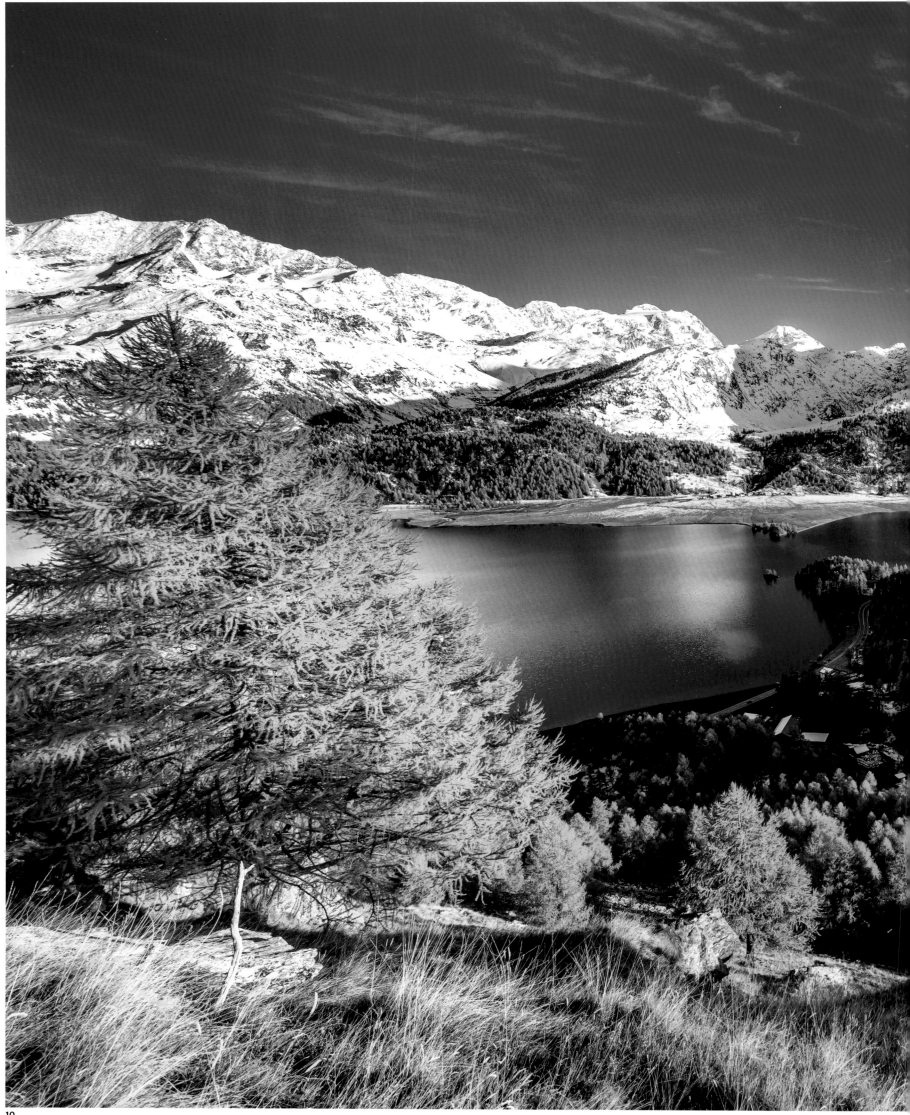

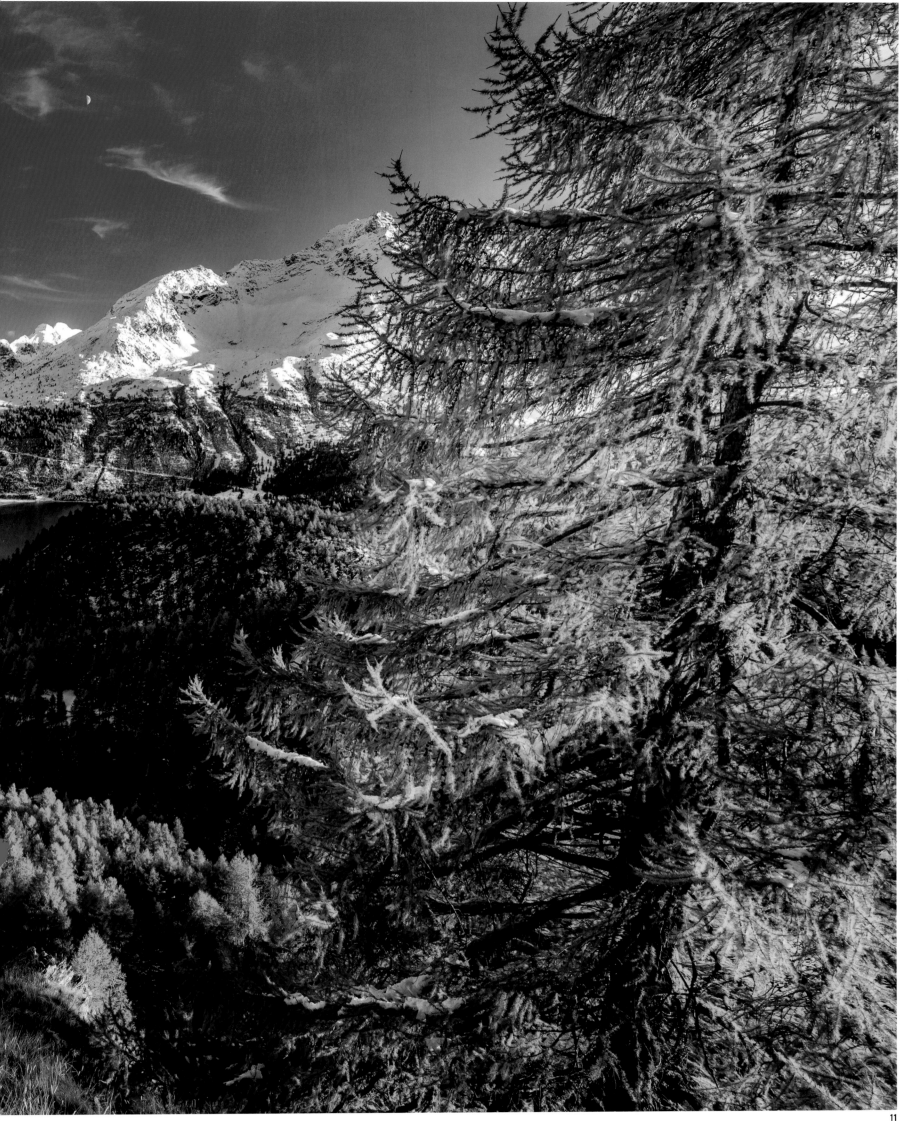

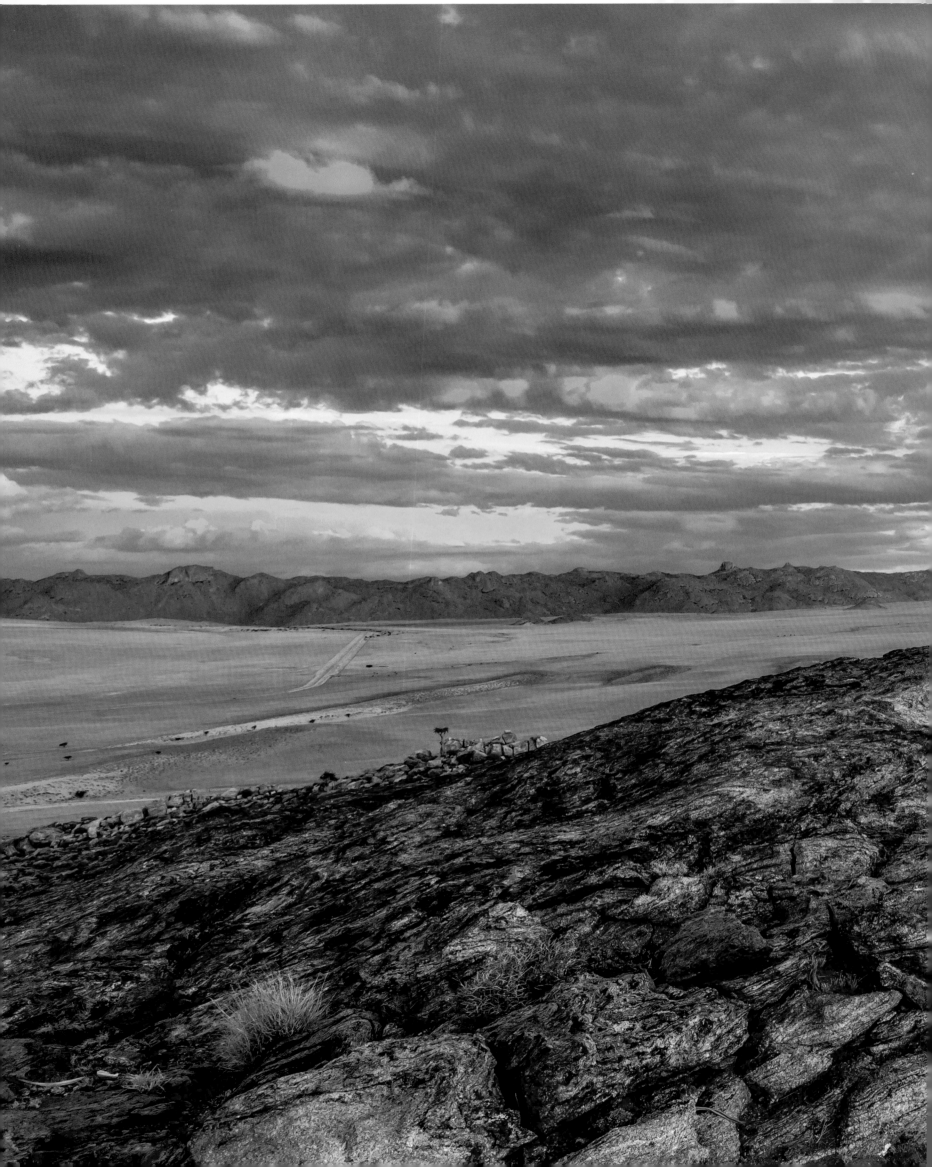

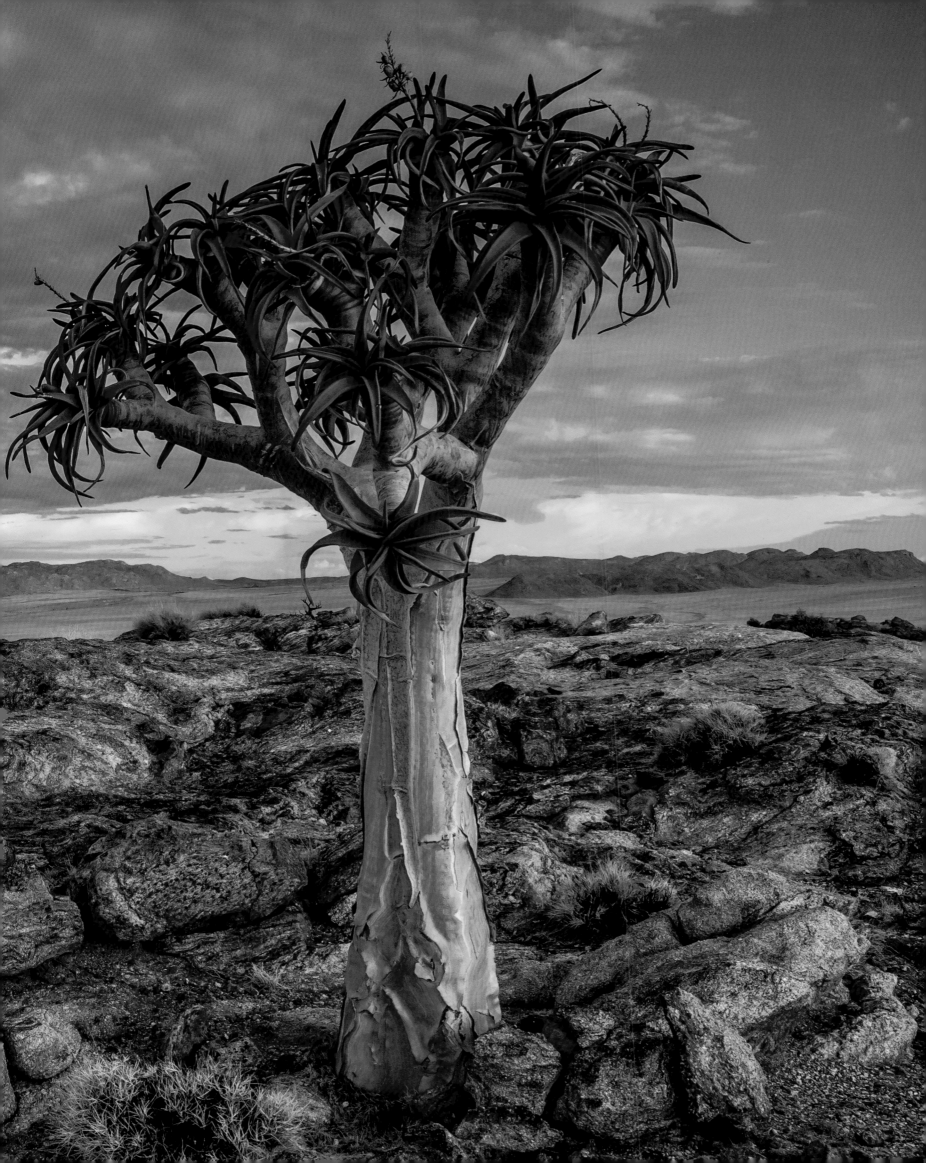

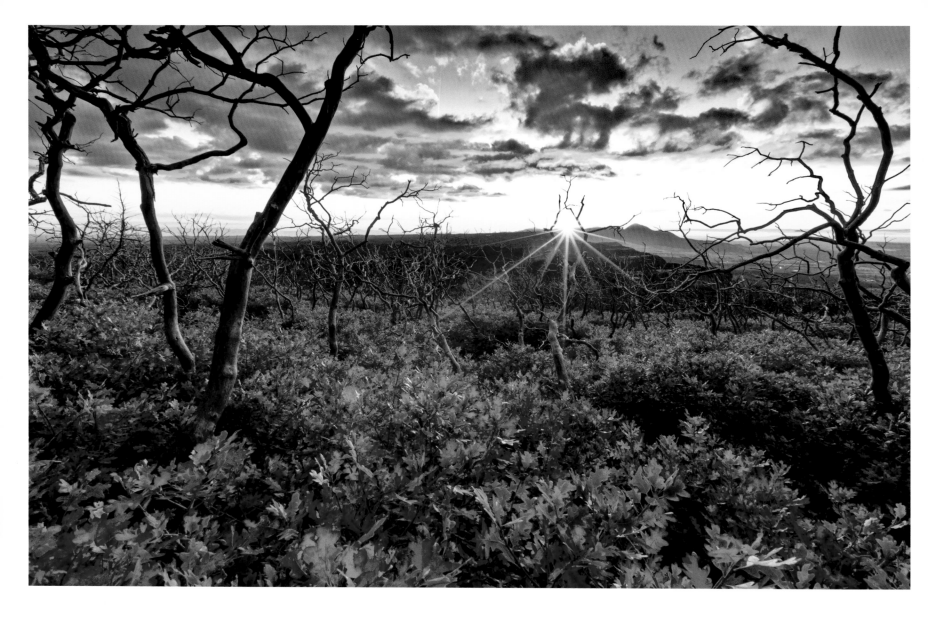

// PREVIOUS PAGE

High over the land of Aus (Klein Aus) in southern Namibia presides this quiver tree, also called a *kokerboom*, awaiting long yearned-for rain. Quiver trees are succulents, the sort of plants able to store water in their pith and foliage for long periods. Standing under a full-grown quiver tree feels like standing beneath a starry sky.

// THIS PAGE

Forest fires are an everyday occurrence in the United States, as here in Mesa Verde National Park in the Southwest. They are much appreciated, too, by trees and other vegetation. Just months after a devastating fire, new plants shoot up from the ground and seize the chance to secure a spot in the sun.

// PAGE 18

The Scottish Highlands are fascinating, with a multitude of wild wonders and many different shades of green best articulated when the sun comes out. The farther you go northward along the west coast of Scotland, the more desolate the hills and mountains become. For me, woods like these are the most beautiful locations in Scotland.

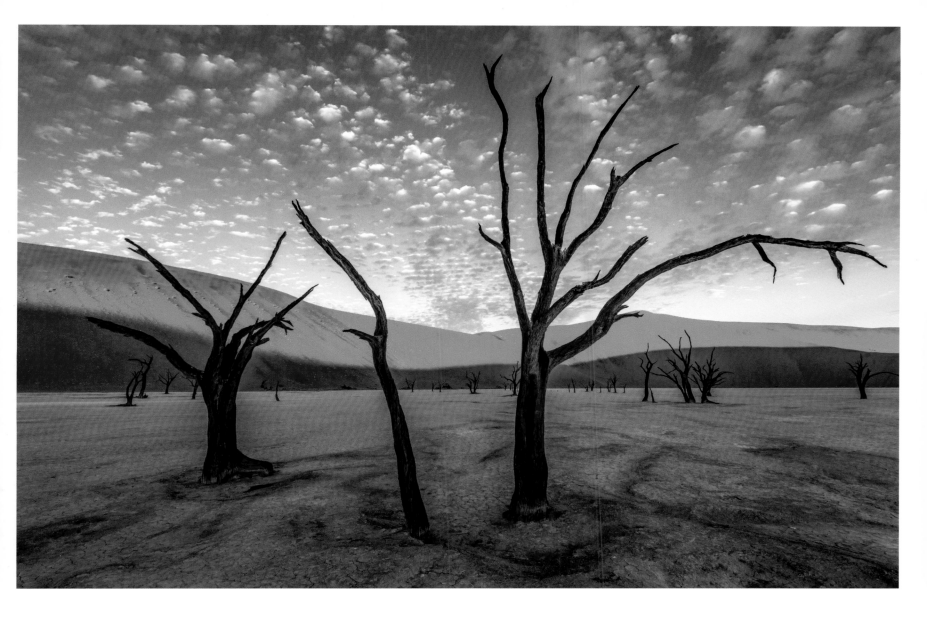

// THIS PAGE

Once, here in Namibia in the midst of Africa's greatest sand dunes, there lived numerous trees. But decades ago the green valley's source of water was cut off by mighty sand dunes, creating a salt pan with died-off trees. People dubbed the area the *Deadvlei*. Today, it seems unimaginable that life once existed here.

// PAGE 19

Few photographers have journeyed into the approximately 5,000 m (16,400 ft.) high Rwenzori Mountains. The paths into the upper reaches are poor and rain occurs practically daily. Ascending means covering 1,000 vertical meters (3,280 ft.) each day in rubber boots, ultimately in order to reach the stands of giant lobelia at the foot of the highest peaks. Nowhere else in the world are there colonies of lobelia this size, and they are regarded as a natural wonder. Because access is difficult, you can go for days or weeks here without seeing another soul.

// PAGE 20/21

New Zealand enthuses me with pristine nature, beautiful forests, and mountains, and innumerable one-of-a-kind waterfalls. Definitely one of the most gorgeous of these cascades is McLean Waterfall in the Catlins. Through the densest rainforest a small, moss-grown canyon makes its way down into a valley.

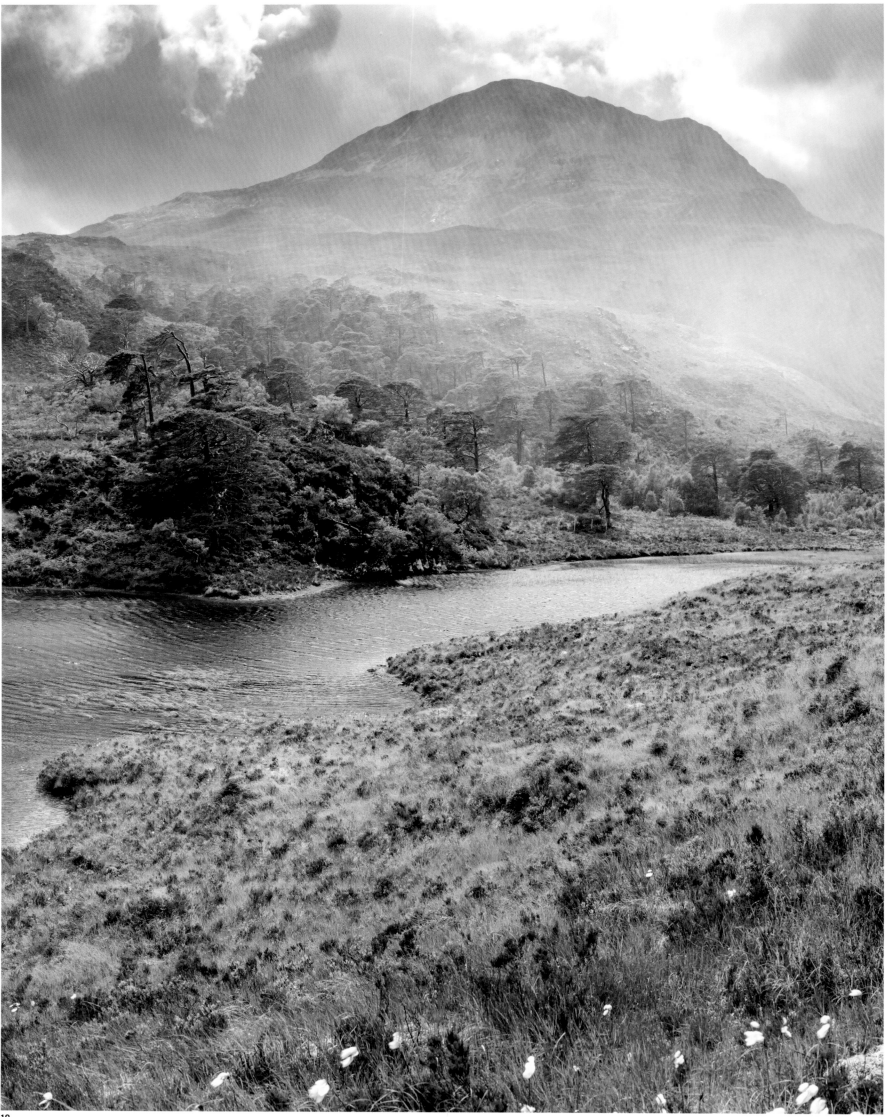

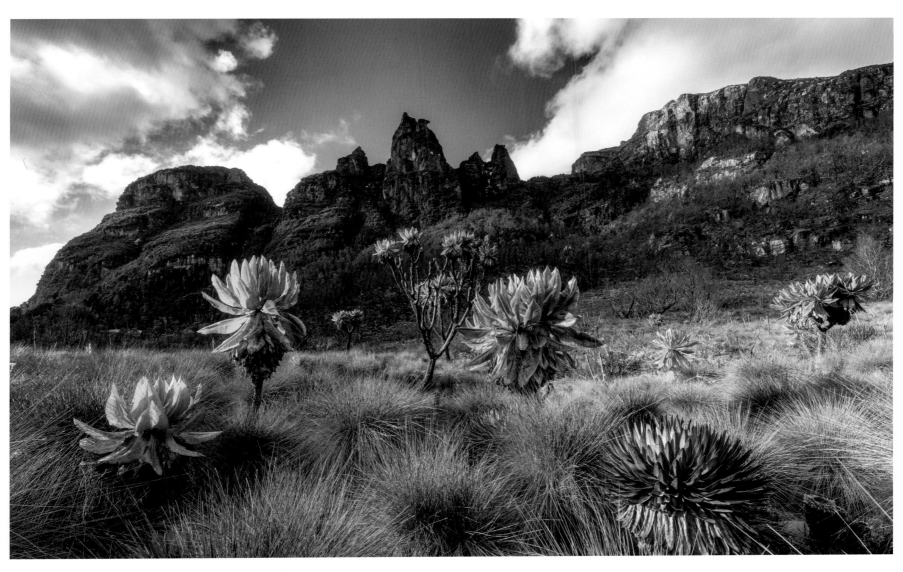

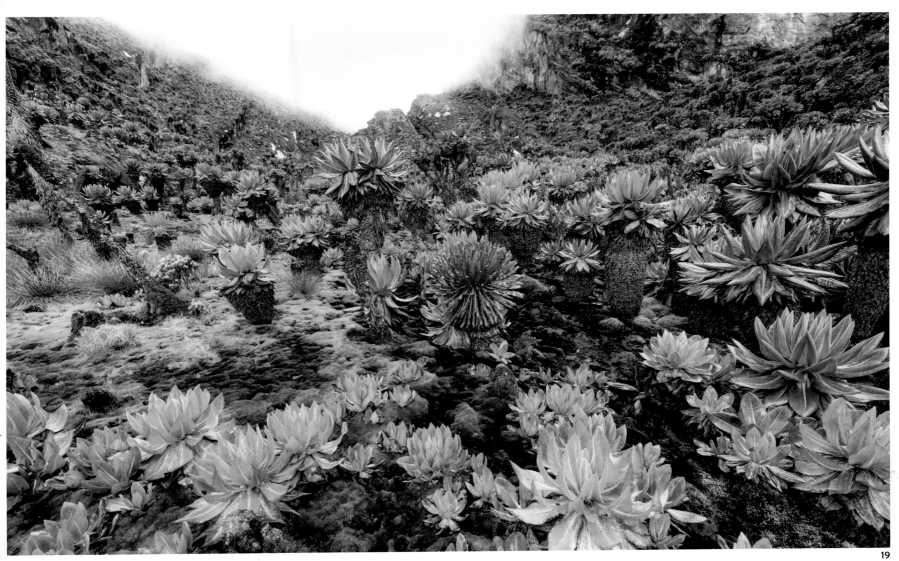

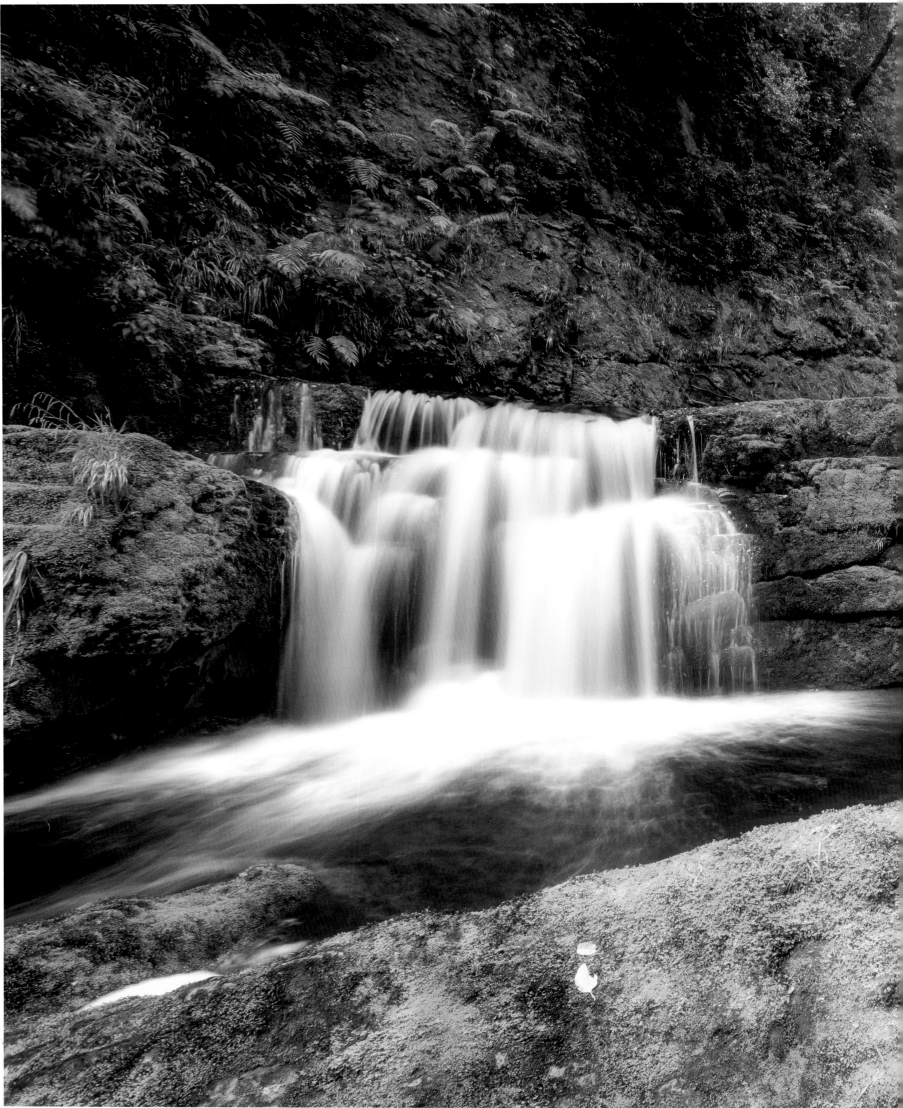

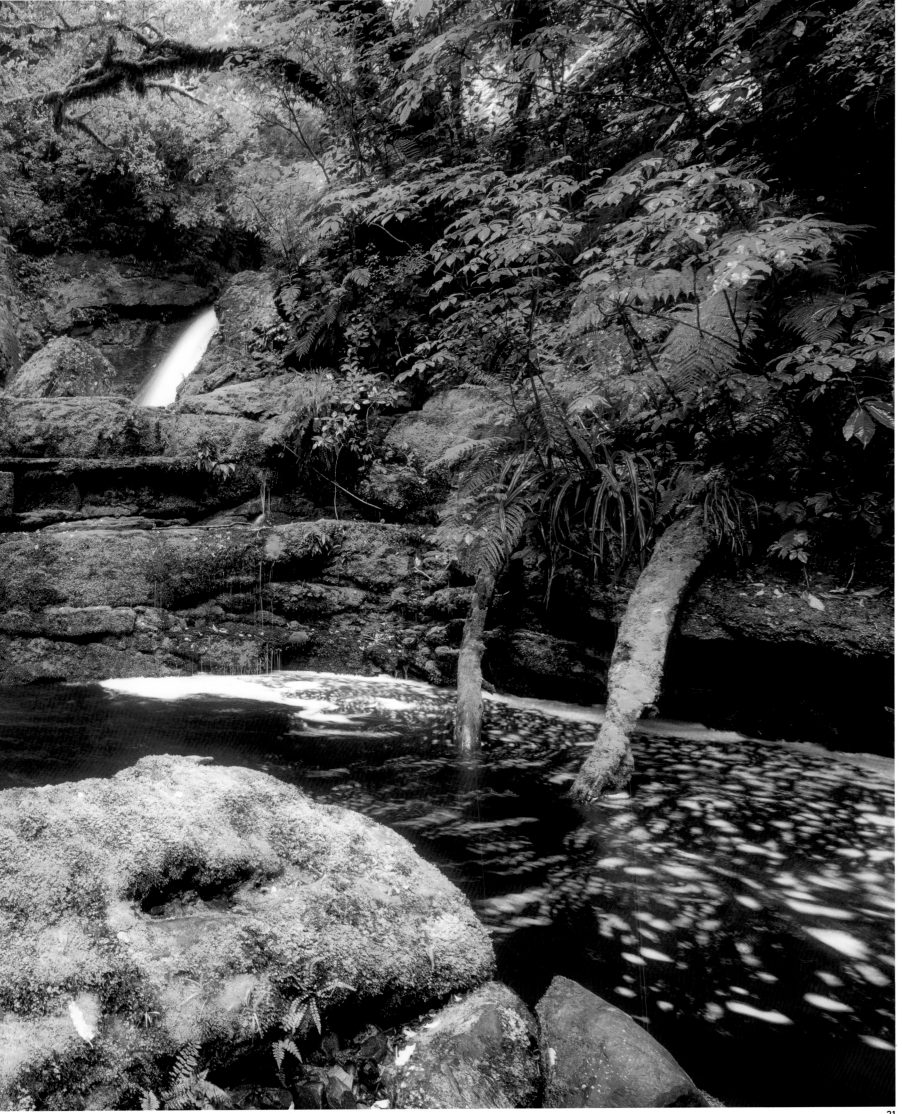

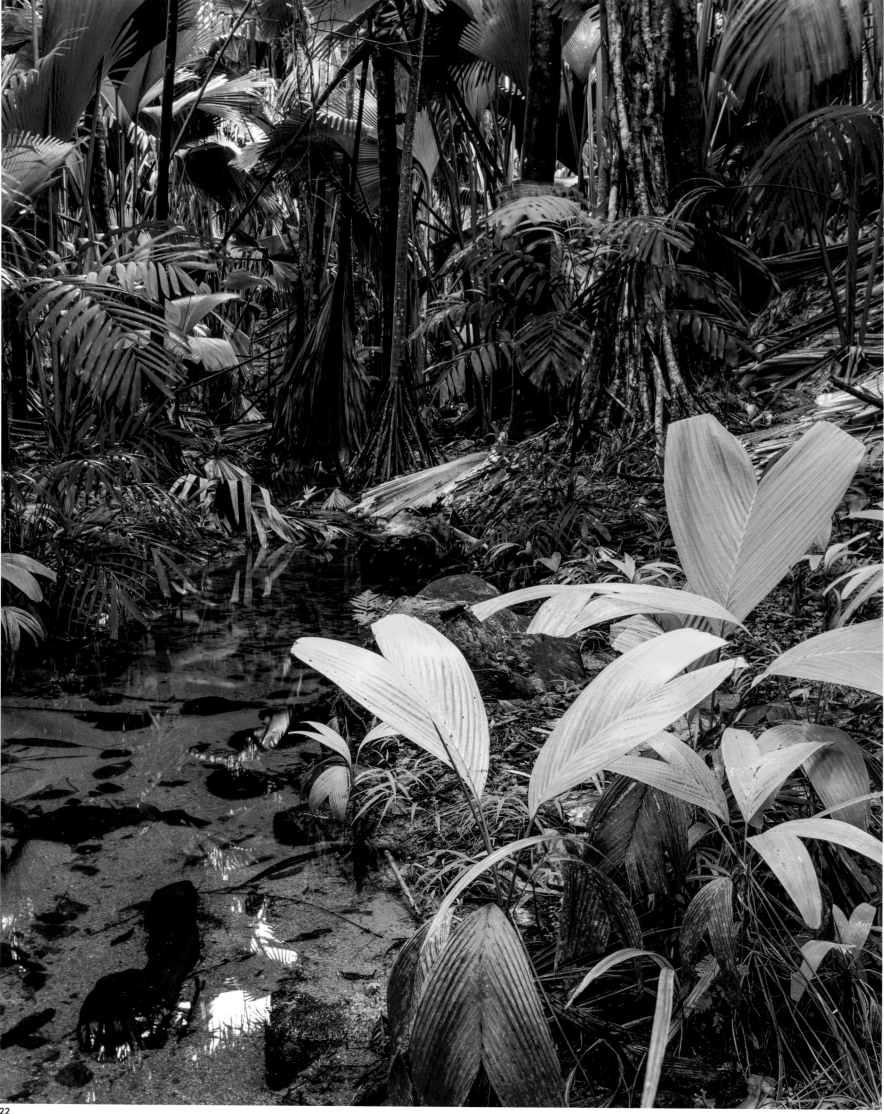

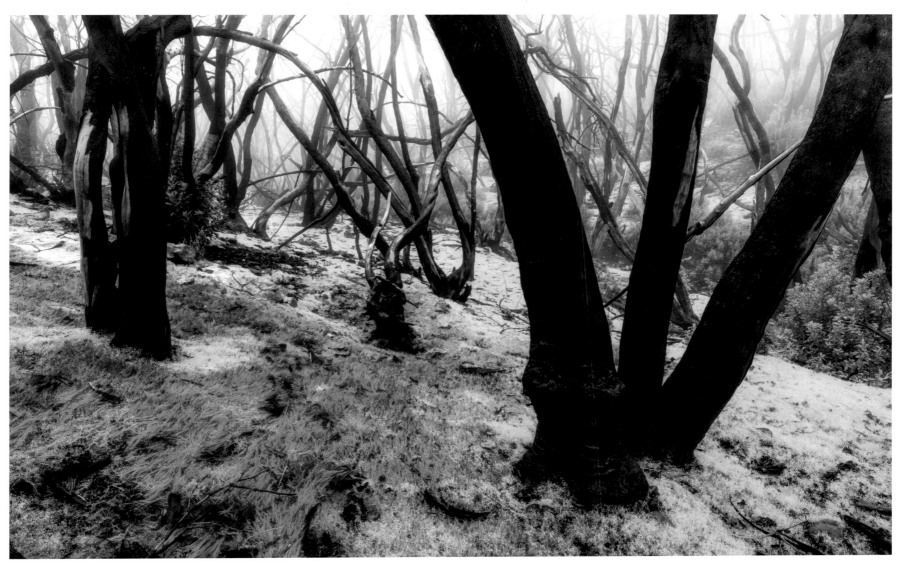

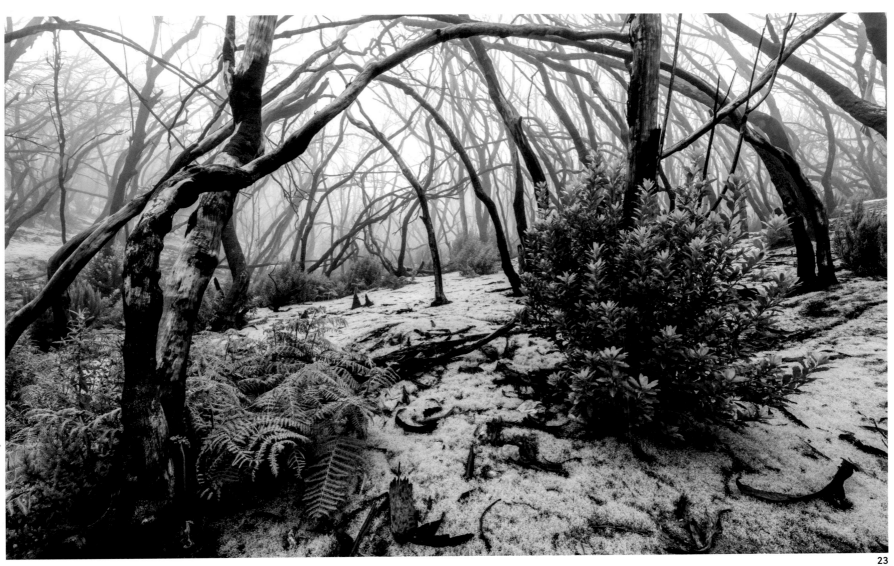

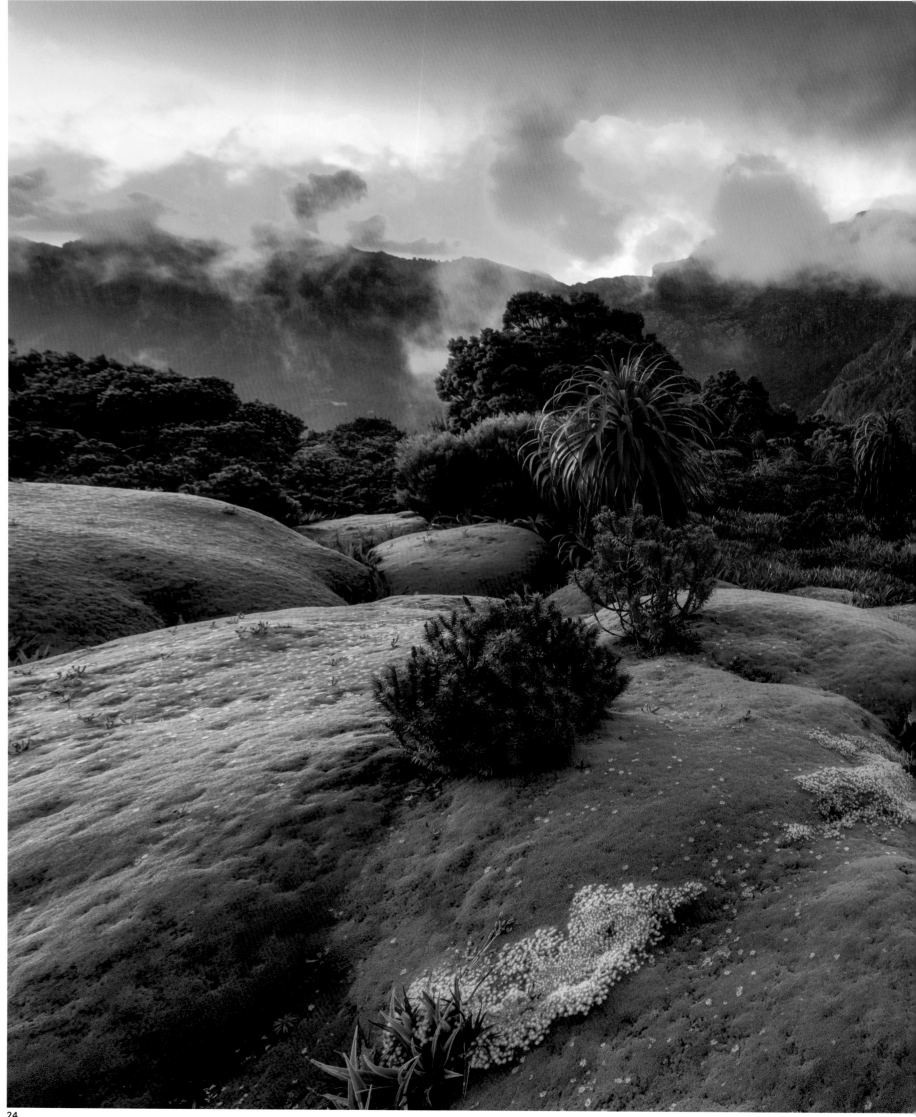

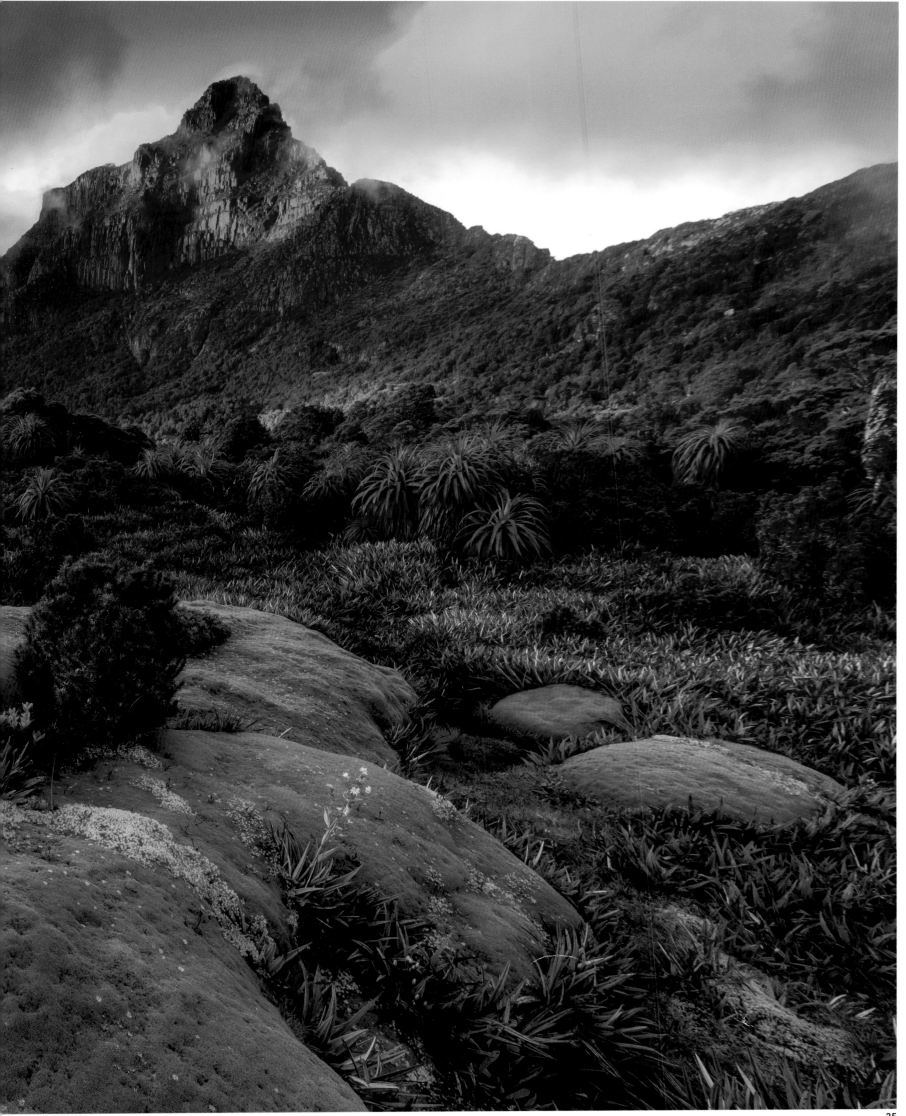

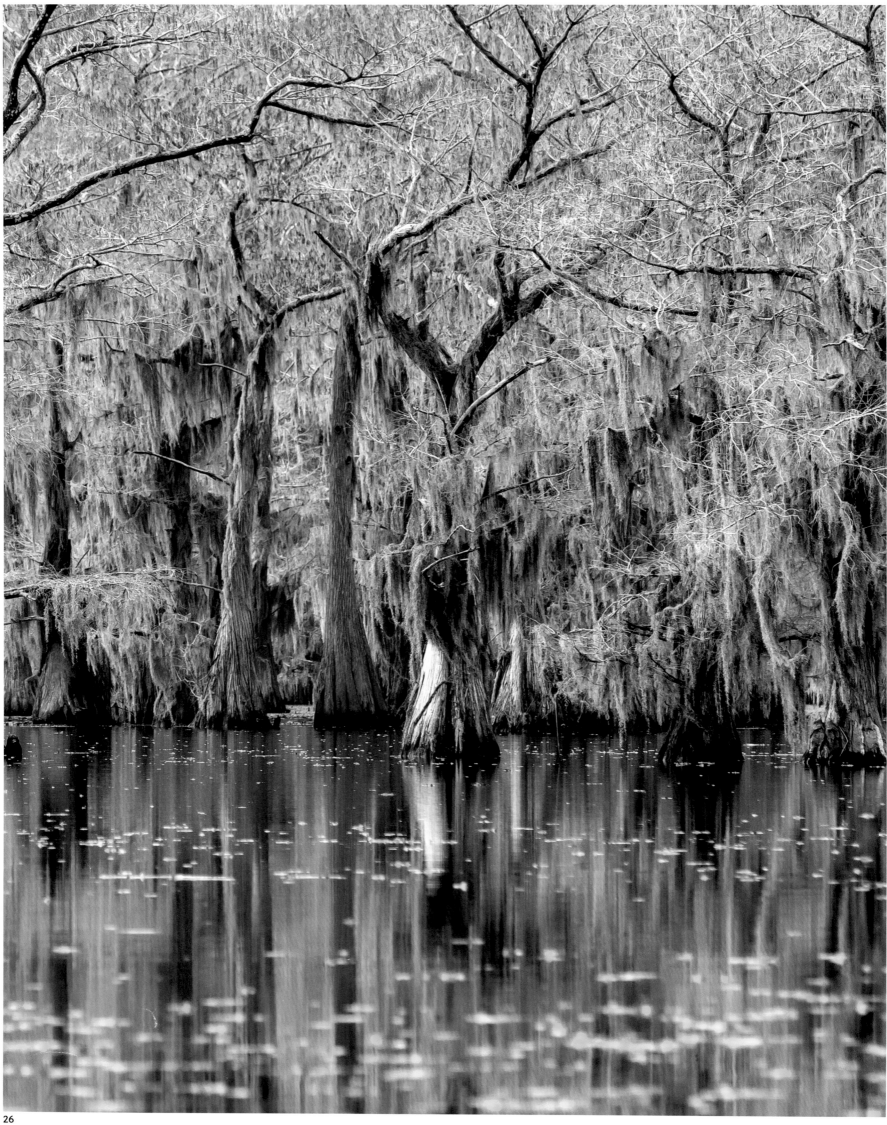

// PREVIOUS PAGE

Another view of Mount Anne with Australia's largest cushion plant and a wonderful pandanus palm in the foreground—a landscape that calls to mind the age of the dinosaurs like none other I've ever seen. In fear that one's footsteps could damage this fragile landscape few have visited, one treads herewith extreme caution.

// THIS PAGE

The cypresses of Louisiana in the United States don't just look old but really are—old. This tree, hung with Spanish moss, has stood in the turbid water for an estimated 1,200 years and produces new shoots every year. I felt honored to share in the experience of this annual wonder from my kayak.

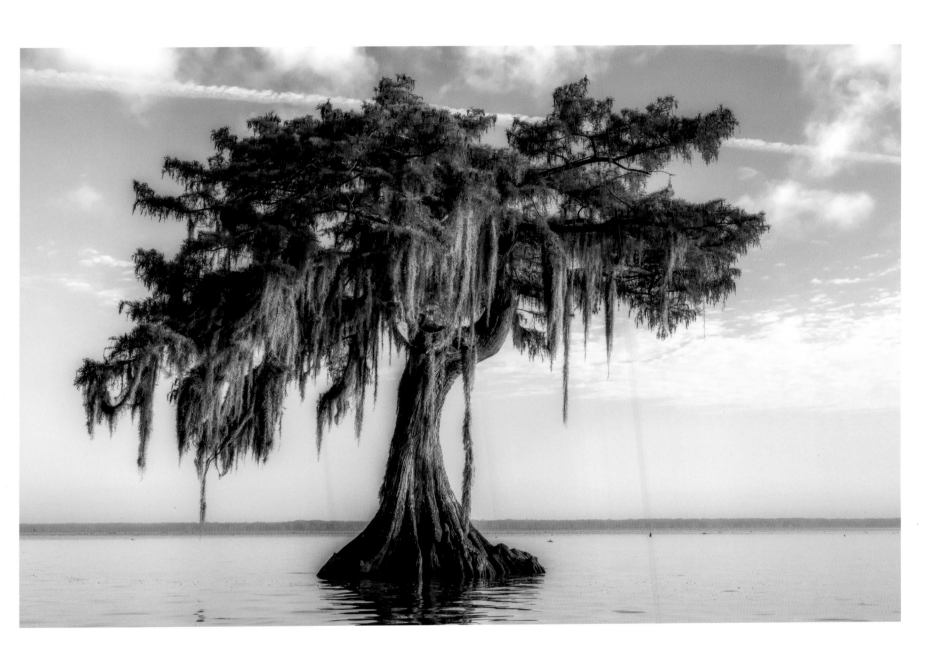

// OPPOSITE PAGE

In 2014, I determined to paddle alone in a kayak through the swamps in the southern United States and record the beauty of the cypress forests. What awaited me was fascinating beyond expectation. Amidst these trunks is an infinite abundance of life. Enormous alligators, turtles, and snakes inhabit this fish-filled wetland.

// NEXT PAGE

I reckon the Hoh Rainforest in Olympic National Park in the western United States among our planet's most beautiful forests. The endless biomass of these woods practically crushes anyone wandering through. Rivers wind their way through a forest grown over with moss and lichens. Annual precipitation can run as high as 4,200 mm (165 in.)—a huge quantity of water.

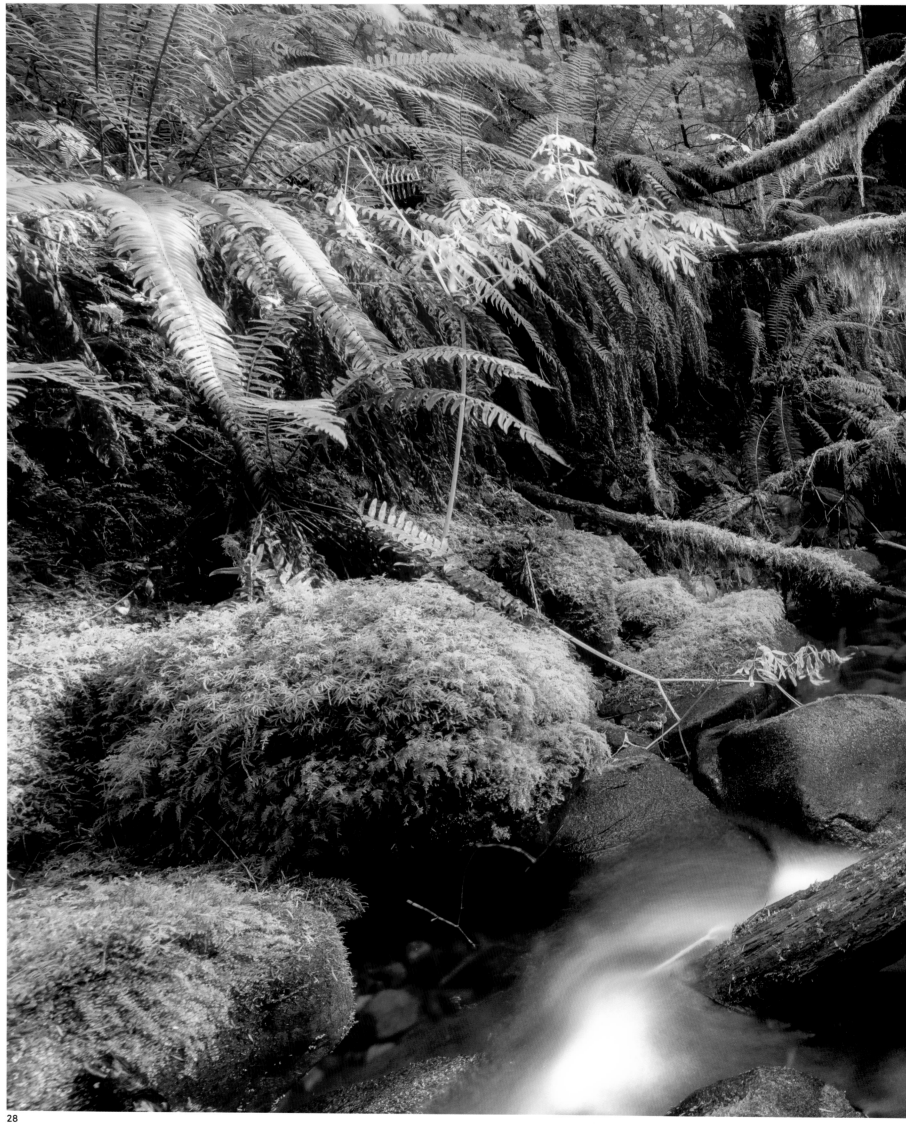

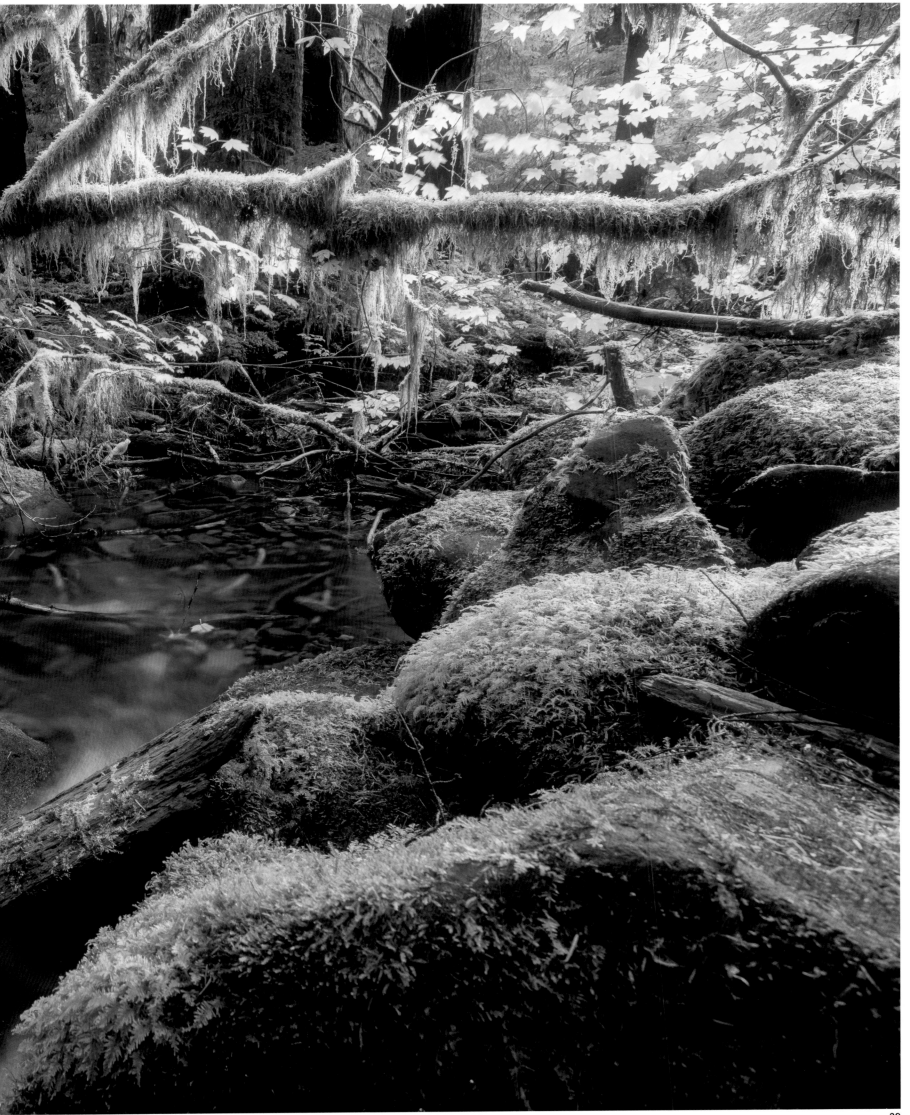

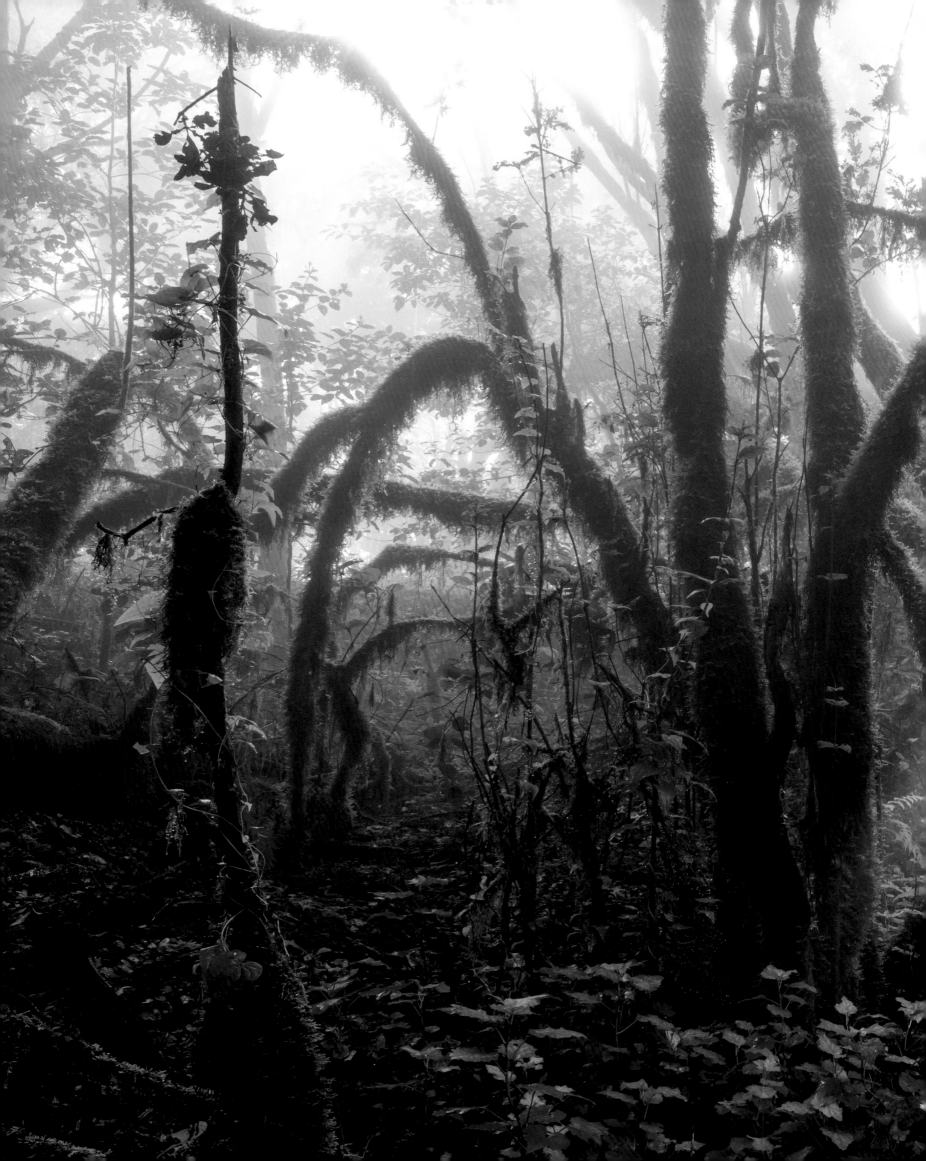

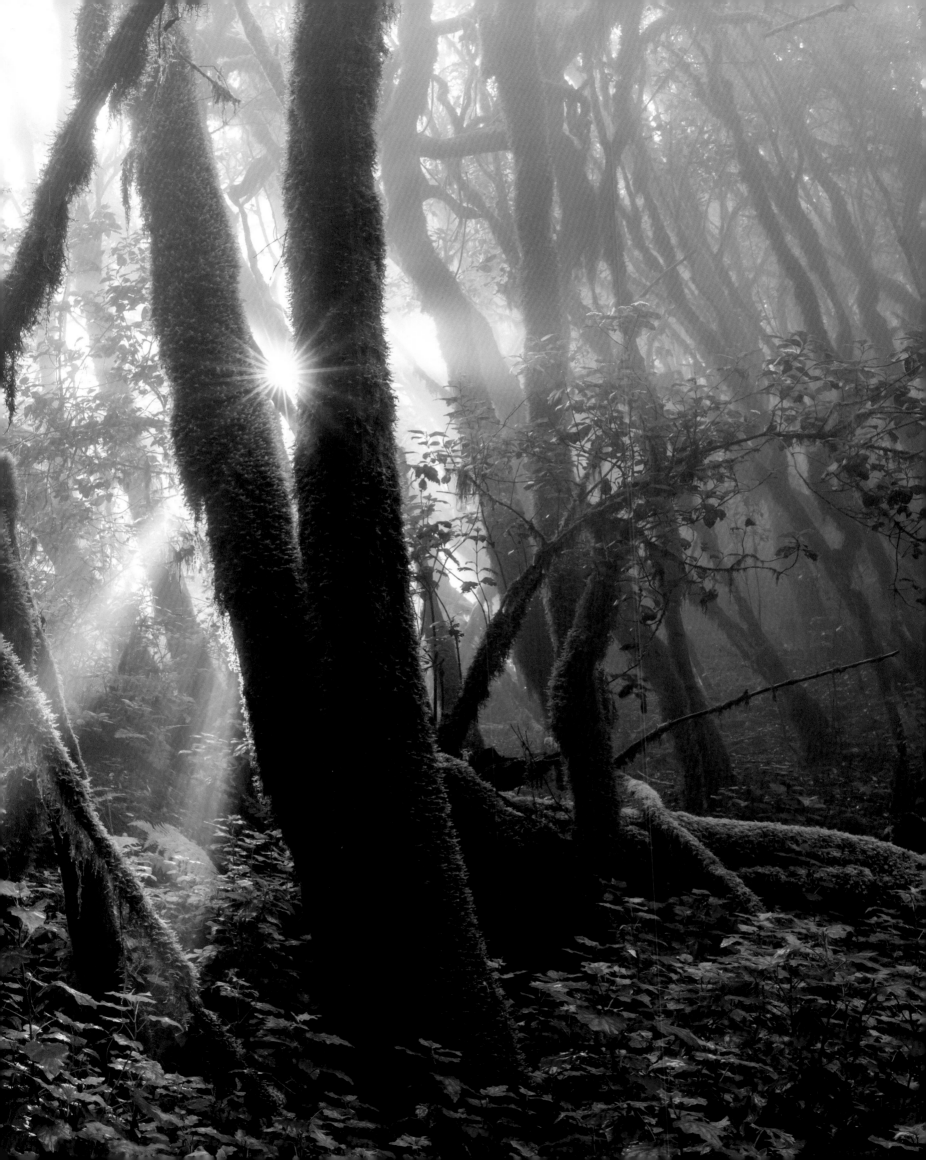

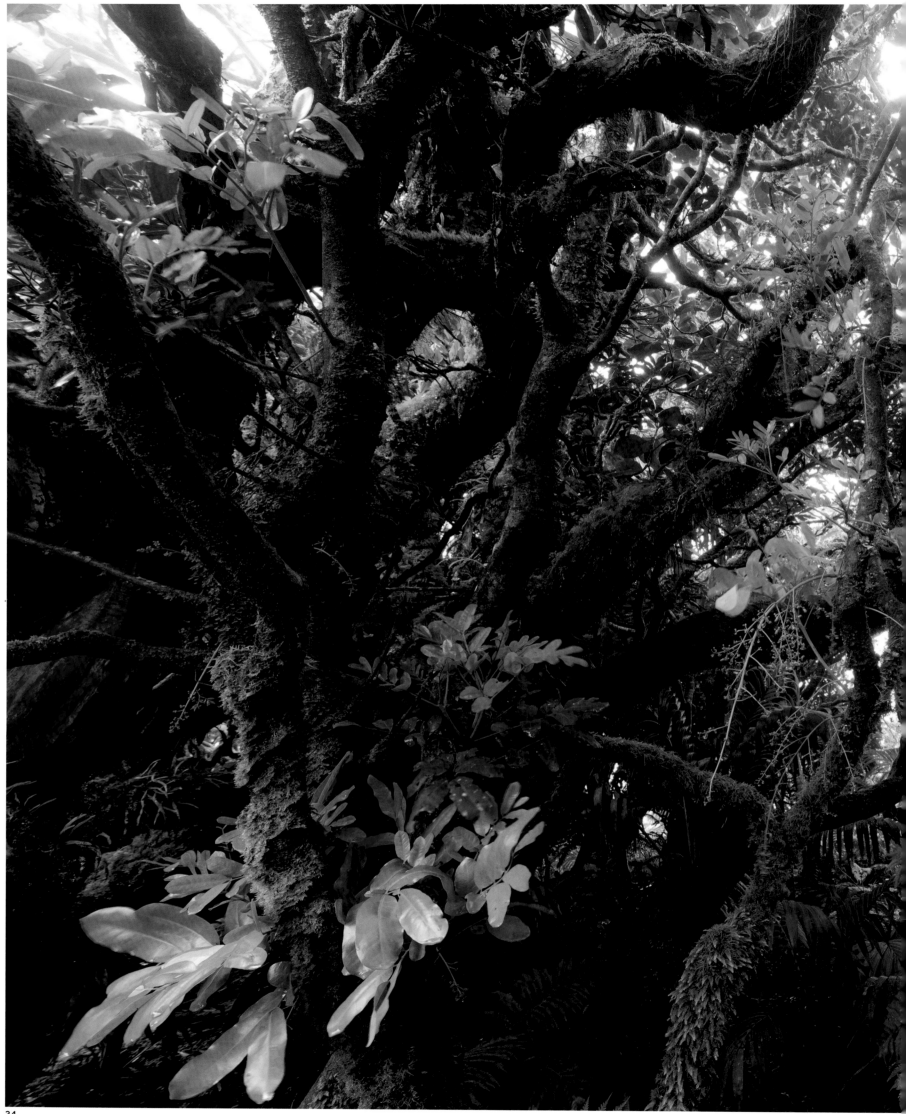

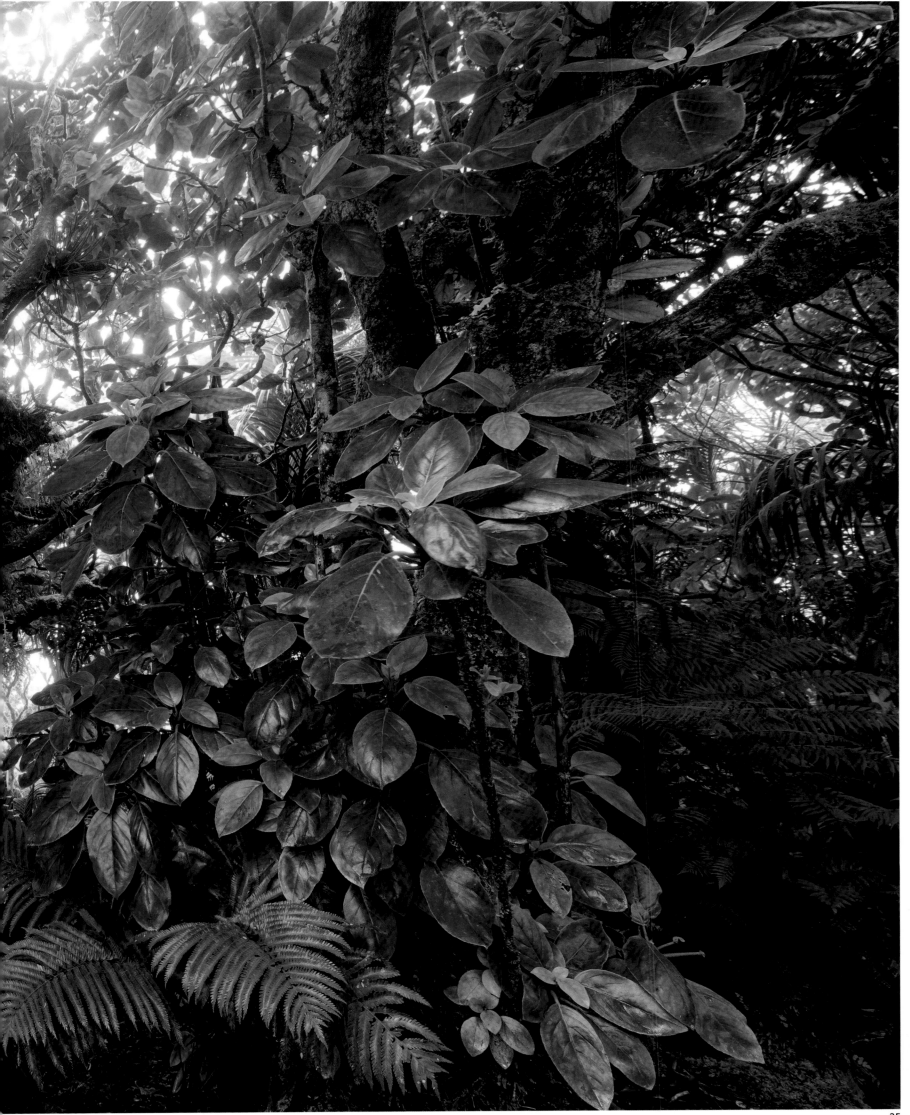

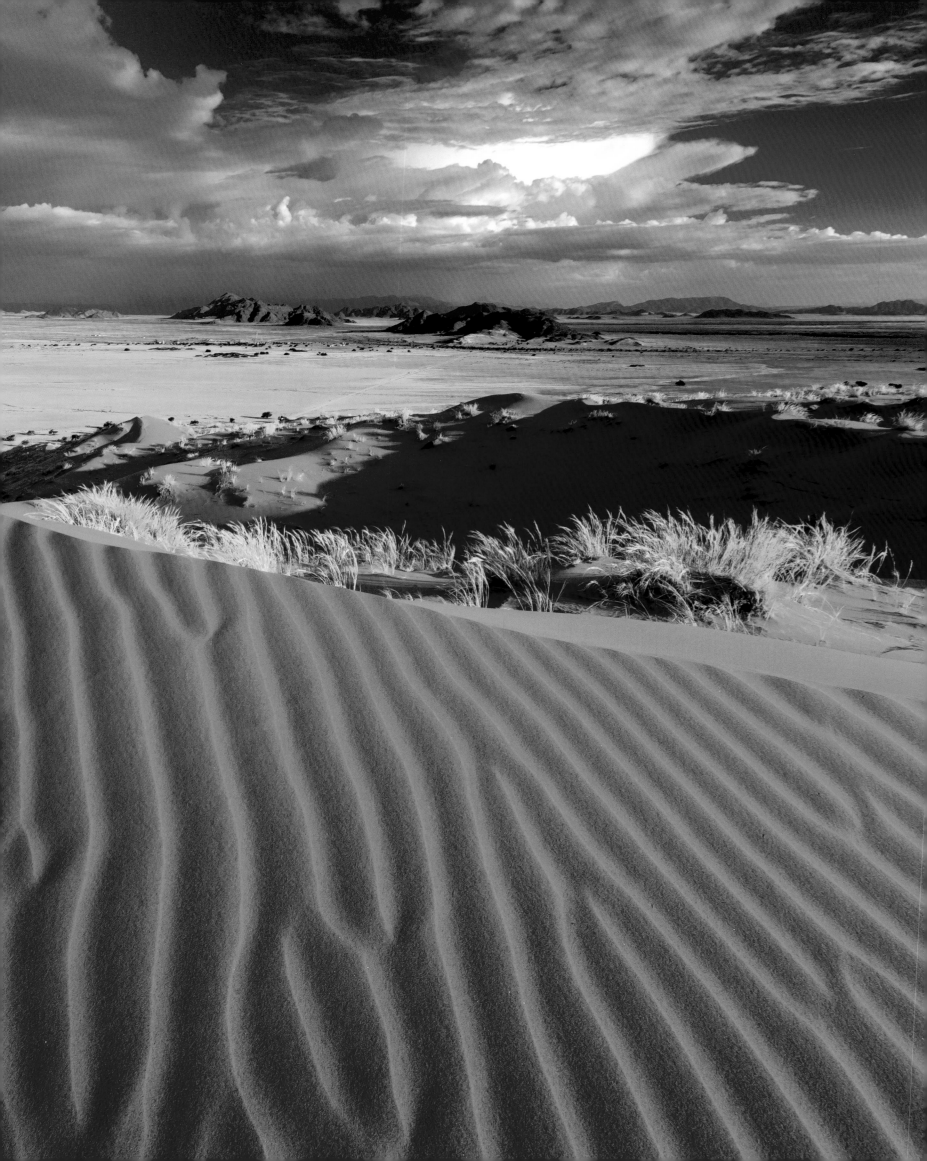

SAND DUNES AND DESERTS //
SANDDÜNEN UND WÜSTEN // LES DUNES ET LES DÉSERTS //

2

Where there is sand, nothing can live. That's what a person might think upon first seeing the great deserts of Africa and elsewhere on earth. In the spring of 2015, I was lucky enough to become one of the few to ever witness a multiday rainfall episode over the Namib Desert. Within two weeks, grass sprang up in never-expected locations, and entire herds of springbok and oryx found, as if by divine grace, a path between the dunes of the Namib-Naukluft Park, which at this point had taken on the appearance of a most beautifully groomed golf course. The healthy green of the grass and the intense red of the still-moist dunes met the eyes with a never-before-seen contrast.

However, there are dunes not only in Africa, but in Tibet among the earth's highest mountains; at the foot of Mount Bromo in Indonesia; in Great Sand Dunes National Park in Colorado in the United States; and in many other locations around the world. All of them are governed by an incomparable stillness. Resulting from the continuous clearing of forests around the world and the overworking of farmland, the world's deserts have been expanding from year to year.

Wo Sand ist, gibt es kein Leben. Dies könnte man beim ersten Betrachten der großen Wüsten Afrikas und anderswo auf der Erde denken. Im Frühjahr 2015 durfte ich als einer der wenigen Zeugen einen tagelang anhaltenden Regenfall über der Wüste Namibias miterleben. Innerhalb zweier Wochen sprießte das Gras an Orten, an denen man es nie zuvor erwartet hätte und ganze Herden von Springböcken und Oryxantilopen fanden wie durch ein Wunder den Weg zwischen den Dünen des Namib-Naukluft-Nationalparks, der nun aussah wie der schönste, gepflegteste Golfplatz. Das frische Grün des Grases und das intensive Rot der noch nassen Dünen boten einen nie gesehenen Kontrast.

Doch Dünen gibt es nicht nur in Afrika, sondern auch in Tibet, zwischen den höchsten Bergen der Erde, am Fuße des Bromo Vulkans in Indonesien, in Colorado im Great-Sand-Dunes-Nationalpark in den USA und an vielen weiteren Orten dieser Erde. Sie alle haben etwas gemeinsam: Es herrscht dort eine unvergleichliche Ruhe. Durch weltweit voranschreitende Rodung der Wälder und Überbeanspruchung der Ackerländer haben Wüsten weltweit von Jahr zu Jahr mehr an Fläche gewonnen.

Il n'y a pas de vie là où il y a du sable. C'est ce qu'on pourrait penser à première vue à la contemplation des déserts d'Afrique et d'ailleurs. Or, au printemps 2015, j'ai eu la chance rare de vivre un épisode pluvieux de plusieurs jours au-dessus du désert de Namibie. En l'espace de deux semaines, l'herbe s'est mise à pousser là où on ne l'attendait sûrement pas, des hordes de springboks et d'oryx ont trouvé, comme par miracle, leur chemin à travers les dunes du parc national du Namib Naukluft qui avait pris l'apparence d'un magnifique terrain de golf parfaitement entretenu. Le vert frais de l'herbe cohabitant avec le rouge ocre des dunes détrempées formait un contraste sans précédent.

Mais les dunes ne sont pas l'apanage de l'Afrique, on en rencontre également au Tibet, entre les plus hautes montagnes au monde, en Indonésie, au pied du volcan Bromo, ou encore dans le Colorado, aux États-Unis, dans le parc national et réserve de Great Sand Dunes, pour ne citer que quelques exemples et en bien d'autres endroits de la planète. Leur point commun: il y règne un calme incomparable. Le déboisement progressif des forêts un peu partout dans le monde et la surexploitation des terres agricoles contribuent d'année en année à la progression des déserts.

// OPPOSITE PAGE

High iron content stains Namibia's sand dunes a flush, rusty red. Hardly any other country in the world enchanted me with as many different colors as Namibia. Many of the images even seem a bit unreal because of the intersection of so many contrasts and hues.

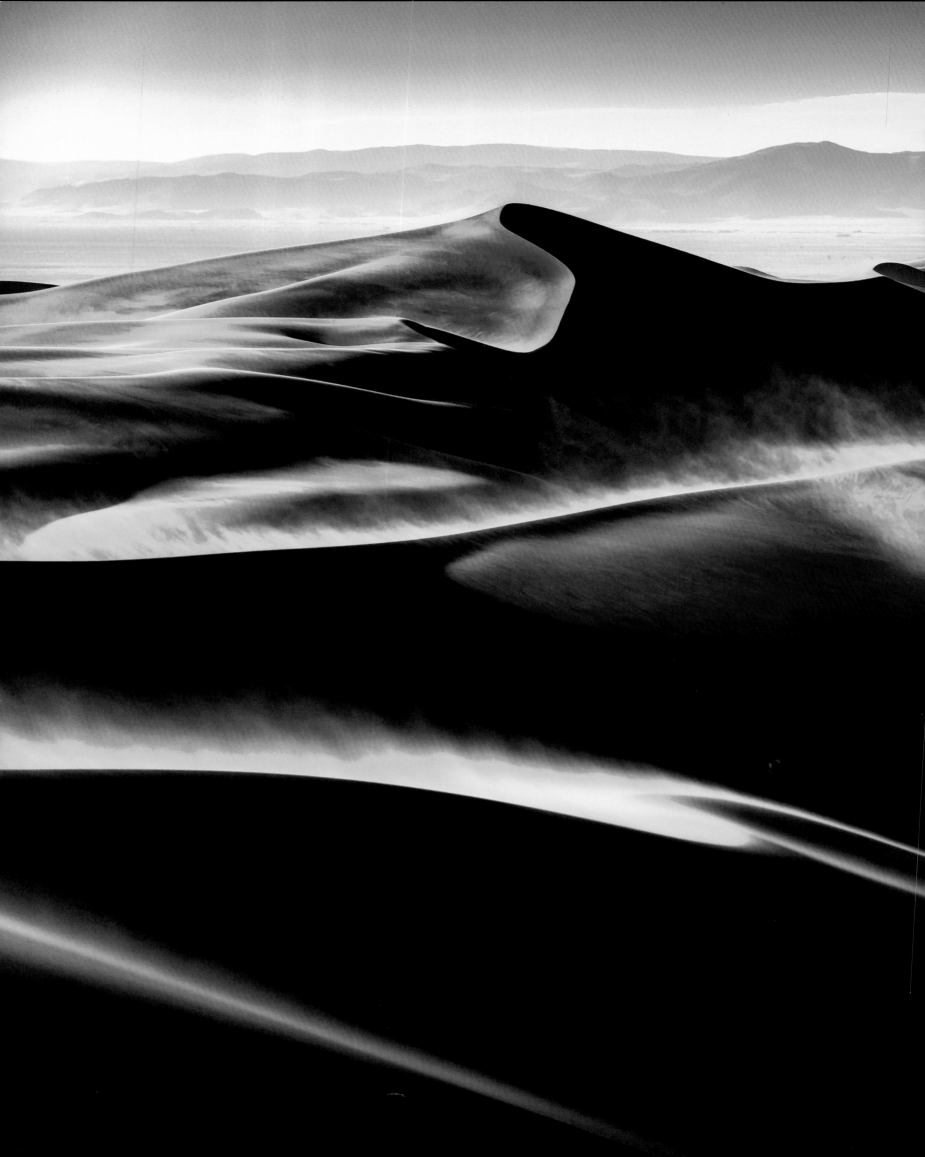

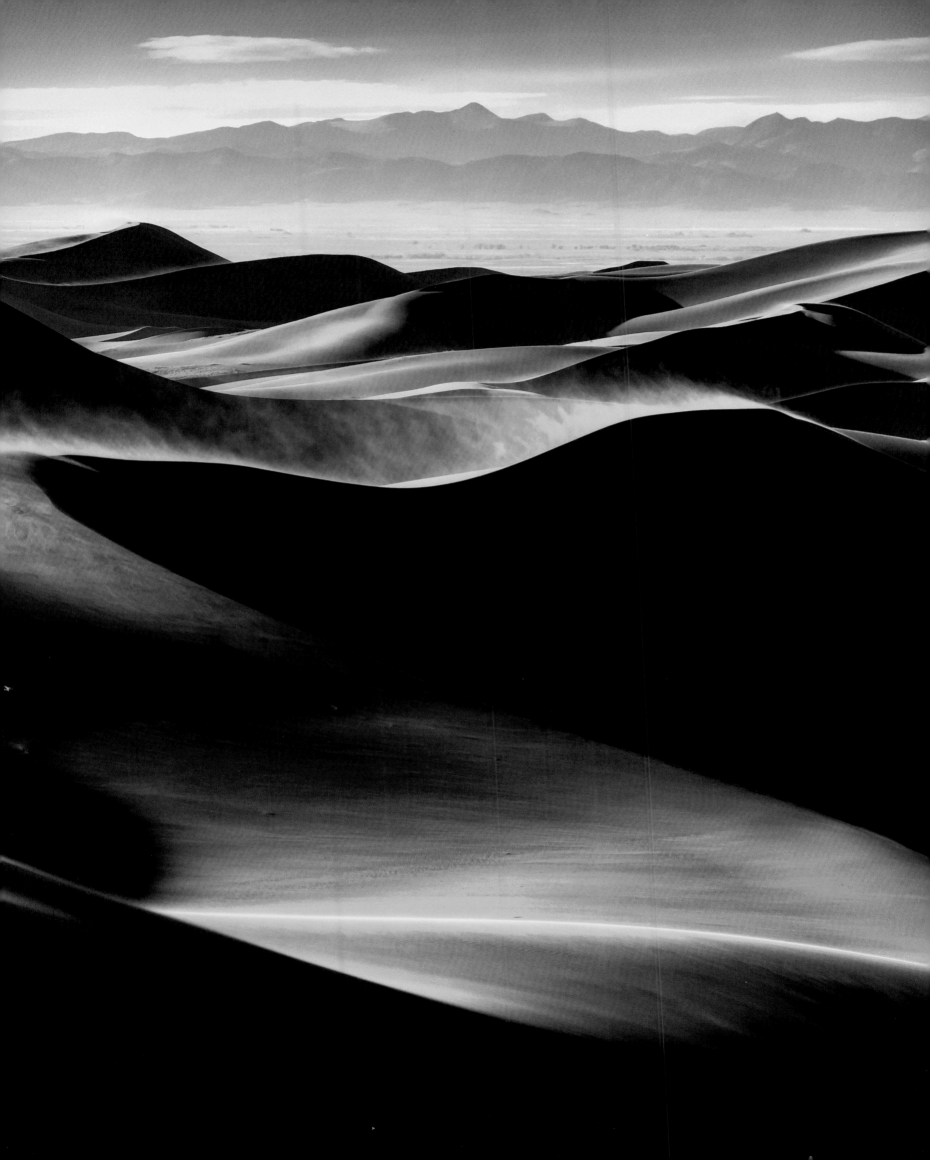

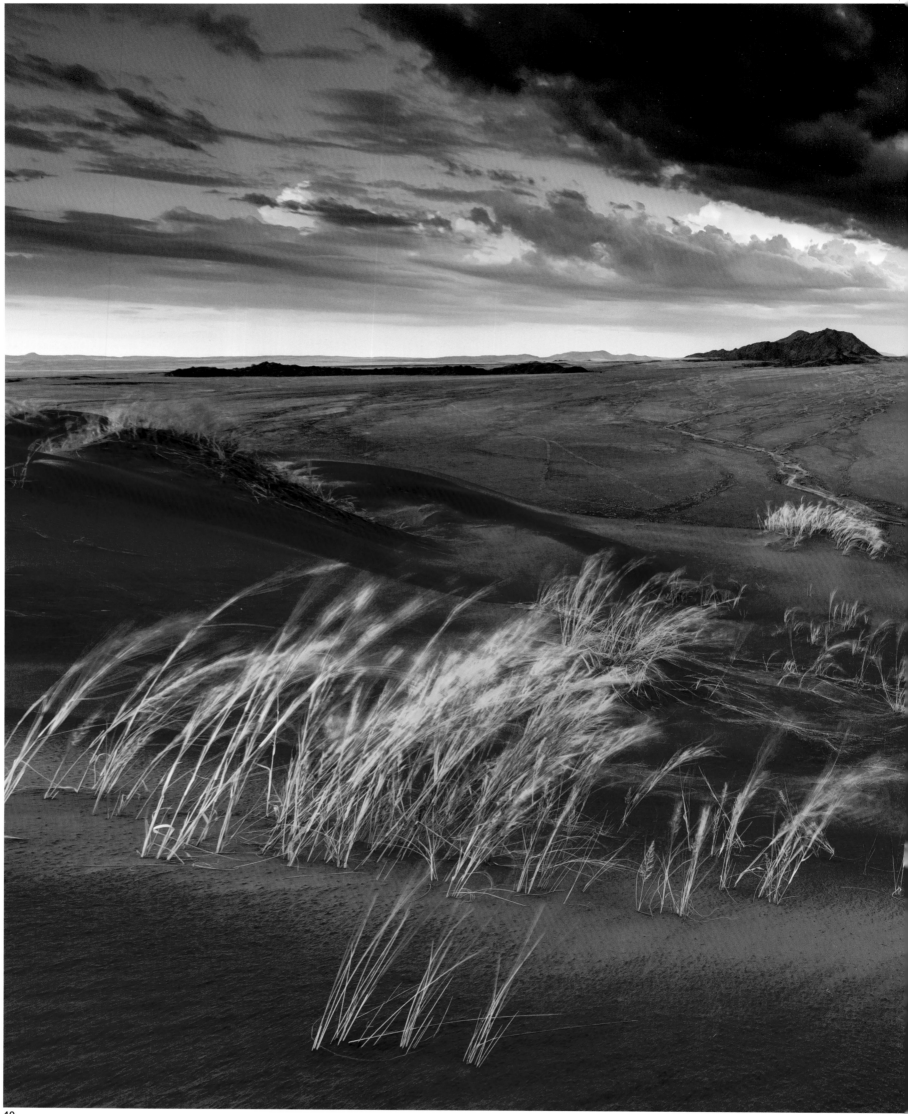

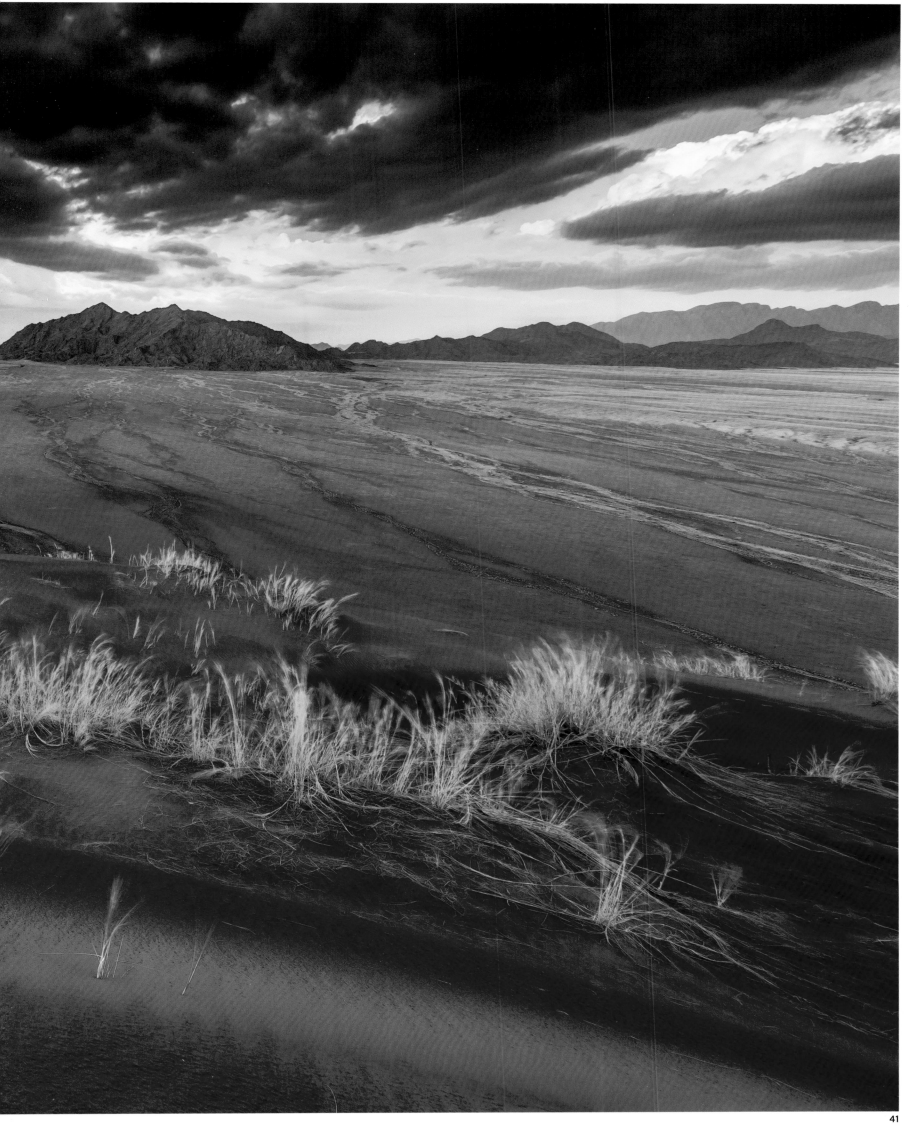

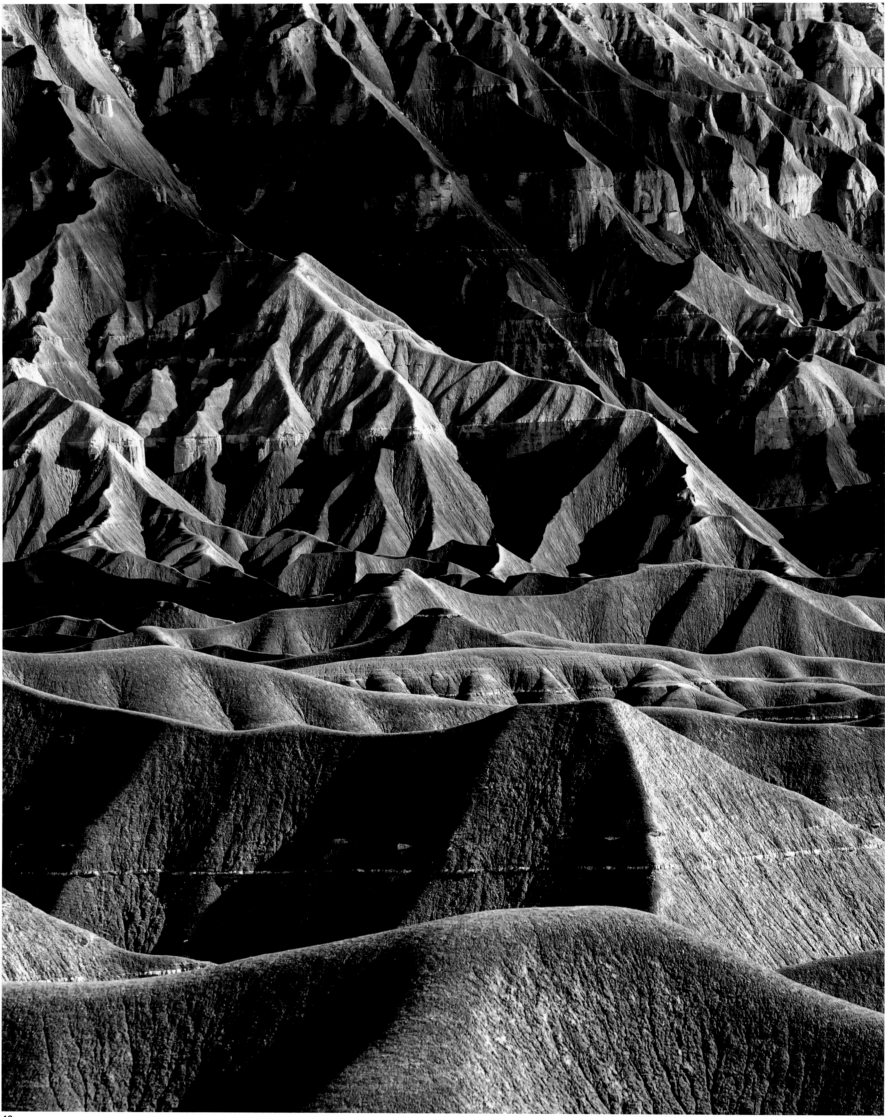

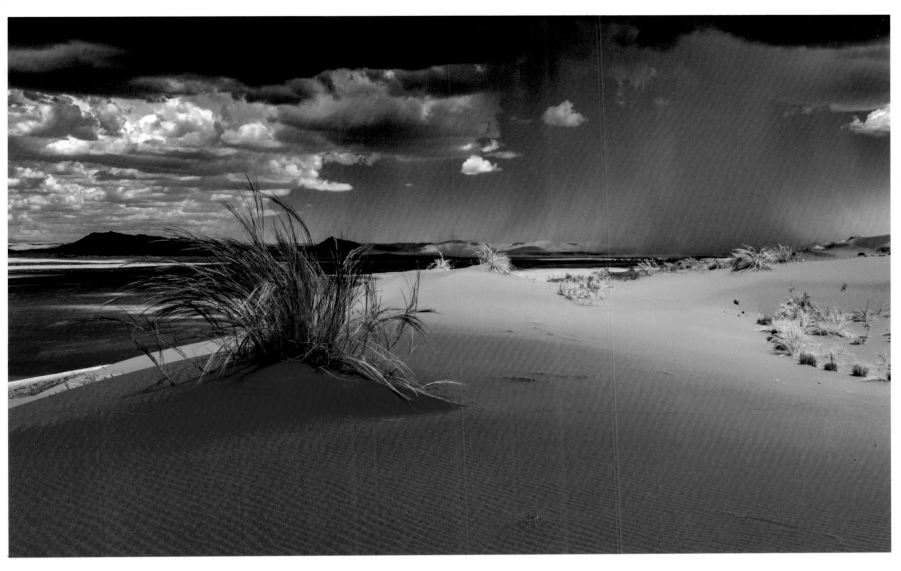

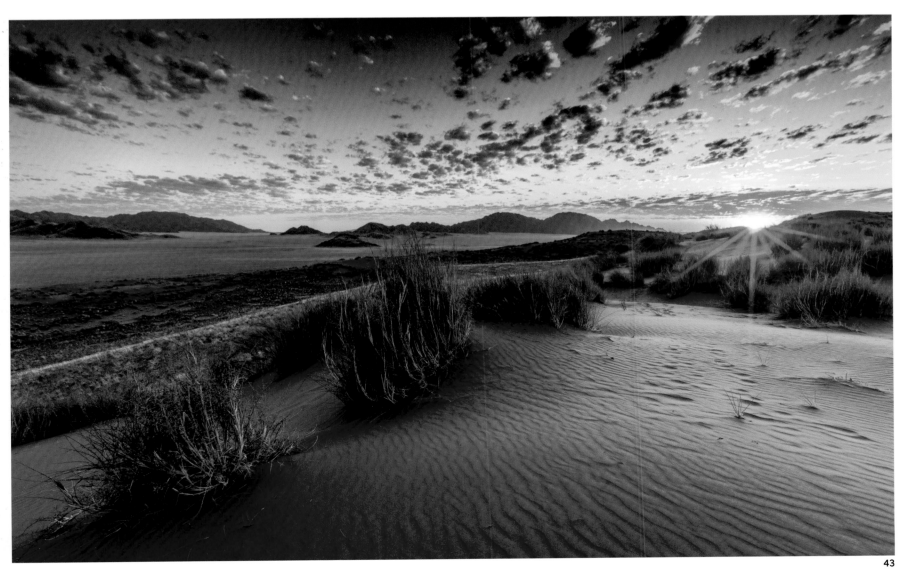

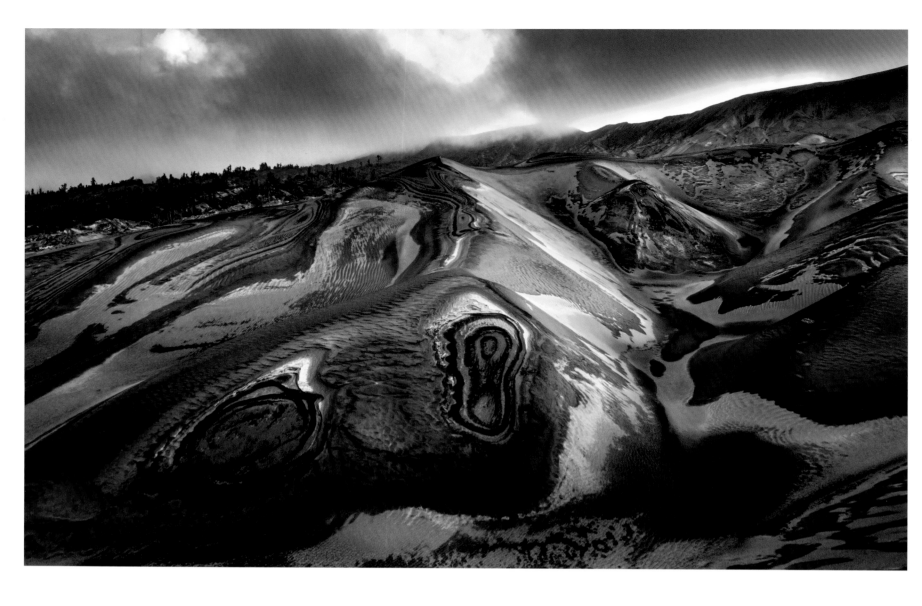

// PAGE 38/39

What looks like Africa is really the Great Sand Dunes National Park and Preserve in the heart of the United States. Giant volumes of sand have collected against the slopes of the Humboldt Peak and Blanca Peak over thousands of years. The dunes are among the tallest in North America. In winter, the dunes completely freeze and are sometimes blanketed by a meter (just over 3 ft.) of snow.

// PAGE 40/41

Namib-Naukluft National Park in western Namibia contains the largest sand dunes in Africa. The most beautiful sand dune to me, called Elim Dune, is covered to the top with dune grass and directly abuts mountains at the edge of the park. For this unique sunset, I have an advancing thunderhead to thank, which made the sky look quite threatening.

// PAGE 42

Badlands National Park lies in the southwest corner of the state of South Dakota. The Badlands are so-called because agriculture seemed unthinkable in this landscape, which farmers then dismissed as "bad land." The different layers and shapes, products of thousands of years of erosion, were incredibly fascinating to me as a photographer.

// THIS PAGE

What looks like sand in this image is actually volcanic ash. Just above these fascinating ash dunes lies the Bromo volcano, which every few years erupts fresh ash deposits. This beautiful landscape is found in the highlands of the island of Java, Indonesia.

// OPPOSITE PAGE

Unlike other deserts that get practically no precipitation, the dunes of Great Sand Dunes National Park and Preserve are blown against the slopes of the Colorado mountains, where they are regularly supplied with water. In cold weather the dunes become frozen at night, and the morning light sets them aglow in bright white light.

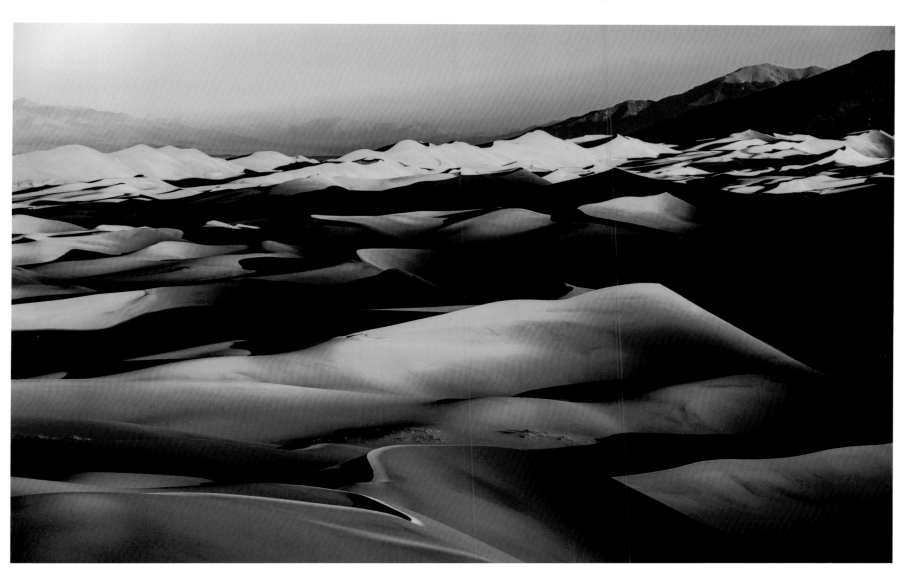

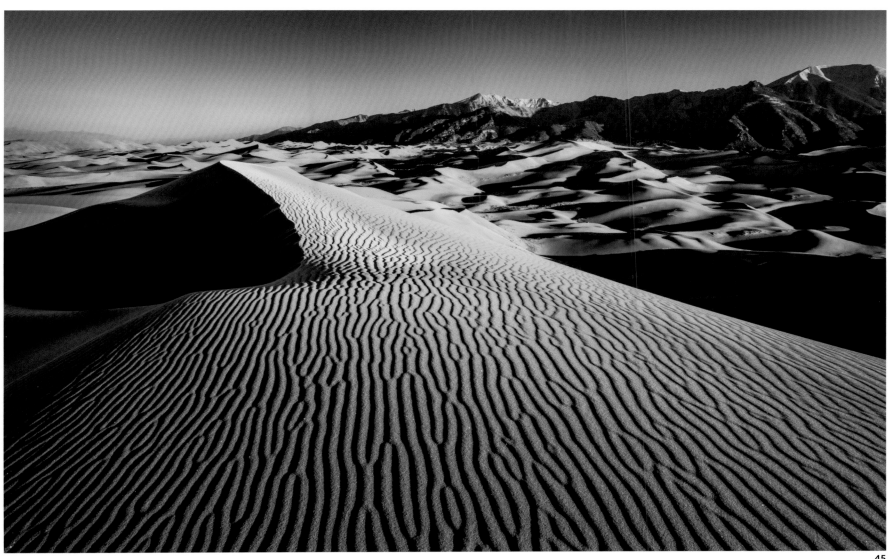

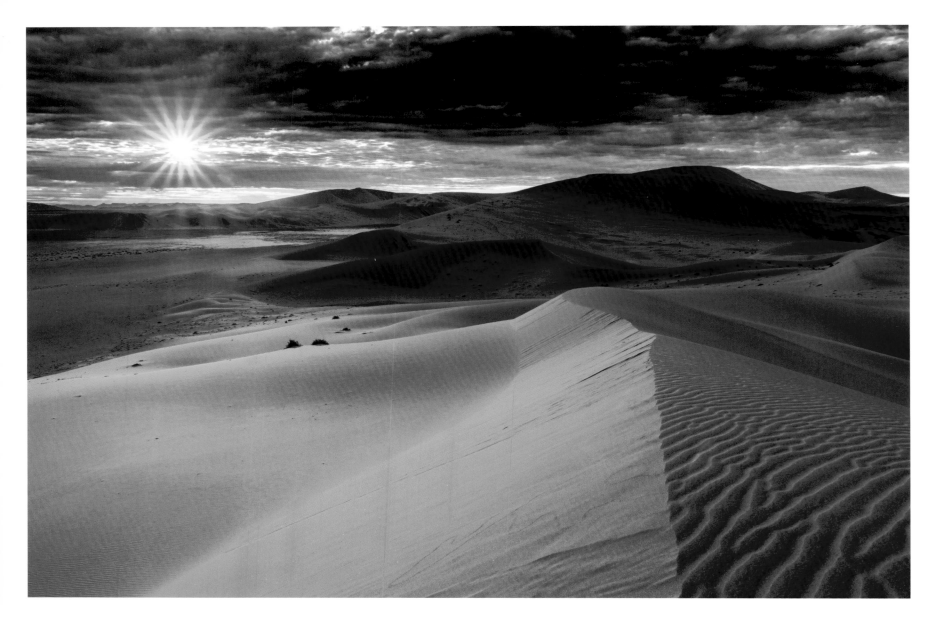

// THIS PAGE

In terms of physical exertion, climbing a 100 m (330 ft.) high sand dune is like hiking up a 300 m (990 ft.) peak. Upon the main ridge, however, you'll enjoy a fantastic view. Because of immense daytime heat in Namibia, people ascend such dunes mostly at night or in early morning.

// OPPOSITE PAGE

When full, the moon appears on the horizon as the sun sets, at which time it can be viewed at the same brightness as the surrounding landscape. In Namibia, you can wait decades to see it rise over such a green surface.

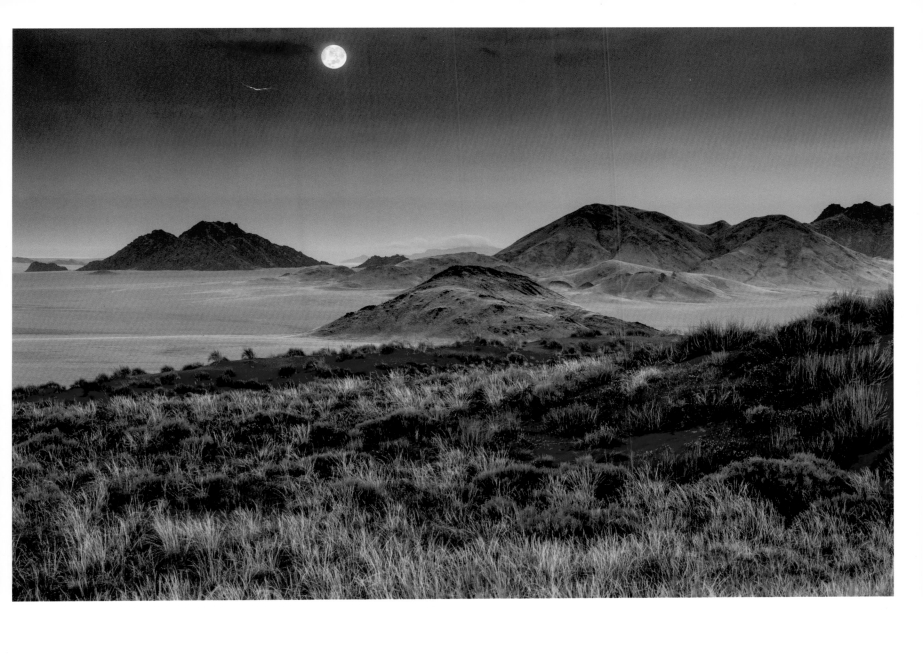

// NEXT PAGE

It is rare to see sand dunes looking like this. After a string of cold days with heavy precipitation, the dunes of Great Sand Dunes National Park and Preserve in Colorado, USA, show themselves in white winter garb. As the sun melts off the snow, it creates the most beautiful structures. Mount Herard (4,068 m; 13,346 ft.) stands in the background.

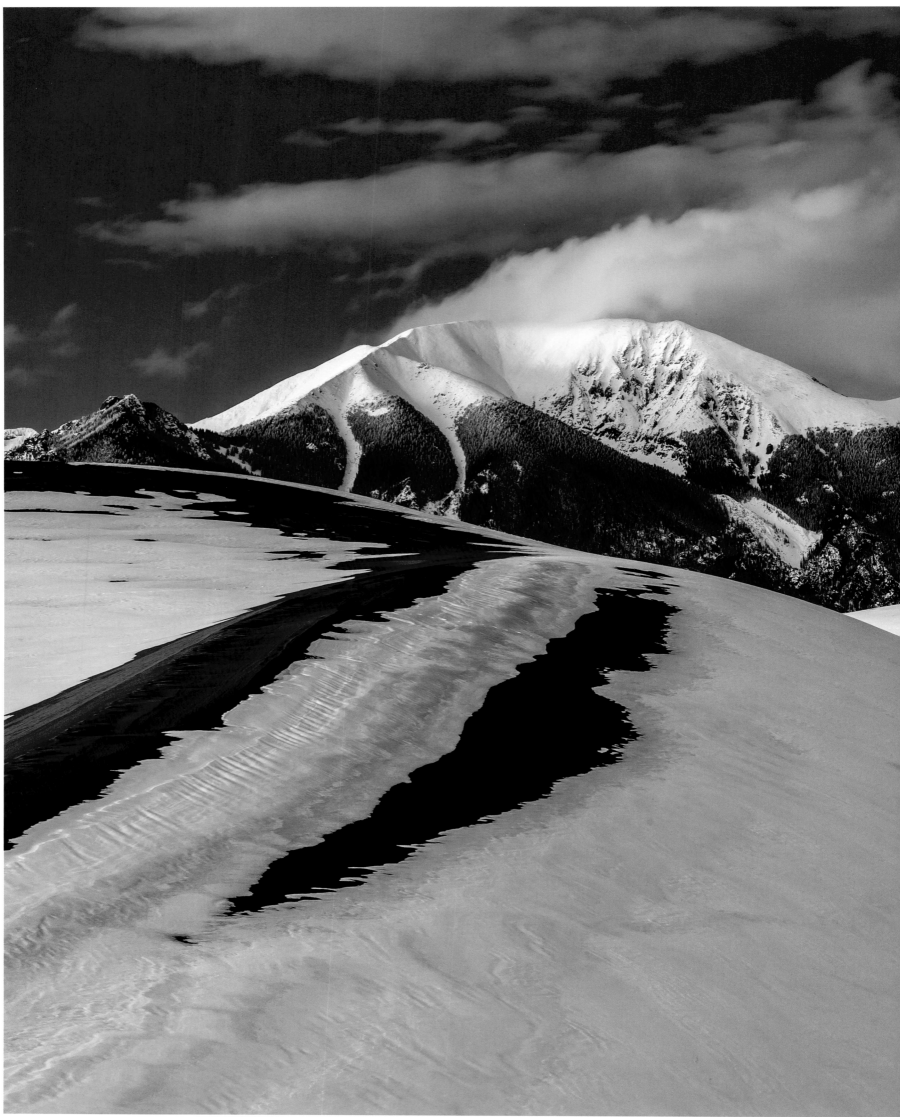

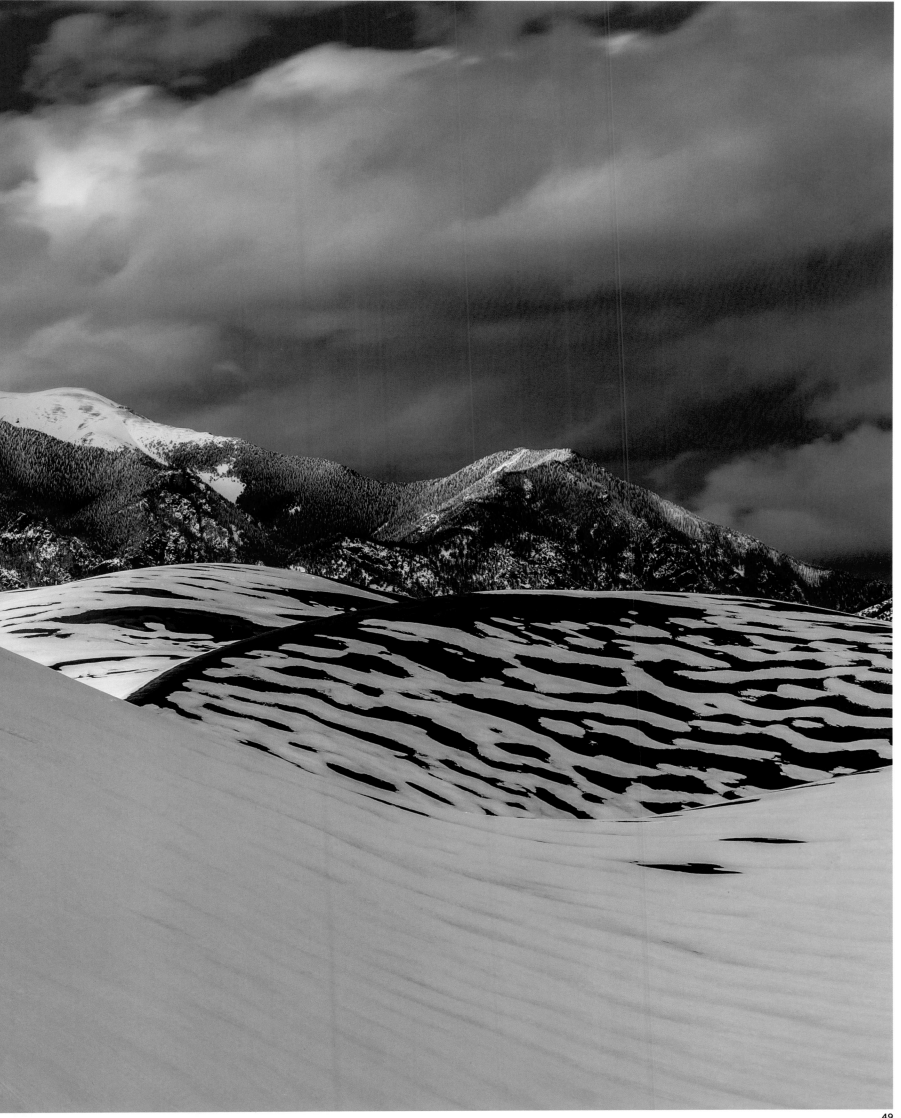

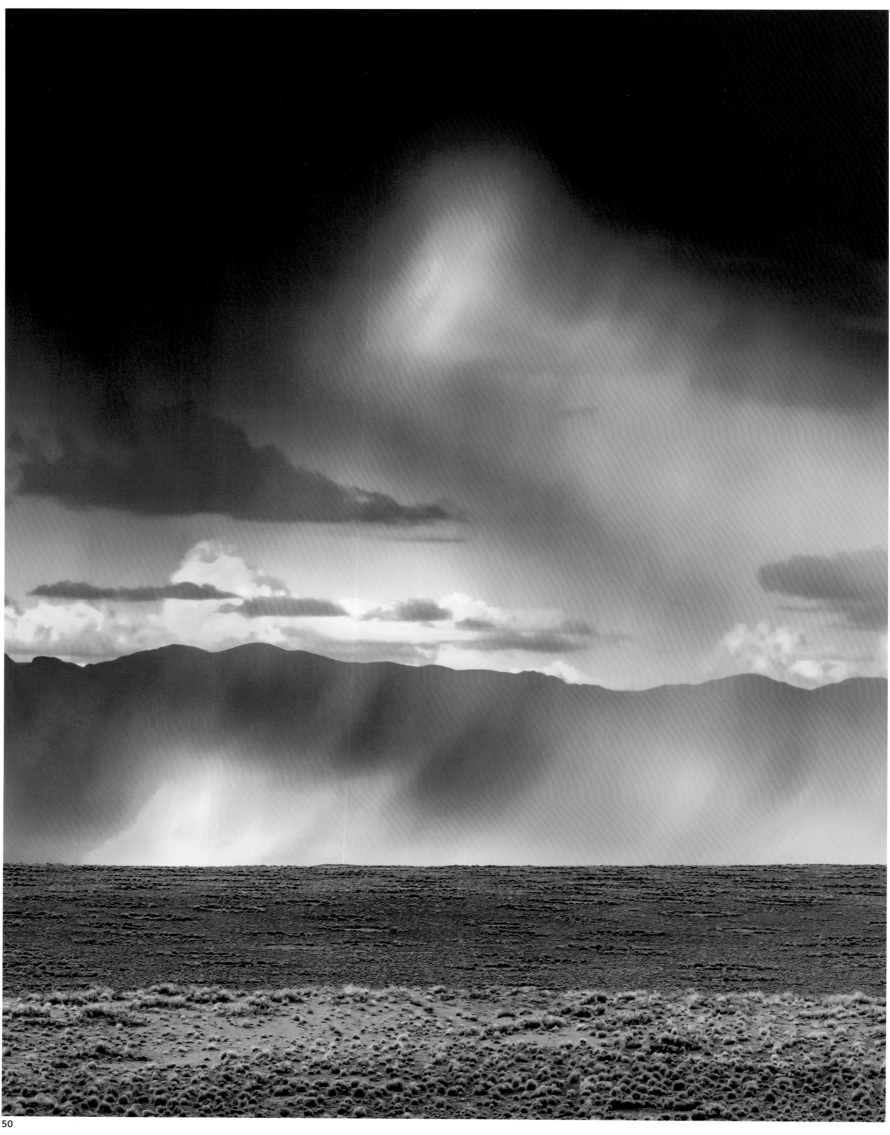

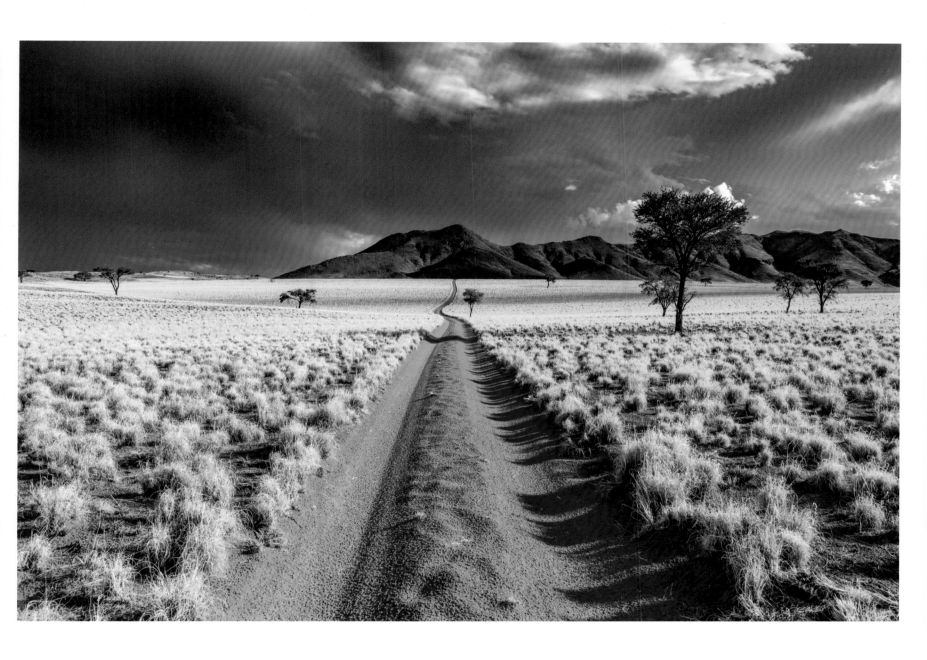

// OPPOSITE PAGE

Many people feel that rain in the desert is the greatest gift to every plant and animal. However, small critters are particularly accustomed to life without rain and live in hollows and burrows in the ground. Every few years rain comes to the lands of Namibia and floods the residences of billions of beetles and reptiles.

// THIS PAGE

It's the farewell display of desiccated, yellow country in Namib Rand Reserve. In the background a powerful front advances with precipitation about to make the whole land over into lush green expanses. These beautiful roads can only be traveled in vehicles belonging to the Wolwedans Lodge.

// NEXT PAGE

Probably one of the rarest photographs I will ever take in my lifetime. Here come the heaviest rains in decades over the Wolwedans dunes in Namib-Naukluft National Park, and I'm in the center of the action with my camera. All told it took me eight trips to Namibia before I finally caught up with rain.

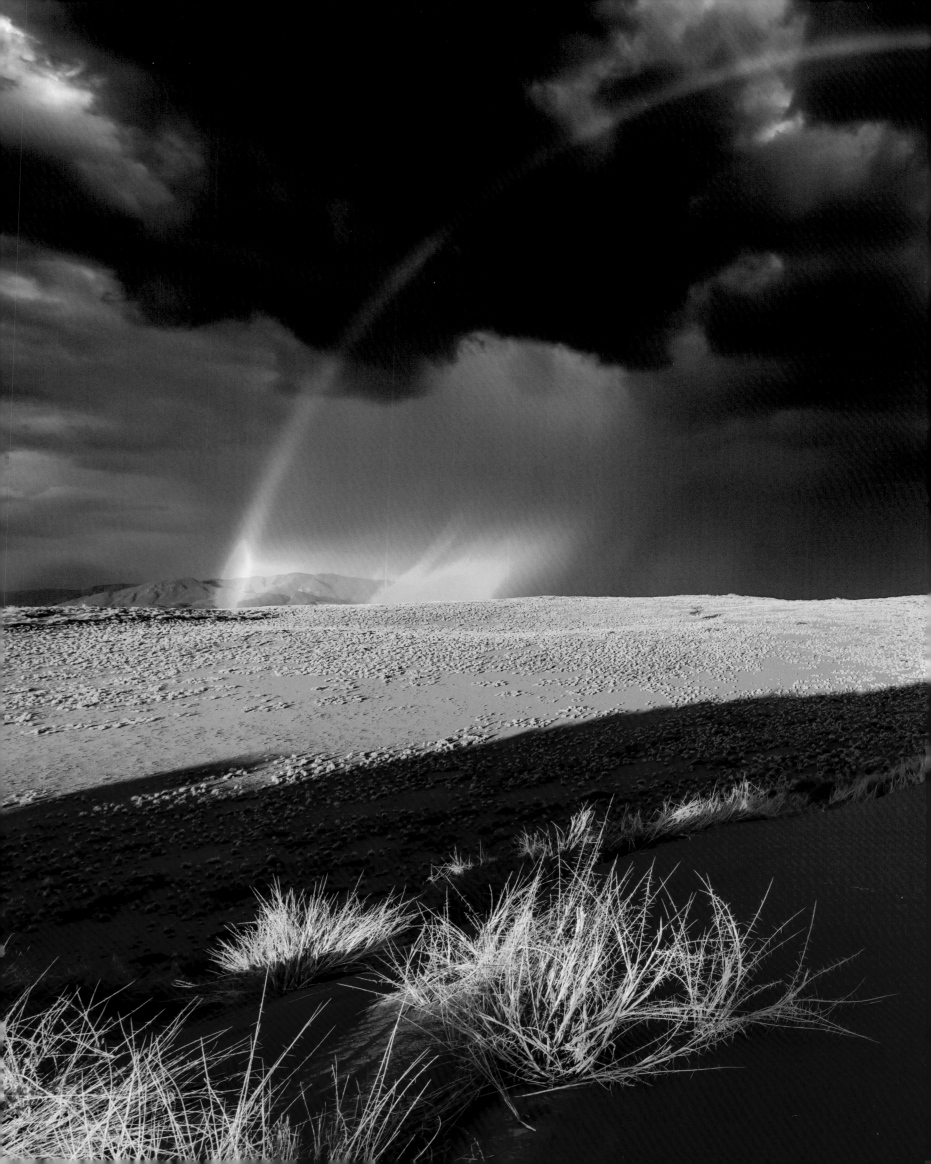

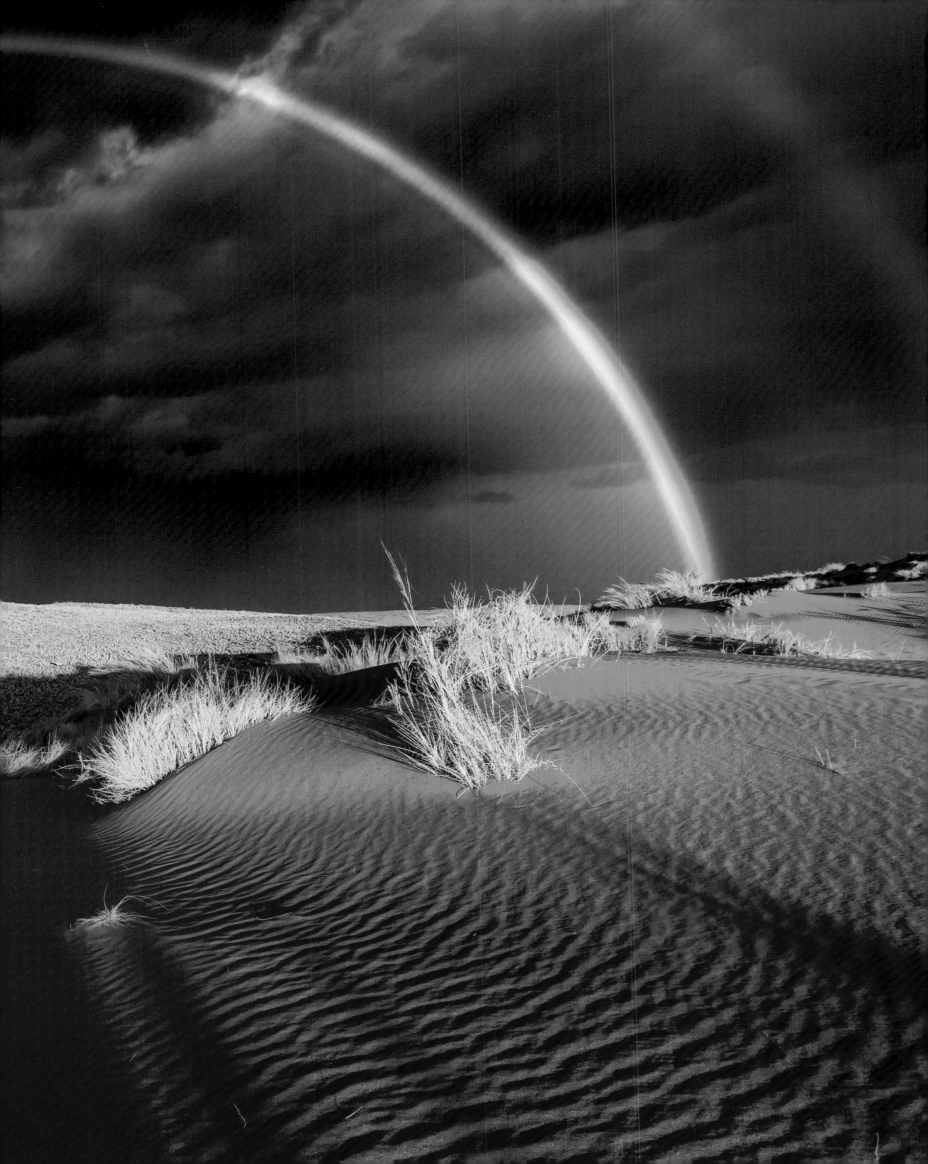

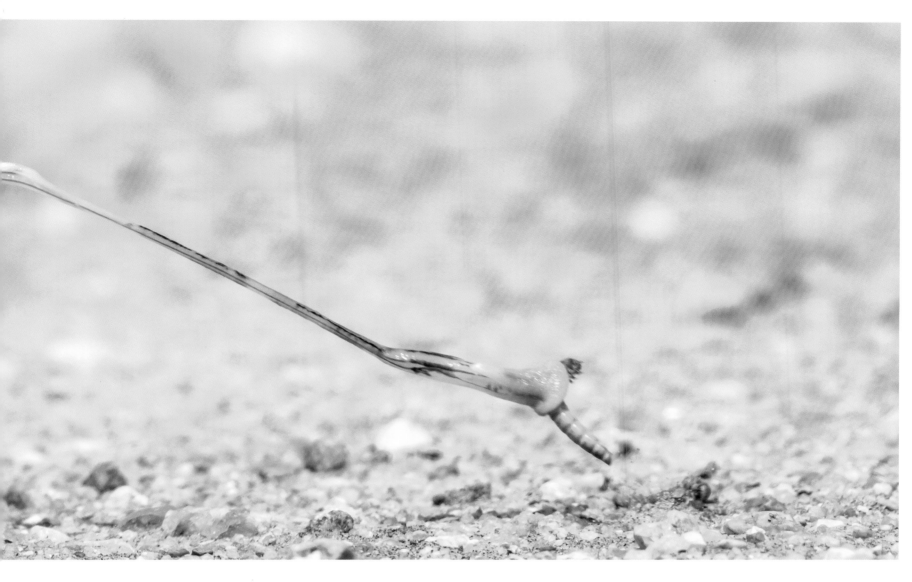

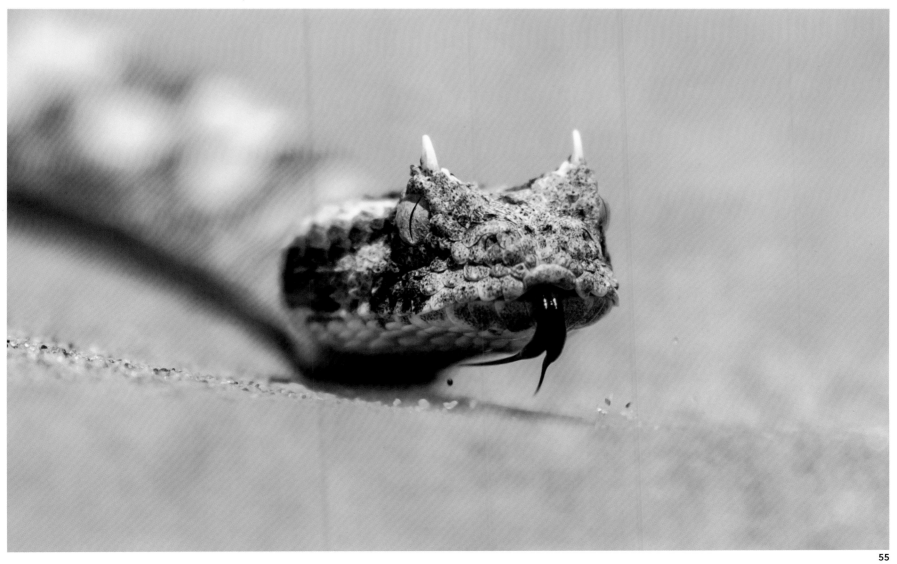

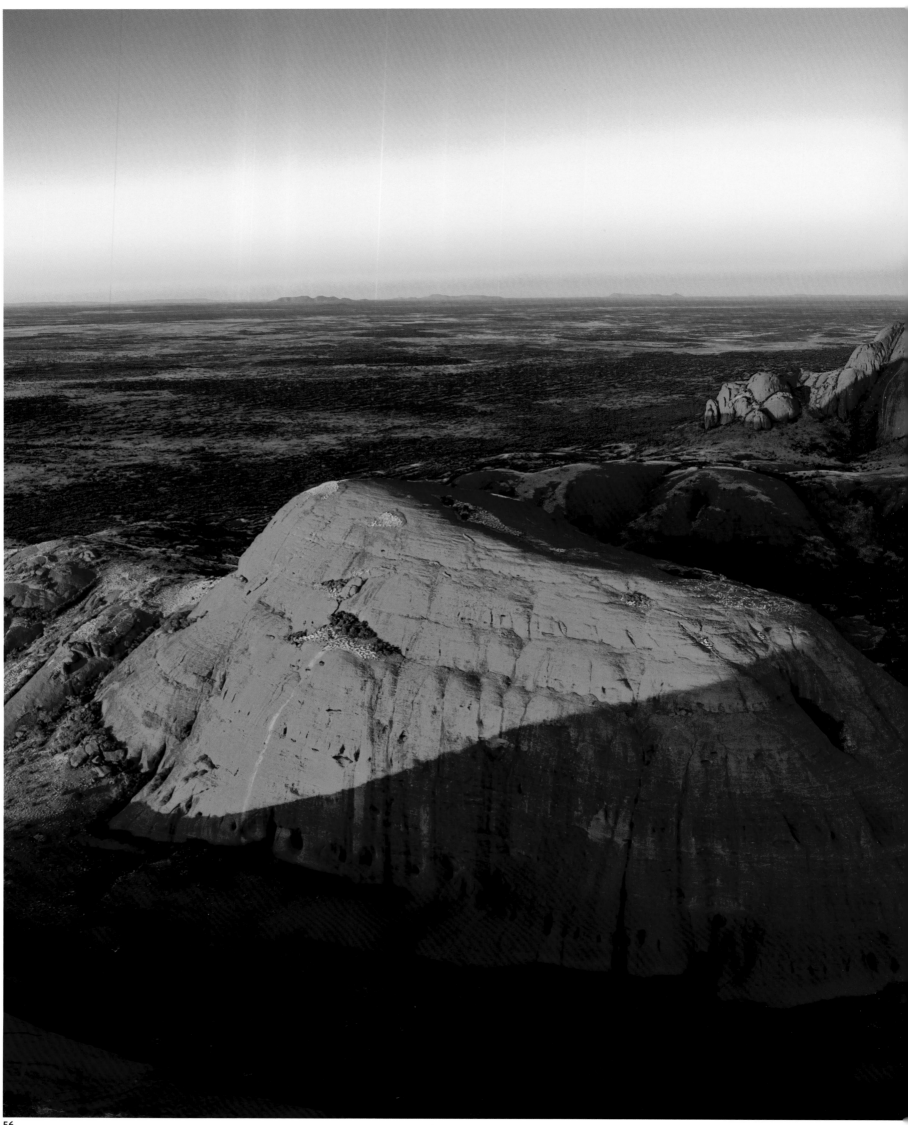

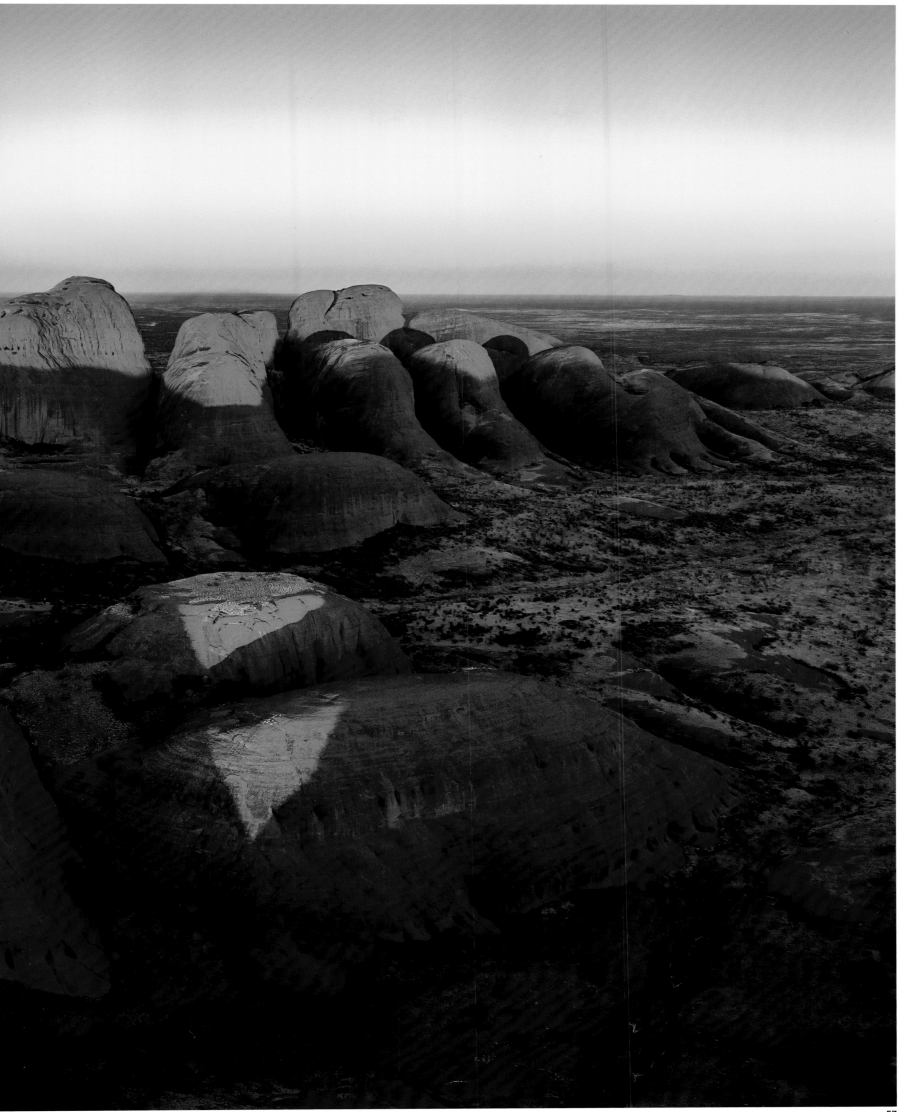

3

ICE AND SNOW //
EIS UND SCHNEE // LA GLACE ET LA NEIGE //

Of the 110 or so trips of the past twelve years, seventy of them have taken me to countries that are home to ice and glaciers. When it comes to the imaginativeness and perfection of Mother Earth, one can hardly do better than icebergs. Every iceberg is unique and represents a singular coincidence of form, color, and size. The most eccentric shapes might appear, as the perfect ice-seahorse in this chapter profoundly demonstrates. But with every iceberg I see, however lovely, I become aware that it's a fragment of a glacier that is now diminished by the size of the piece before me.

The mighty glaciers of Greenland and the Antarctic extend over hundreds and thousands of kilometers. They're a kilometer (3/5 mi.) thick in some places, and yet they're shrinking rapidly as they lie. Every time I return to a familiar glacier, the march or the paddle out to it is longer than the last time. For me, the most rewarding method of photographing glaciers and icebergs is to slowly glide along in a kayak, surrounded by these blue giants from the past.

Von all meinen rund 110 Reisen der vergangenen 12 Jahre hatten 70 davon Länder zum Ziel, in denen es Eis und Gletscher gibt. Eisberge sind an Einfallsreichtum und Perfektion von Mutter Erde kaum zu übertreffen. Jeder Eisberg ist einzigartig und in seiner Form, Farbe und Größe nur einmal zu finden. Es kann zu den skurrilsten Formen kommen, wie das perfekte Eis-Seepferd in diesem Kapitel eindrücklich zeigt. Doch bei jedem noch so schönen Eisberg den ich sehe, wird mir bewusst, dass er von einem Gletscher abbrach, der nun um dieses Stück kleiner ist.

Die mächtigen Gletscher Grönlands und der Antarktis erstrecken sich über Hunderte oder gar Tausende von Kilometern, sind teils kilometerdick und doch schrumpfen sie mit einer rasanten Geschwindigkeit vor sich hin. Bei jedem Besuch mir bekannter Gletscher wird der Fußmarsch oder die Bootsfahrt länger. Die für mich schönste Art, Gletscher und Eisberge zu fotografieren, ist im Kayak langsam vor mich hinzugleiten, umgeben von den blauen Riesen der vergangenen Zeit.

Parmi les 110 voyages que j'ai réalisés au cours des 12 dernières années, 70 avaient pour destination des pays où je trouvais de la glace et des glaciers. Tous les icebergs rivalisent d'ingéniosité et de perfection avec notre mère la Terre. Chaque iceberg est unique dans sa forme, sa couleur et sa taille. Il peut prendre les formes les plus extraordinaires, en témoigne dans ce chapitre l'impressionnant hippocampe de glace. Mais chaque iceberg que je rencontre me rappelle aussi qu'un jour il a fait partie d'un glacier, qui est maintenant amputé de ce morceau.

Les énormes glaciers du Groenland et de l'Antarctique qui s'étendent sur des centaines et des milliers de kilomètres, atteignant par endroits quelque 1 000 mètres d'épaisseur, sont cependant en train de fondre à grande vitesse. Chaque fois que je retourne sur un glacier qui m'est familier, le temps d'accès à pied ou en bateau s'en trouve rallongé. La plus belle manière pour moi de photographier glaciers et icebergs est à bord d'un kayak, ce qui me permet de glisser sur les eaux parmi les géants bleus des temps passés.

// OPPOSITE PAGE

During my thirty-six trips to Iceland so far, I have already spent upwards of eighty days on the shores of Jökulsárlón. Where in 2003 I was by myself on the beach among hundreds of icebergs, I now must pick my way among hundreds of other tourists who've discovered the beauty of this location on Iceland's southern coast.

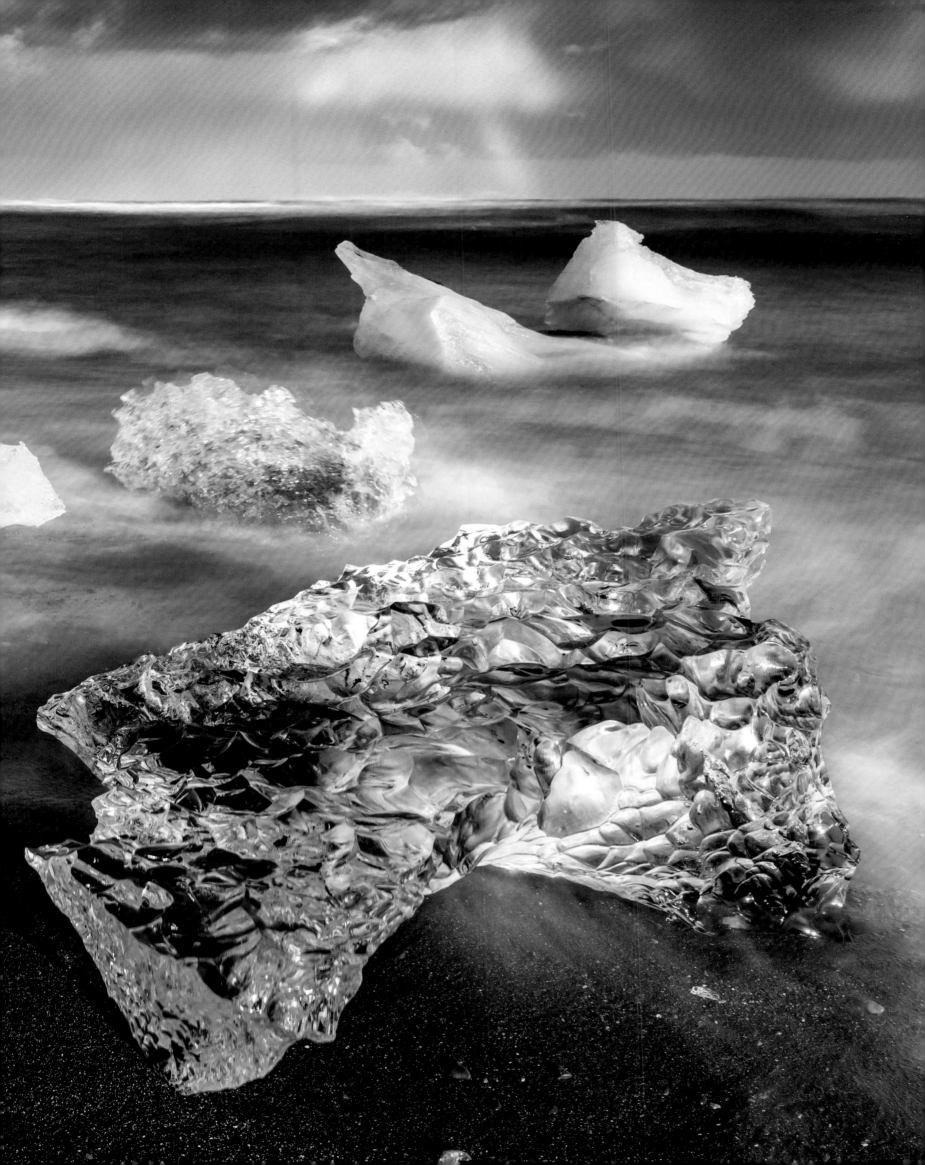

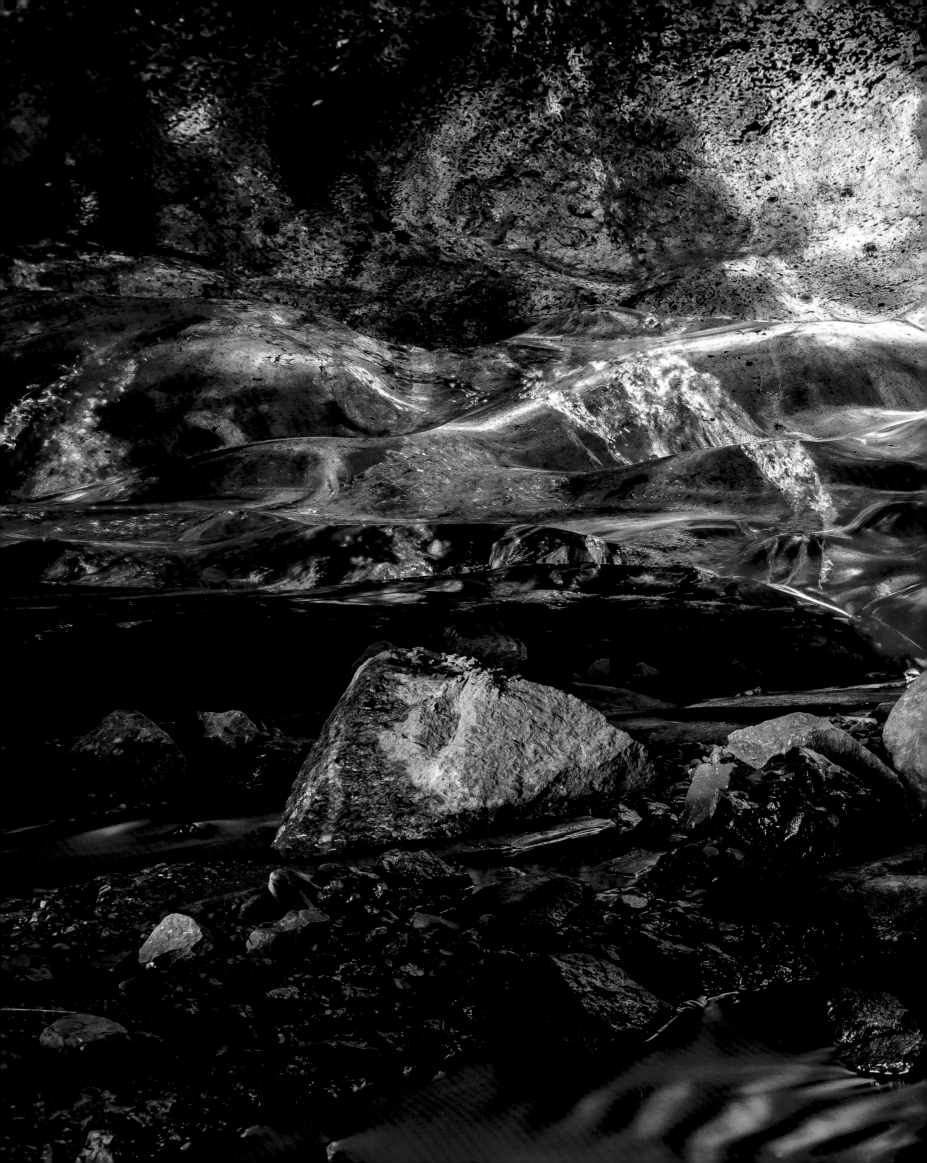

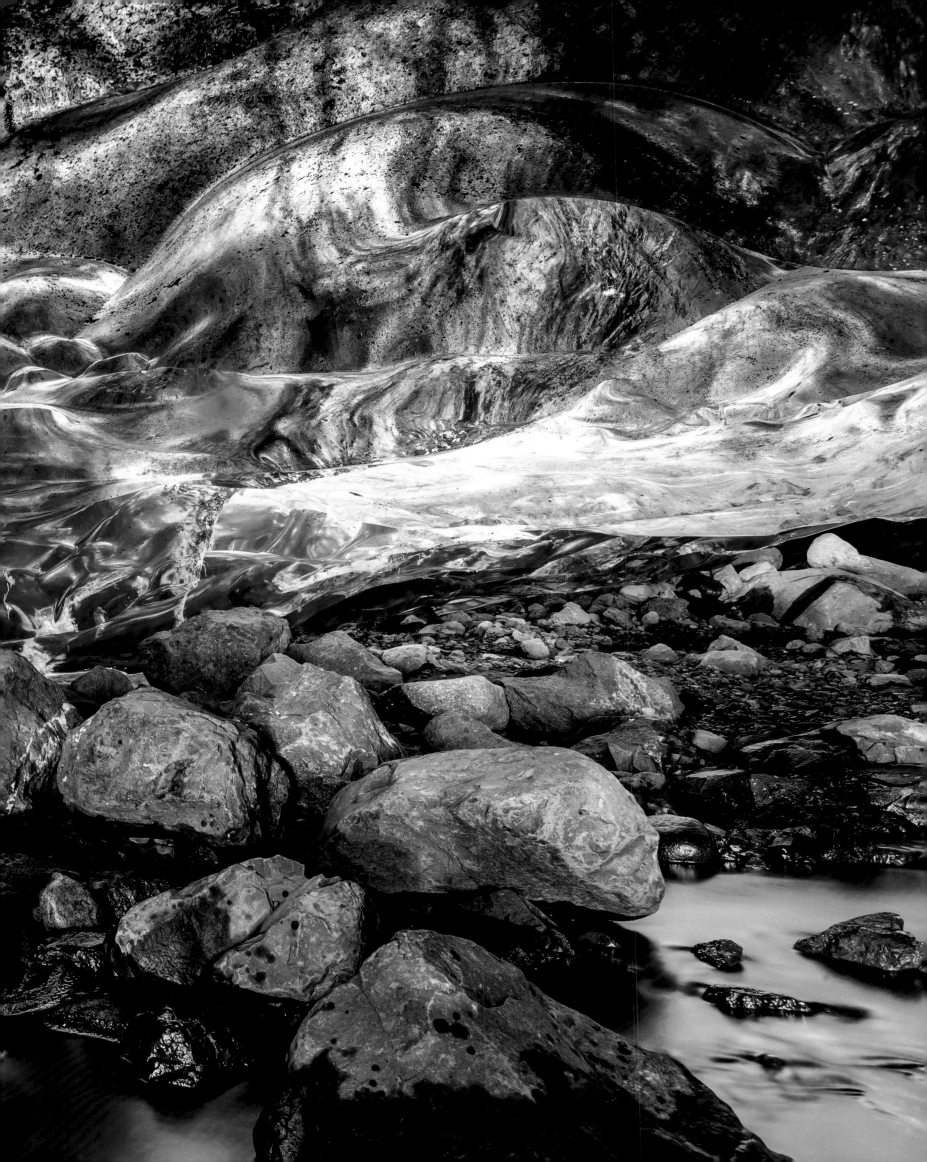

// PREVIOUS PAGE

During the summer glacial melt, meltwater bores tremendous tunnels through and under the ice. In the cold winter months when the supply of fresh meltwater ceases, the drained caves reveal their full size and beauty. Thanks to a tripod and long exposure times it's possible photographically to capture daylight shimmering through the glaciers.

// OPPOSITE PAGE / TOP

The gigantic Vatnajökull or Vatna Glacier calves into a fresh water lagoon called Jökulsárlón on Iceland's southern coast. This lagoon full of icebergs is linked to the ocean via a small canal. Each tide washes some of the icebergs onto Iceland's black North Atlantic shore. One of the most stunning natural wonders of our earth.

// OPPOSITE PAGE / BOTTOM

Hardly any glacier on Greenland's west coast calves as intensely or melts as rapidly as Eqi Glacier. The disintegrating terminus, which can be 170 m (over 550 ft.) high, retreats back toward the ice sheet by dozens of meters a year. Across from this active glacier is the unique Eqi Lodge, my staging point for many tours of the surrounding mountains.

// NEXT PAGE

These ice sculptures arise every year on the banks of Seljalandsfoss, a waterfall on Iceland's south shore. The waterfall plunges over a rocky cliff that only gets sun for a few hours a day, with constant strong winds. In the background you can see the front range of the southern plateau.

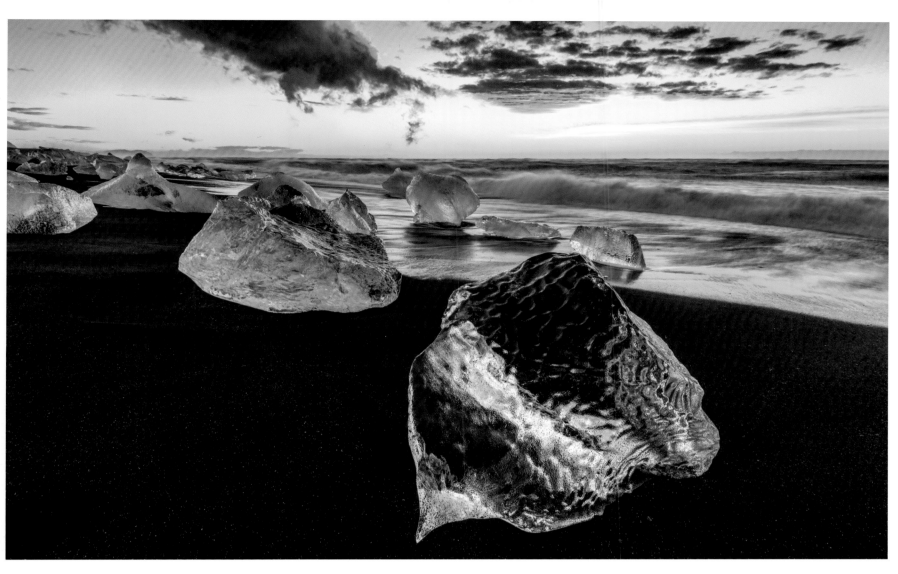

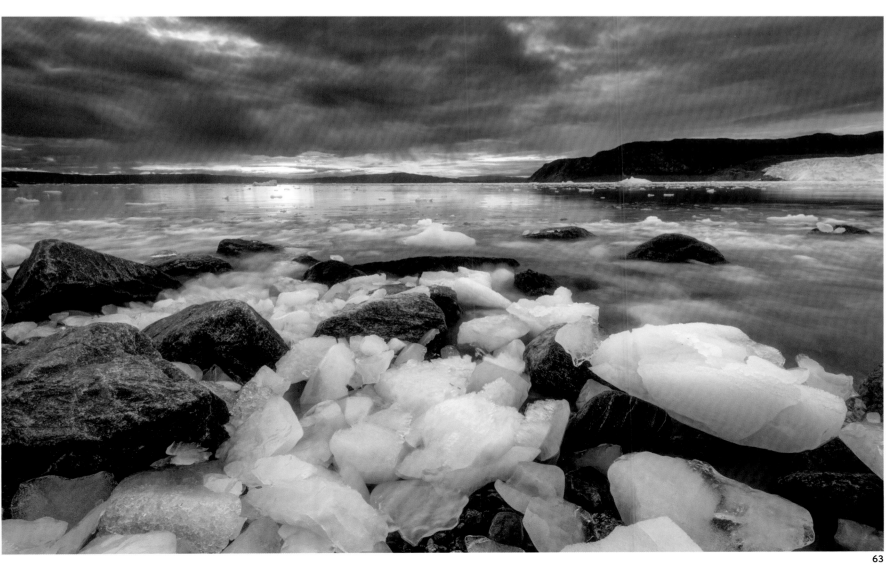

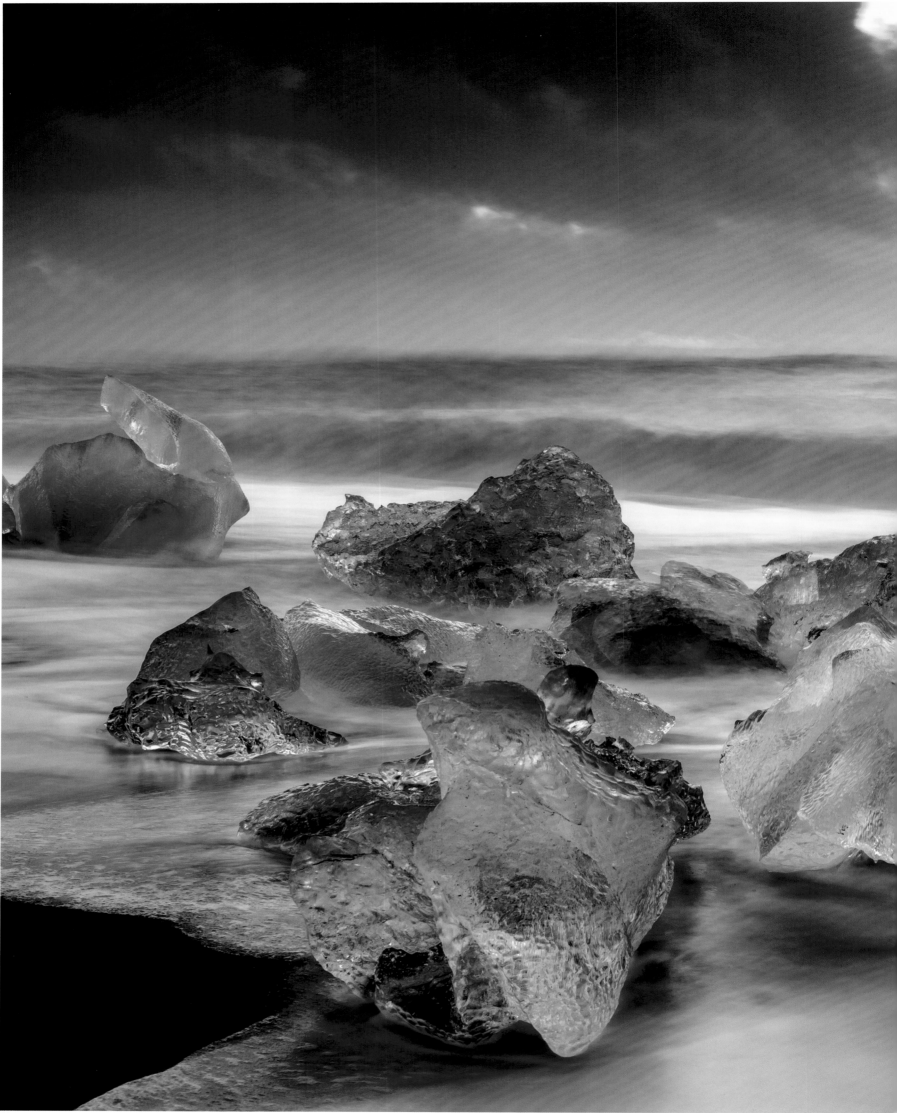

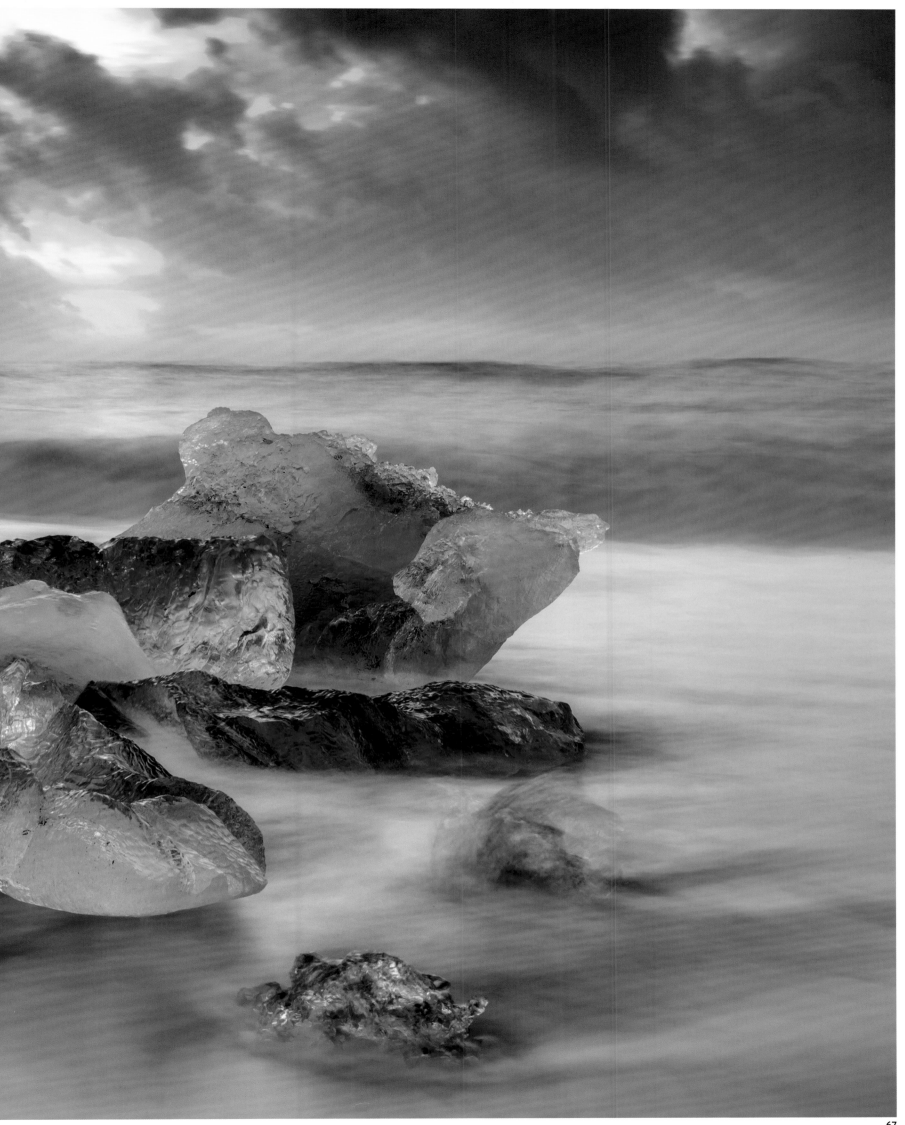

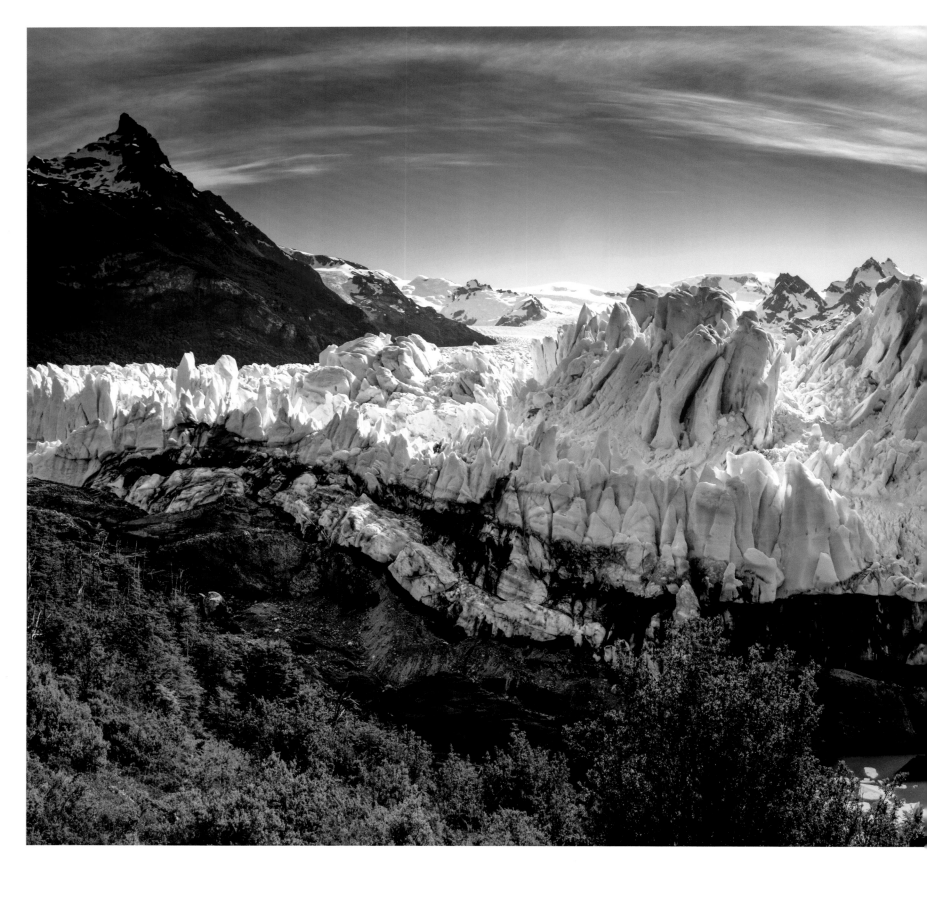

// PREVIOUS PAGE

Heavy surf makes icebergs on the black beach near Jökulsárlón melt faster than one might think. The older the ice, the bluer and more translucent the iceberg. Snow accumulates upon glaciers over millennia and further compresses underlying layers of ice. Compression forces air out of the ice, eventually yielding completely transparent ice.

// THIS PAGE

Here is the best-known and most beautiful glacier in South America, Perito Moreno Glacier in Los Glaciares National Park, Argentina. The glacier, 30 km (18.6 mi.) long with an almost 4.5 km (2.8 mi.) wide calving terminus, is known as the largest glacier in South America's Andes. It had long been regarded as the fastest-growing glacier in the world, but as it turns out, this glacier is merely stretching. The volume of ice in the Andes is shrinking year by year.

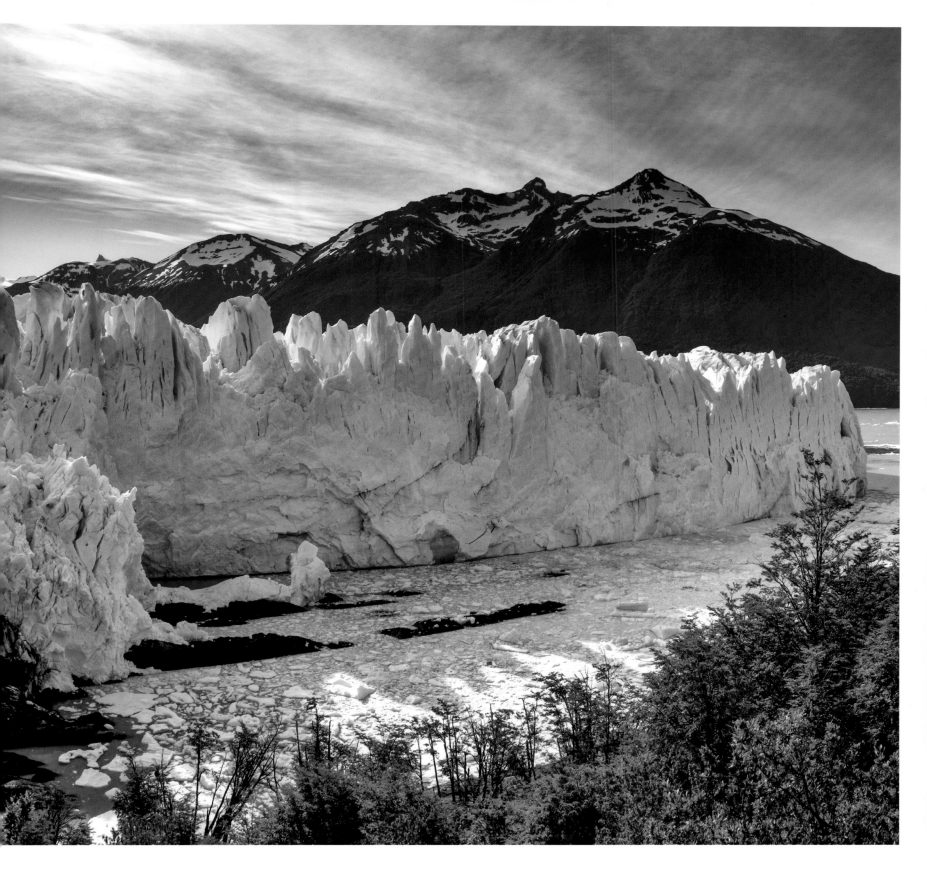

// NEXT PAGE

On my first trip to Greenland on 2012, I paddled in my kayak along the country's west coast and was able to photograph breathtaking icebergs in the southwestern fjords up close. At the time, the left portion of this block of ice instantly reminded me of a pterodactyl, a kind of flying dinosaur.

// PAGE 72/73

The Greenlandic glacier known as Jakobshavn Isbræ is one of the largest glaciers in the northern hemisphere. Its flow rate of 7,000 m (4.35 mi.) per annum earns it the record of being the world's fastest-moving glacier. The glacier terminates after 80 km (49.7 mi.) onto well-known Disko Bay, south of the Greelandic town of Ilulissat. For me, it's definitely one of the most beautiful glaciers my eyes have been privileged to see.

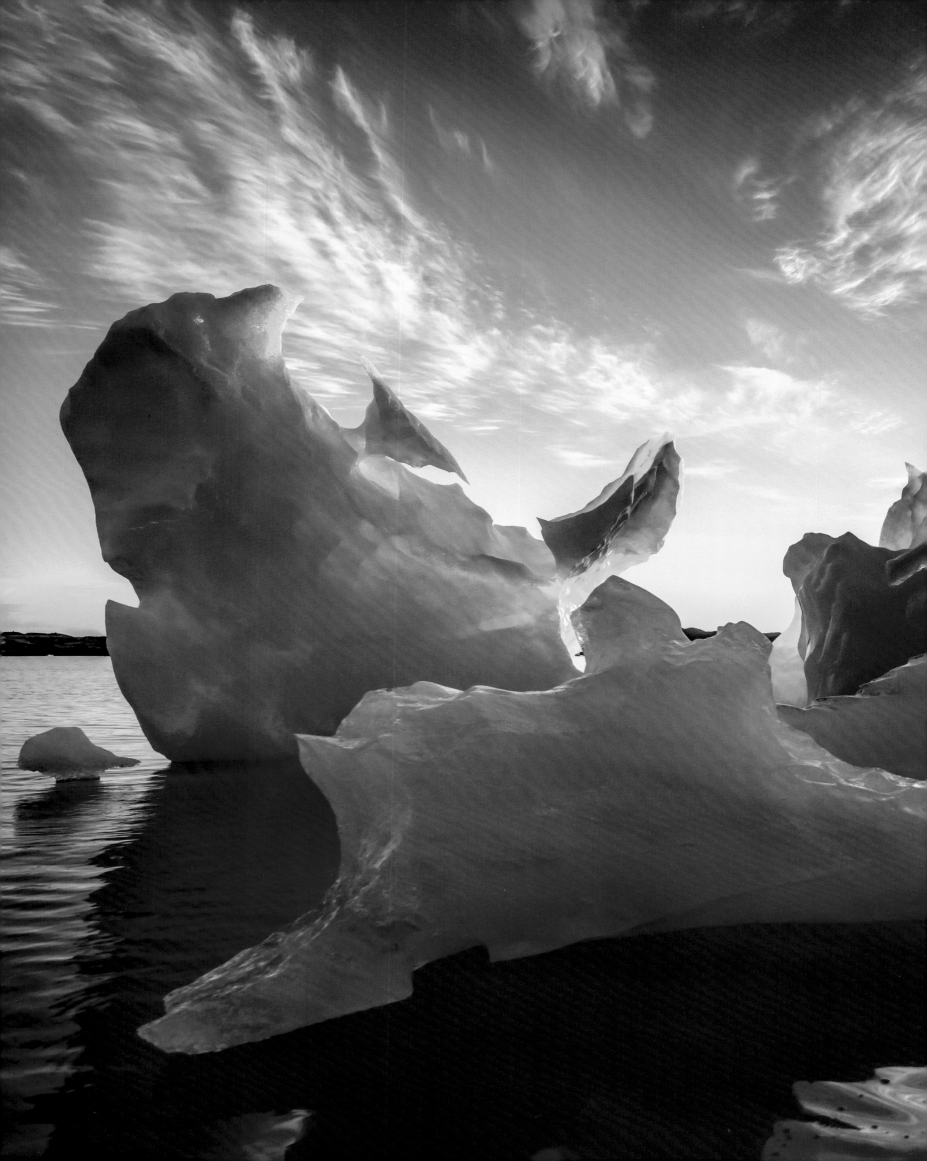

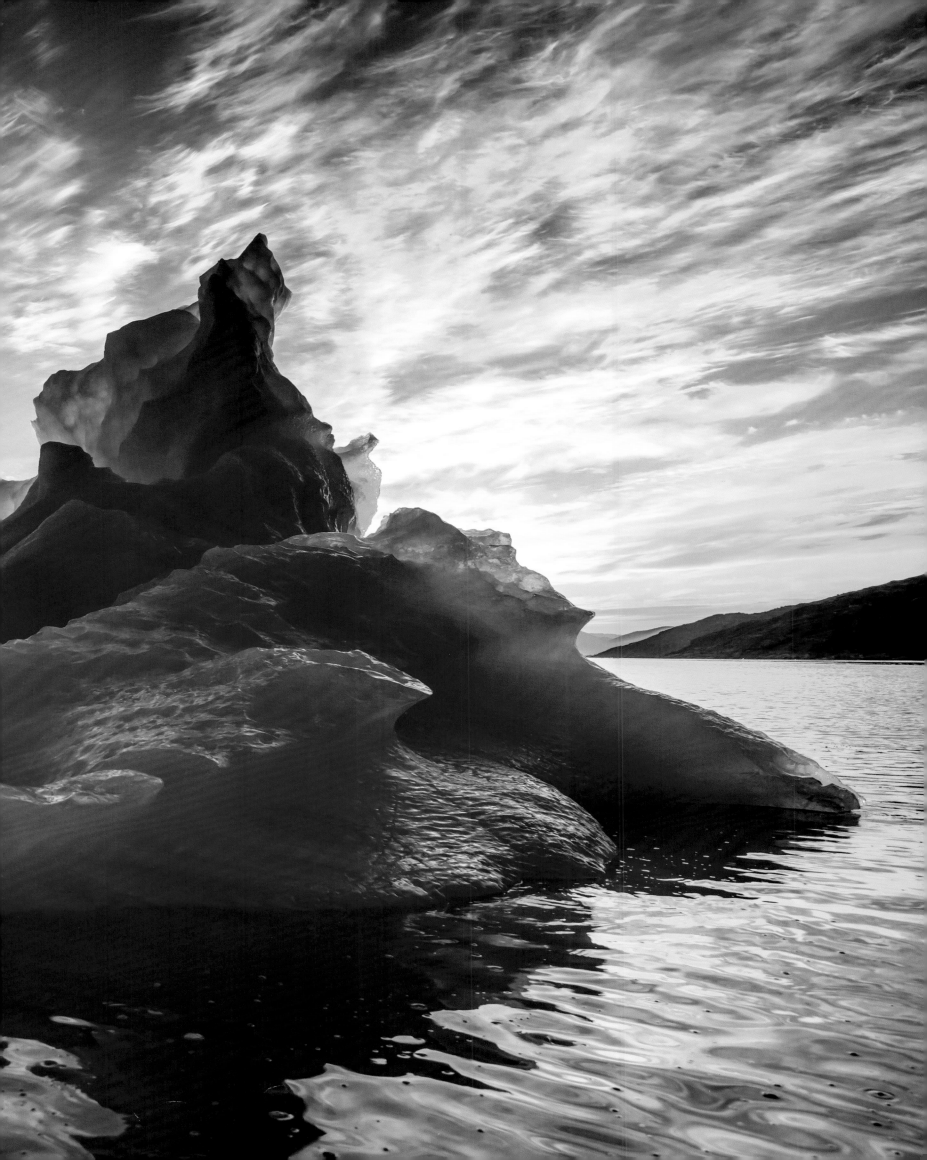

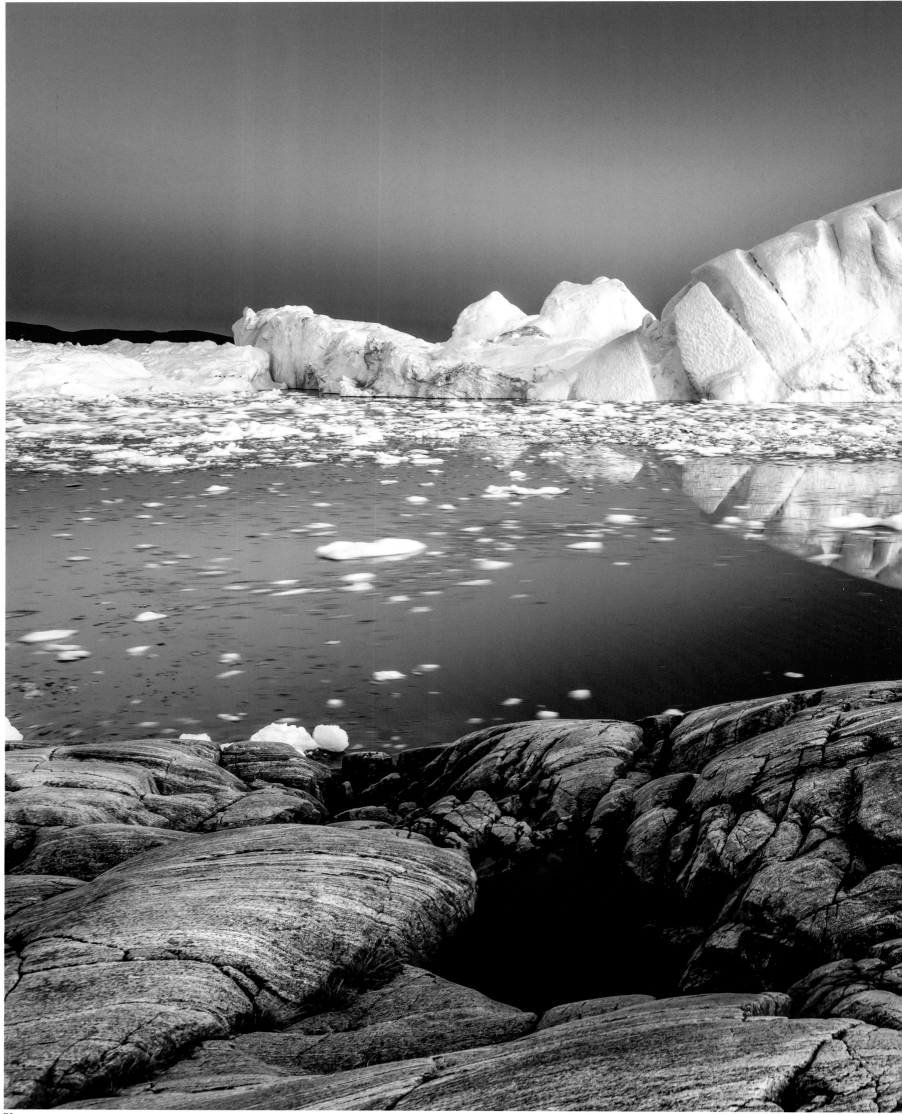

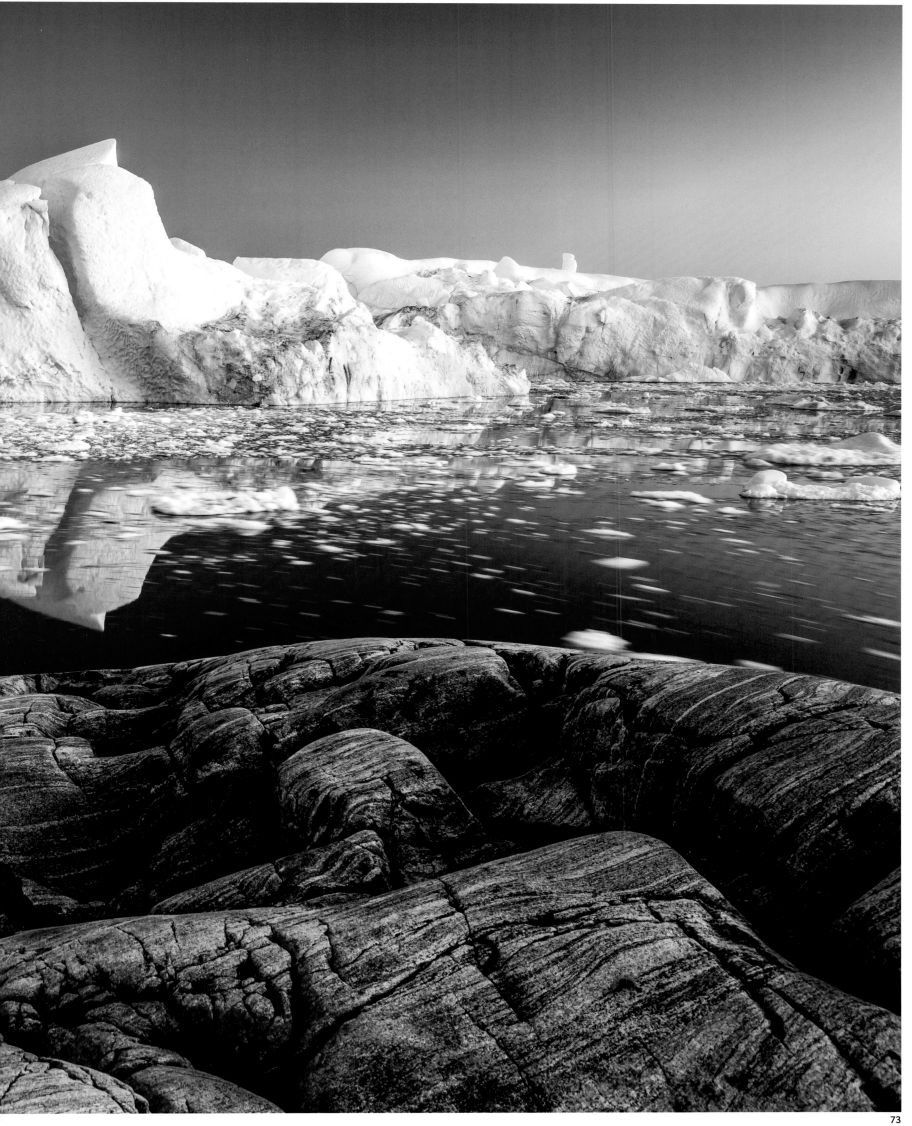

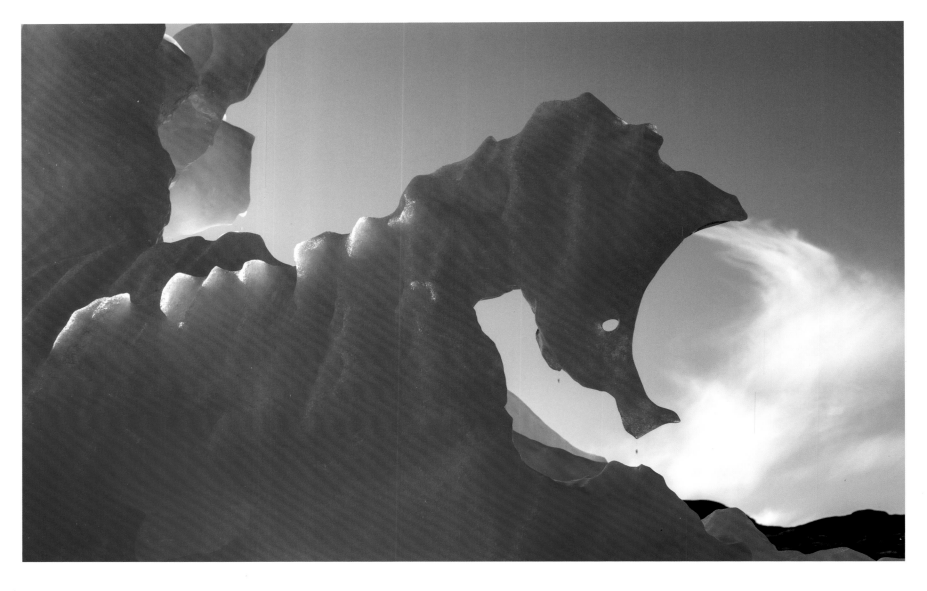

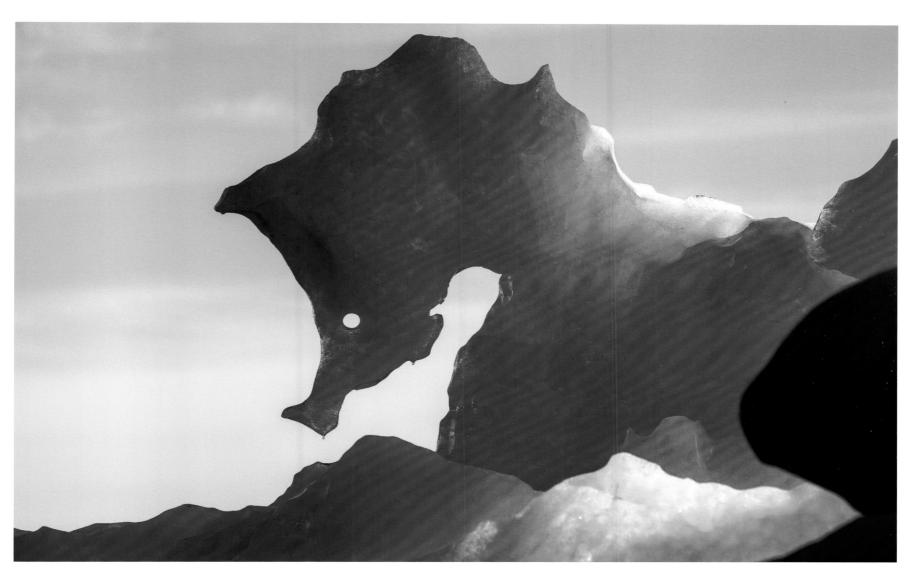

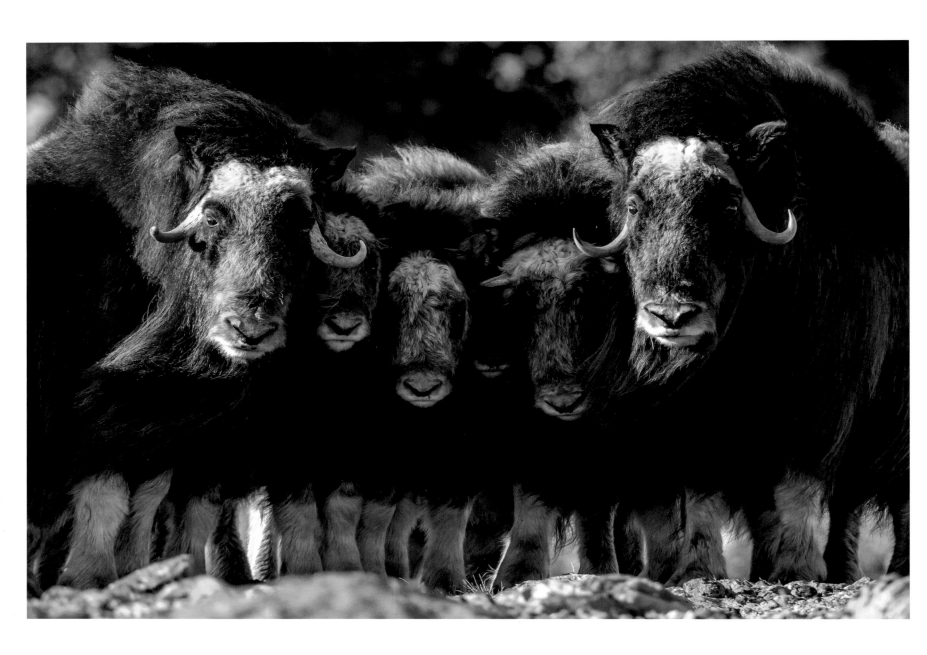

// PAGE 74/75 / TOP

Natures is famously the greatest architect. I discovered this absolutely perfect, 3 x 3 m (nearly 10 ft.) high and wide sea horse during my first kayak expedition in Greenland in August, 2012. I was so fascinated I took dozens of images from every angle before paddling on to the next iceberg.

// THIS PAGE

Had I planned this image of wild muskox on the Greenland ice sheet, I might have spent years waiting for this moment. I got this image far away from civilization during the course of hours executing my approach of a large herd of muskox. I must have gotten too close, for the cows formed a kind of protective wall around the calves. The symmetry of this wall could not have been better.

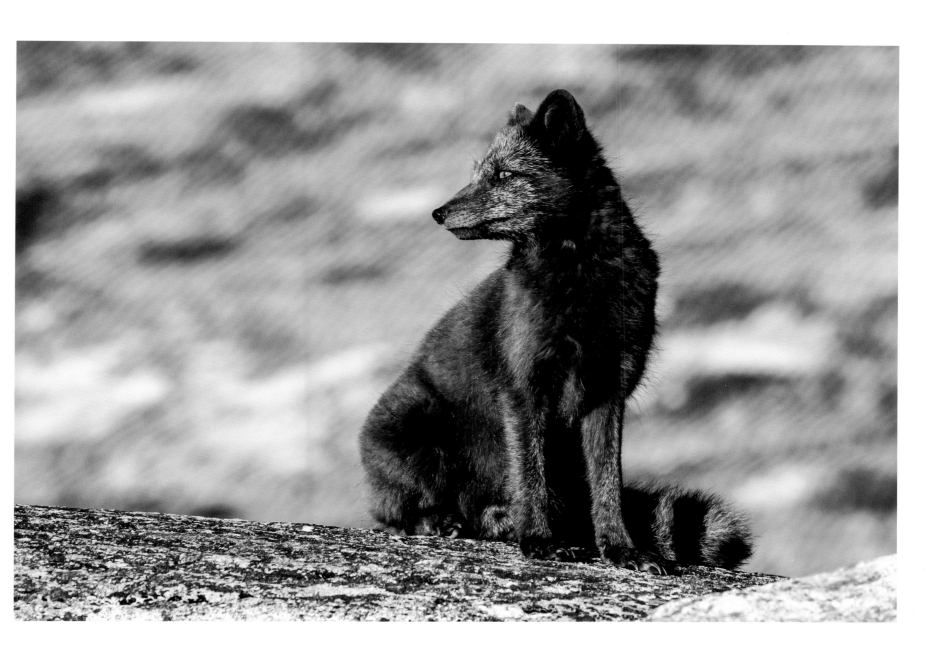

// THIS PAGE

Among mammals and just like muskox, they are most tolerant of cold: the Arctic fox. This young black Arctic fox inhabited an area near Eqi Glacier where humans had never been a threat, so it came up to within a few meters of me.

// NEXT PAGE

These gentoo penguins, found in the Antarctic, are just returning from a cold-water fishing expedition and are warming themselves among blocks ice. It never ceases to amaze me what hostile environments these penguins can live in.

// PAGE 82/83

I discovered this solitary ice giant in the fjords of southwestern Greenland near the settlement of Narsarsuaq. An iceberg this size reads like an open book. Every groove stands for an orientation relative to the water surface, and the color of ice betrays its age and the depth at which it lay buried in the glacier.

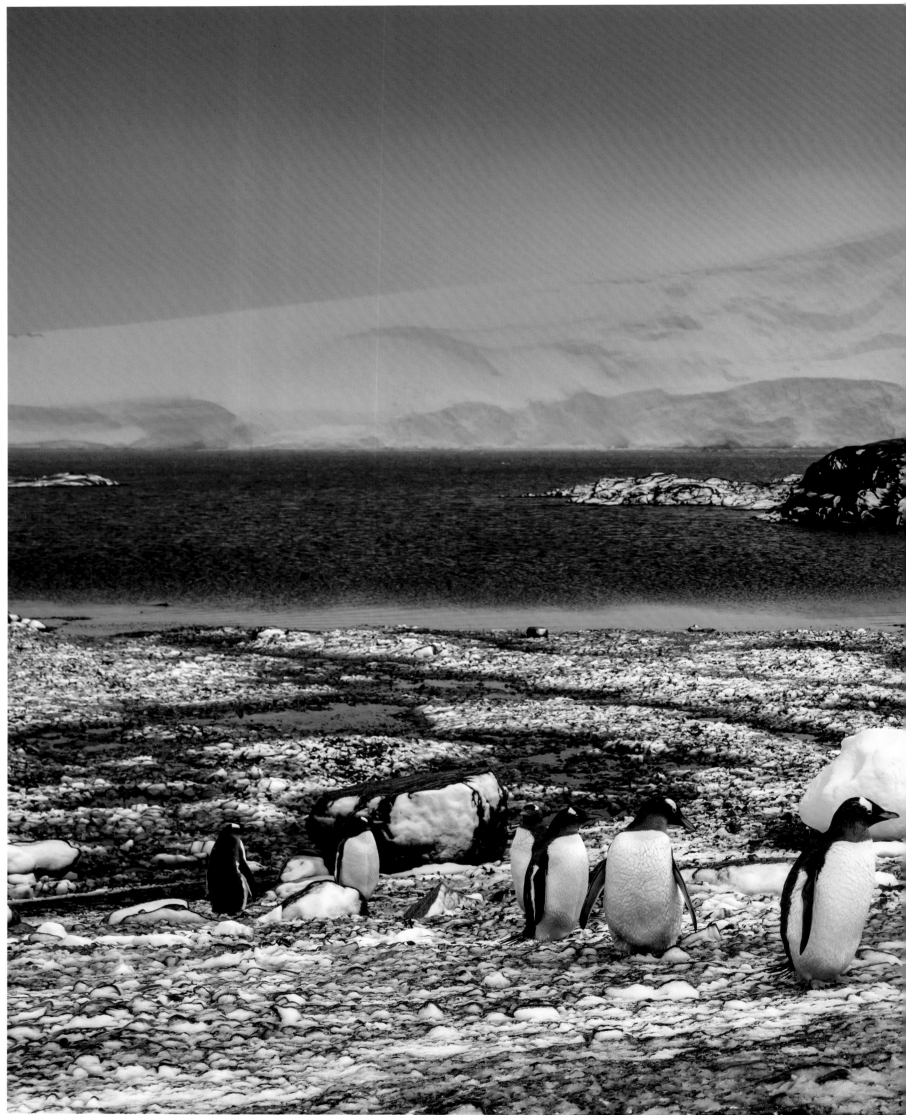

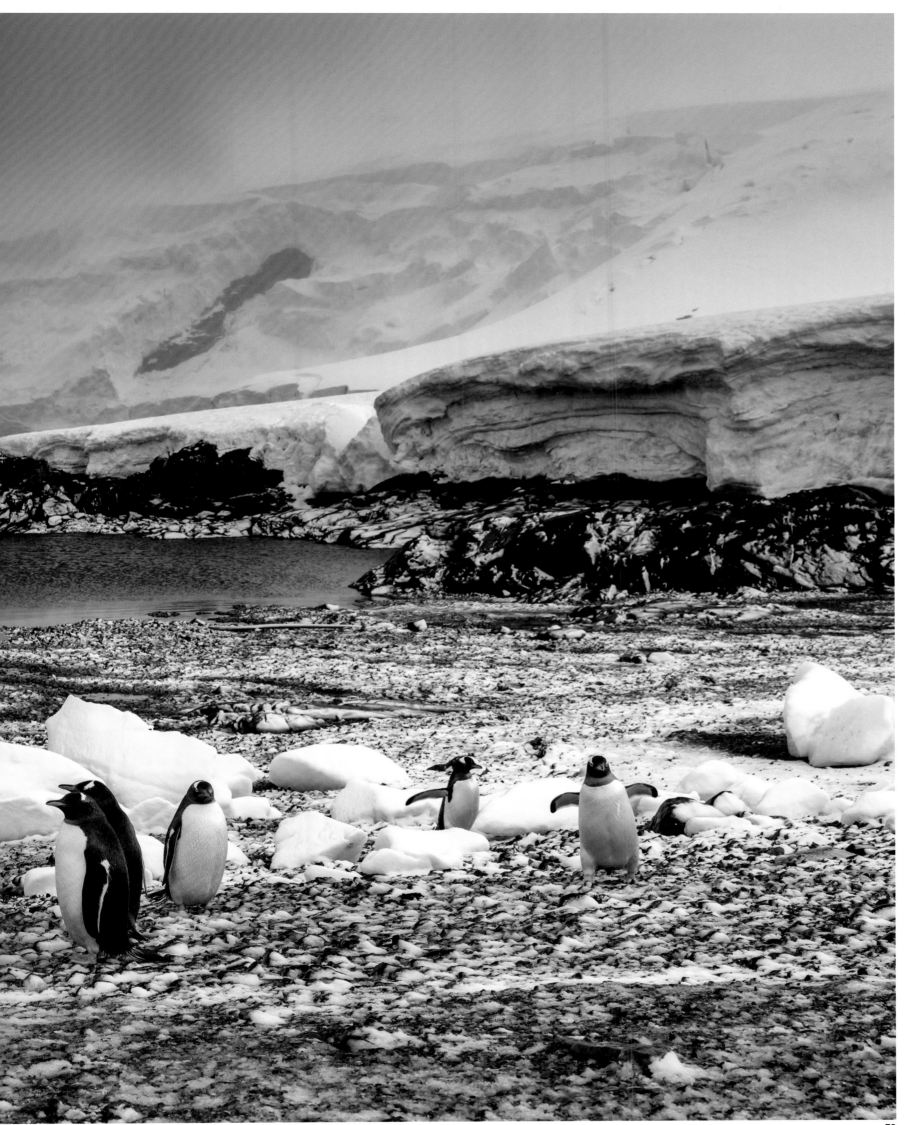

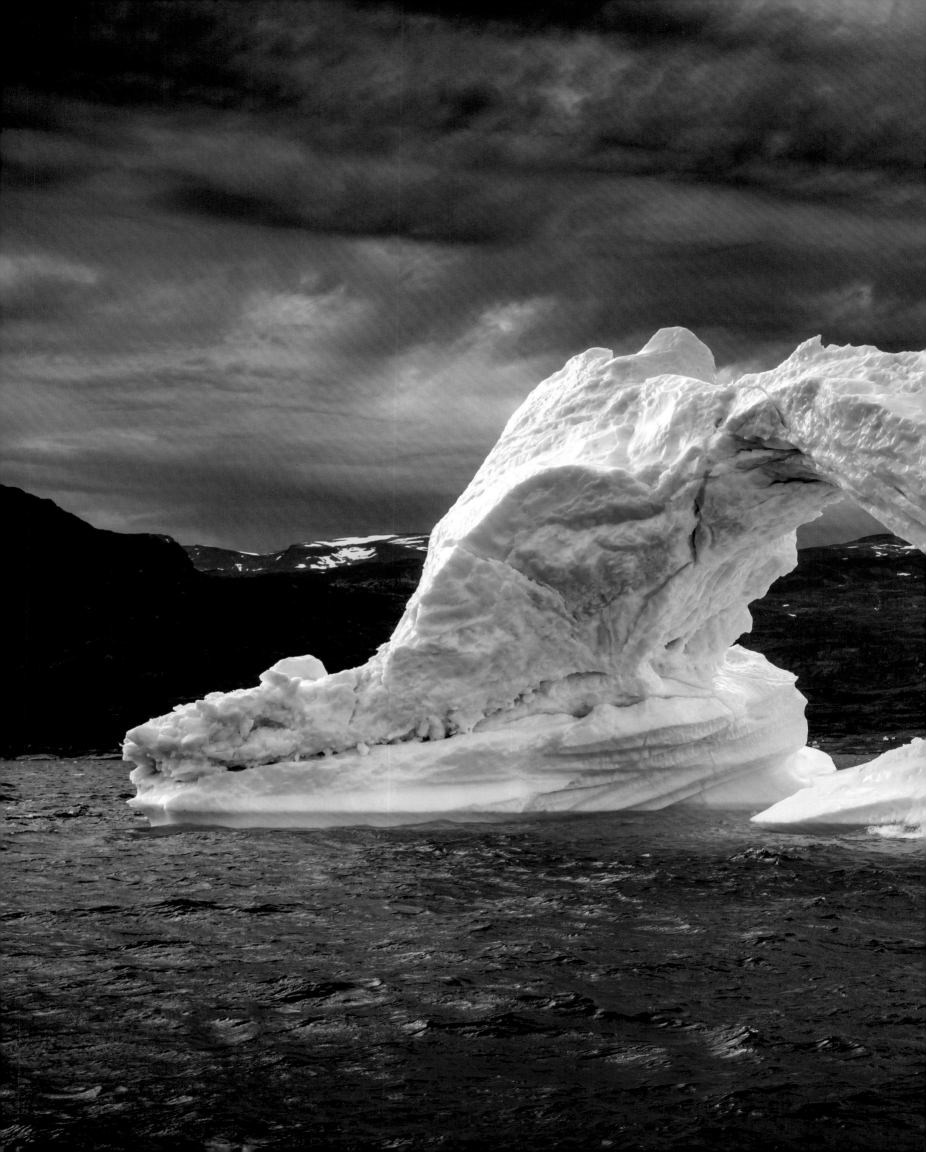

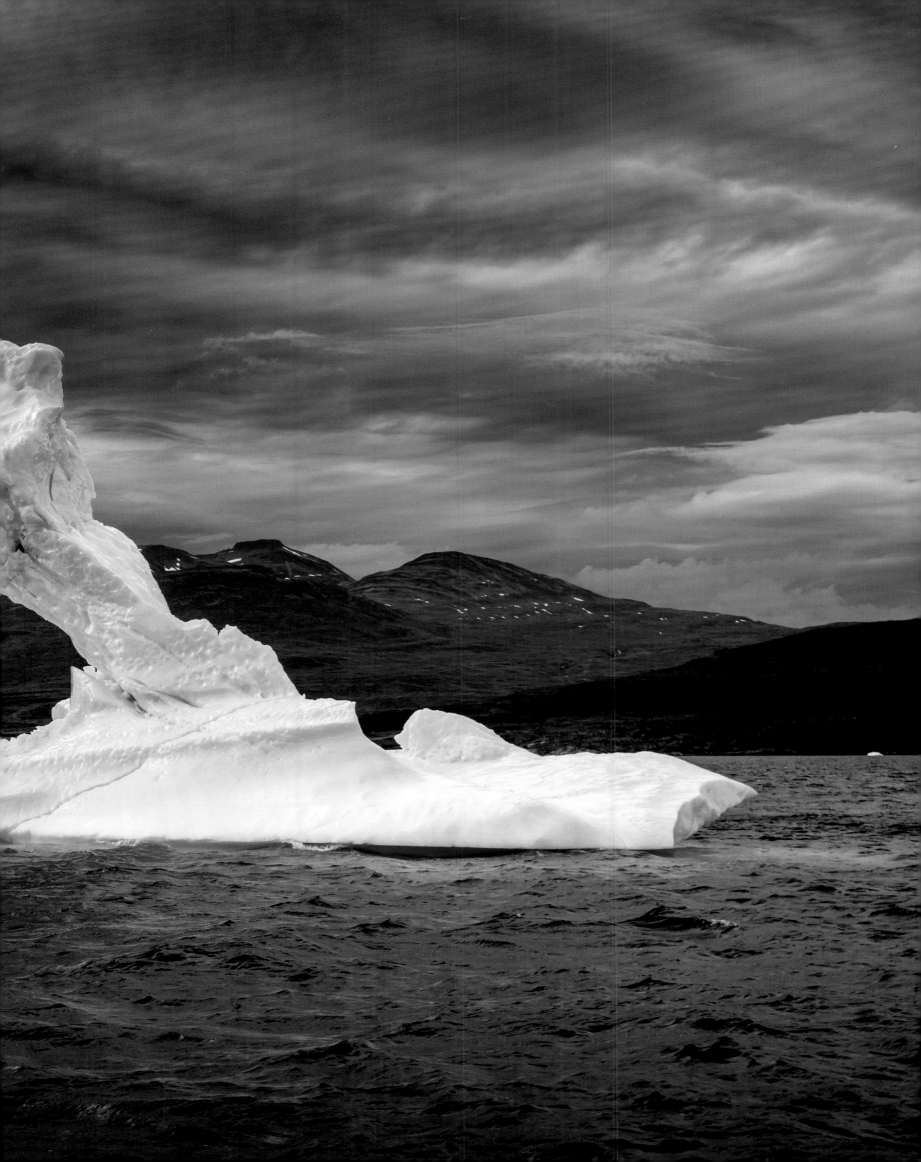

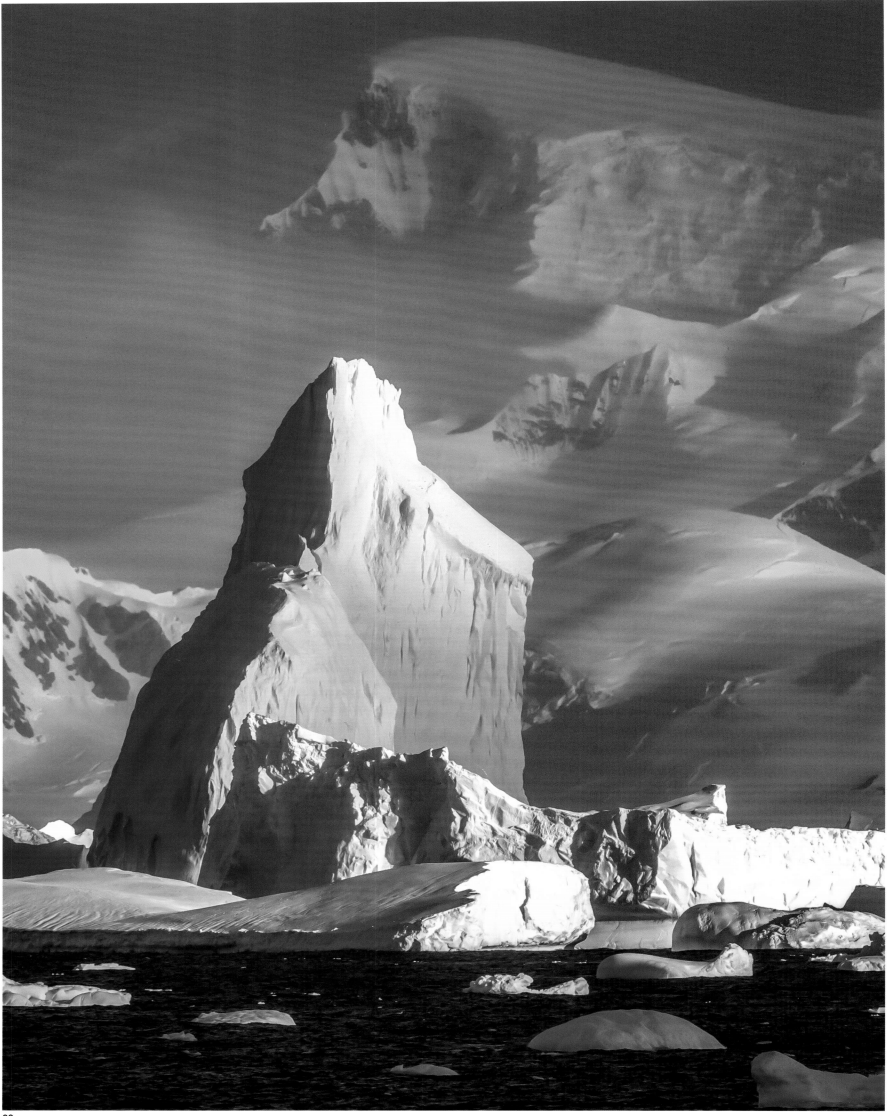

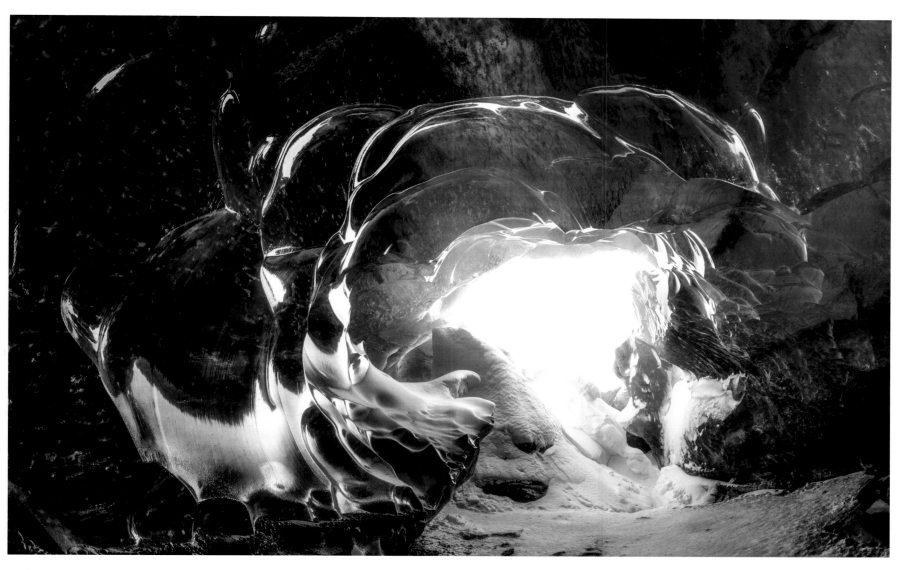

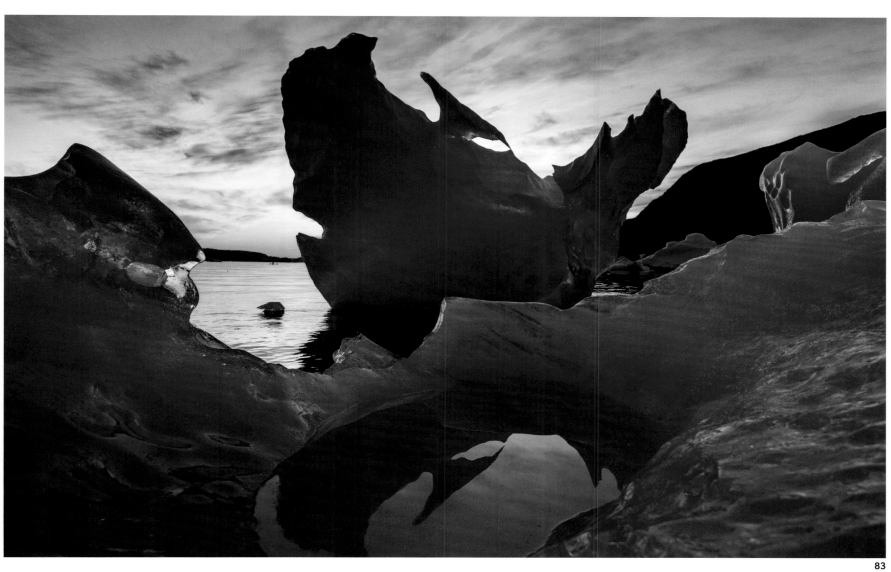

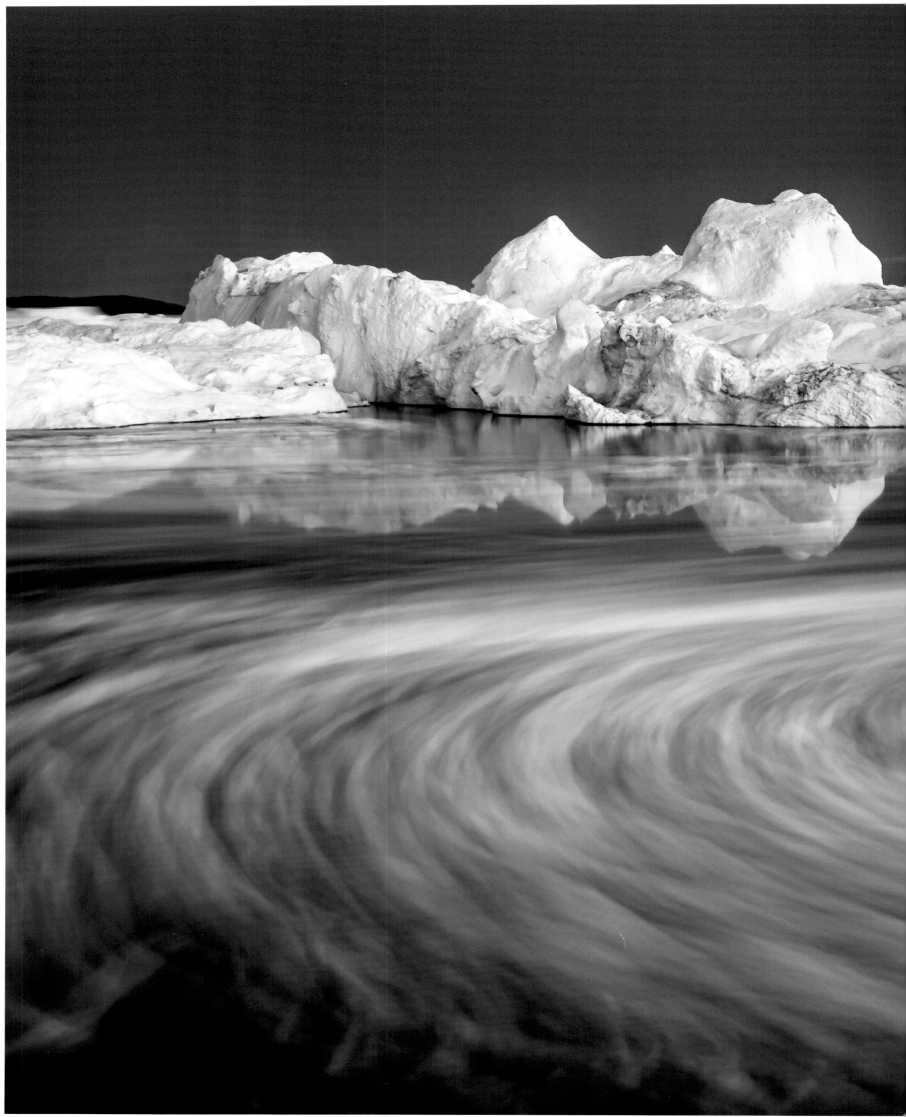

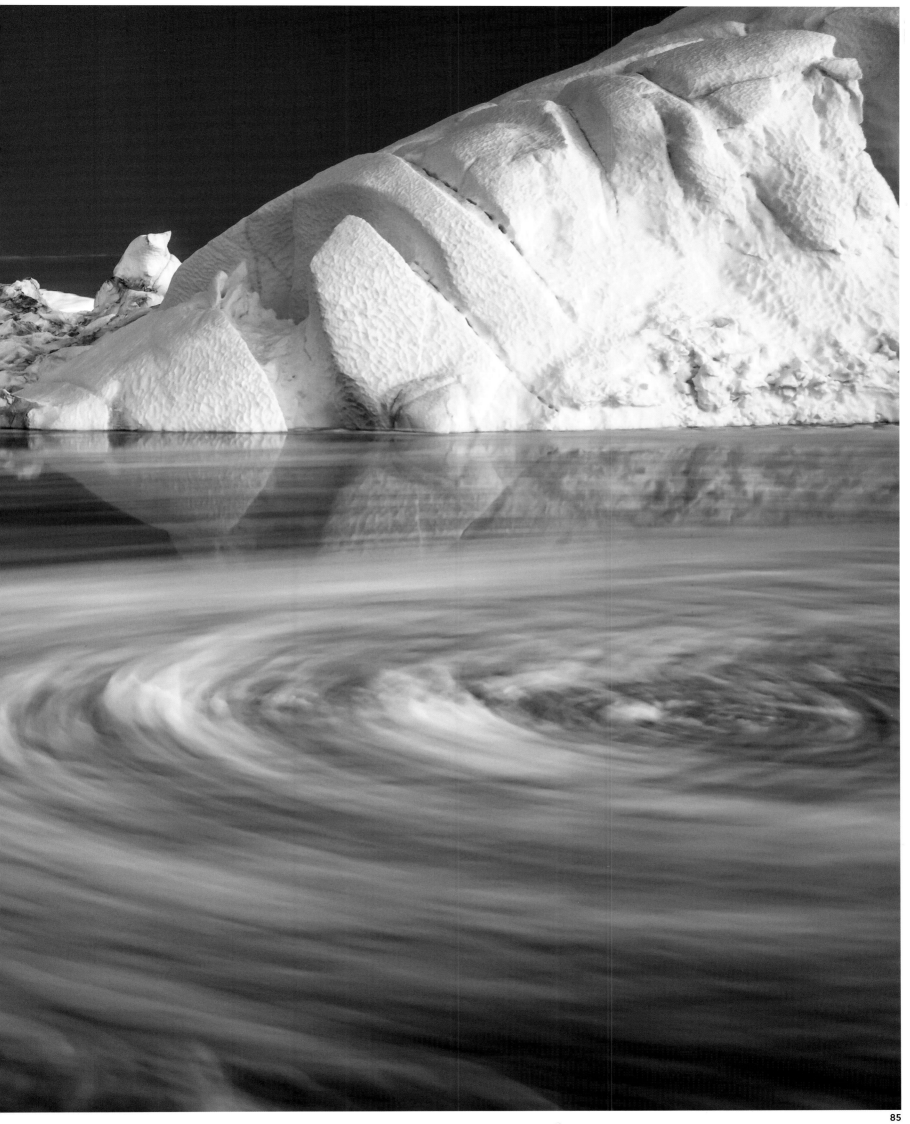

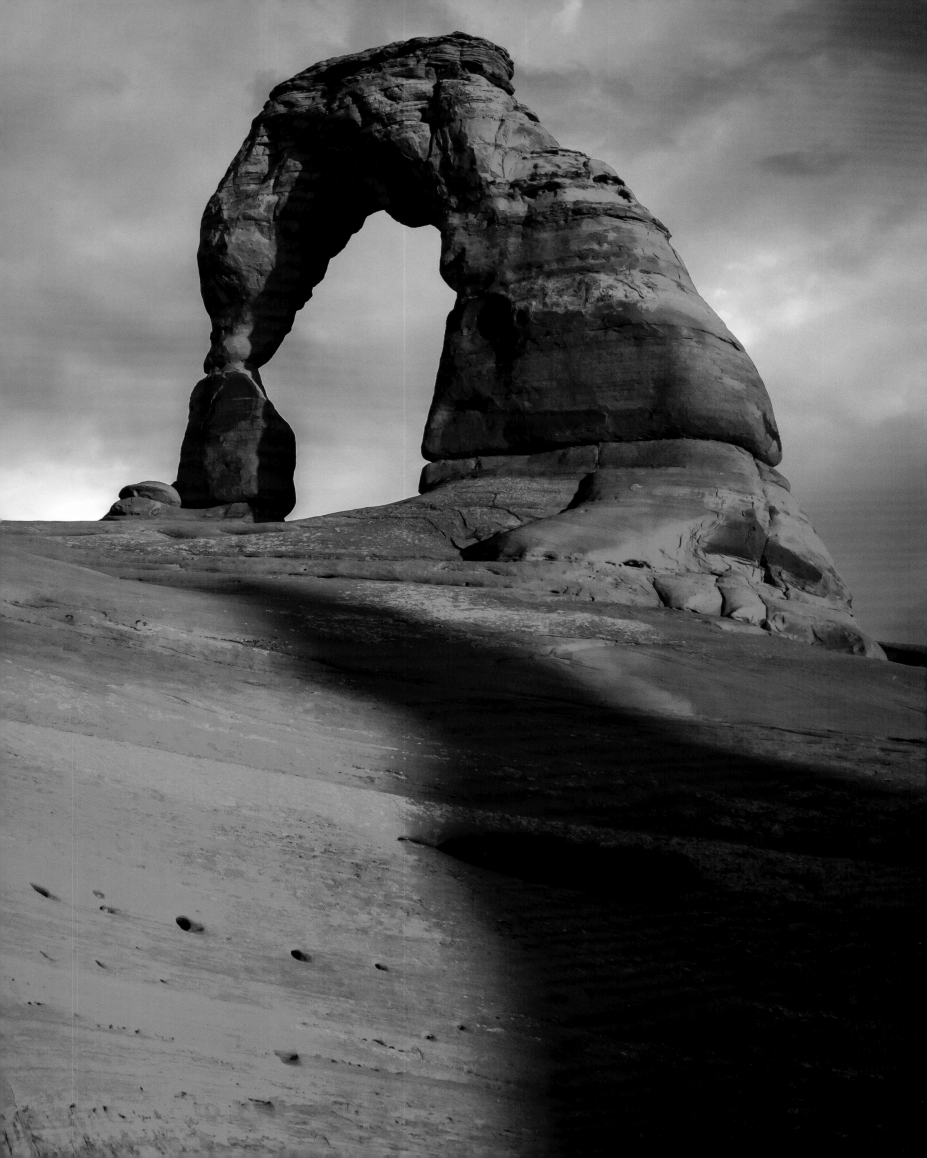

The driving force in this chapter is erosion. Areas exposed to the action of water, wind, and glaciers over millions of years receive deep scars in the form of canyons. This is how nature created the greatest of them all, the Grand Canyon in the United States. The quality of a given rock layer and different regimes of wind and water give rise to so-called hoodoos, which are turret-like formations of sedimentary rock, as well as to arches, narrow slot canyons, as well as other structures. In the United States, Utah's Bryce Canyon is a model of the perfect coordination between rock and erosion. Hundreds of fire-red hoodoos overtop one another in successive rows along the semicircular canyon rim.

In 2011, after numerous journeys in the American southwest, I had the utterly infrequent honor of photographing Bryce mantled in fresh snow after several days of blizzard conditions. But Bryce Canyon isn't the only place to exhibit hoodoos. Across the entire Colorado Plateau, there may be thousands of spots like this, of which several have already been declared as national parks. The rock layers are the books of bygone eras. Geologists read them like others read novels, and we photographers record their appearances for posterity.

Die treibende Kraft in diesem Kapitel ist die Erosion. Werden Regionen über Jahrmillionen Wasser, Wind und Gletschern ausgesetzt, hinterlässt dies tiefe Spuren in Form von Canyons. Auf diese Weise erschuf die Natur auch den größten von allen, den Grand Canyon in den USA. Abhängig von der Gesteinsschicht und der Wasser- und Windmenge entstehen jedoch auch sogenannte Hoodoos (turmartige Formationen aus Sedimentgesteinen), Steinbögen, enge Slotcanyons oder sonstige Gebilde. Das Vorzeigebeispiel für ein perfektes Zusammenspiel aus Gestein und Erosion liefert der Bryce Canyon in Utah, USA. Hunderte feuerrote Hoodoos türmen sich hier auf einer halbkreisförmigen Abbruchkante hintereinander auf.

Im Jahre 2011, nach zahlreichen Reisen in den Südwesten der USA, wurde mir die äußerst seltene Ehre zuteil, den Bryce nach einem tagelangen Blizzard in frischem Winterkleid zu fotografieren. Mit diesen besonderen Gebilden steht der Bryce Canyon jedoch nicht alleine da, denn auf dem gesamten Colorado Plateau lassen sich Tausende solcher Gegenden finden, von denen viele bereits zum Nationalpark ernannt worden sind. Gesteinsschichten sind die Bücher der alten Zeit. In ihnen lesen Geologen wie andere in Romanen – und wir Fotografen halten dies für die Nachwelt fest.

La vedette de ce chapitre est l'érosion. La Terre, exposée pendant des millions d'années à l'eau, aux vents et aux glaciers, en a gardé des traces profondes, les canyons. Et c'est ainsi que Dame Nature a créé le plus grand de tous, le Grand Canyon, aux États-Unis. En fonction des couches rocheuses, de la pluviométrie et de la force des vents, se forment également ce qu'on appelle des hoodoos (colonnes naturelles de roches sédimentaires), des arches en pierre, des canyons en fente et d'autres formations encore. Bryce Canyon en Utah, aux États-Unis, est un exemple parfait d'interaction entre l'érosion et les formations géologiques. Des centaines de hoodoos pointent vers le ciel, disposés en immense amphithéâtre naturel au bord d'un plateau.

En 2011, alors que j'en étais à mon énième voyage dans le sud-ouest des États-Unis, j'ai eu le privilège rare de photographier Bryce Canyon sous un manteau blanc immaculé après plusieurs jours de blizzard. Les hoodoos de Bryce Canyon ne sont pas un phénomène isolé sur le plateau du Colorado, on en observe dans des milliers d'autres endroits, dont la plupart sont également des parcs nationaux. Les strates rocheuses sont les livres des temps anciens, les géologues les lisent comme des romans – et nous nous chargeons photographier pour la postérité.

// OPPOSITE PAGE

Delicate Arch in Arches National Park in Utah, USA, is the most famous regional feature. What in photographs appears to be wild and desolate is in fact one of the most popular destinations in the United States. Hundreds of photographers and nature lovers perch on the rocks every evening and watch the sun's last rays illuminate the arched rock all in red.

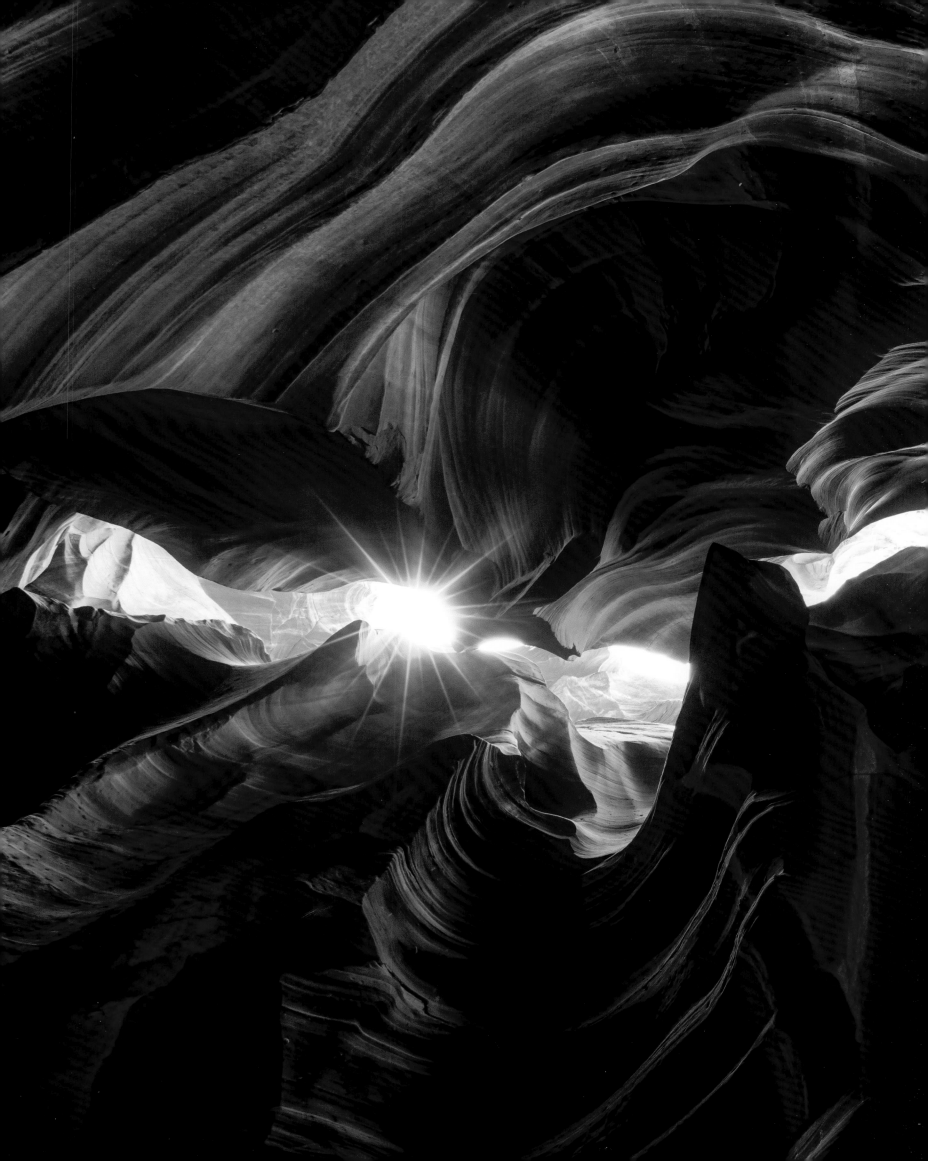

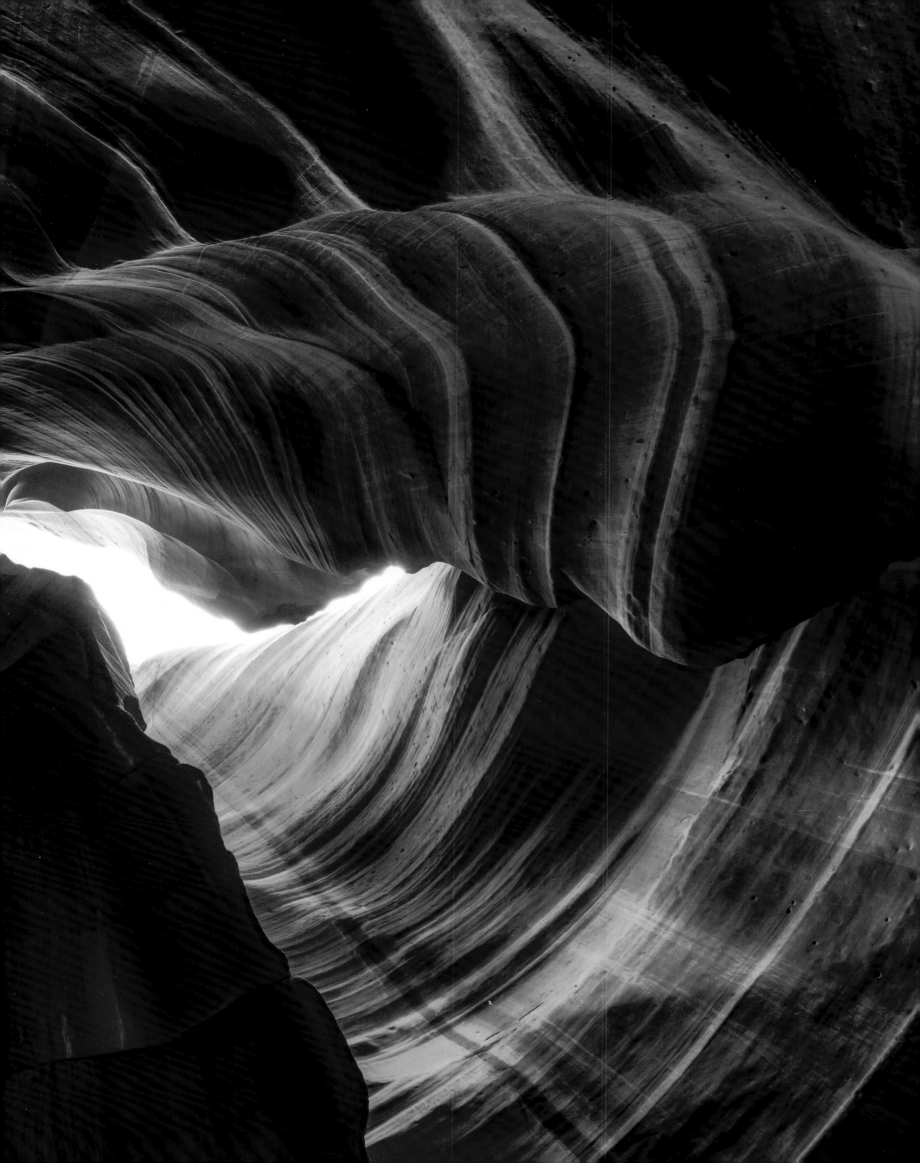

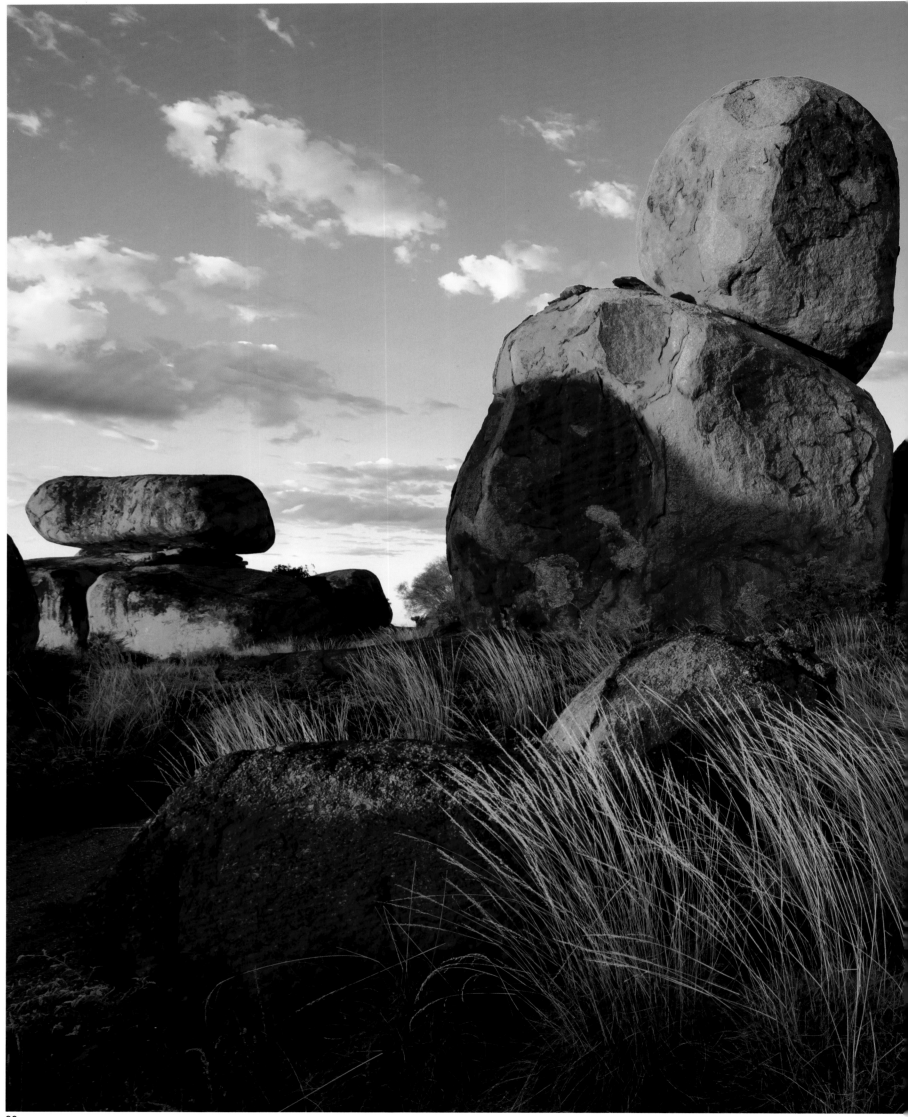

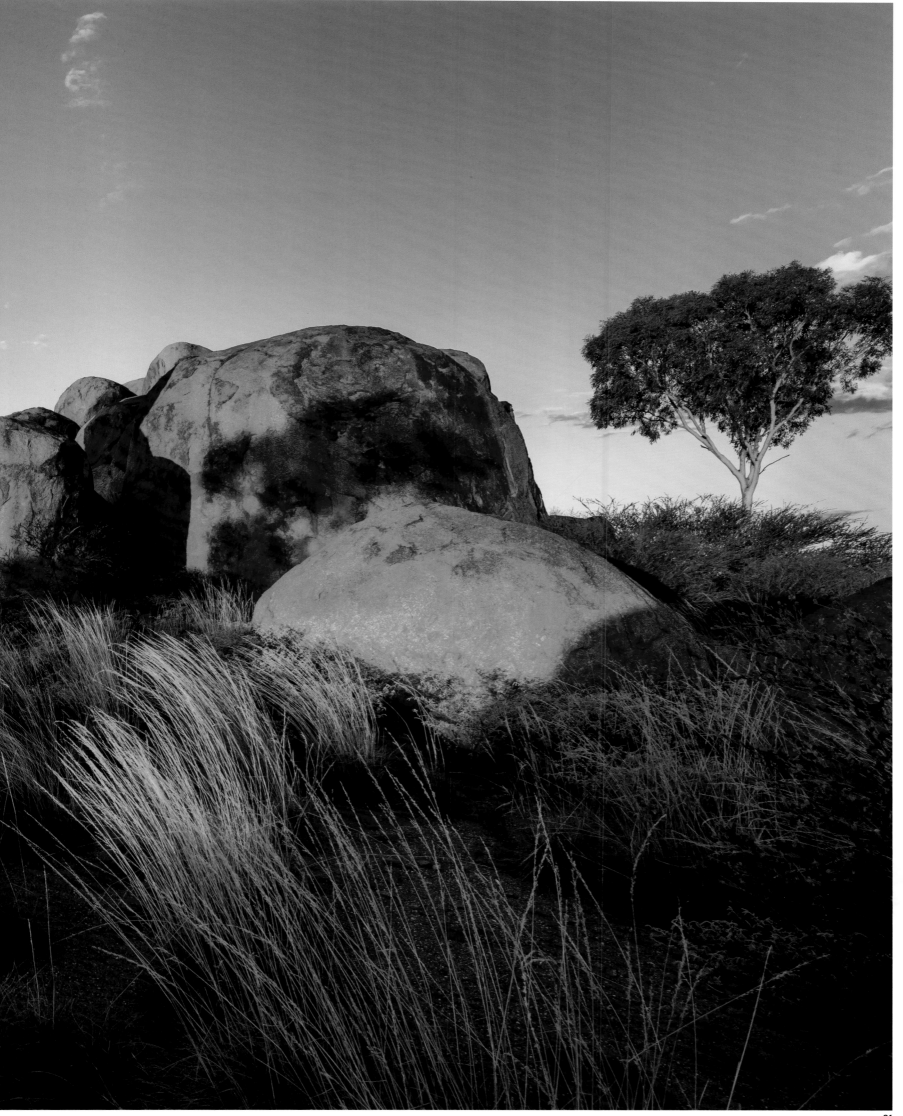

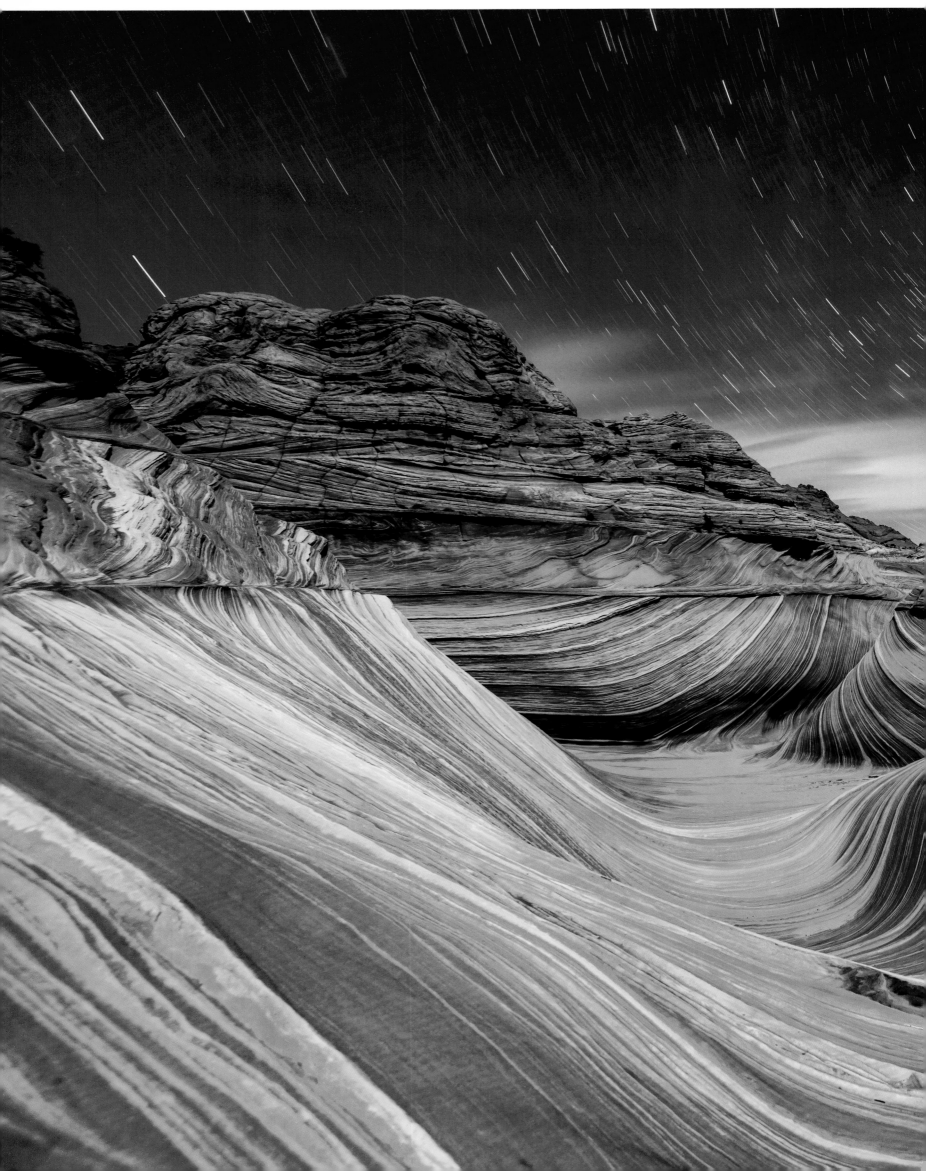

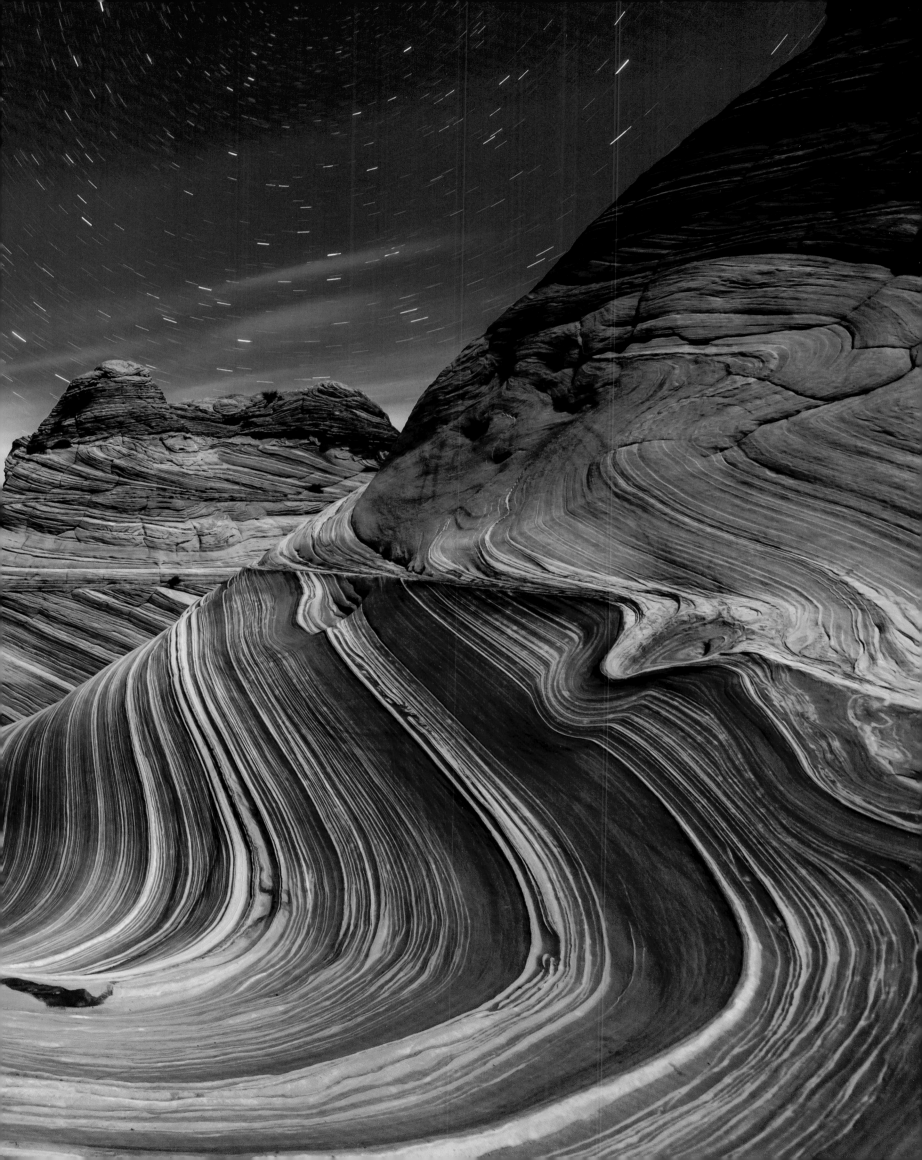

// THIS PAGE

In the middle of Namibia's flat, rocky desert the peaks of the Spitzkoppe rise up nearly 1,200 m (about 3,900 ft.). This inselberg is designated the "Matterhorn of Namibia" due to its striking shape. The Spitzkoppe was formed by an intrusion of magma into overlying strata, the removal of which over millions of years left only the erosion-resistant granite intact.

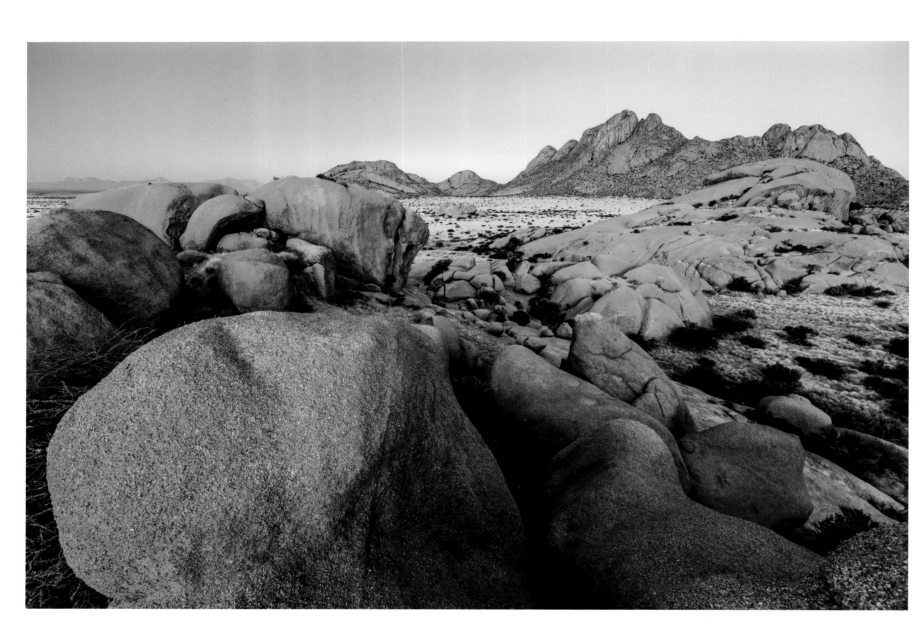

// OPPOSITE PAGE

This beautiful lake on the Colorado Plateau in the United States is a human creation. In 1963, an enormous dam was built in the heart of Glen Canyon, backing up the Colorado to form today's Lake Powell. I shot this image from Alstrom Point. The grand overlook is only accessible to large off-road vehicles.

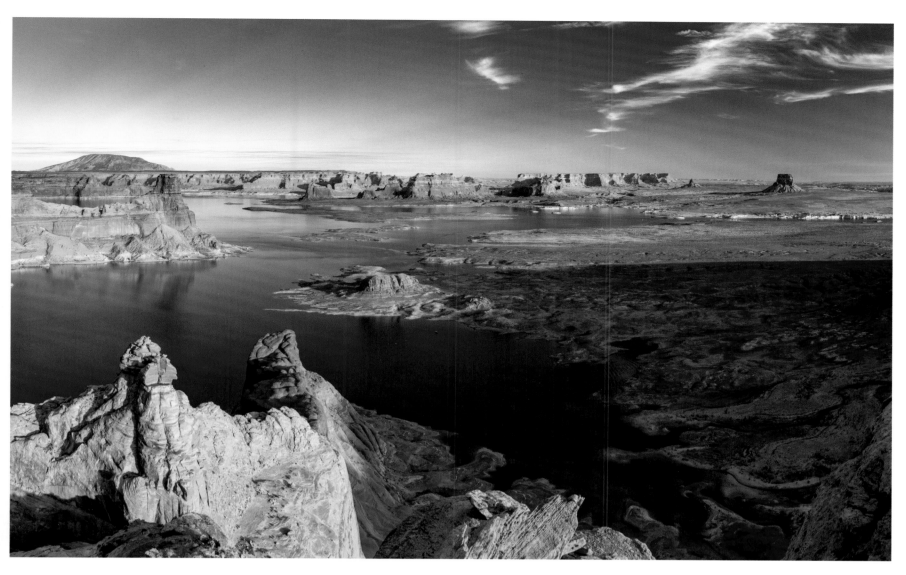

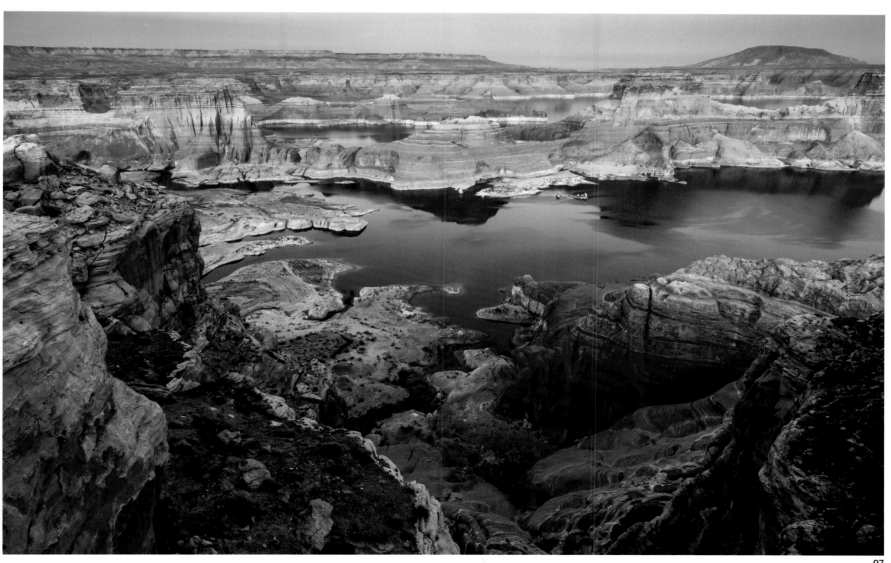

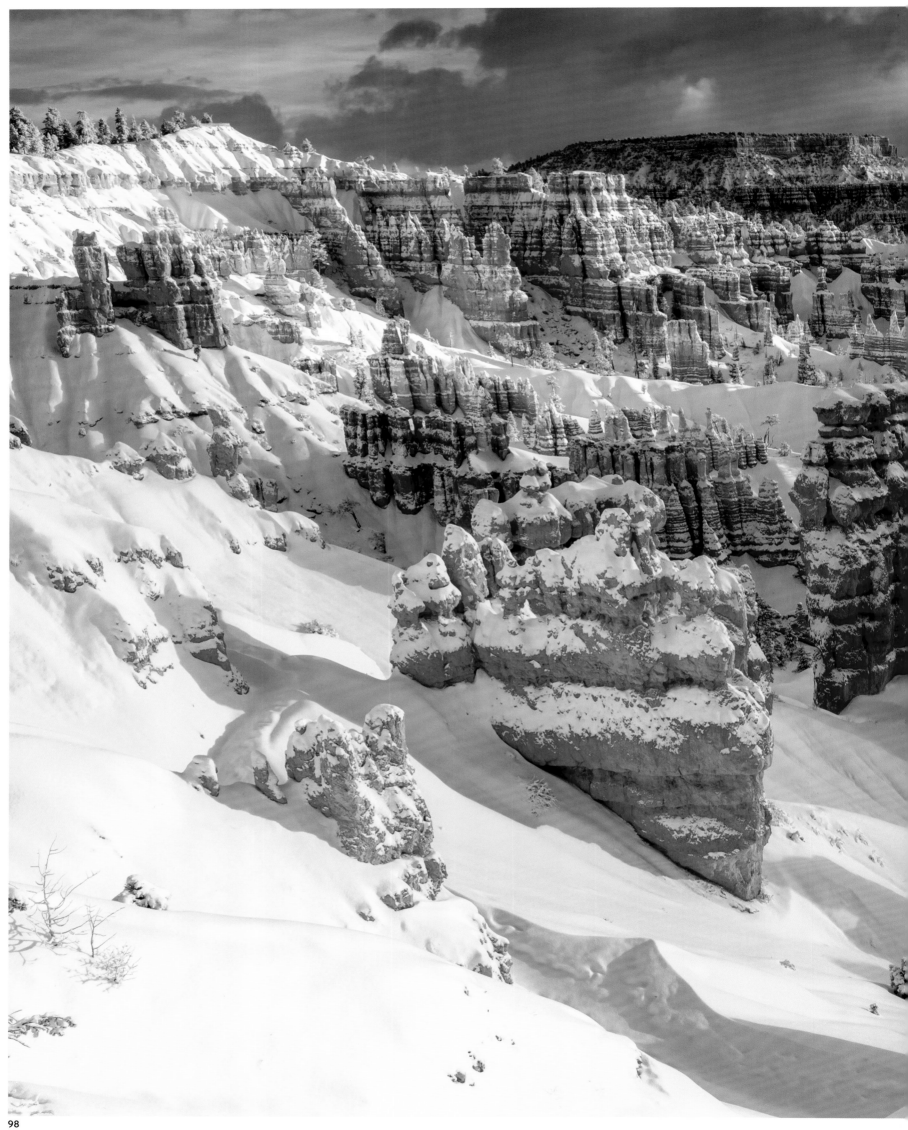

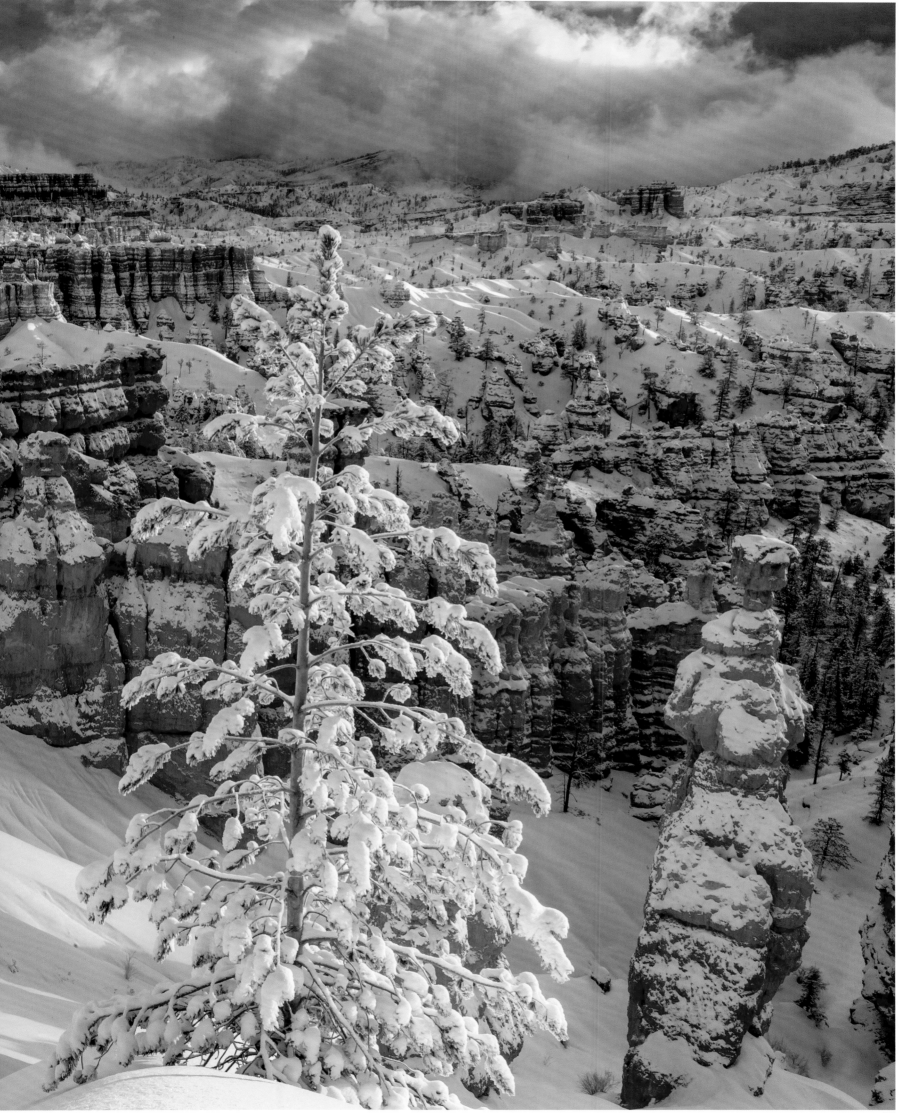

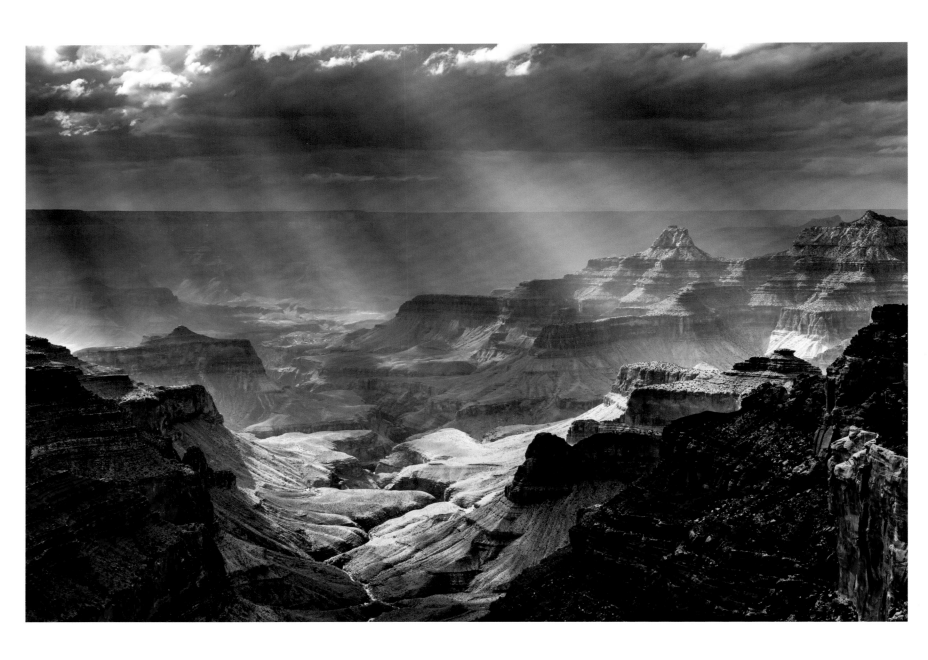

// PREVIOUS PAGE

By far the most beautiful canyon in North America, to me, is Bryce Canyon. Hundreds of fire-red, so-called *hoodoos* jut skyward from the canyon, seeming almost like a huge flaming forest. I always dreamt of photographing this canyon in a brand-new winter coat. On my third trip to the United States, in January 2010, my wish finally came true one day after a massive blizzard.

// THIS PAGE

The Grand Canyon in the United States' Southwest, 445 km (277 mi.) long and 1,800 m (5,900 ft.) deep, is the largest canyon in North America. This image was shot at the less touristy North Rim of the Grand Canyon. For the photographer in me, sunrays through haze are among the most beautiful of all atmospheric appearances.

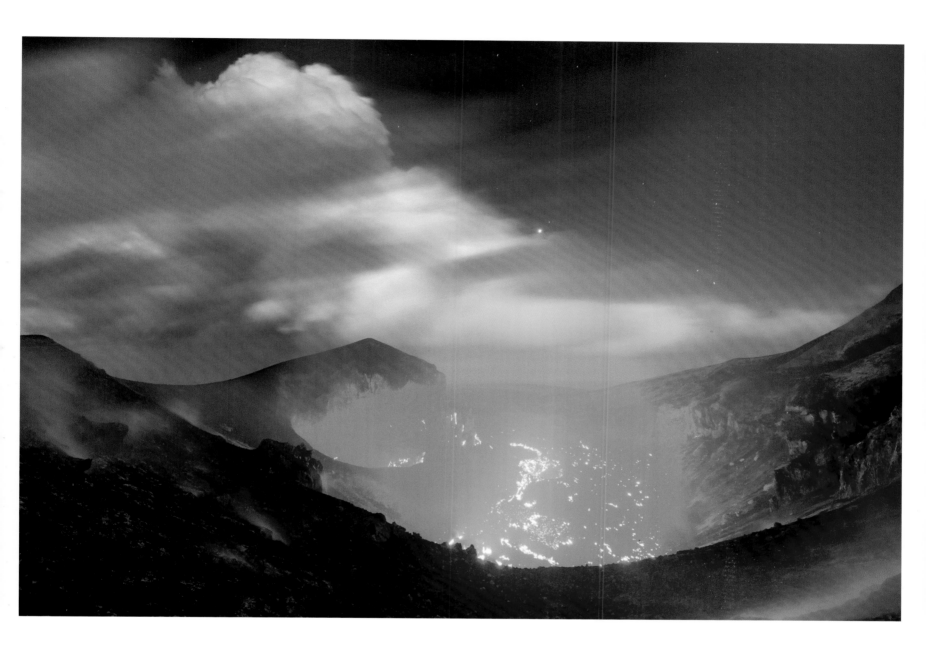

// THIS PAGE

One of those images for which I risked my life, as I learned a few weeks later. Despite the Indonesian government's closure of the volcanic island Anak Krakatau to visitors, a volcanologist and I got ourselves dropped off on the island, and I made an ascent. When I got to the top I saw why it was forbidden to be there. Compared with two-month-old photographs, the lava dome had drastically risen, and three weeks after my visit Krakatau erupted once again.

// NEXT PAGE

During summer at the Grand Canyon, visibility runs about 40 km (25 mi.). On clear, very cold winter days visibility can far exceed 100 km (62 mi.). Marvelous to behold in this image is the snow line, making one aware that the canyon is so deep that the floor and rim are subject to extreme temperature differences.

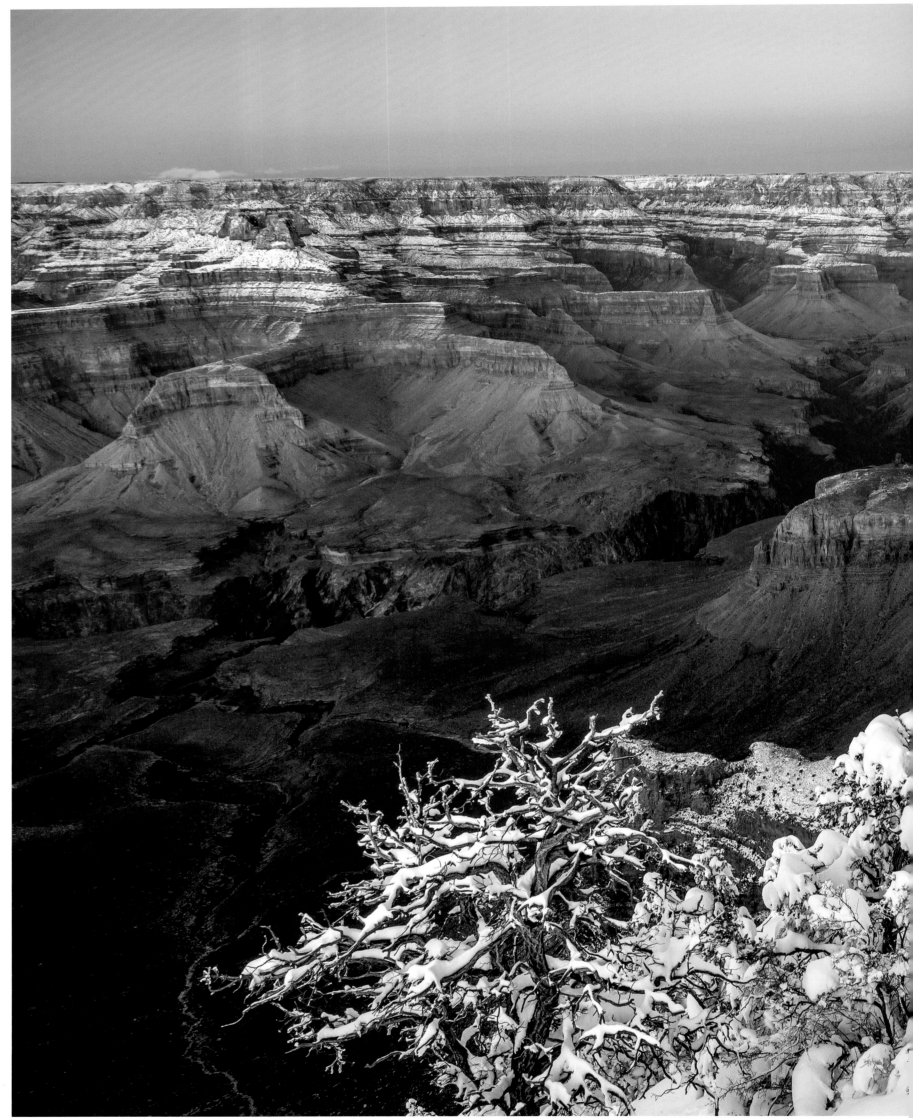

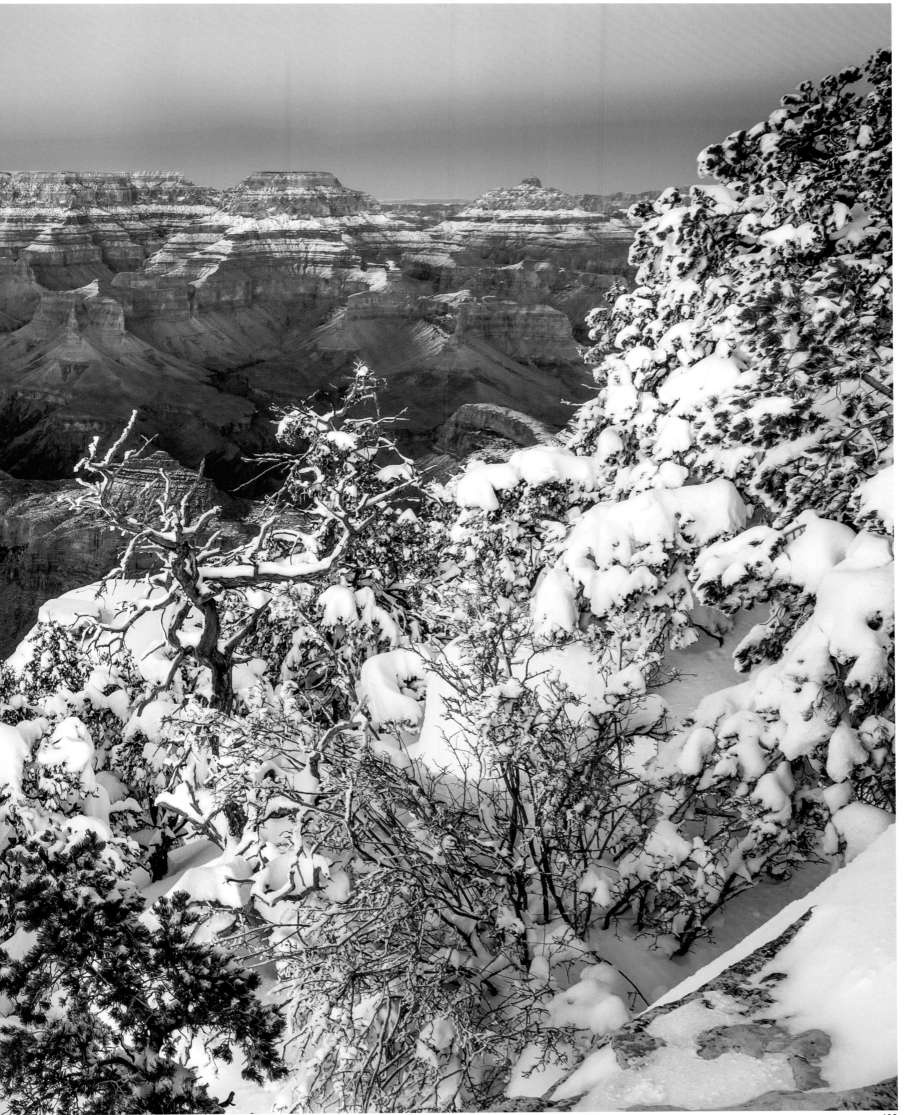

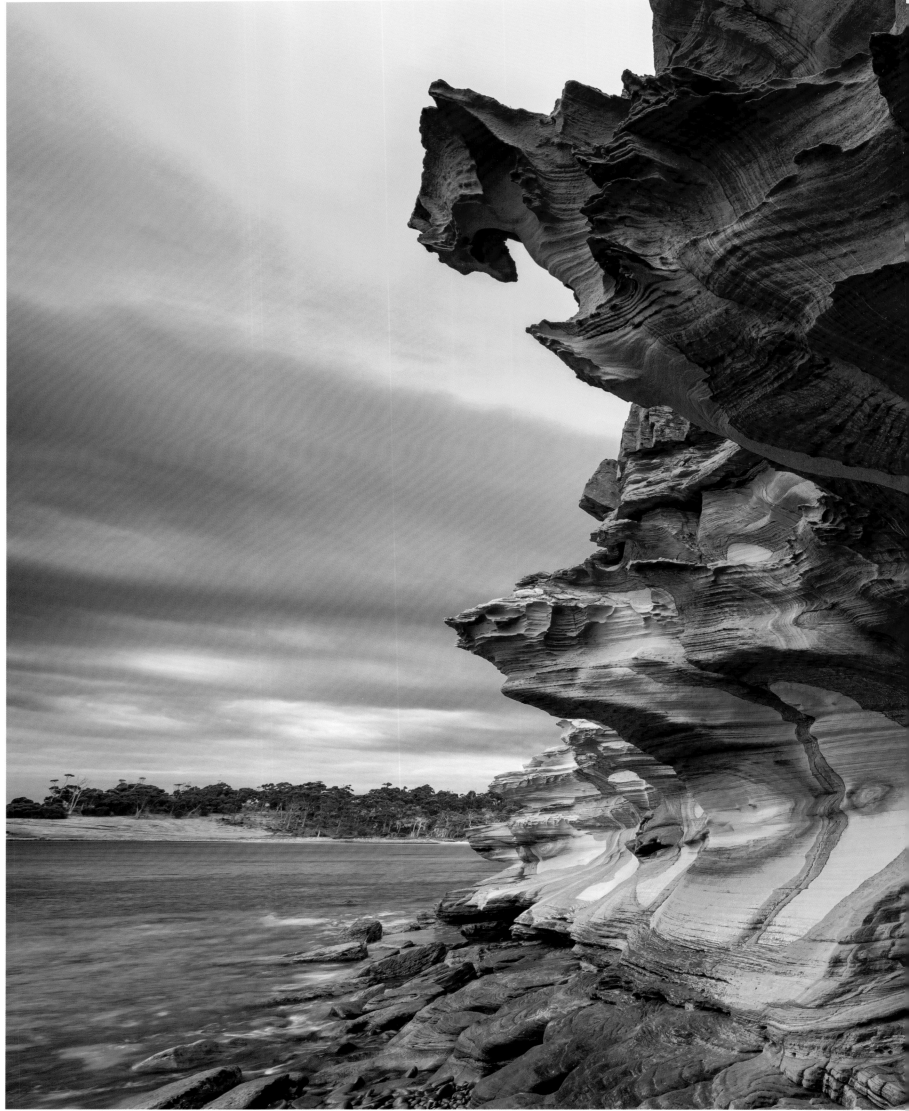

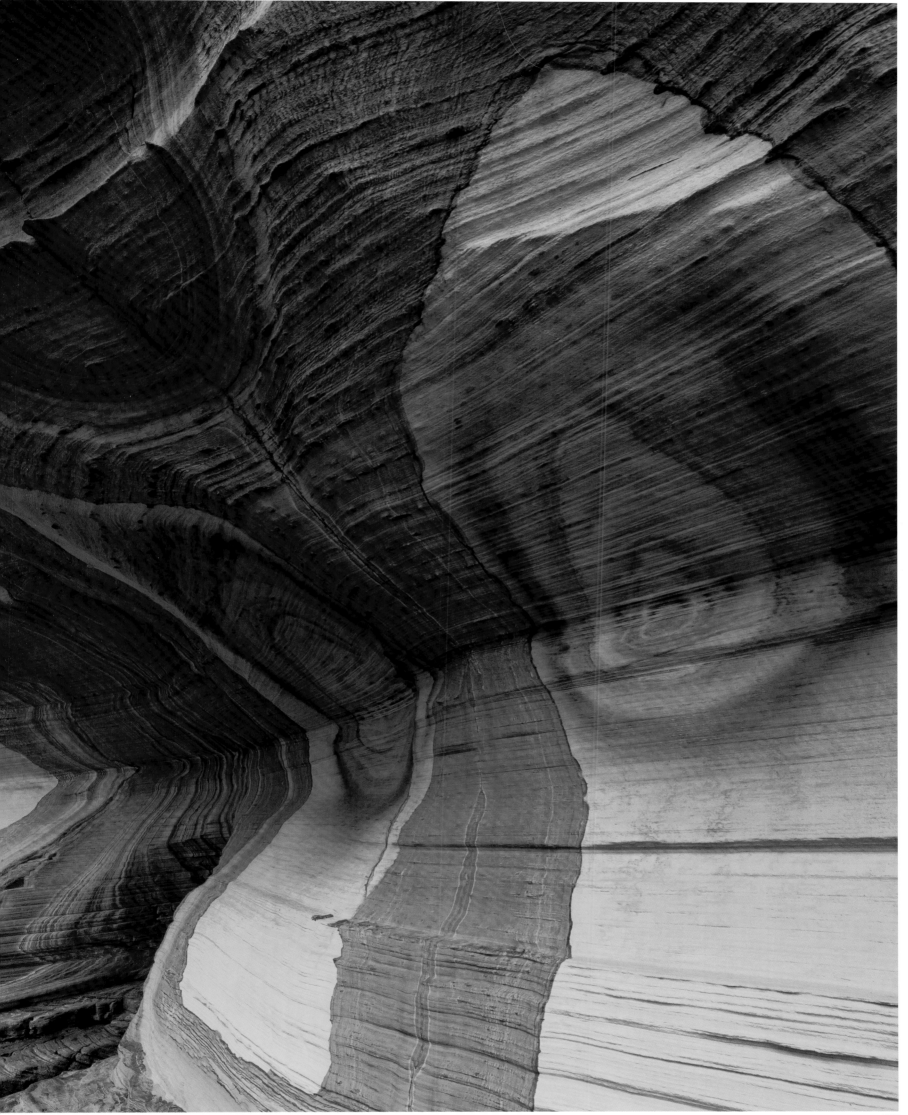

// PREVIOUS PAGE

This incredible seeming wall of sandstone is the Painted Cliffs on Maria Island in Tasmania, Australia. The spectacular object of these images is one of the most impressive natural features I have ever been permitted to see. On this particular evening, the setting sun lit up clouds in the sky in every shade of red, and the Painted Cliffs caught fire in the light.

// OPPOSITE PAGE / TOP

Glowing brightly, the mountains in Zion National Park in Utah, USA, tower over forests. On my own, I hiked for days through canyons and expanses of Zion in constant astonishment. Especially during fall, when deciduous trees are turning and the sun sets, the landscape lights up in most wonderful hues.

// NEXT PAGE

It looks as if it was composed on a computer. In Namibia, however, after it's been raining for hours and the sun shines onto rocky mountains one last time before the sun setting, you stand there as a photographer before an unbelievable sight. This image was taken not far from Ai Aiba Lodge near the town of Omaruru.

// PAGE 110/111

These rocks on Kangaroo Island, south of Australia, could not be more aptly named: Remarkable Rocks. Absolutely remarkable as well was the light I was privileged to experience on this morning. Bad weather was approaching out of the west, and rain was palpably close by as the rising sun found a little gap in the clouds and bathed the rocks in unique light.

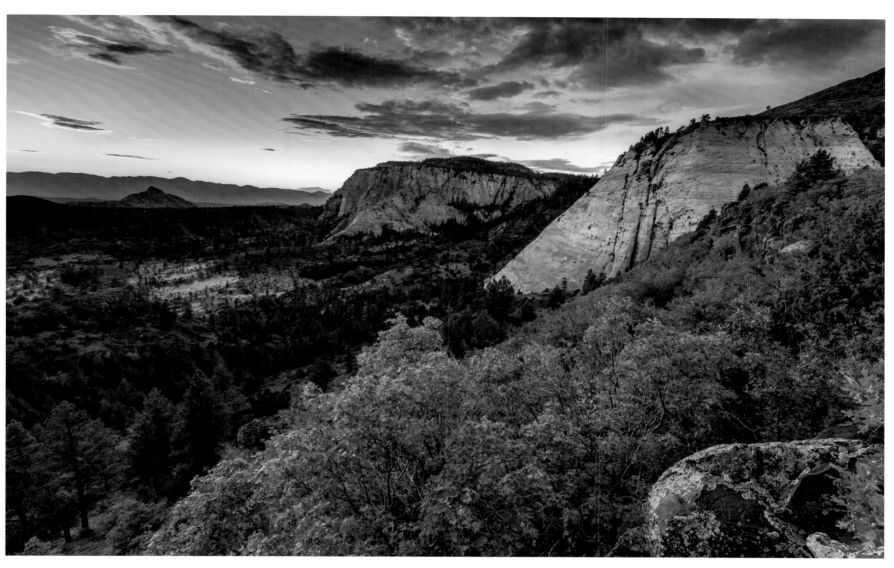

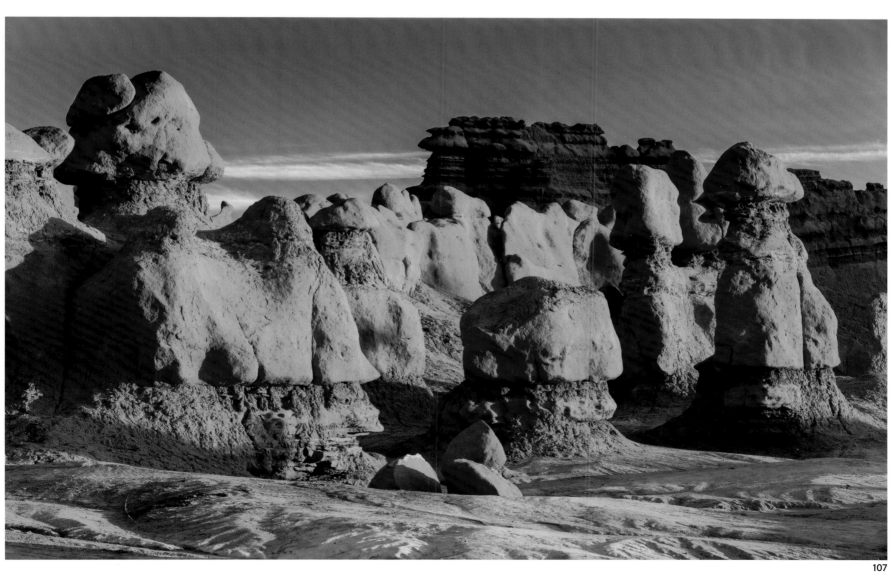

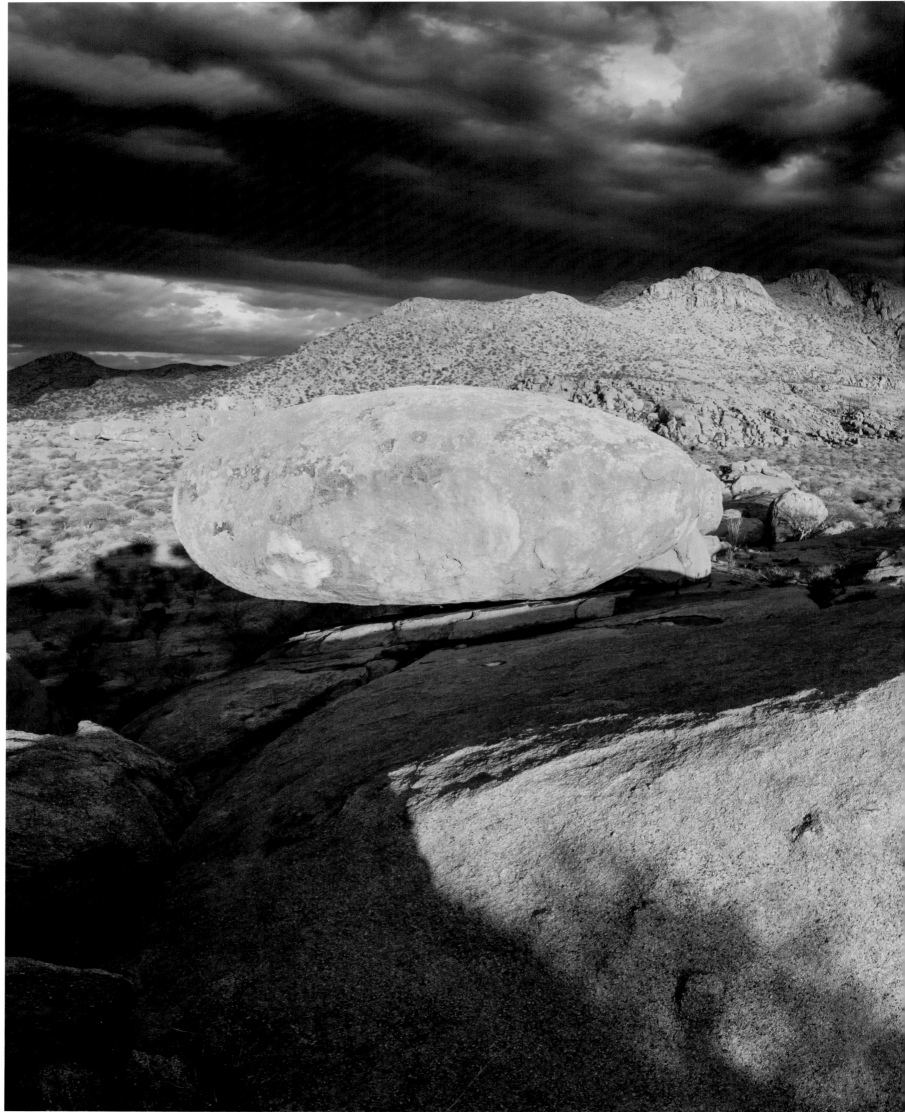

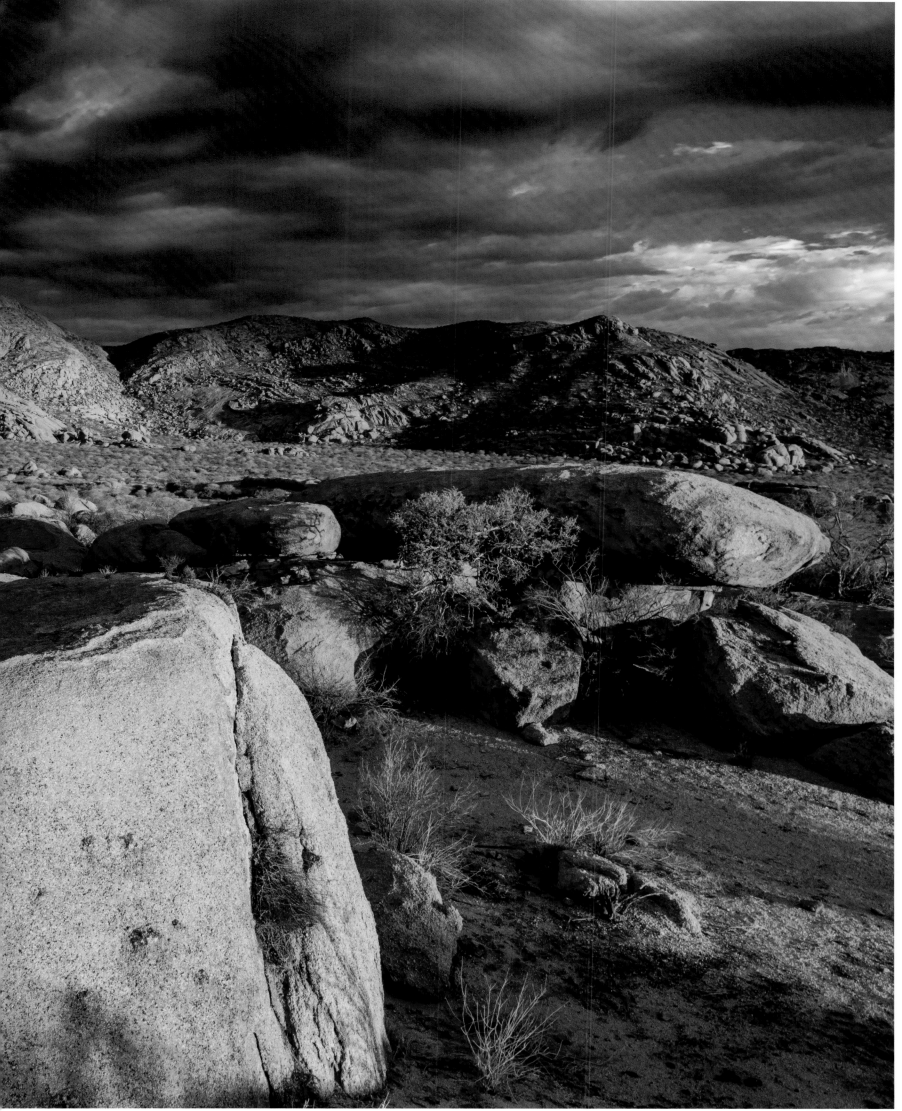

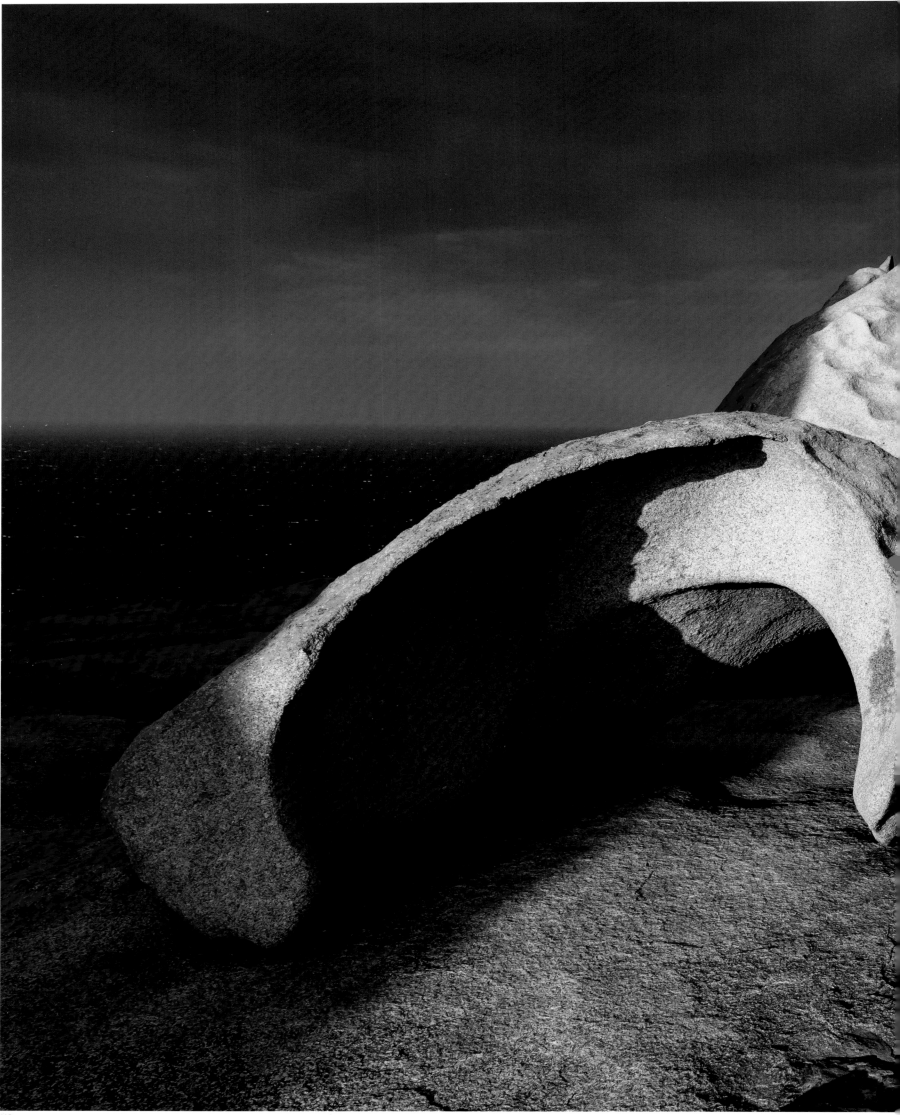

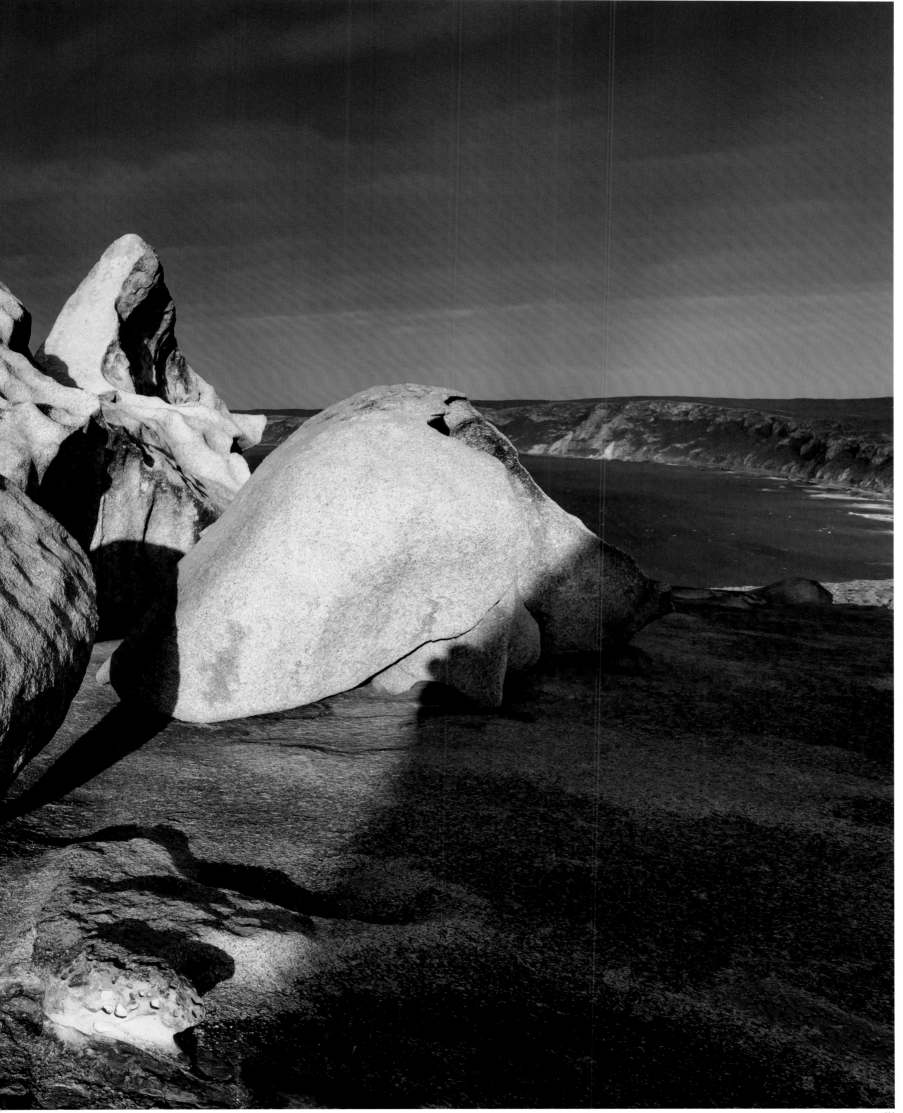

MOUNTAINS //
BERGE // LES MONTAGNES //

Humans have always been drawn to them, fascinated by their supposed unattainable quality: mountains. I have been especially taken with three special mountains. The first is Everest, at circa 8,848 m (29,035 ft.) the world's highest mountain above sea level. Then Denali, formerly called Mount McKinley in Alaska, and then comes Cerro Torre in Patagonia. The observer standing at Everest Base Camp on the Tibetan side sees its North Face as a vertical wall towering toward heaven. The needle-like granite spire of Cerro Torre renders ascent all but impossible.

But the mountain whose dimensions are even more impressive to me is Denali, which (unlike Everest) towers for more than 5,000 m (16,400 ft.) above its surrounding landscape. From its vantage point in the middle of the national park of the same name, it keeps watch over the lakes, rivers, forests, hills, and mountains that make the park one of the most beautiful in North America. Even in Switzerland, straddling the border with Italy, there is the Matterhorn, a pinnacle whose shape and detachment from its neighbors are like nothing else on earth. The biggest problem for me as a photographer, especially under such extreme meteorological conditions as wind and thunderstorms, is coping with the urge to stand on every mountain at once. If every one of those wonderful, lens-shaped lenticular clouds should appear—which happens mostly atop exposed peaks—then I invariably slip into a photographic delirium that lasts until my memory cards are all full.

Sie ziehen die Menschen seit jeher an und faszinieren mit ihrer vermeintlichen Unerreichbarkeit. Die Rede ist von den Bergen. Angetan haben es mir dabei drei besonders. Zum einen der Mount Everest, der mit ca. 8 848 Metern den höchsten Gipfel über dem Meer besitzt, dann der Mount Denali, ehemals Mount McKinley, in Alaska und zu guter Letzt der Cerro Torre in Patagonien. Steht man am Everest Basecamp auf der tibetischen Seite, ragt die „Northface" wie eine gerade Wand in den Himmel und die nadelartige Form aus Granit des Cerro Torre macht ein Besteigen fast unmöglich.

Der Mount Denali beeindruckt mich aber noch mehr, da er (anders als der Everest) die umgebende Landschaft mit mehr als 5 000 Metern weit überragt. Inmitten des gleichnamigen Nationalparks liegend, wacht er über die Seen, Flüsse, Wälder, Hügel und Berge, die den Nationalpark zu einem der schönsten von Nordamerika machen. Doch auch in der Schweiz, an der Grenze zu Italien, findet sich ein Berg, dessen Form und freistehende Position weltweit einzigartig ist: das Matterhorn. Für mich als Fotografen stellt es das größte Problem dar, vor allem bei extremen Wetterlagen wie Sturm oder Gewitter, den Wunsch zu verspüren, auf allen Bergen gleichzeitig stehen zu wollen. Dabei lässt mich die wunderschöne linsenartige Wolkenart Lenticularis, die meist nur über exponierten Berggipfeln auftaucht, jedes Mal in einen fotografischen Rausch fallen, der mit vollen Speicherkarten endet.

De tout temps, l'homme éprouve une grande attirance pour elles, leur prétendue inaccessibilité le fascine. Elles, ce sont les montagnes, et trois d'entre elles m'attirent particulièrement. Il s'agit de l'Everest, qui, avec ses quelque 8 848 mètres est considéré comme le plus haut sommet du monde au-dessus du niveau de la mer, le Denali, anciennement mont McKinley, en Alaska, et le Cerro Torre, en Patagonie. Vu depuis le camp de base, le versant nord côté tibétain s'élance vers le ciel comme un mur. Les pics et les parois granitiques du Cerro Torre rendent une ascension presque impossible.

Mais pour moi, le sommet encore plus impressionnant que l'Everest, également considéré selon les critères utilisés comme le plus haut sommet du monde, est le Denali. Il s'élève au-dessus d'une plaine en altitude, ce qui lui confère une élévation verticale de plus de 5 000 mètres. Situé dans le parc national du même nom, il veille sur de nombreux lacs, rivières, forêts, collines et montagnes, qui font de ce parc l'un des plus beaux d'Amérique du Nord. Mais la Suisse aussi possède un pic singulier par son aspect pyramidal, le Cervin, situé sur la frontière italo-suisse. Pour le photographe que je suis, le plus grand problème est de ressentir l'envie de vouloir gravir tous les sommets en même temps, surtout dans des conditions climatiques extrêmes comme les tempêtes ou les orages. Le merveilleux spectacle du nuage lenticulaire qui coiffe seuls les sommets les plus exposés me fait généralement succomber à un accès de mitraillage photographique, qui se solde par le remplissage de plusieurs cartes mémoire.

// OPPOSITE PAGE

The Matterhorn is Switzerland's chief landmark. Even for me as a Swiss, it is always a spellbinding sight. Here it makes an especially beautiful presentation across the Stellisee (Lake Stelli). On windless days one can make two Matterhorns out of one.

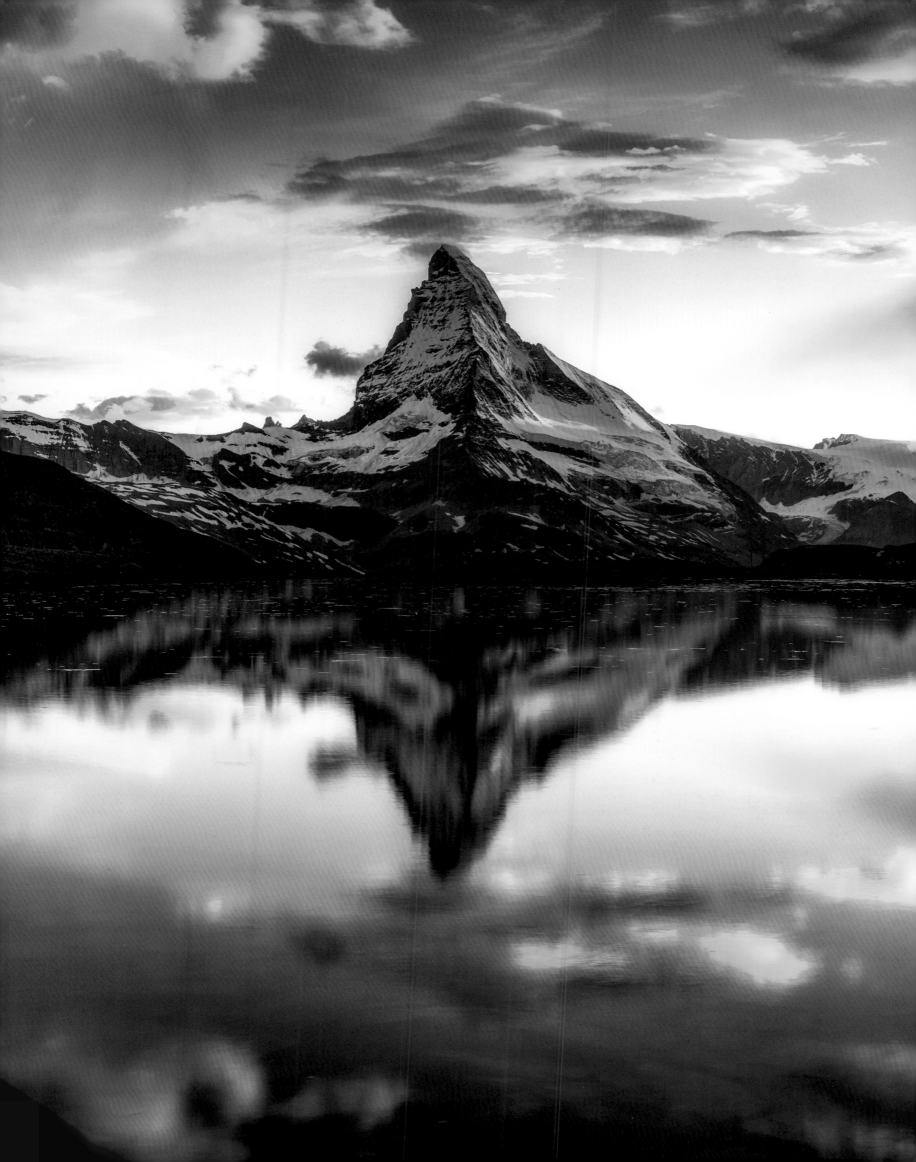

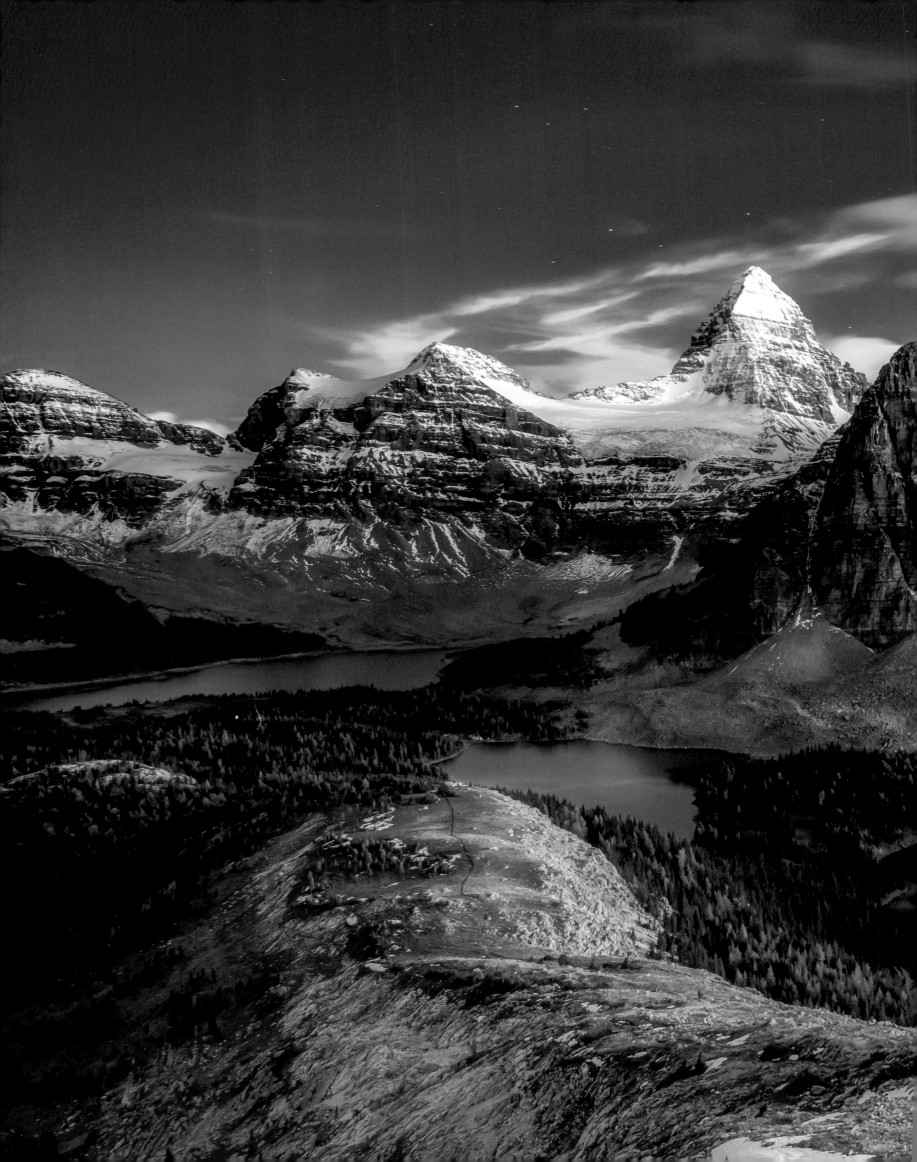

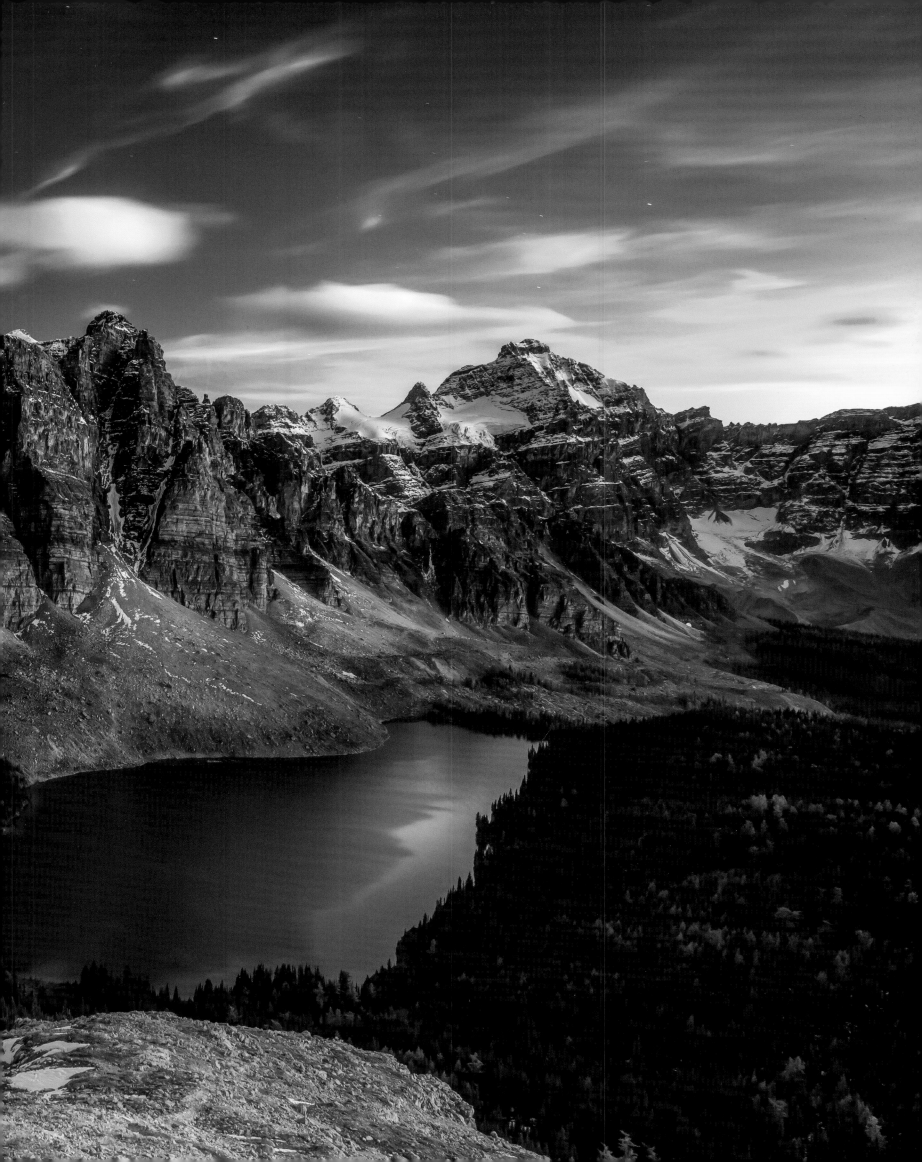

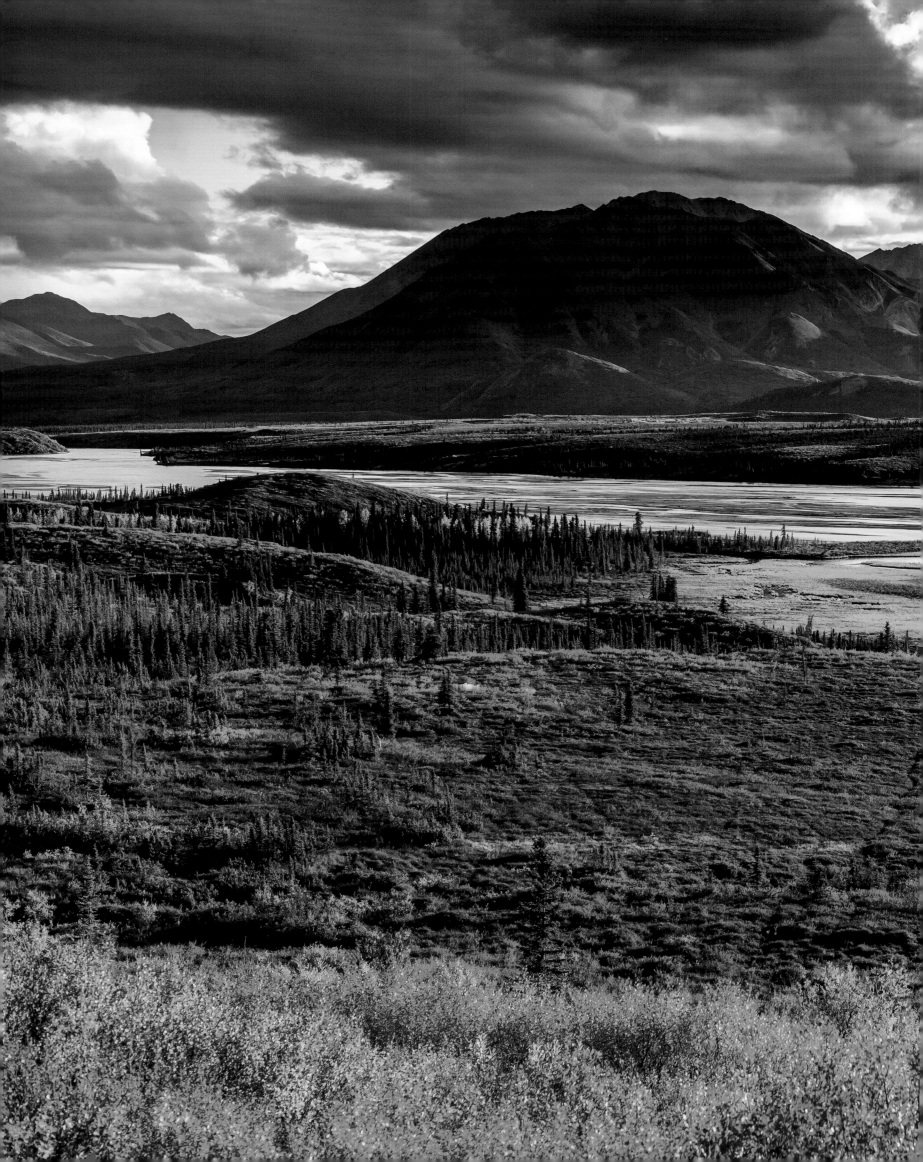

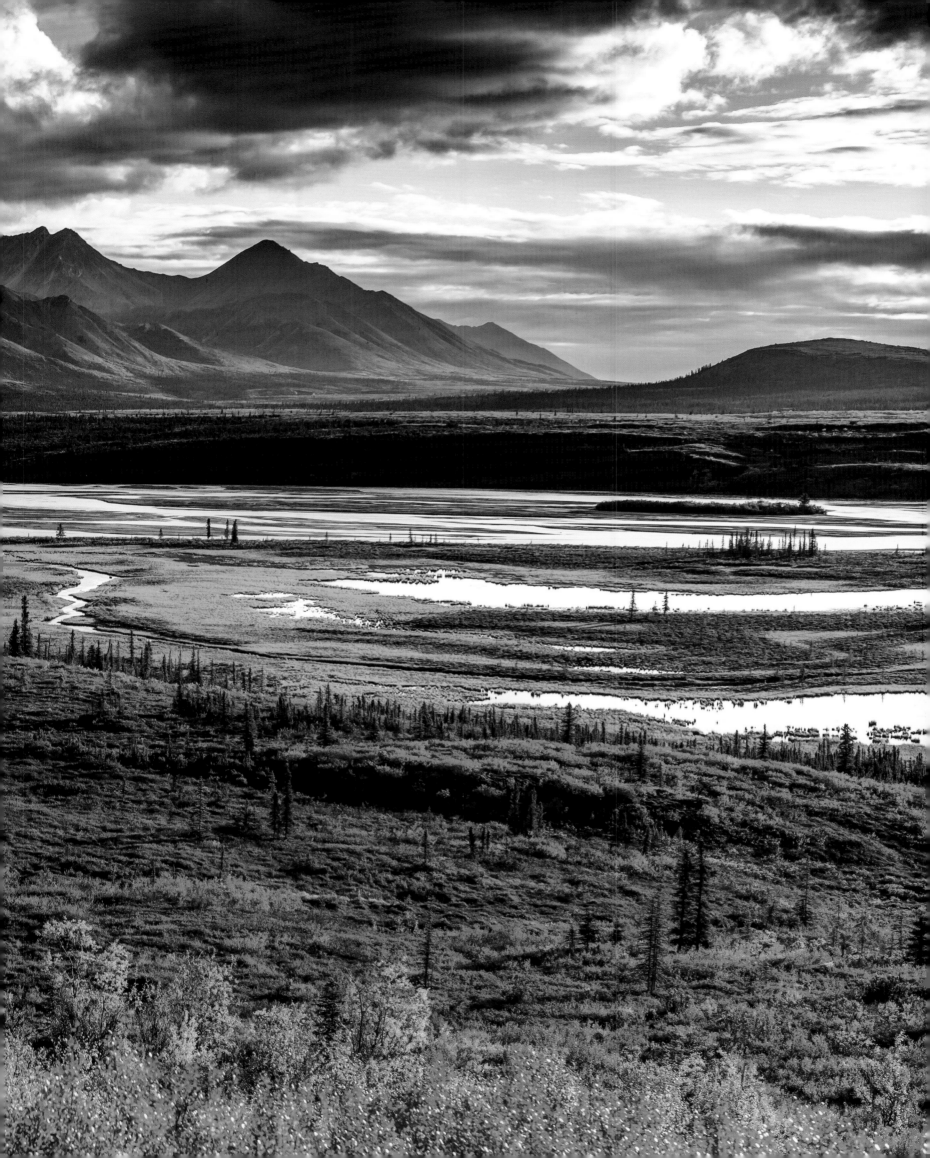

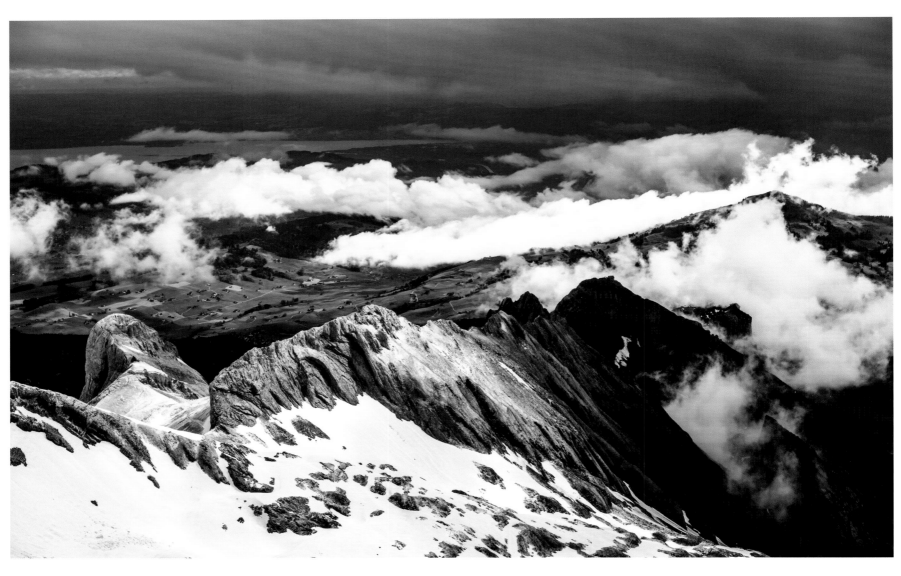

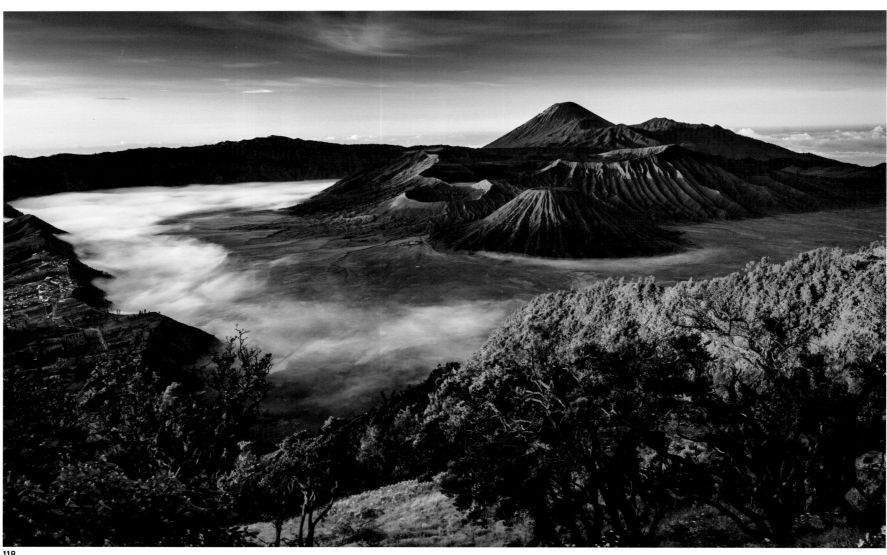

// PAGE 114/115

In the Canadian Rockies is a mountain many people call the Matterhorn of Canada. It takes a two-to-four-day hike or a helicopter flight out of Canmore to get there. In this image, the whole mountain chain reveals itself at its best.

// PREVIOUS PAGE

To have been in Alaska to see the fall foliage is a must for every photographer. For just a few weeks in August and September, the whole countryside is transformed in a colorful magnificence. This image is from along the little-driven Denali Highway.

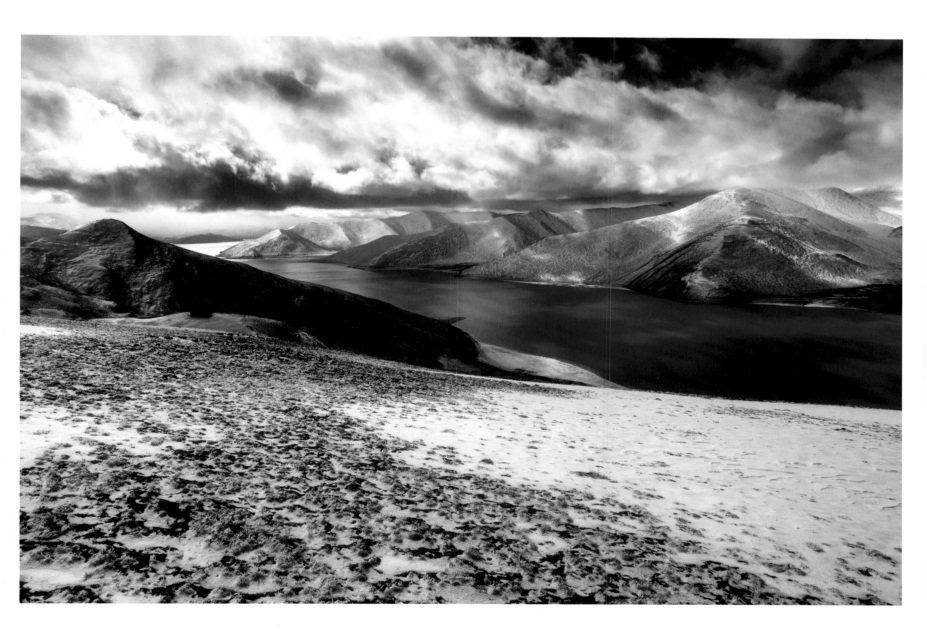

// THIS PAGE

The surface of this lake, called variously Yamdrok or Yamzho Yumco in the Shannan region in Tibet, is 4,400 m (14,435 ft.) above sea level and stretches over 130 km (81 mi.). The very thin air makes it hard to breath on the passes above the lake. I got to experience one of the season's final days on which the lake had not iced over.

// OPPOSITE PAGE / TOP

This image is home for me. It's taken on my home mountain, Säntis, around 2,500 m (8,200 ft.) high in the Alps in eastern Switzerland. The green hills of Appenzell appear beyond the rocky eastern grade. Way out on the horizon you can make out Lake Constance at the borders of Switzerland, Germany, and Austria.

// OPPOSITE PAGE / BOTTOM

Every day hundreds of people rise in the wee hours to come to this spot. Best views are limited to a few spots, so I had to arrive at the viewing platform at 2 a.m. to set up my tripod. As dawn slowly arrived to reveal strips of fog across the Bromo caldera, all my drowsiness departed and I got to witness a unique sunrise over the Semeru and Bromo volcanoes on Java, Indonesia.

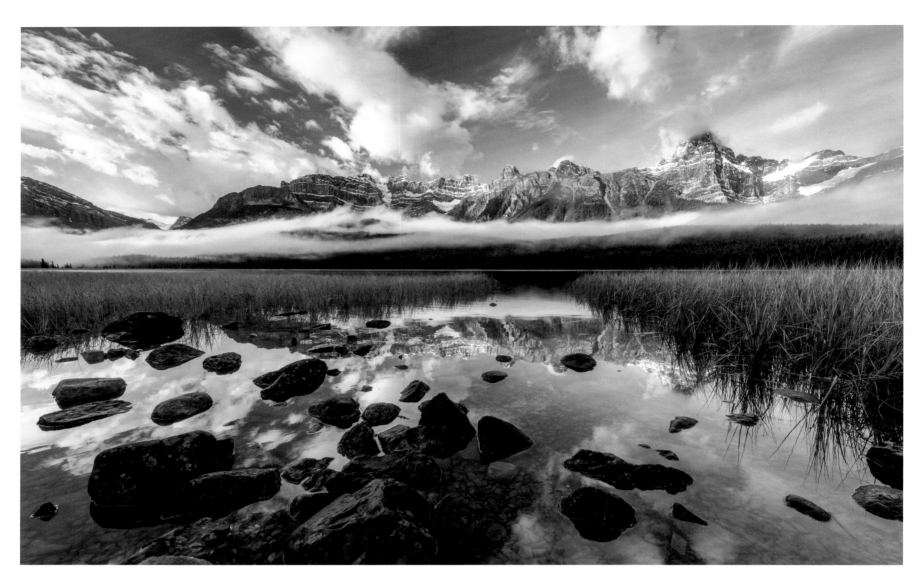

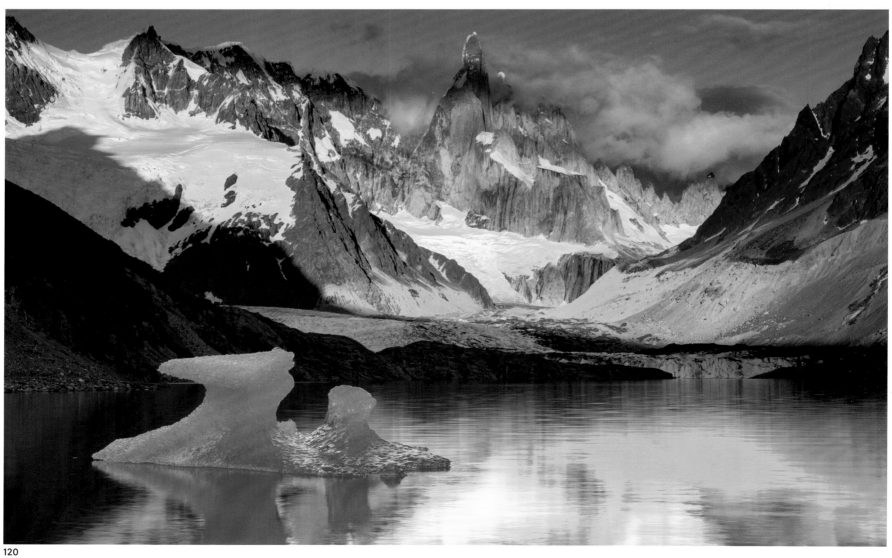

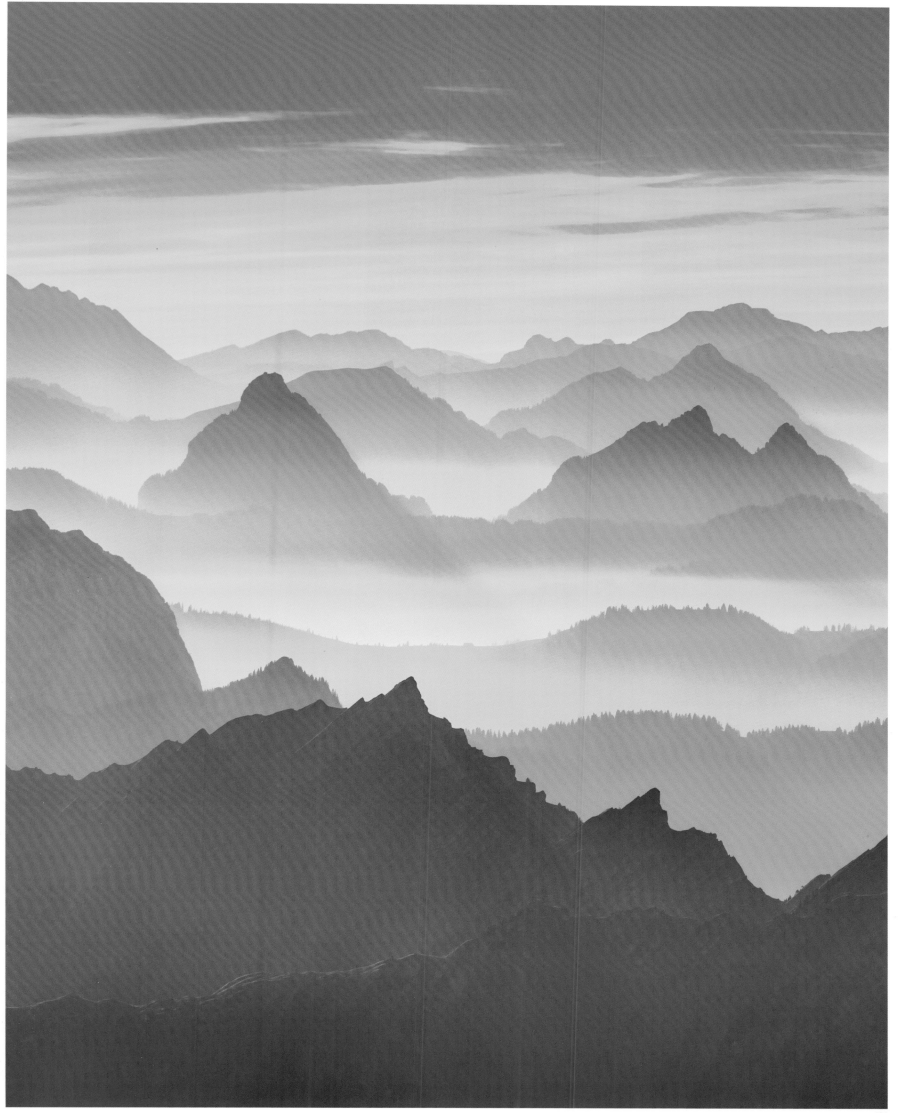

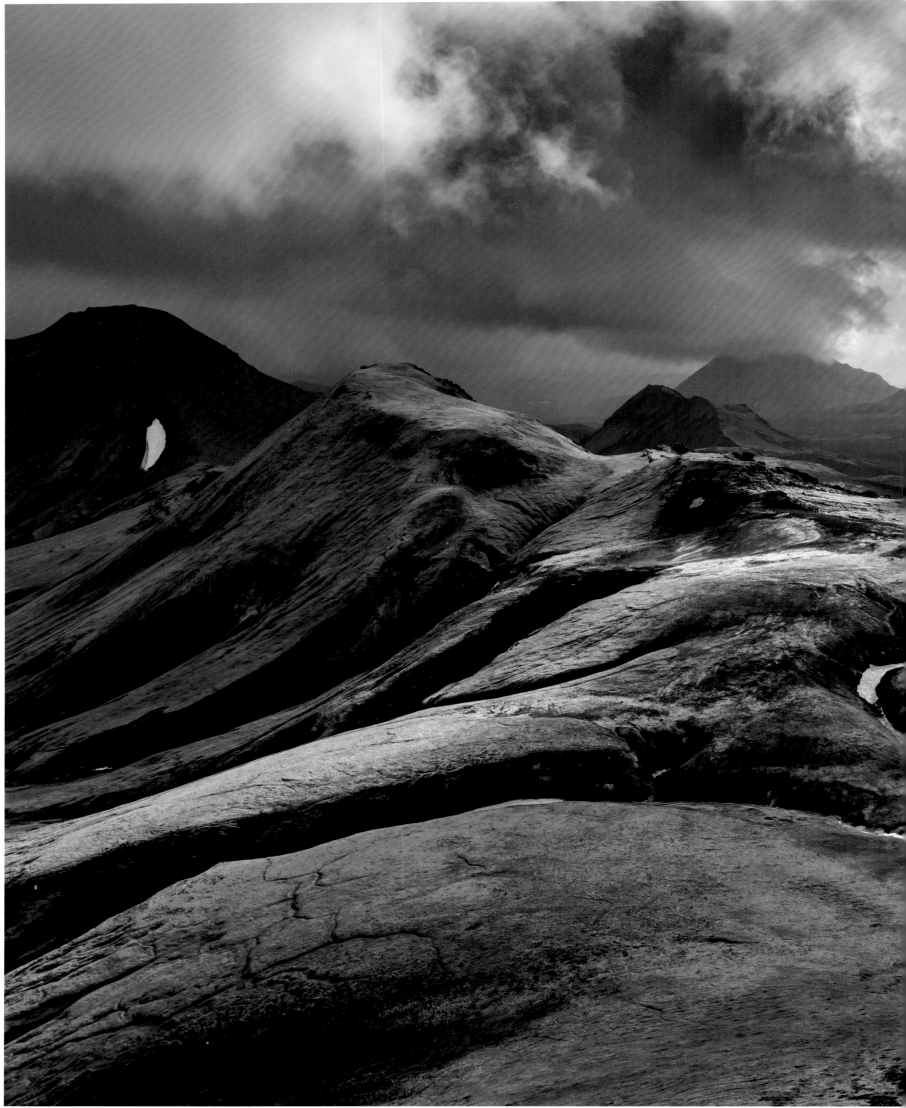

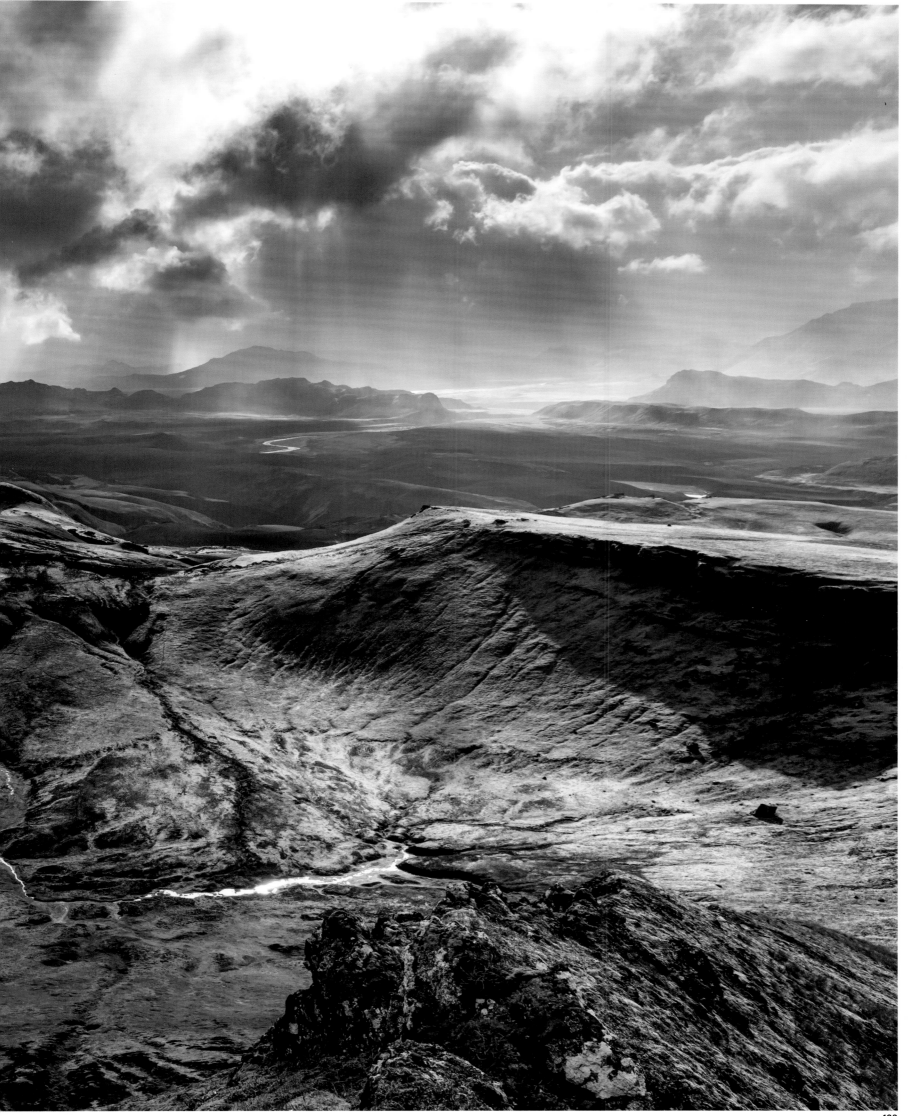

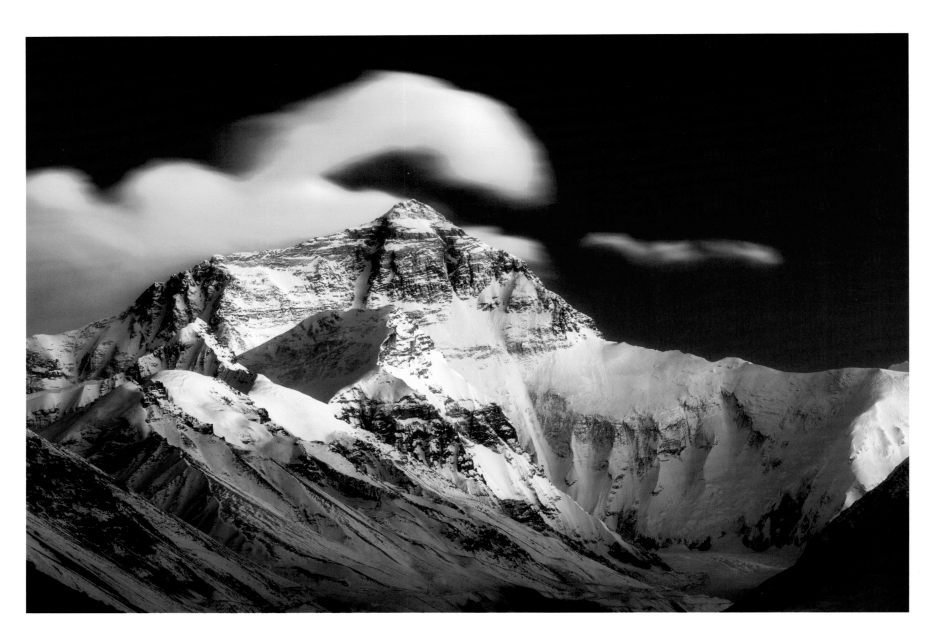

// PREVIOUS PAGE

This is where it all began. At seventeen years old, I set out with camping gear and supplies for an almost two weeks' trek across the Icelandic plateau. It still isn't hard to be alone here for days at a time without seeing a single soul. A part of my own soul will probably always wander through this moss-grown land.

// THIS PAGE

Mount Everest is not only the highest mountain on earth, but for me its North Face is also among the most beautiful and imposing. I spent two days at Base Camp on the Tibetan side enjoying the view of the 8,848 m (29,029 ft.) high Everest.

// NEXT PAGE

An image showing the sun rising and setting at the same time. The peaks of Lofoten in Norway were carved by glaciers into shapes the likes of which are found in few other locations on earth. Among these peaks, at the foot of Reinebringen upon which this image was taken, lies the picturesque village of Reine.

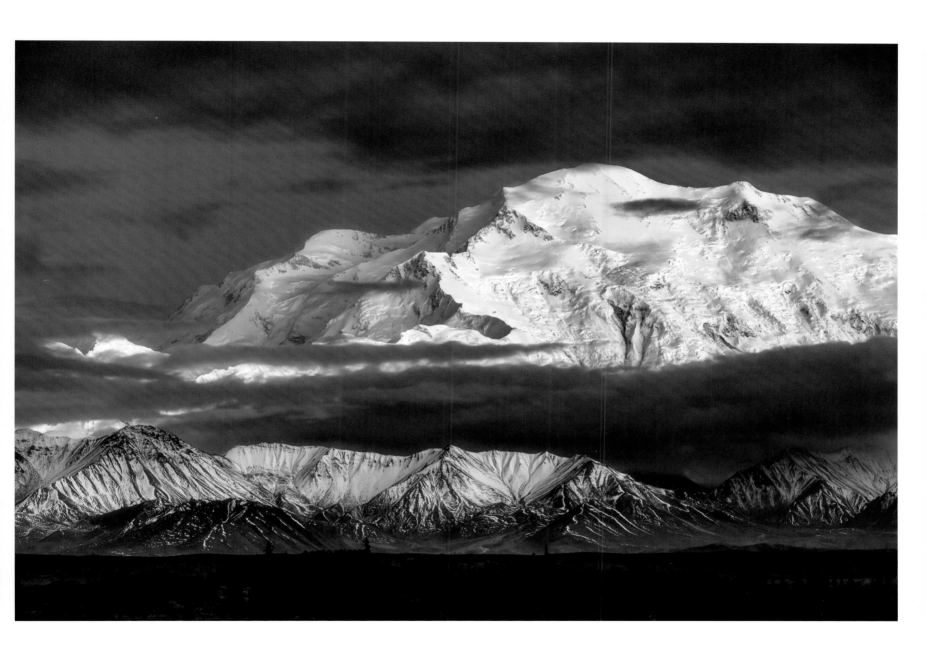

// THIS PAGE

Denali, formerly known as Mount McKinley, is certainly the most impressive mountain I have ever laid eyes upon. Unlike the mountains of the Himalayas, where valleys already lie thousands of meters above sea level, this pluton rises out of the surrounding landscape just a few hundred meters above sea level and towers more than 5,000 m (16,400 ft.) above it.

// PAGE 128/129

In 2008, I did a six-week solo trek through the Patagonian national parks at a time when this image of the Cuernos, in Torres del Paine National Park, was still uncommon. Today it is one of South America's most photographed subjects. For obvious reasons: Torres des Paine National Park is irresistibly attractive with azure lakes, colossal glaciers, and unparalleled peaks.

// PAGE 132/133

This unique natural wonder is found at the center of the island of Bohol in The Philippines. In all there are 1,770 grass-covered hills up to 120 m (about 400 ft.) high. The Chocolate Hills owe their name to the dry season, during which the grass blanket takes on a chocolate-brown color.

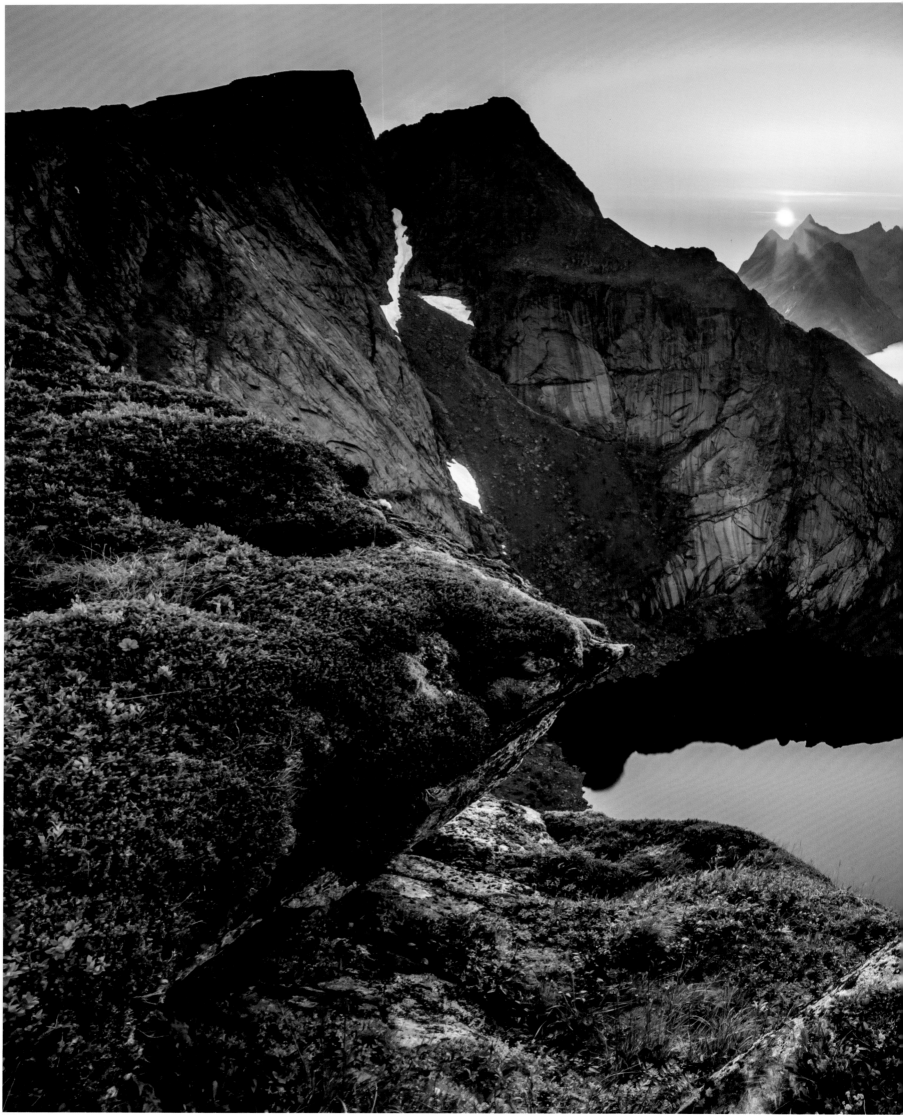

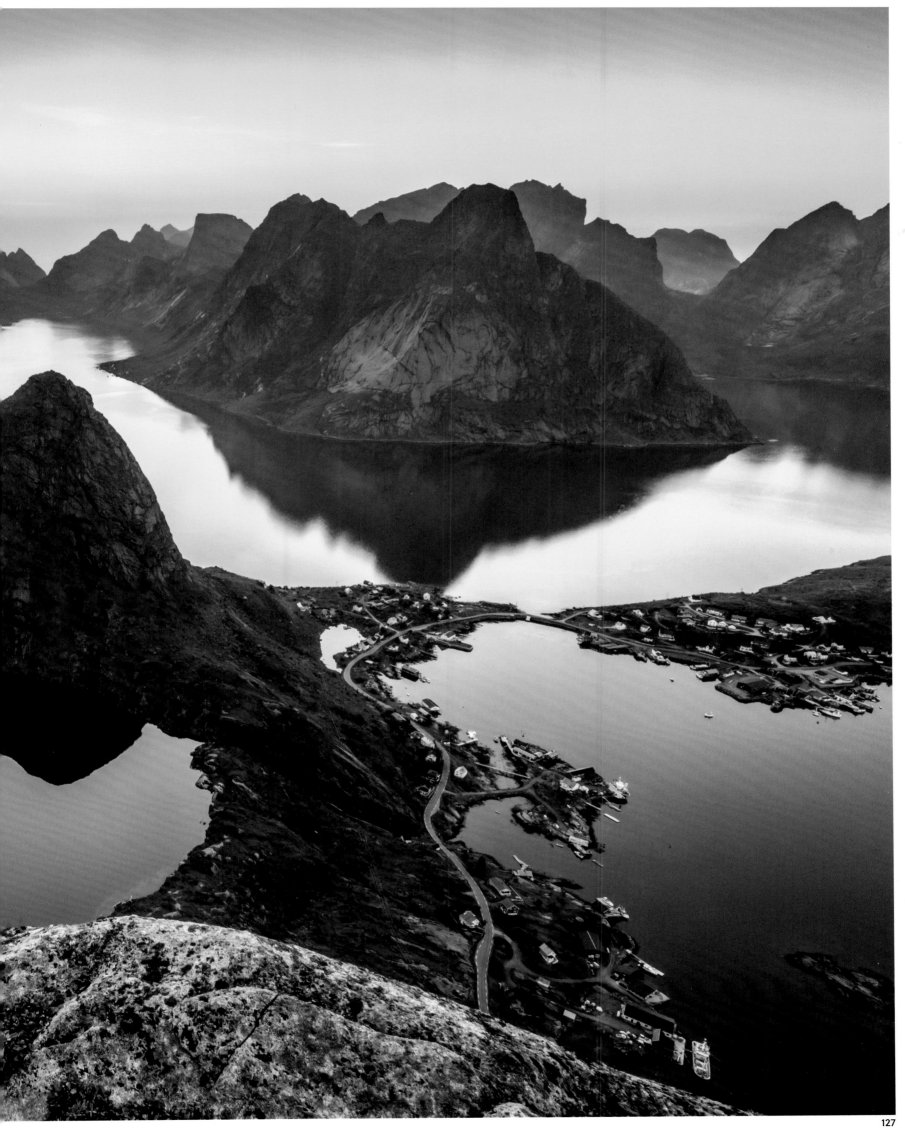

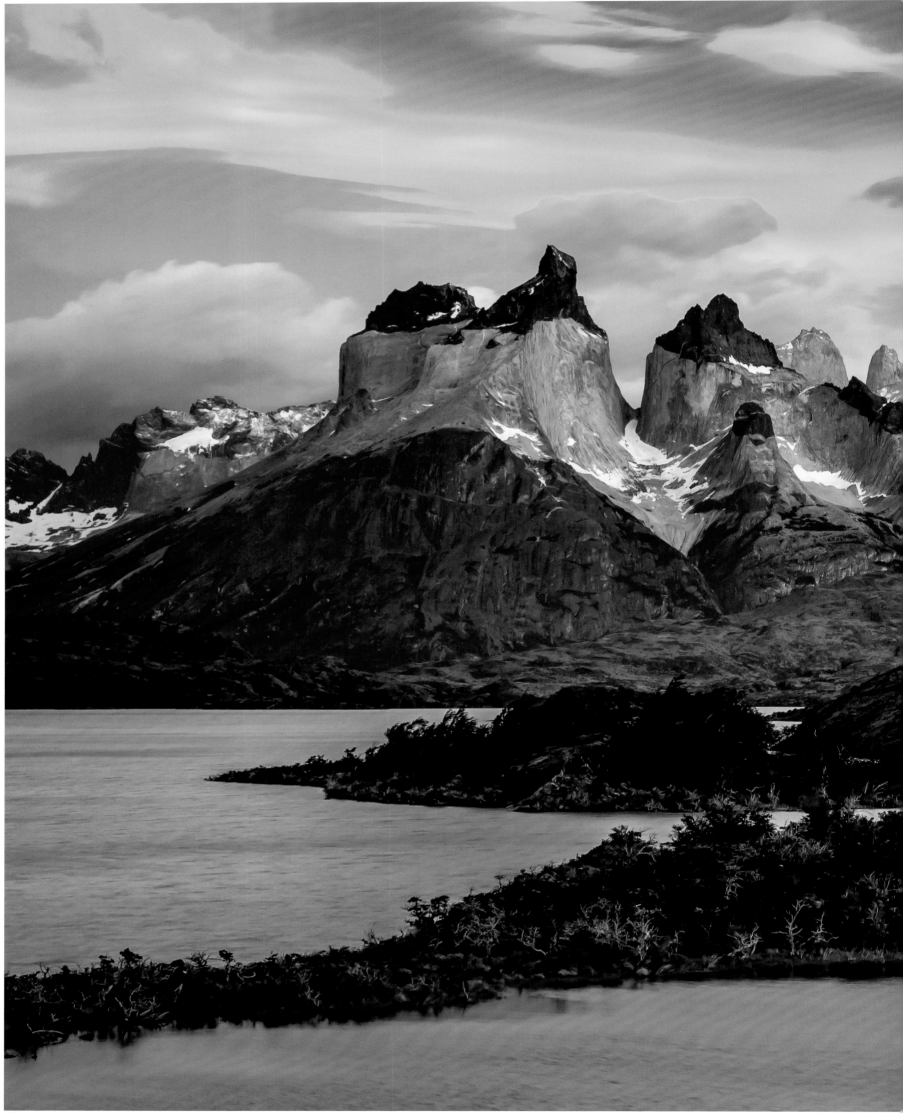

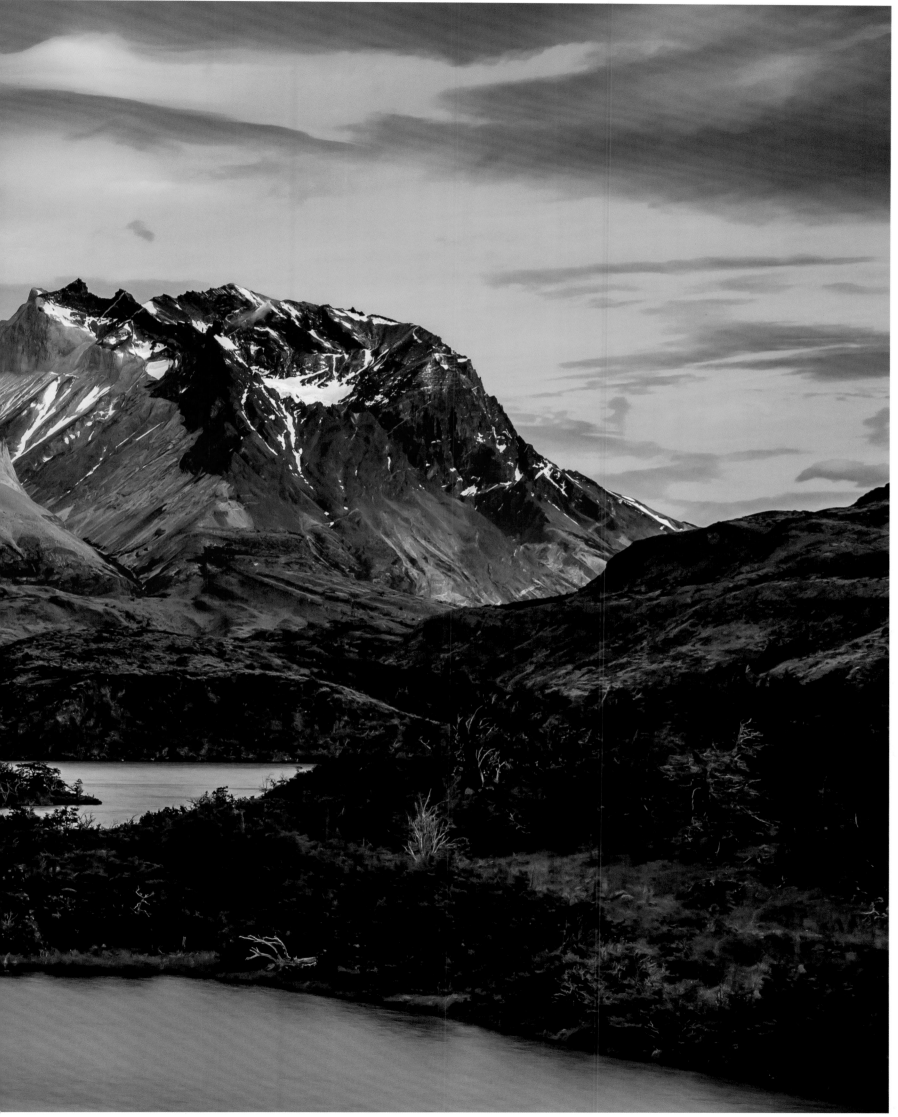

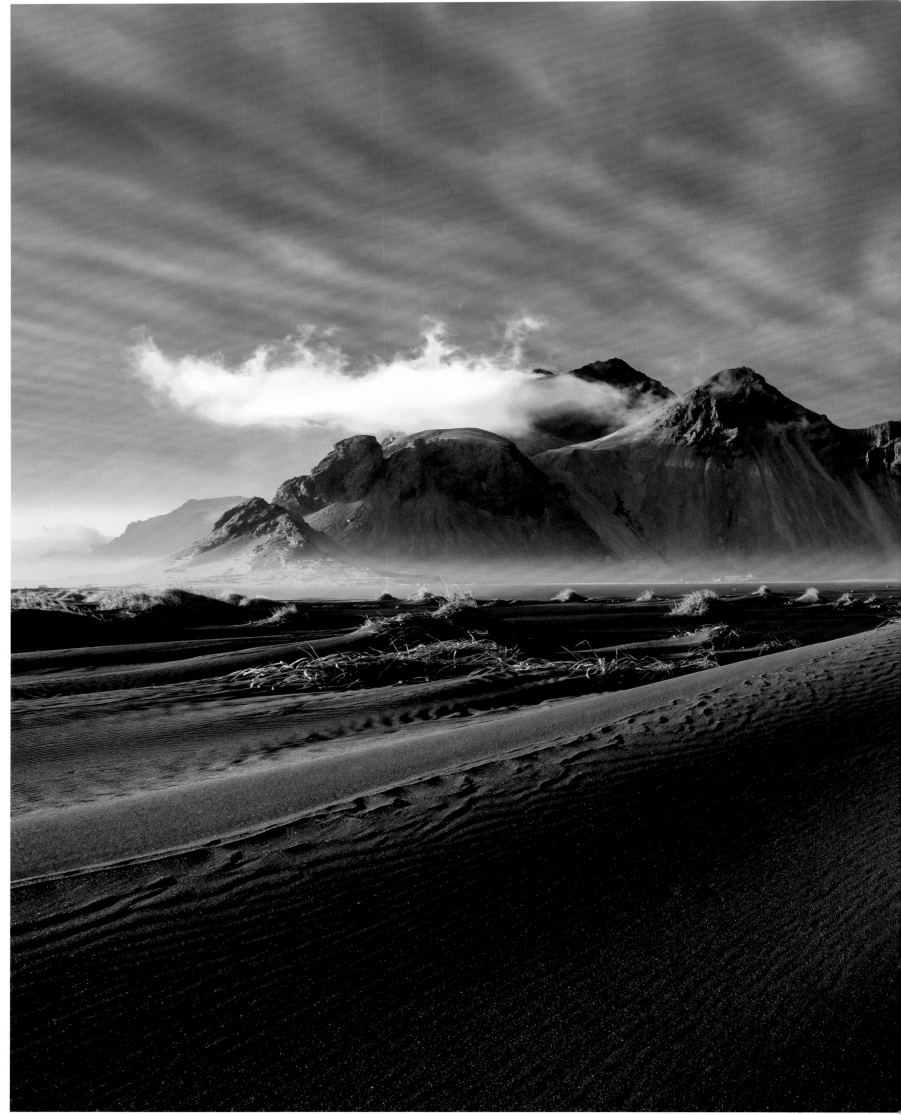

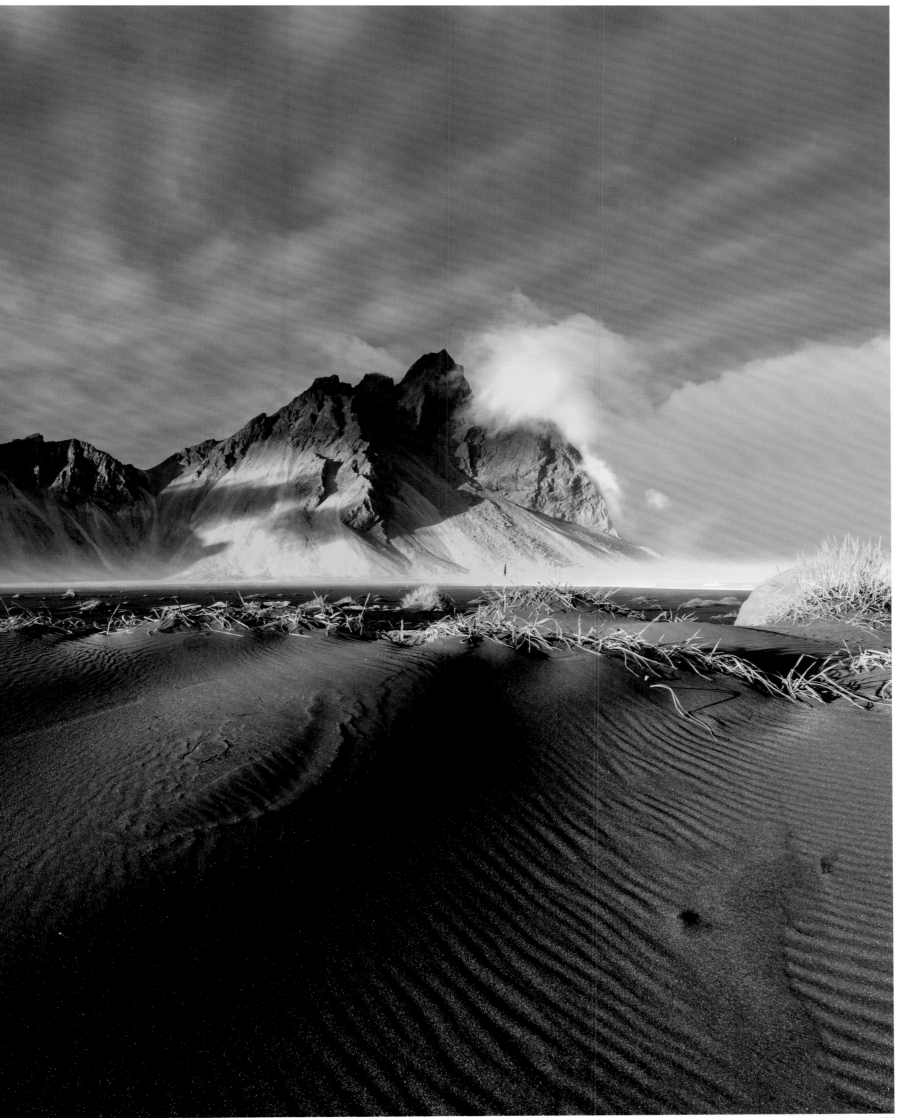

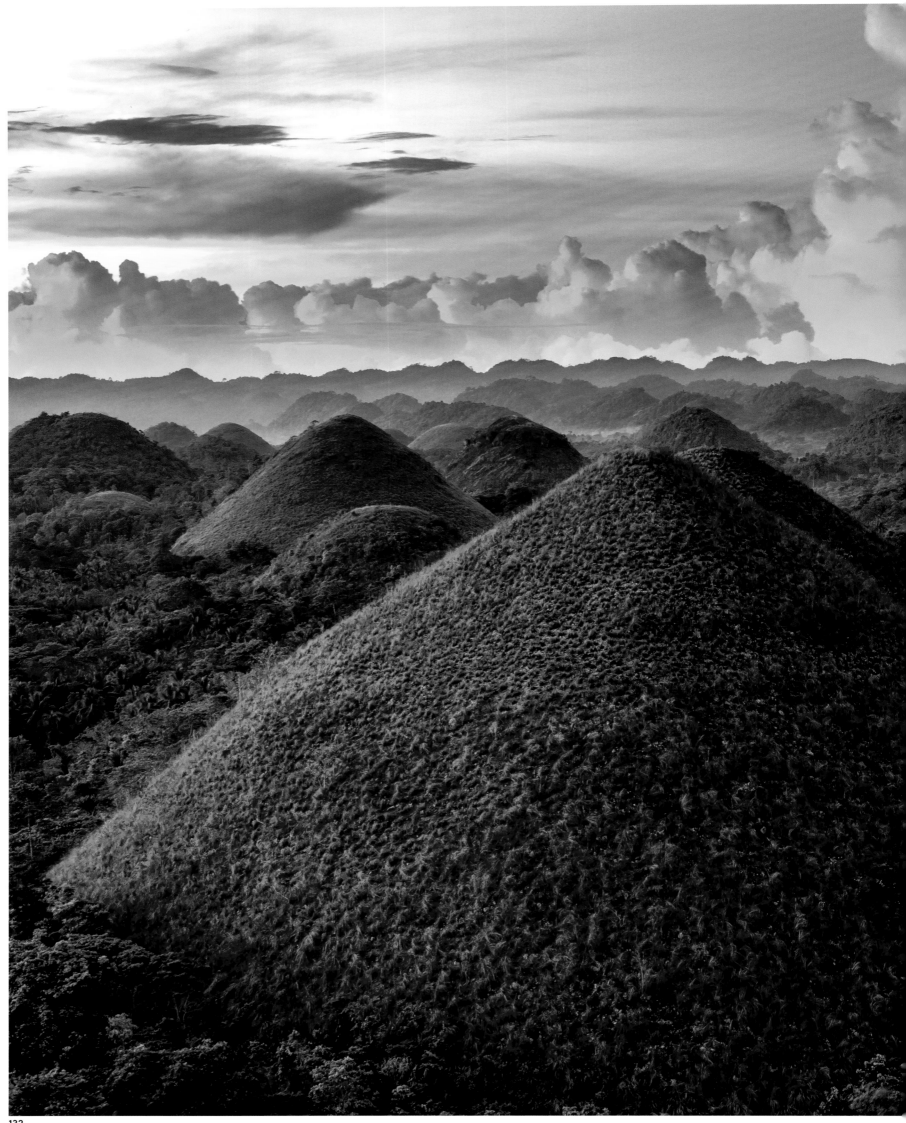

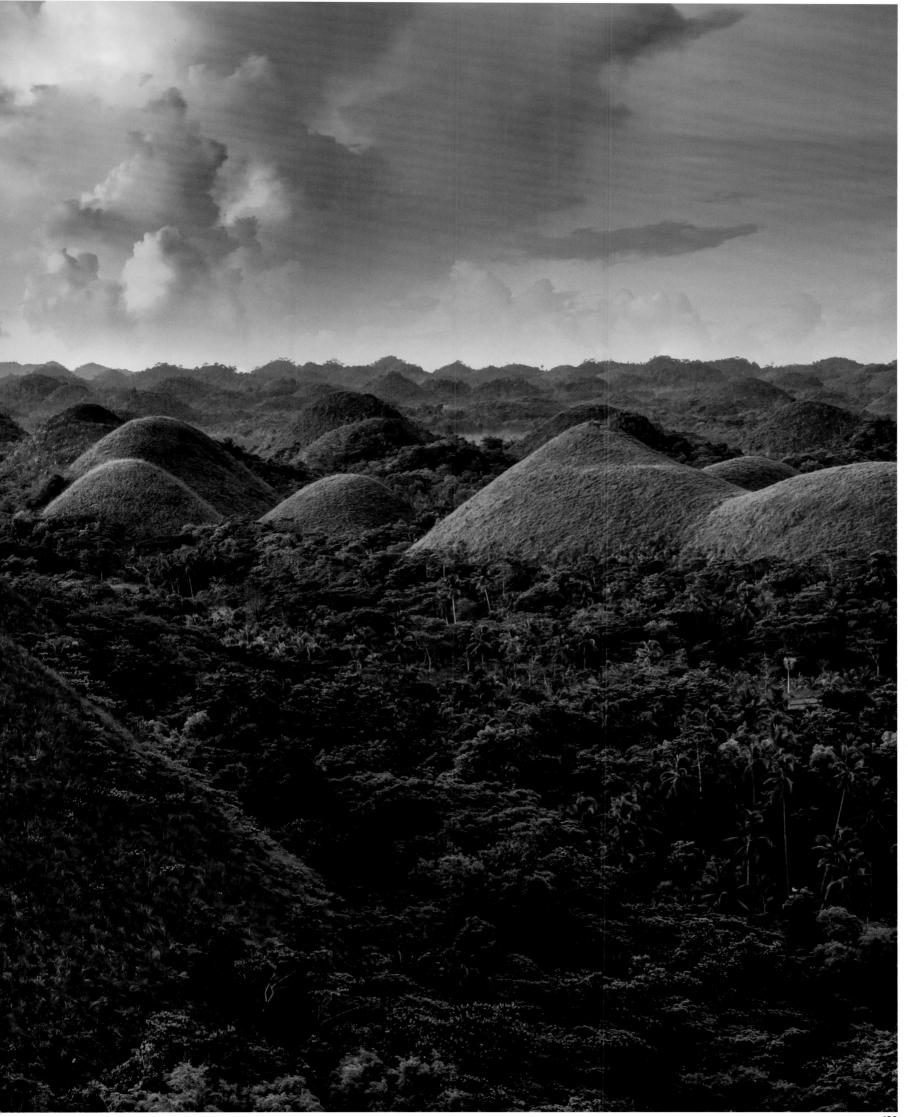

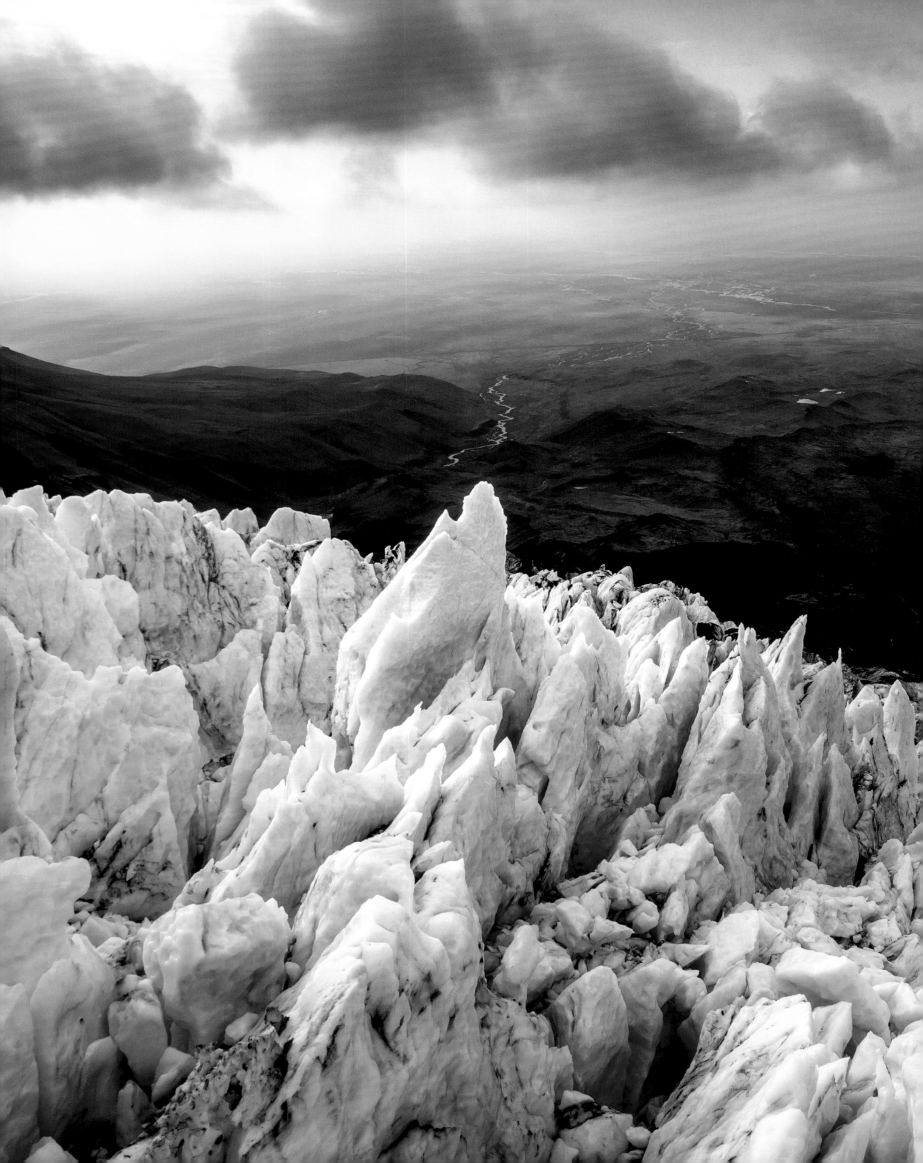

When the very first multicopters ("drones") hit the market at the end of 2013, I was one of the few photographers who had foreseen the success of these amazing gadgets. After investing much time, money, and aggravation in a self-assembled eight-rotor multicopter, when the 15 kg (33 lb.) device was operating without malfunction, I brought the flying camera on trips to Namibia, Iceland, Norway, Scotland, Chile, Argentina, and Switzerland. In spite of the logistical nightmare, the newly acquired perspective was a godsend. Finally, images could captured that before would have necessitated a helicopter or small airplane. Photography flights would only ever lift off in good, bright weather conditions. But now with the drone, flight became possible any time. For a year, I devoted all my efforts toward drone photography and complemented my portfolio accordingly. But by 2015, the technology had lost its charm. With millions of drones sold, what first had wowed onlookers and locals now became the target of a thicket of prohibiting signs as well as threats and dirty looks. Today, I make no exceptions: I only fly where nobody can see or hear. The "perspective from the air" is one I cannot and will not do without.

Als Ende 2013 die ersten Multicopter, auch Drohnen genannt, auf den Markt kamen, war ich einer der wenigen Fotografen, die den Erfolg dieser „Wundertechnik" kommen sahen. Nachdem ich viel Geld, Zeit und Nerven in einen selbst zusammengebauten 8-motorigen Multicopter investiert hatte und das 15 Kilogramm schwere Gerät fehlerfrei lief, nahm ich die fliegende Kamera mit nach Namibia, Island, Norwegen, Schottland, Chile und Argentinien sowie mit in die Schweiz. Die neu gewonnene Perspektive war trotz der extremen, logistischen Probleme ein Segen. Endlich waren Bilder möglich, die bislang nur mit Hubschraubern oder Kleinflugzeugen machbar gewesen wären. Doch im Gegensatz zu Fotorundflügen, die bloß bei guten und hellen Wetterbedingungen stattfanden, war die Drohne zu jeder Tages- und Jahreszeit startbereit. Während eines Jahres konzentrierte ich mich voll und ganz auf die Drohnenfotografie und ergänzte so mein Portfolio entsprechend. Schon im Jahr 2015 war die Freude an der Technik dann vorbei, denn was anfänglich mit Freude bei den Zuschauern und anwohnenden Menschen begann, endete, aufgrund millionenfacher Verkäufe kleinerer Drohnen, in einem Wald voller Verbotstafeln, böser Blicke und Drohungen. Mittlerweile fliege ich ausnahmslos dort, wo mich niemand sieht oder hört. Ganz auf die „Perspektive Luft" verzichten kann und will ich nicht mehr.

Vers la fin de l'année 2013, quand sont apparus sur le marché des multicoptères, encore appelés drones, j'étais parmi les premiers à anticiper le succès de ces engins miraculeux. Il m'a fallu investir une somme rondelette, beaucoup de temps et de la patience pour construire un multicoptère de quinze kilogrammes équipé de huit moteurs au fonctionnement impeccable avant de pouvoir emporter mon appareil photo volant dans mes expéditions en Namibie, Islande, Norvège, Écosse, Argentine, au Chili, mais aussi en Suisse. Les perspectives obtenues résolument nouvelles m'ont dédommagé des problèmes de logistiques extrêmes. Il était enfin devenu possible de réaliser des photographies que seuls des photographes à bord d'un hélicoptère ou d'un avion léger pouvaient réaliser. Mais contrairement à ces photos-là, qui ne pouvaient être faites que par de bonnes conditions météo et de luminosité, le drone était prêt à décoller à tout moment. Pendant une année entière, je me suis concentré sur la photo aérienne en drone, mon portfolio s'épaississant au fur et à mesure. Cet engouement pour le gadget technique d'abord accueilli avec joie par les badauds et les riverains est retombé dès 2015. Les ventes de petits drones par millions ont suscité l'érection d'une forêt de panneaux d'interdictions, des regards méchants et des menaces. Aujourd'hui, mon engin ne survole que des endroits déserts où il n'y a personne pour me voir ou m'entendre. Car il est pour moi exclu de renoncer complètement à "la vue depuis les airs".

// OPPOSITE PAGE

This image of Vatnajökull (Vatna Glacier) in Iceland would have been impossible to achieve without technology that became available only a few years ago. That's because this part of the glacier was inaccessible either on foot or by helicopter. Modern drone technology made it possible for me to take this photograph from just a few meters over the heavily riven glacier in 2016.

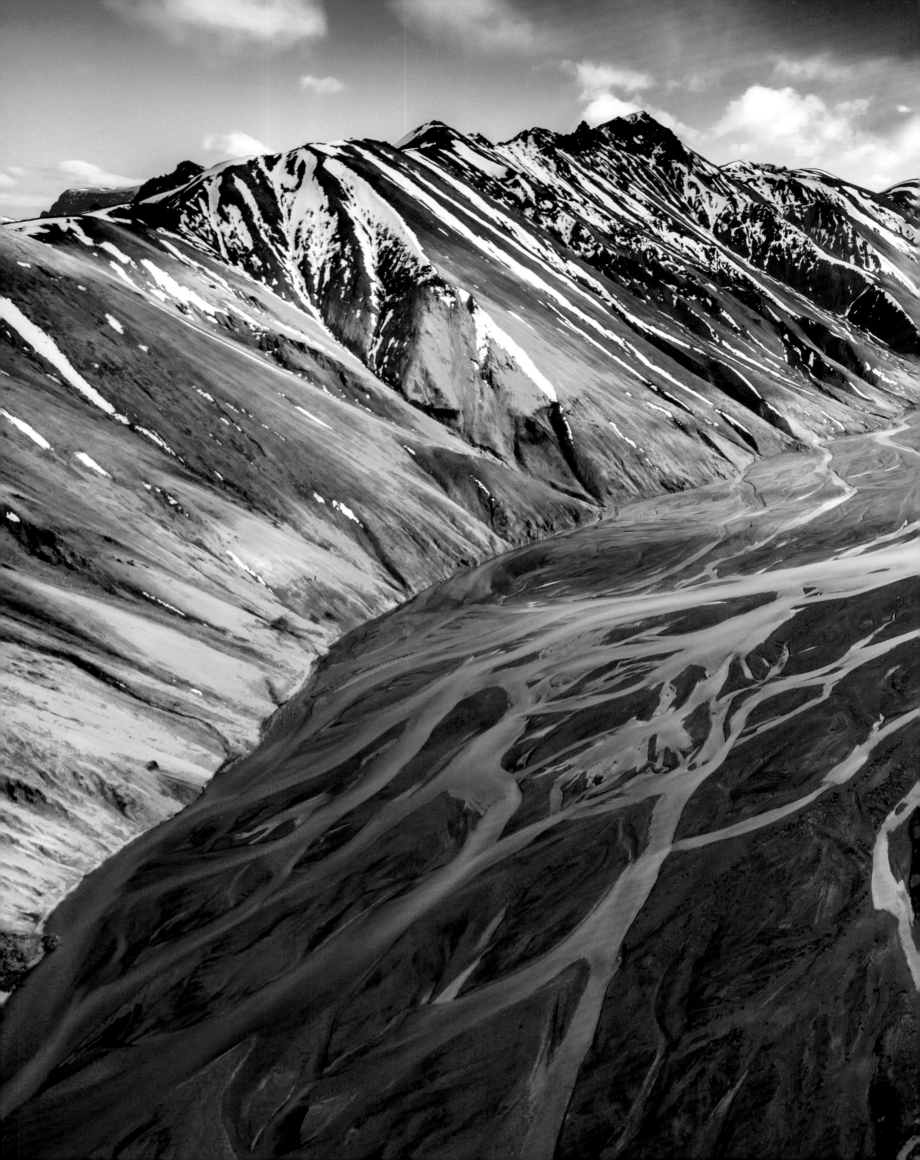

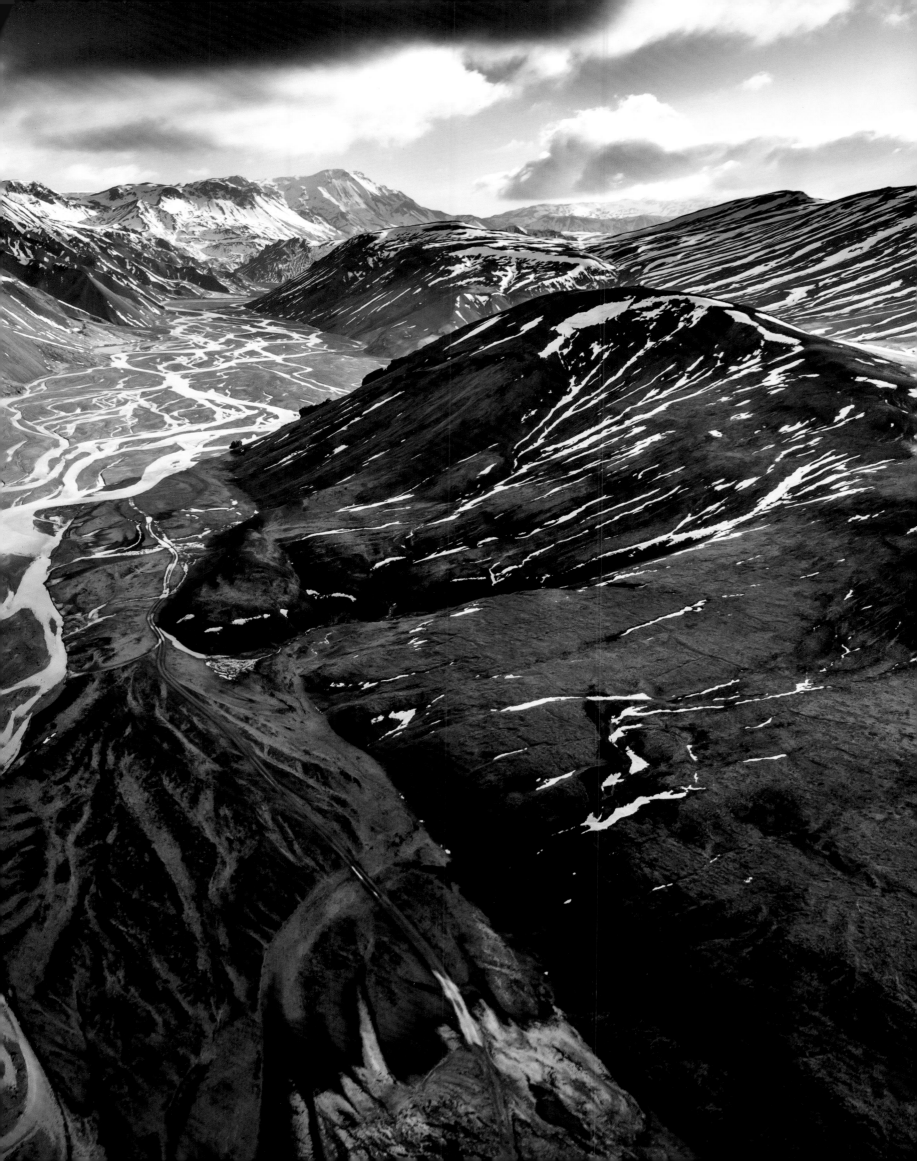

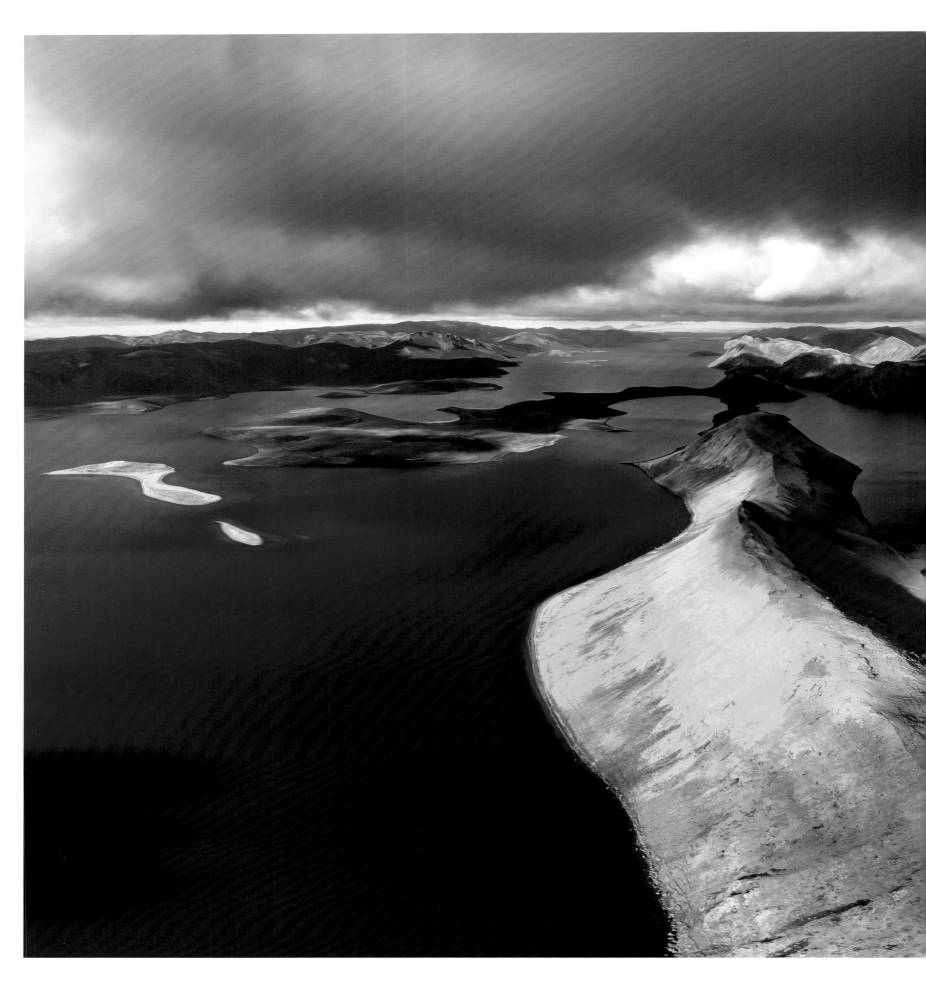

I've hiked across the peaks of Landmannalaugar on the Icelandic plateau several times. In 2014, I finally got to explore this fascinating landscape with the eight-rotor, over 12 kg (26 lb.) multicopter I had at the time. I can still remember my joy upon first sight of the successful photograph on my camera monitor.

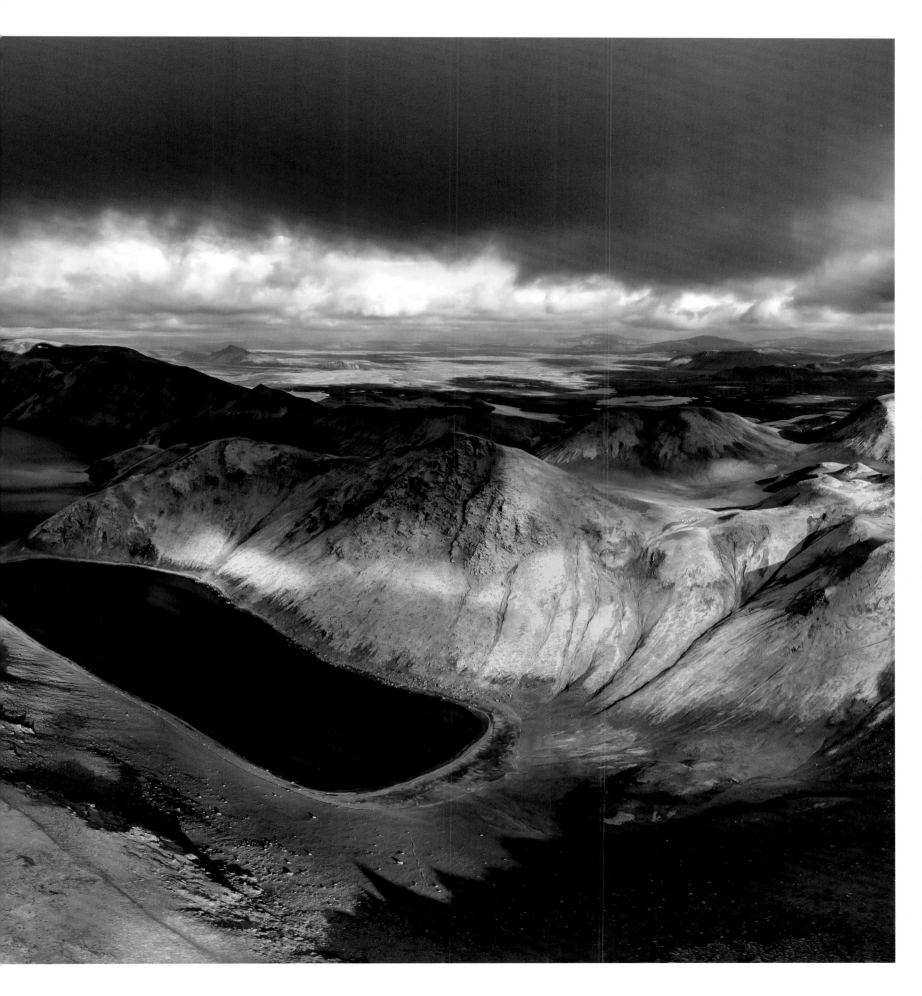

// THIS PAGE

This spot on Langisjór, a lake on the Icelandic plateau, is a personal refuge for me. I walked its shores for weeks, camped atop a peak by myself and looked out into the distance. This aerial image consists of sixteen individual exposures taken in the summer of 2016 and stitched together into a panoramic image.

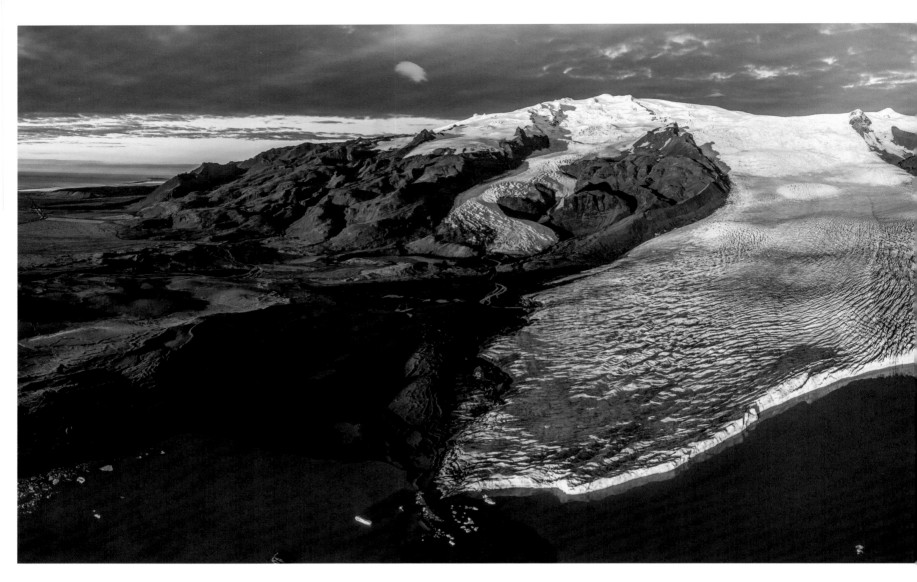

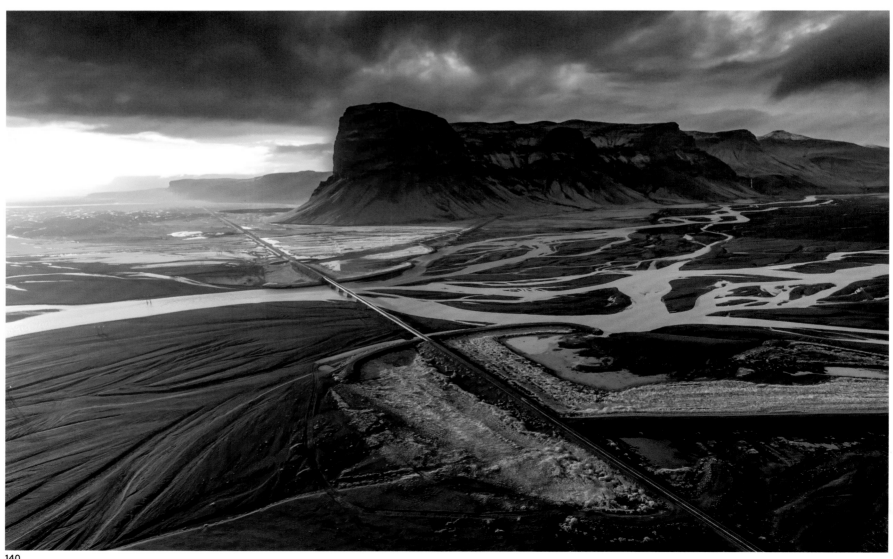

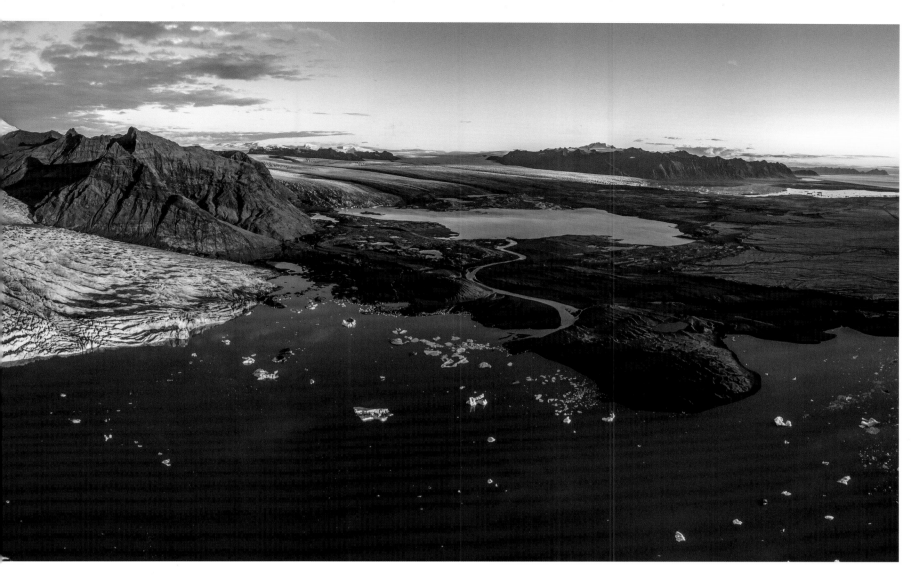

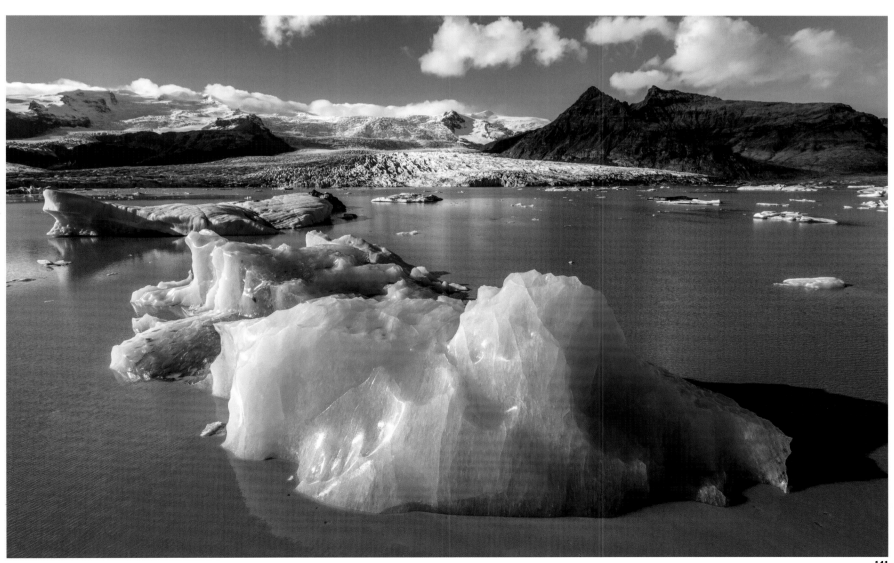

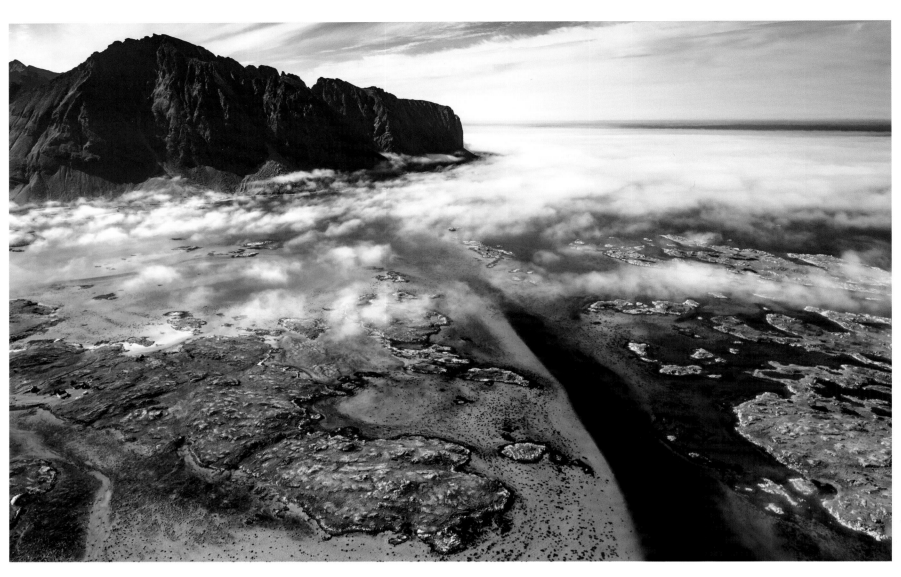

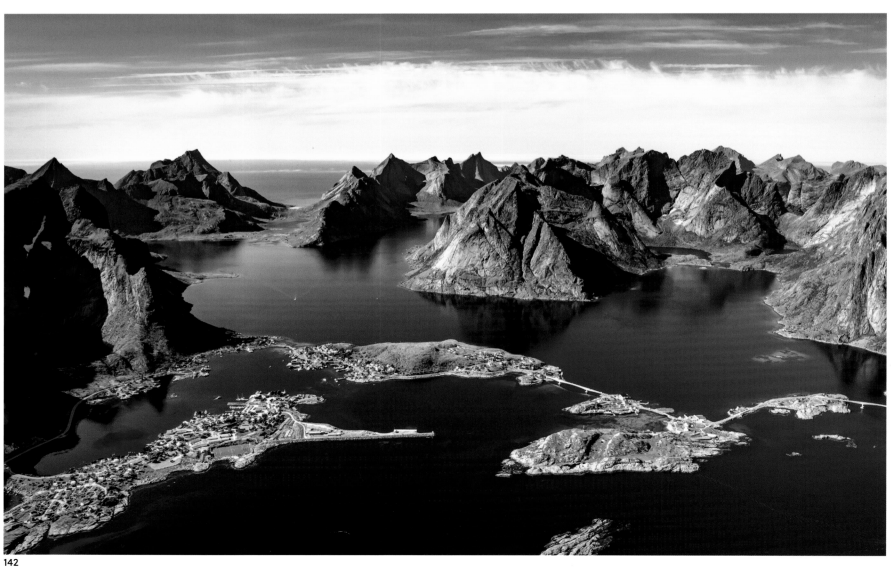

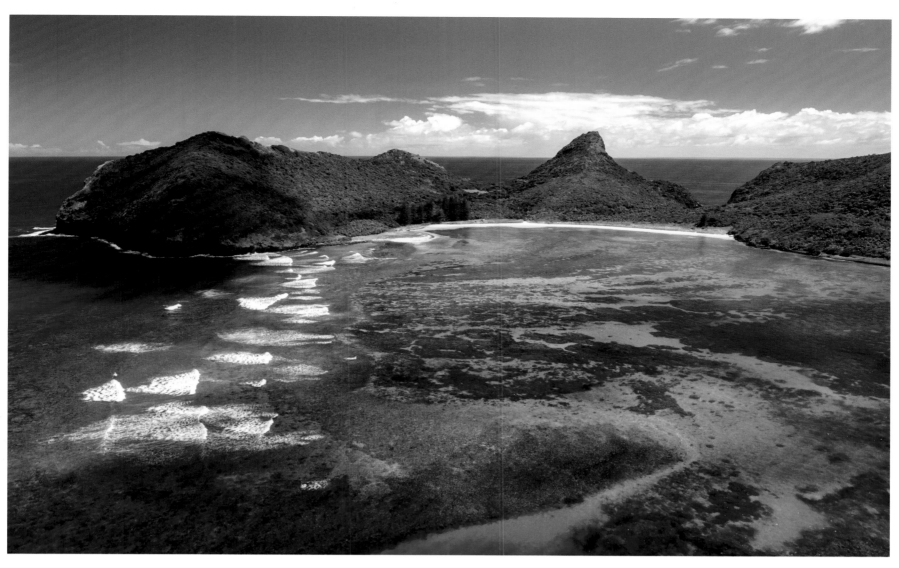

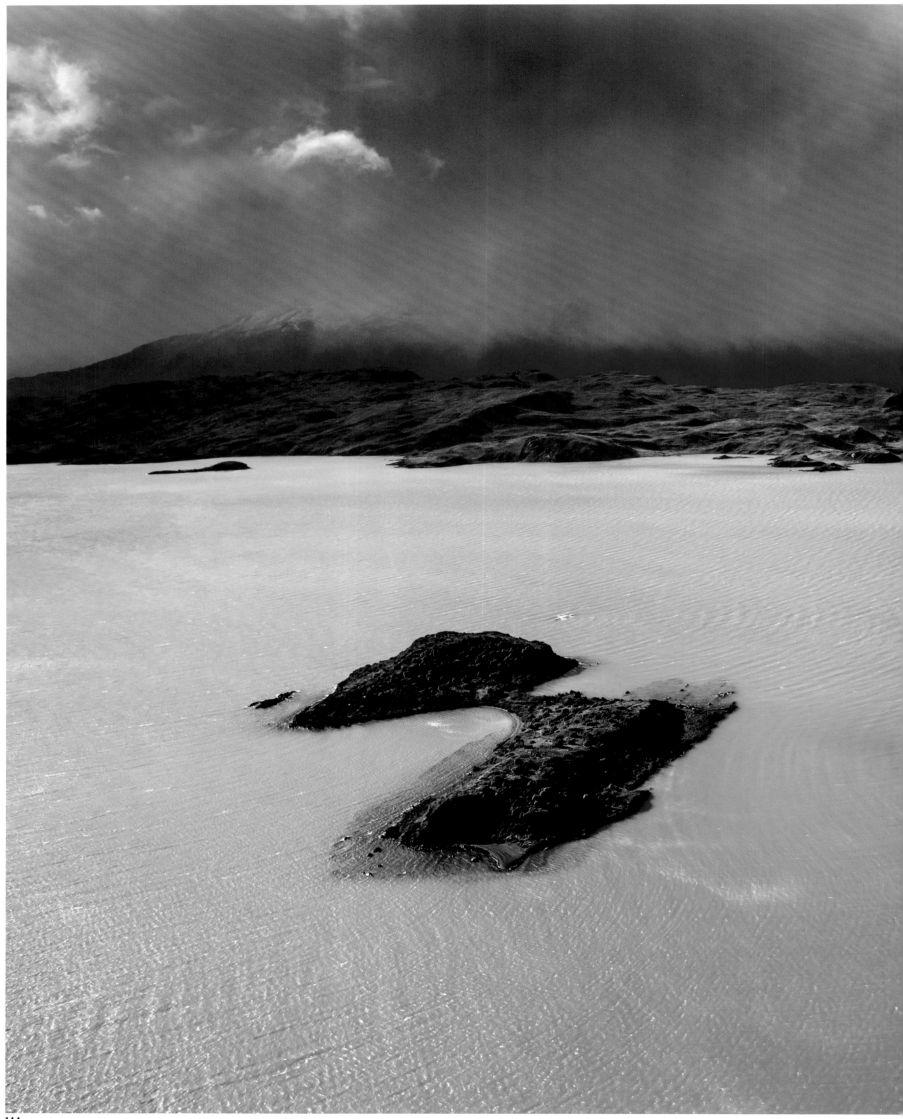

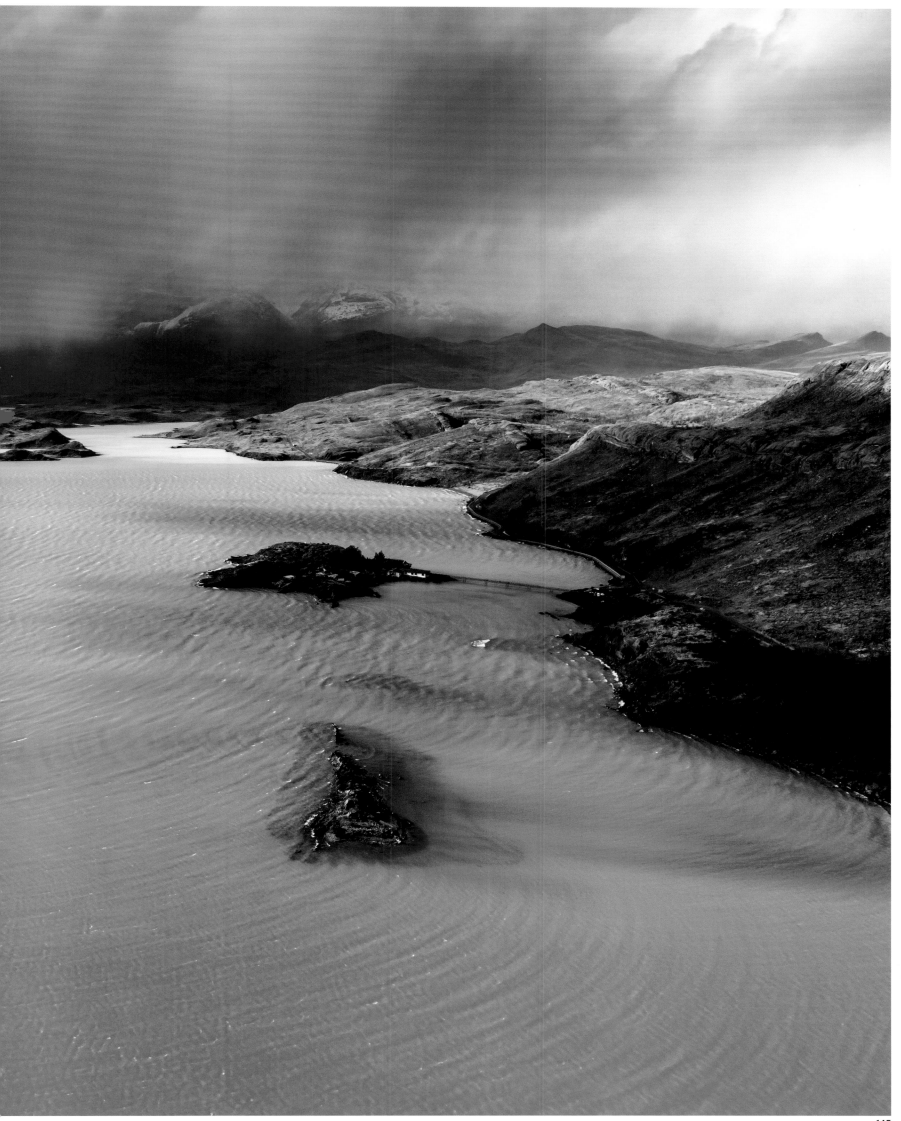

// PREVIOUS PAGE

Torres del Paine National Park in Chile is one of the windiest places in the world. Winds of 100 kmh (62 mph) are not uncommon. I had never flown my 13 kg (29 lb.) multicopter in winds like this before. On this flight, the battery was exhausted after just five instead of usually seventeen minutes. Miraculously there were no major incidents during all its Patagonian flights.

// THIS PAGE

This image features Klöntalersee, a lake in the Canton of Glarus, in early summer. The lake is recovering slowly from its winter water cut-off as vital arteries now replenish its supply. Because the lake does not exit the shadow of steep surrounding mountains until late spring, it was long an important source of ice for use as a coolant.

// OPPOSITE PAGE

It will be hard to outdo the saturated colors of streams that feed Patagonia's lakes. As much as 50 km (about 31 mi.) from Lago Argentino I wondered why clouds in the sky were glowing markedly in such rich green. As in the Namibian desert, where red sand dunes cast sunlight onto clouds in a brilliant orange, so does the color of the water alter the clouds in Patagonia.

// NEXT PAGE

An aerial photograph of crescent moon–like Lord Howe Island, about 600 km (373 mi.) east of Australia. In the background one can recognize 875 m (2,871 ft.)-high Mount Gower, and the misty rain forest situated on the up-permost plateau, one of the most beautiful I got to see in Oceania.

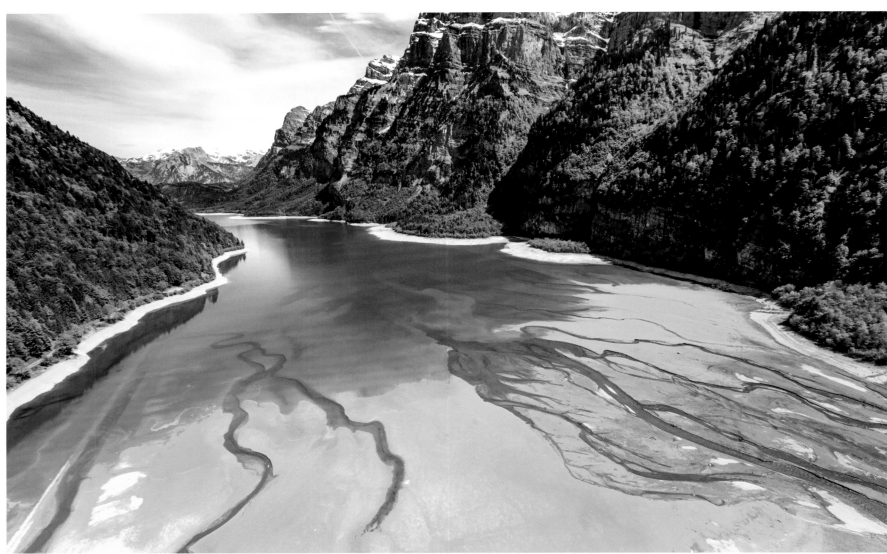

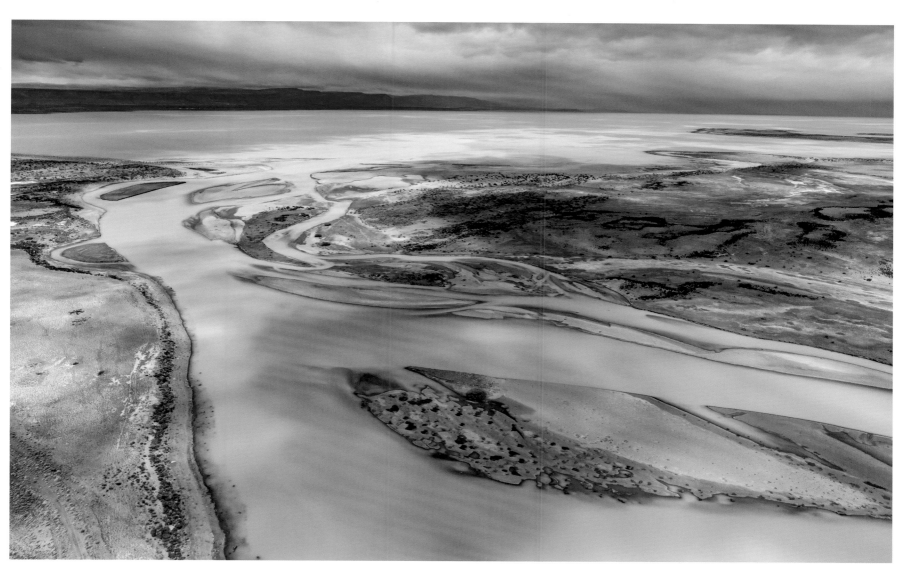

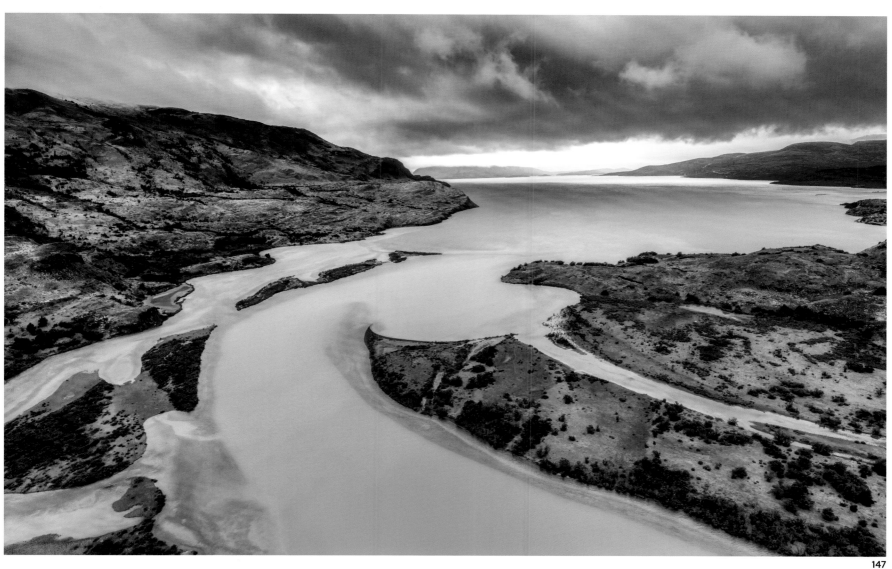

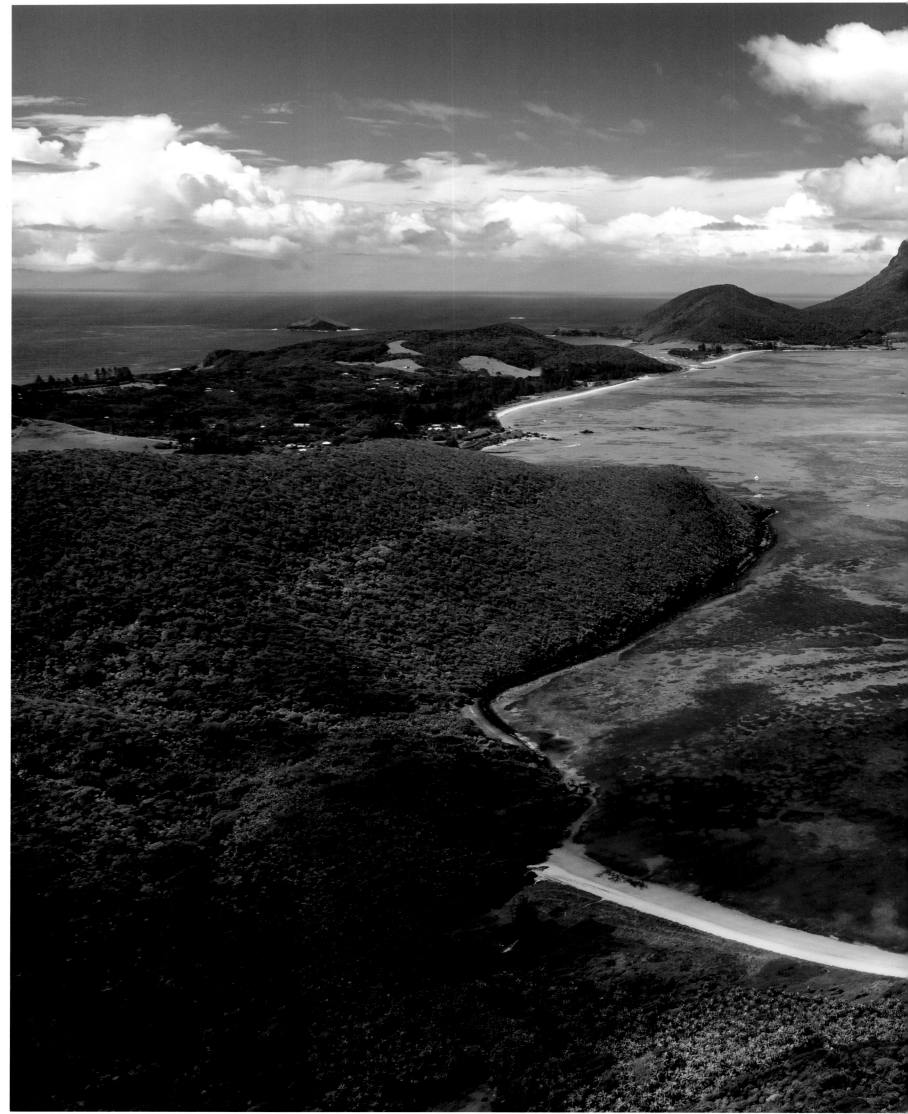

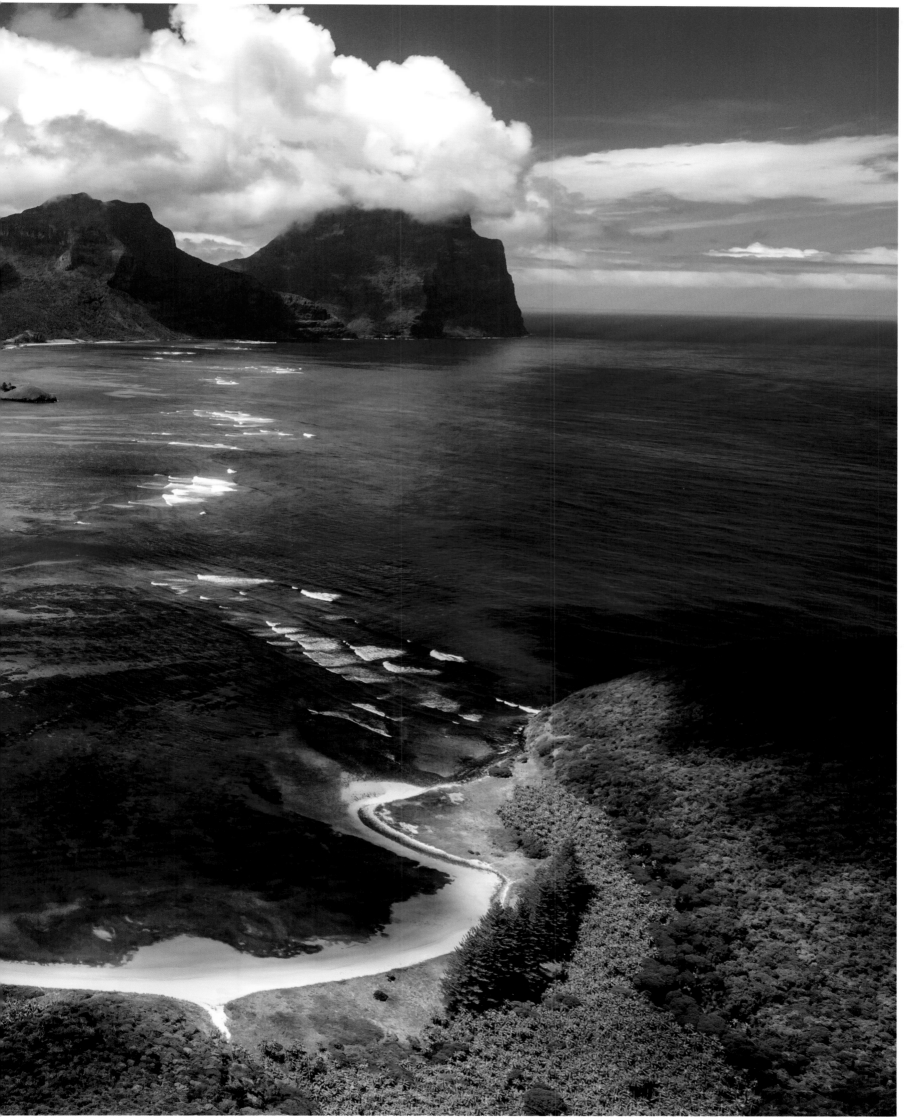

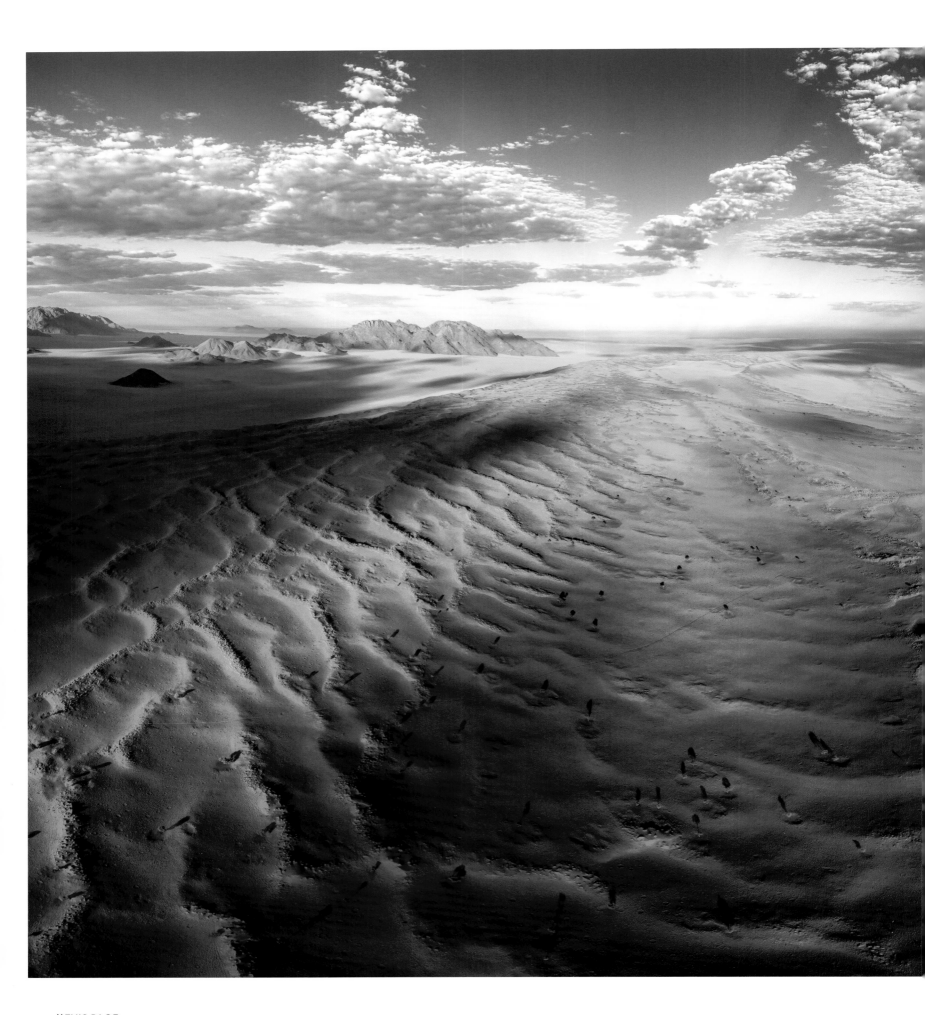

// THIS PAGE

The most recent development in photographic technology, thanks to flying cameras, is the possibility of shooting aerial panoramic images. This image shows a lovely pattern of dunes not far from Wolwedans Dunes Lodge in NamibRand Nature Reserve in Namibia. The image is composed of eighteen individual exposures.

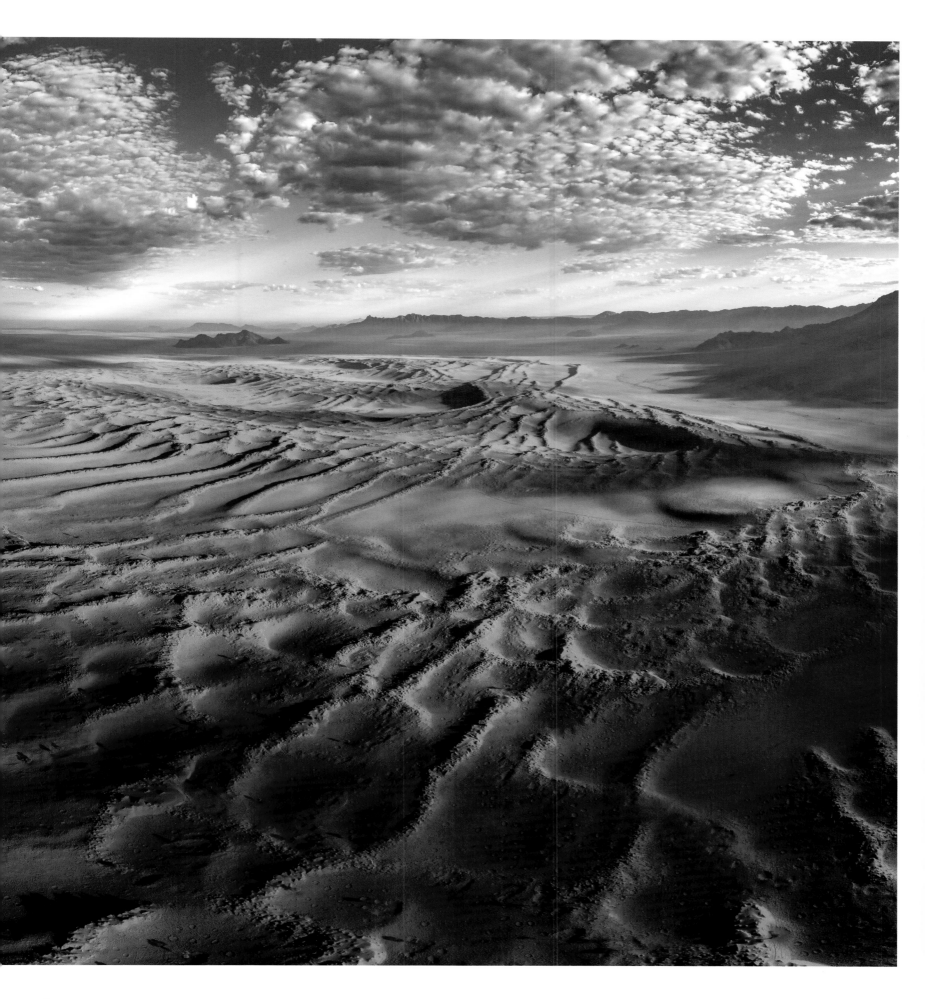

// NEXT PAGE

In the desert of NamibRand Nature Reserve one finds giant acacias, or camel thorn trees, growing in the red sand. Here is a fantastic aerial image. A weather front, poised to rescue the land from years of drought, can be seen advancing in the background.

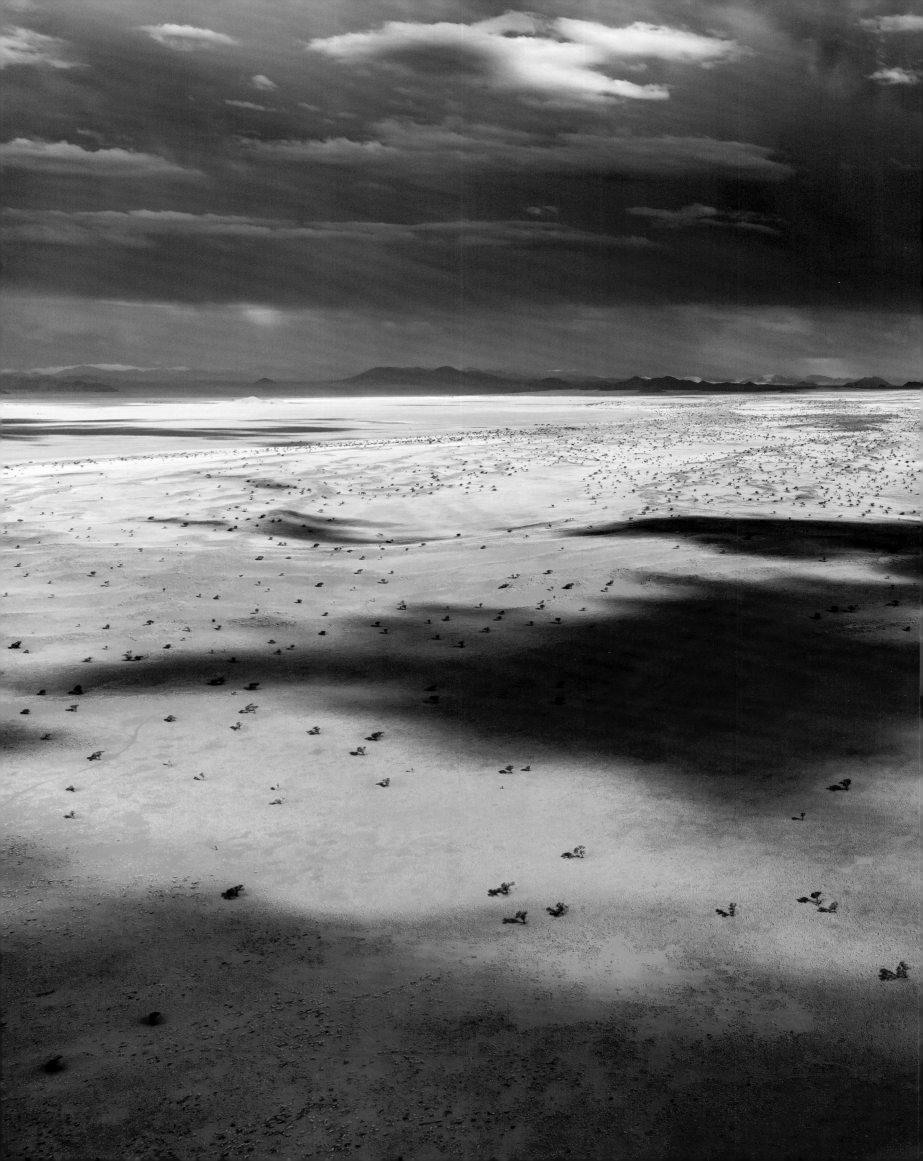

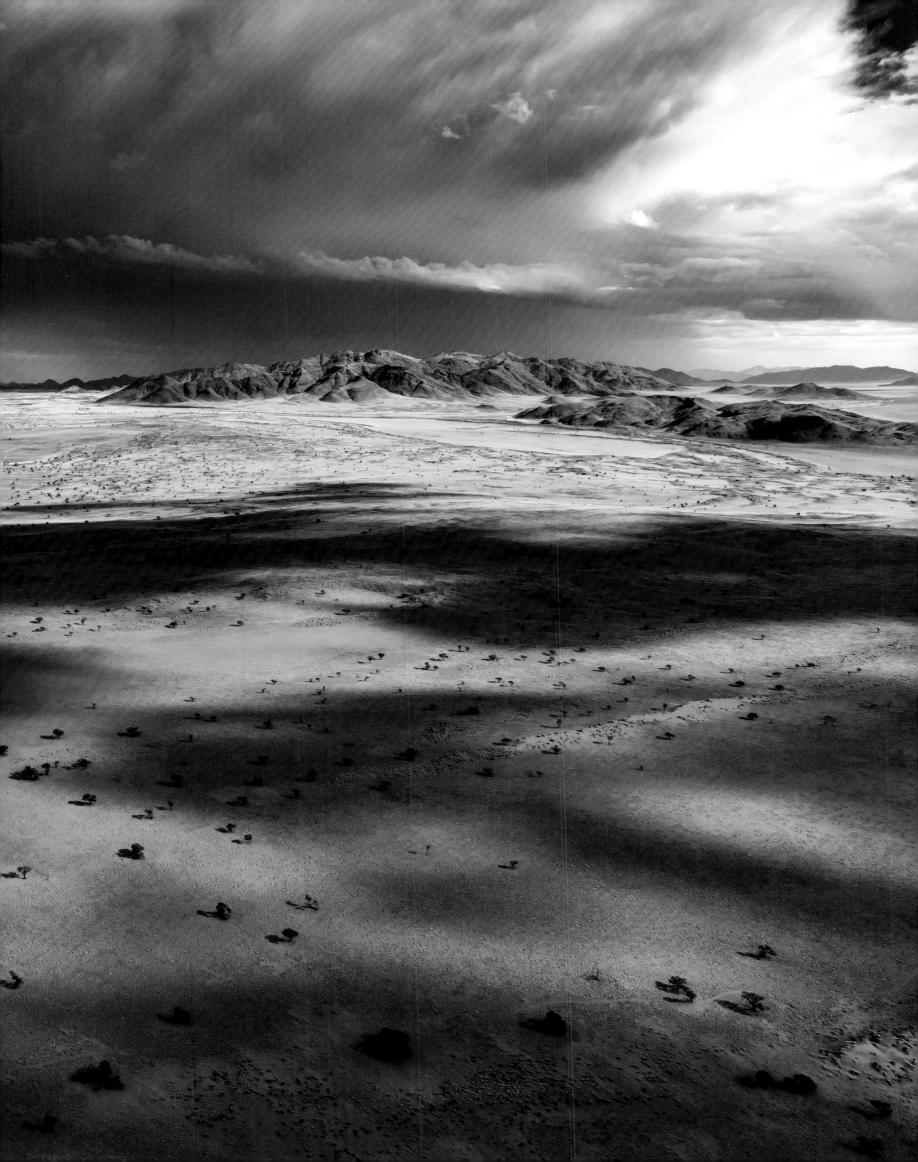

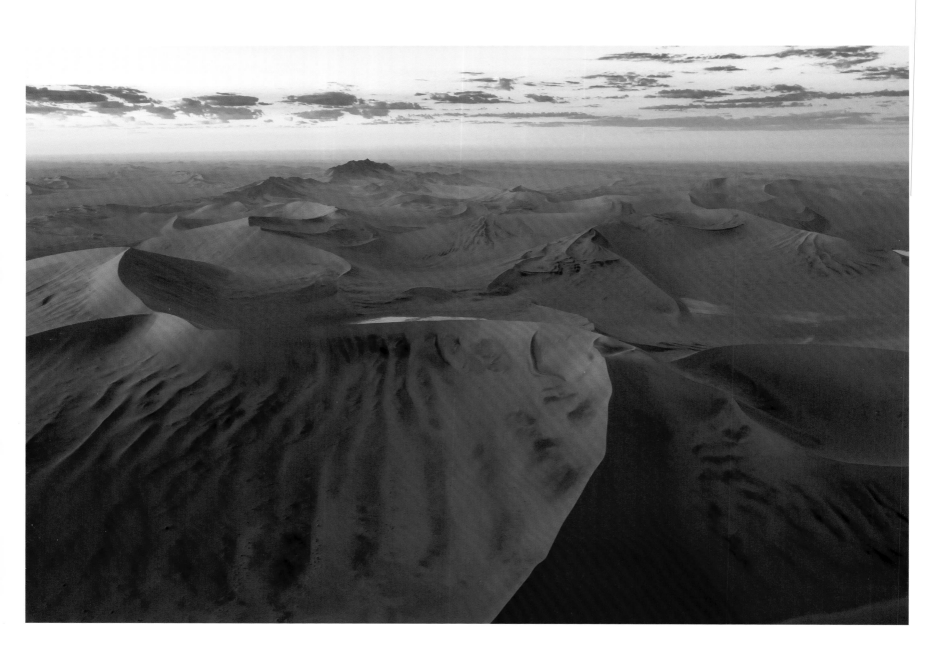

Among the largest and oldest sand dunes on earth are the star and linear dunes of Namib-Naukluft National Park in Namibia. The black patterns on the dunes are composed mainly of iron oxide you can collect with a magnet.

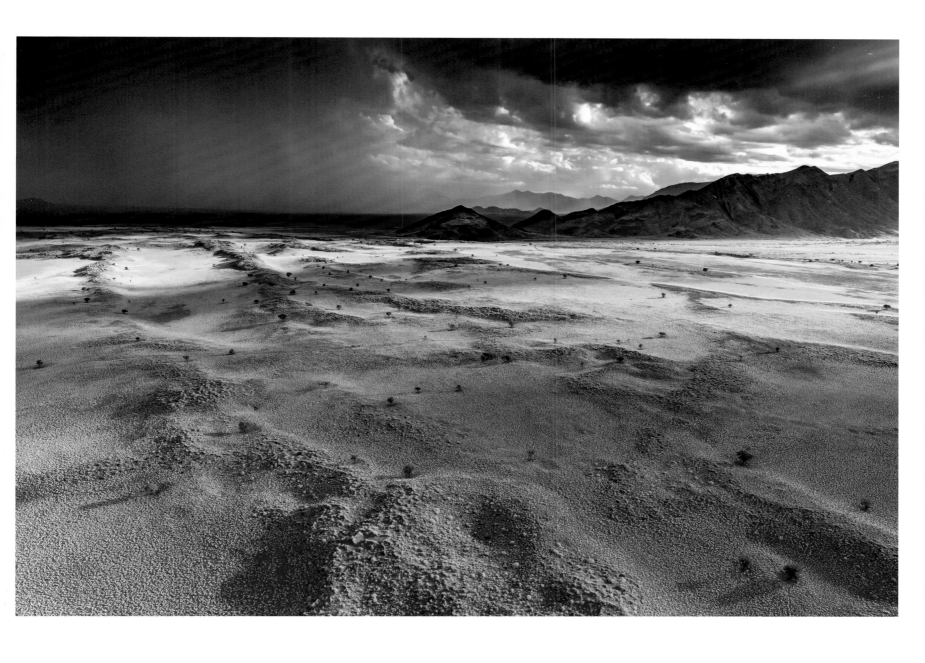

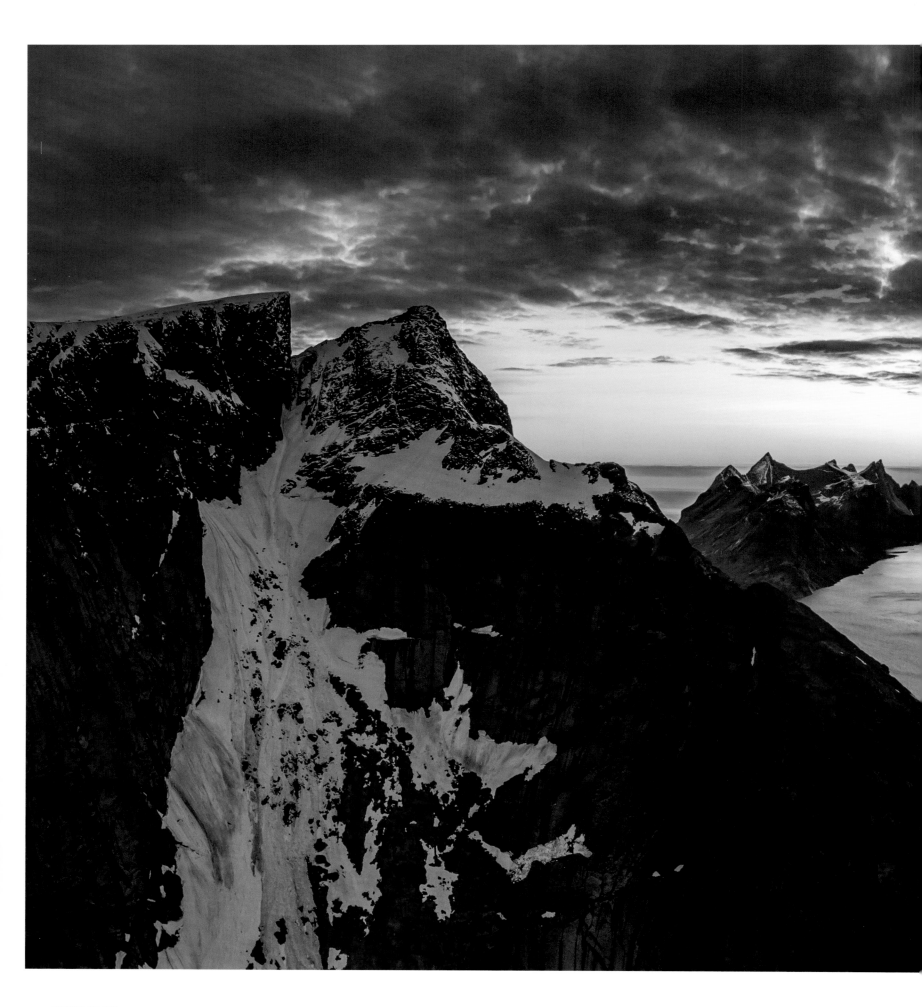

// THIS PAGE
Such an image would hardly be possible without a multicopter. At 1:30 a.m. at the darkest hour of night, the midnight sun sits on the horizon, illuminating the body of clouds and putting the entire splendor of the mountains of Lofoten, Norway, on display.

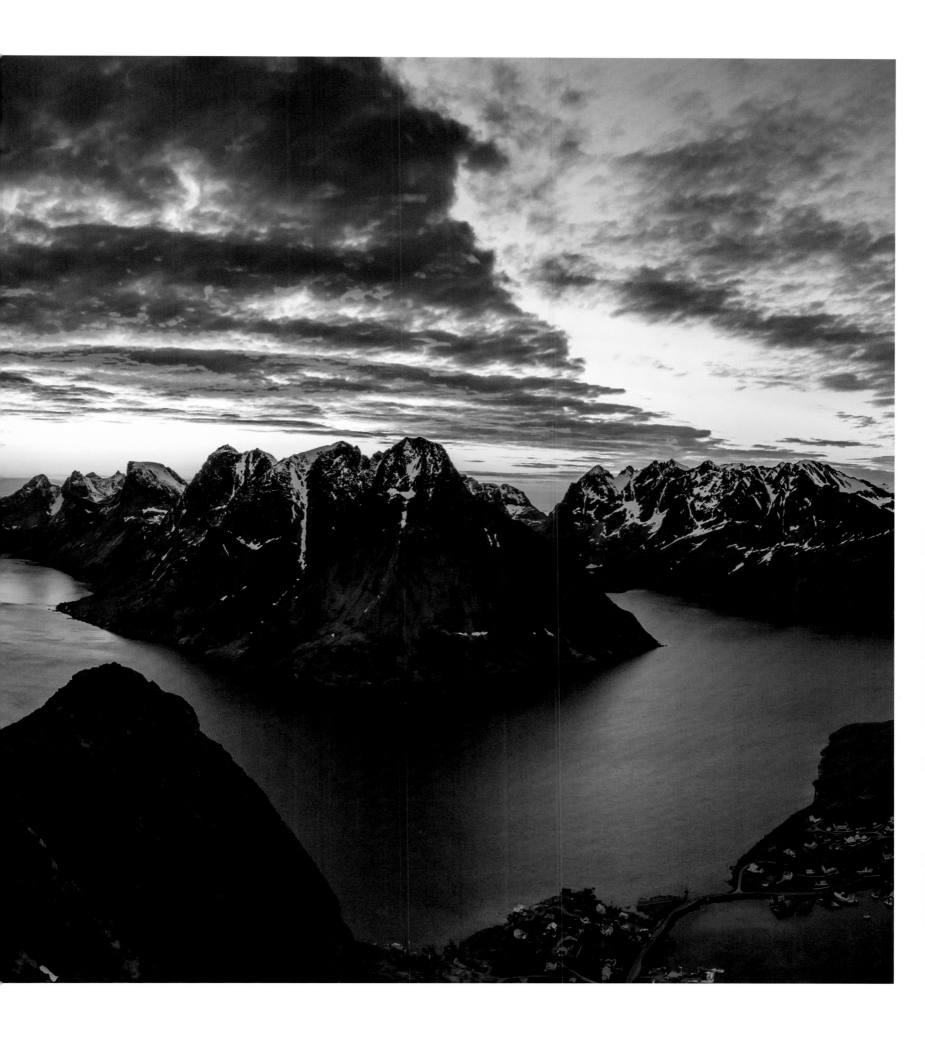

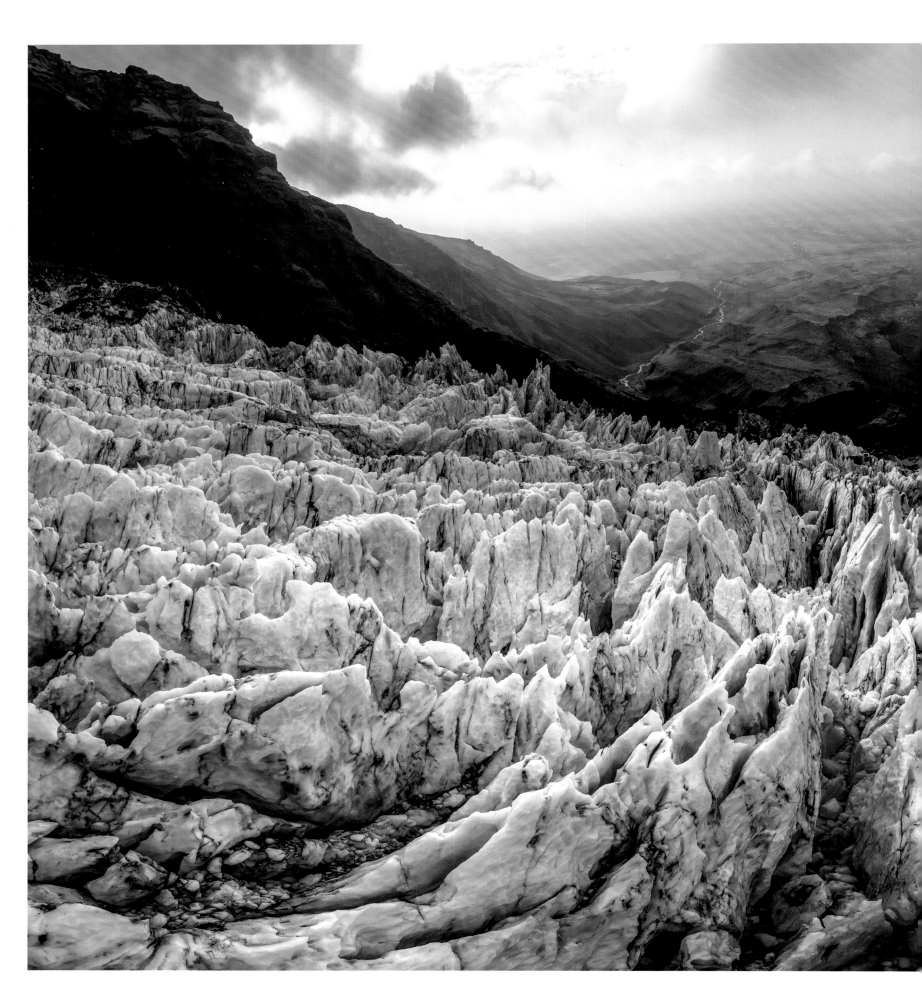

// THIS PAGE

Numerous arms branch off Vatnajökull, Iceland's largest glacier, into a valley. This image was captured with the multicopter. A total of twenty-two photographs from two series were composed into a panoramic image after the fact, in order to demonstrate the true size and beauty of the glacier.

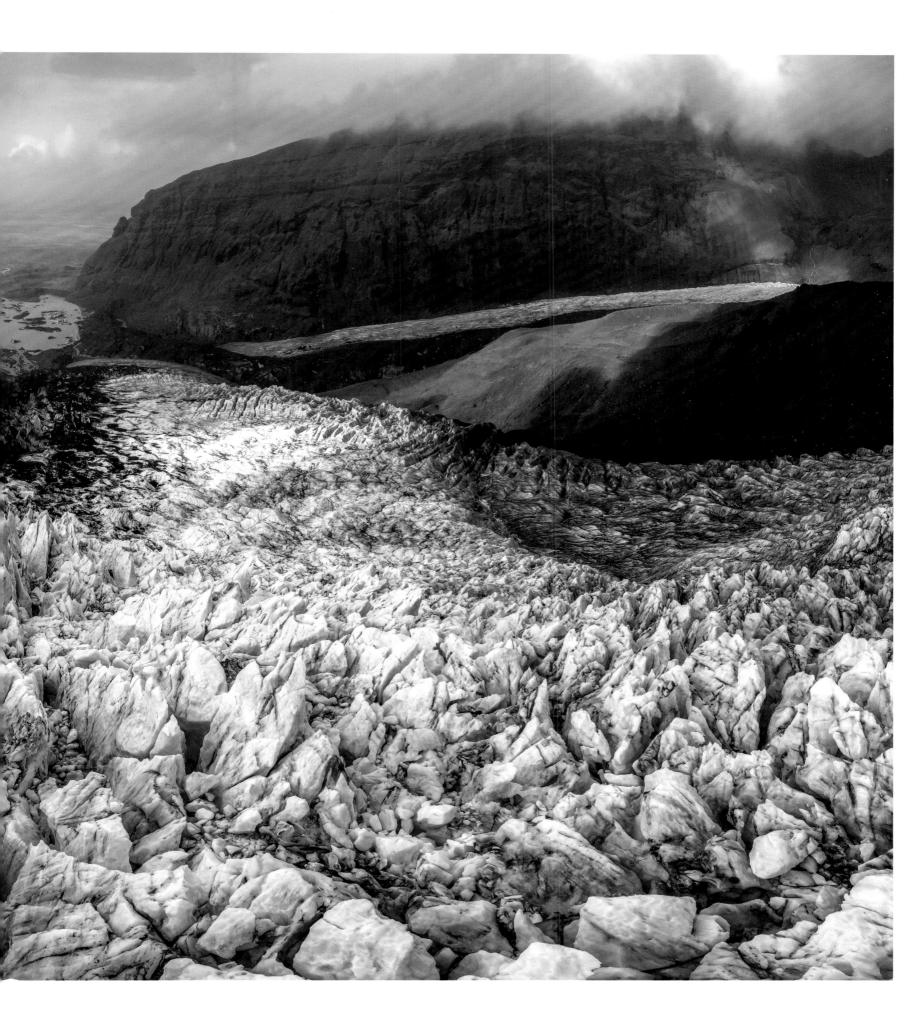

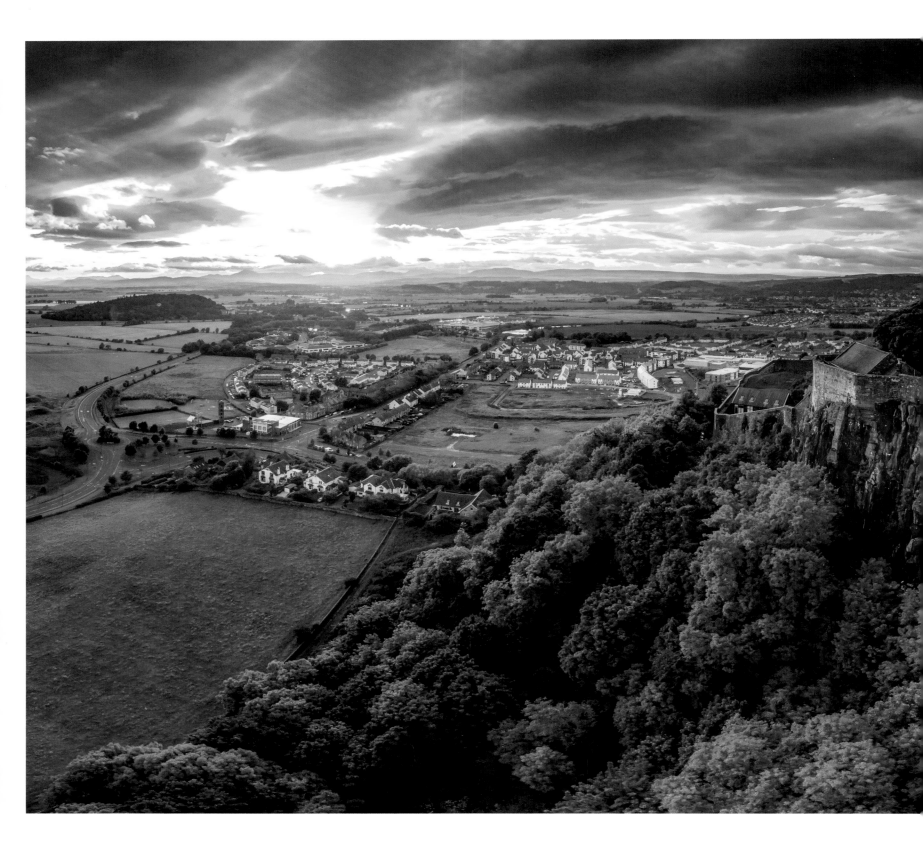

// THIS PAGE

This aerial panorama shows the fantastic Stirling Castle in the south of Scotland in its enormity. From its strategically advantageous position on the River Forth, the castle played an important role in Scotland's history and was attacked or besieged at least sixteen times. The history of Stirling Castle stretches back to the year 1,110.

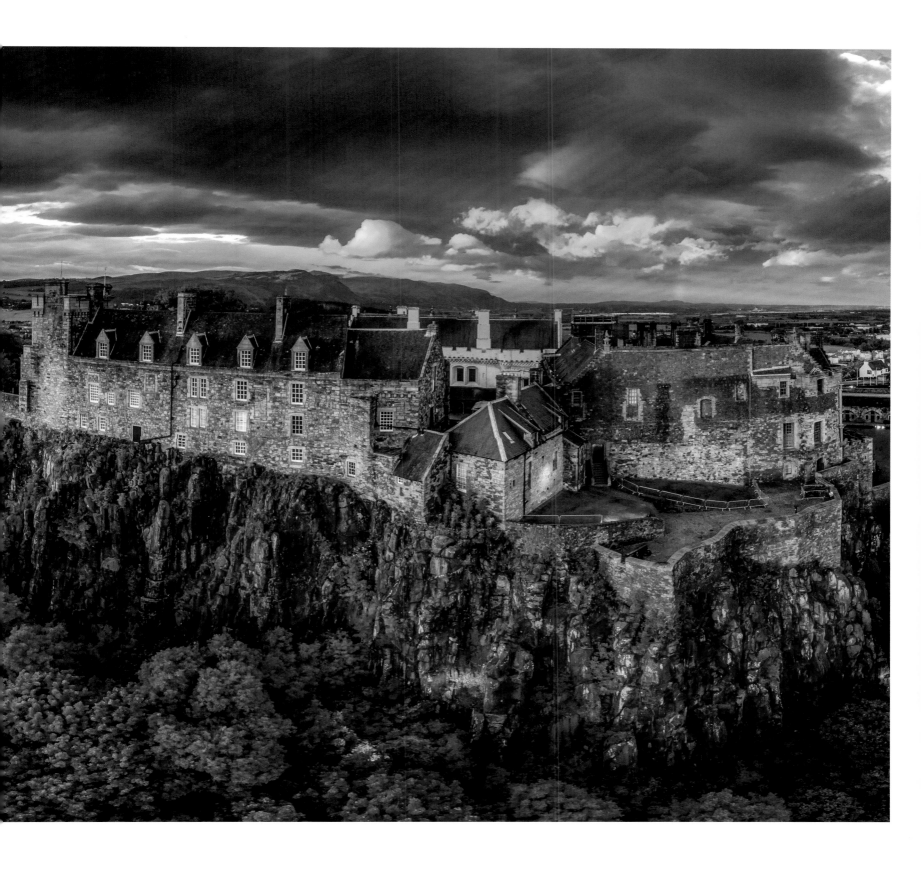

7

RIVERS, LAKES AND COASTS //
FLÜSSE, SEEN UND KÜSTEN // LES FLEUVES, LES LACS ET LE LITTORAL //

Oceans cover 71 percent of our planet. The coastlines—where sea meets continent—stretch for hundreds of thousands of kilometers. As a photographer, I find them especially alluring. The steeper and less accessible, the more beautiful. Without a doubt the Faroe Islands are considered a paradise for lovers of coasts, where the wild sea encounters ancient islands formed mostly of volcanic tablelands. They boast the world's highest vertical cliff with the imposing dimension of 750 m (2,461 ft.). Iceland's coasts are dominated mainly by black basalts, which generate extreme contrasts against the white sea spray. They are unlike Scotland or Norway, which offer both abrupt rocky cliffs as well as white sand beaches whose light-green water is reminiscent of the Caribbean, with sand dunes and gently swaying dune grasses. As a lover of moving water, I also thought it fitting to include waterfalls—like the one at the Subway in Zion National Park in the United States, or the numerous primeval forest falls on the island of Réunion.

71 % unseres Planeten sind mit Ozeanen bedeckt. Es gibt Hunderttausende von Kilometern, an denen das Festland und das Meer sich treffen - die Küsten. Diese sind es auch, die mich als Fotografen besonders interessieren. Je schroffer und schwieriger erreichbar sie sind, umso schöner. Mit der weltweit höchsten senkrechten Klippe, die eine beeindruckende Dimension von 750 Metern besitzt, gelten die Färöer Inseln definitiv als Paradies für Küstenliebhaber. Hier trifft die raue See auf ein urtümliches Land, das zum Großteil aus Plateaubergen besteht. In Island dominiert an den Küsten hauptsächlich schwarzer Lavastein und Basalt, der in Verbindung mit der weißen Gischt für extreme Kontraste sorgt. Schottland und Norwegen hingegen bieten nebst schroffen Felsklippen auch karibisch anmutende weiße Sandstrände mit hellgrünem Wasser, Sanddünen und sanft schwingenden Dünengräsern. Für einen Liebhaber von bewegtem Wasser liegt es nahe, dass in meiner Auswahl auch Wasserfälle (wie jene in der Subway im Zion Nationalpark in den USA oder den zahlreichen Urwaldfällen der Insel La Réunion) nicht fehlen.

Approximativement 71 % de la surface de la Terre est recouverte d'océans. Sur des centaines de milliers de kilomètres, les terres et les mers se rencontrent pour former le littoral. C'est cette bande de terre qui m'intéresse particulièrement en tant que photographe. Plus le littoral est escarpé et difficile d'accès, plus il est beau. Avec ses escarpements vertigineux parmi les plus remarquables du monde, s'élevant à quelque 750 mètres, les îles Féroé sont un paradis pour les amateurs de falaises. Une mer souvent déchaînée rencontre des terres intactes constituées majoritairement de plateaux. En Islande, les côtes sont essentiellement composées de pierre de lave et de basalte, sur lesquelles l'écume blanche crée des contrastes impressionnants. L'Écosse et la Norvège, qui présentent également un littoral très accidenté, offrent aussi le charme des Caraïbes avec leurs plages de sable blanc et leurs eaux vert jade, leurs dunes de sable émaillées d'herbes ondoyantes. Avec mon choix d'intégrer à ce livre les chutes d'eau, dont le Subway, boyau tubulaire creusé dans la roche, situé dans le parc national de Zion, aux États-Unis, ou les nombreuses cascades des forêts tropicales sur l'île de la Réunion, les amoureux des eaux en mouvement ne seront pas en reste.

// OPPOSITE PAGE

Situated northwest of Reykjavík, Iceland, is Snæfellsnes, a peninsula known for numerous natural wonders. One of the most beautiful spots on Snæfellsnes is Kirkjufellsfoss, which lies at the foot of Kirkjufell, the waterfall's mountain namesake.

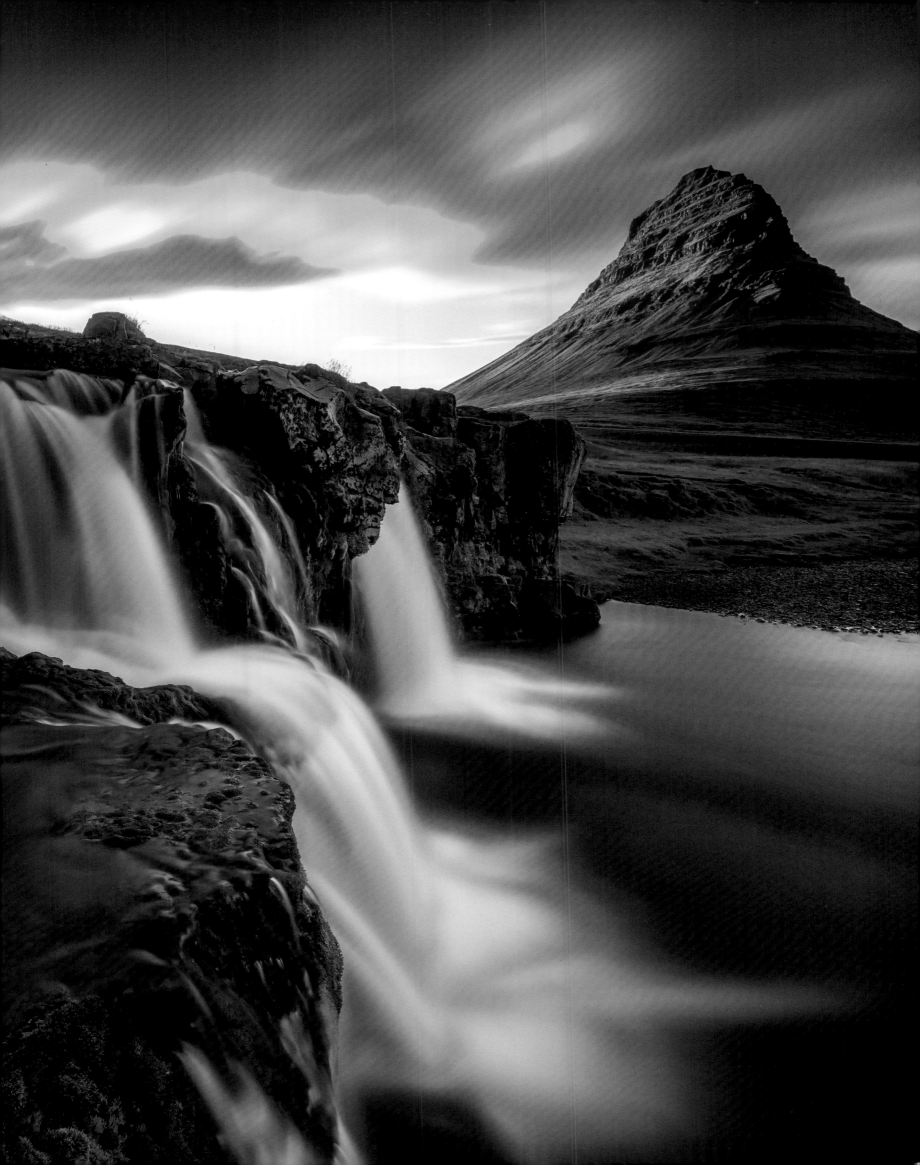

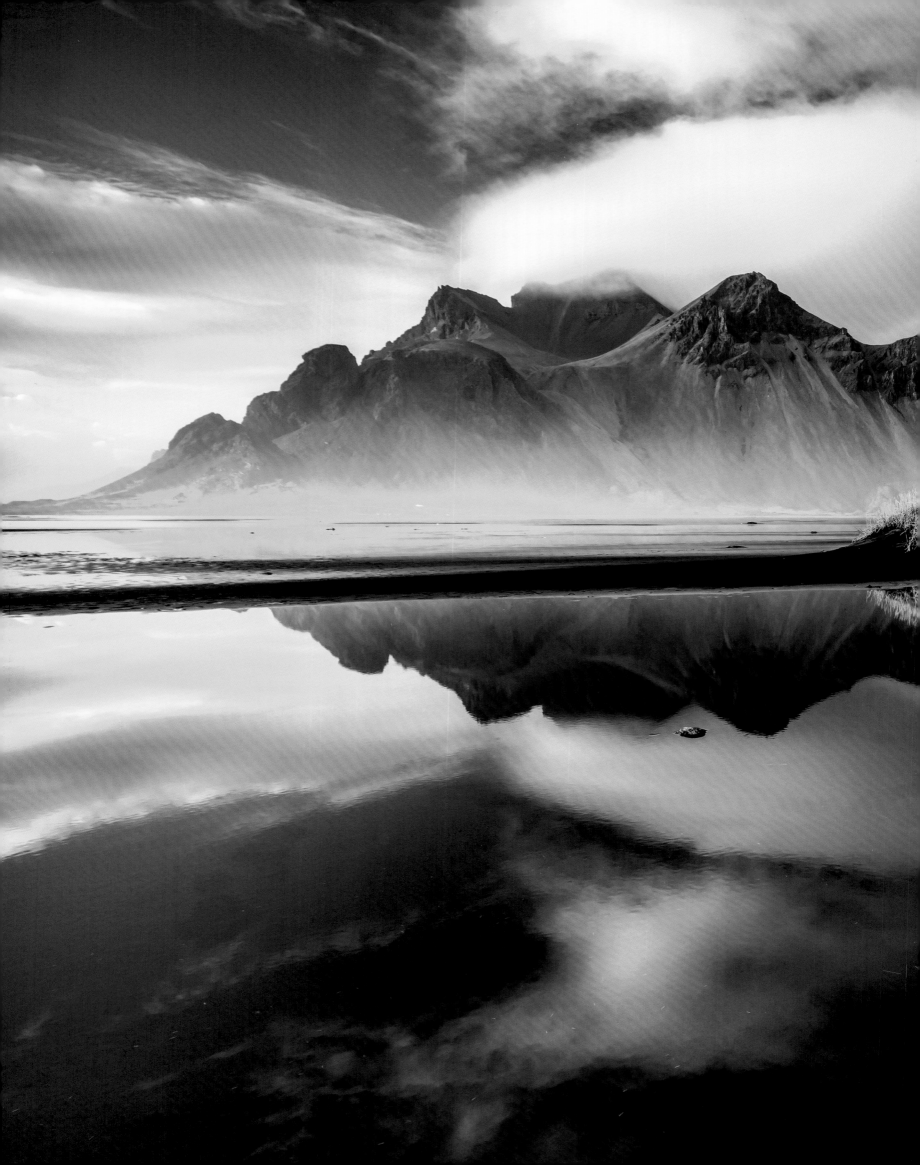

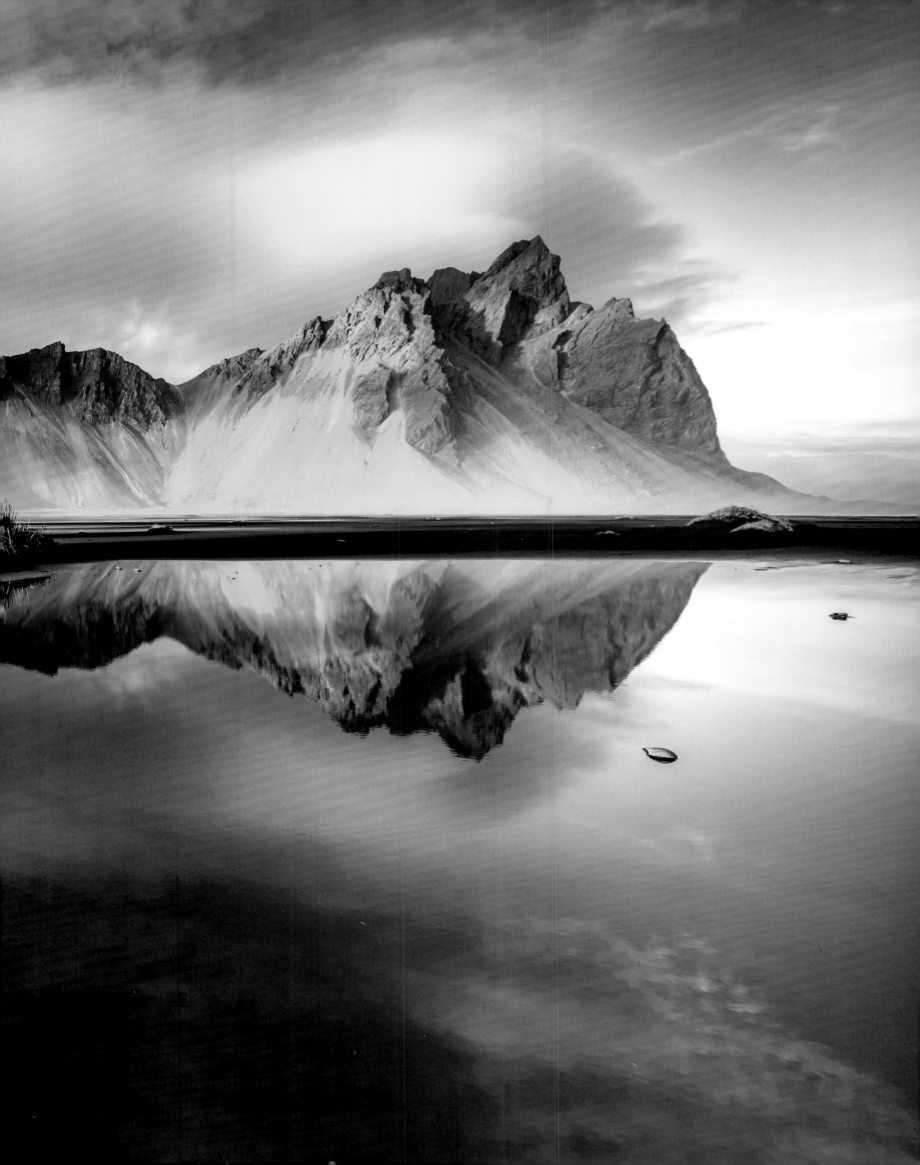

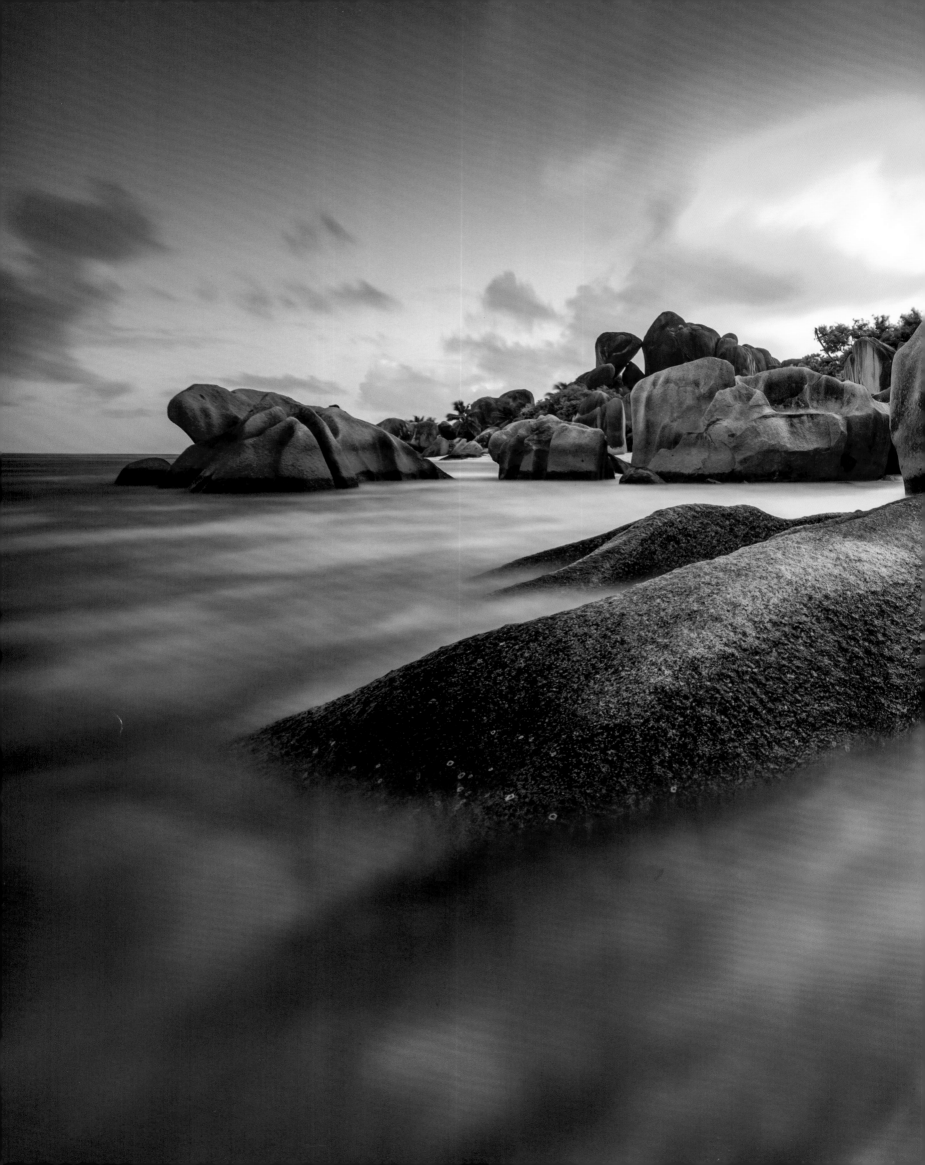

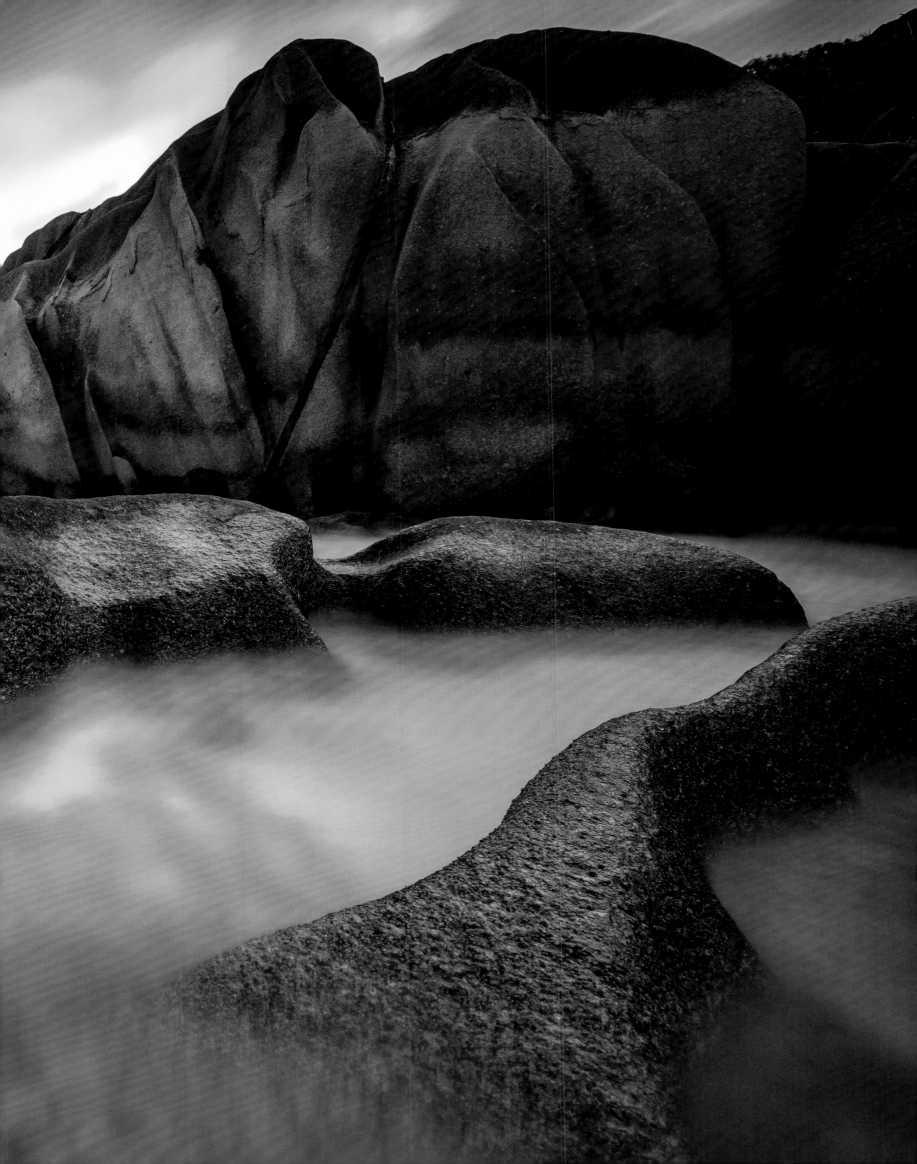

// PAGE 164/165

Mighty tides leave huge pools impounded on the shore at Stokksnes in the south of Iceland. However infrequently, the Icelandic wind will now and again die down to provide a moment of calm. If at this moment one is standing at the edge of a lake of seawater, wonderful reflections of Vestrahorn may appear.

// PREVIOUS PAGE

The Seychelles in the Indian Ocean are an archipelago of 115 islands. One of the most beautiful is La Digue. Especially spellbinding is the famous beach Anse Source d'Argent in the southwestern part of the island. For this image, I set up my tripod in water and exposed the sensor for approximately one minute.

// THIS PAGE

As ominous as this spot looks in the image, that's how beautiful it is to photographers. Horns at the coast near Reykjanesviti, Iceland, defy harsh North Atlantic conditions.

// OPPOSITE PAGE / TOP

Long exposure times get you smooth surfaces no matter how rough the sea. The west coast of Scotland near Ullapool gives off unparalleled color. I've spent many hours here watching fishing boats return to port.

// OPPOSITE PAGE / BOTTOM

The sun had slipped below the horizon and there was a slight rain. But on account of the beautiful atmospheric mood I could not bring myself to pack up the camera. At Second Beach in Olympic National Park in Washington, USA, one often finds blood stars, which make for something of a flash in an otherwise very triste natural setting.

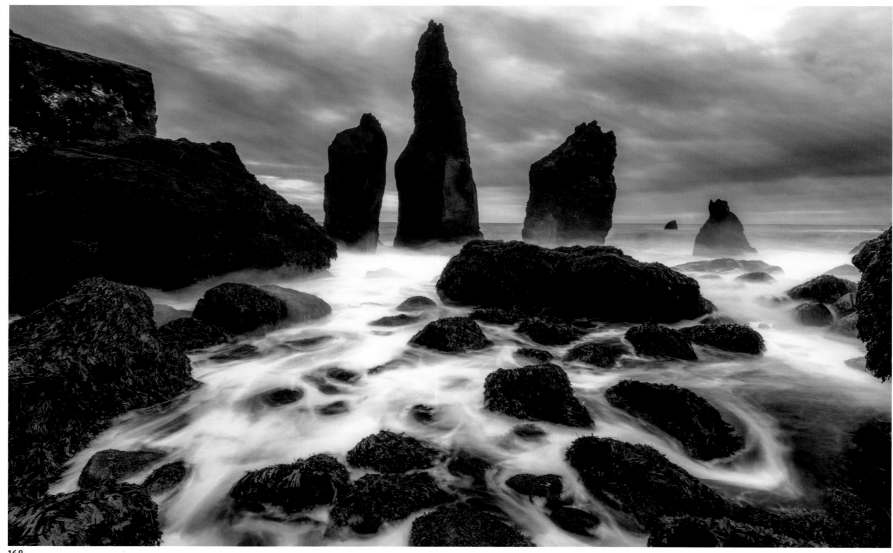

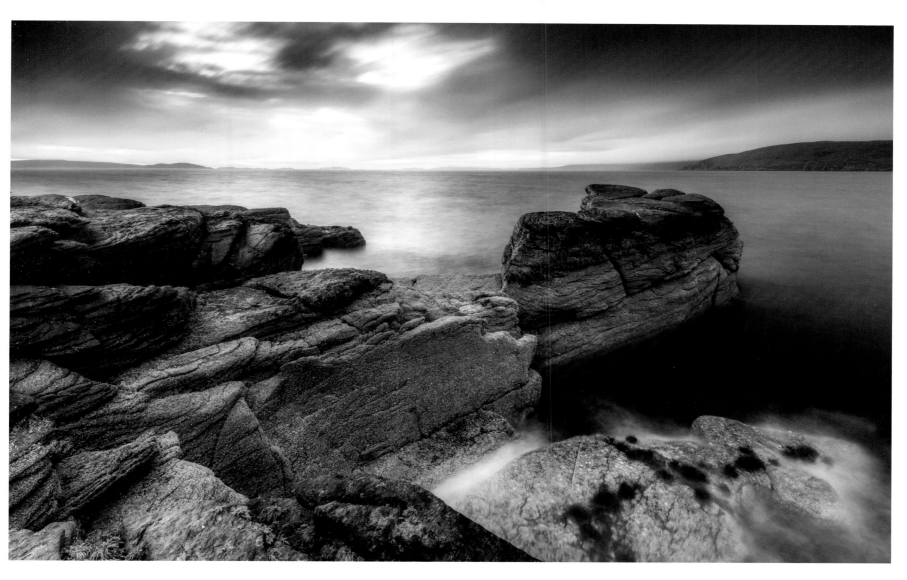

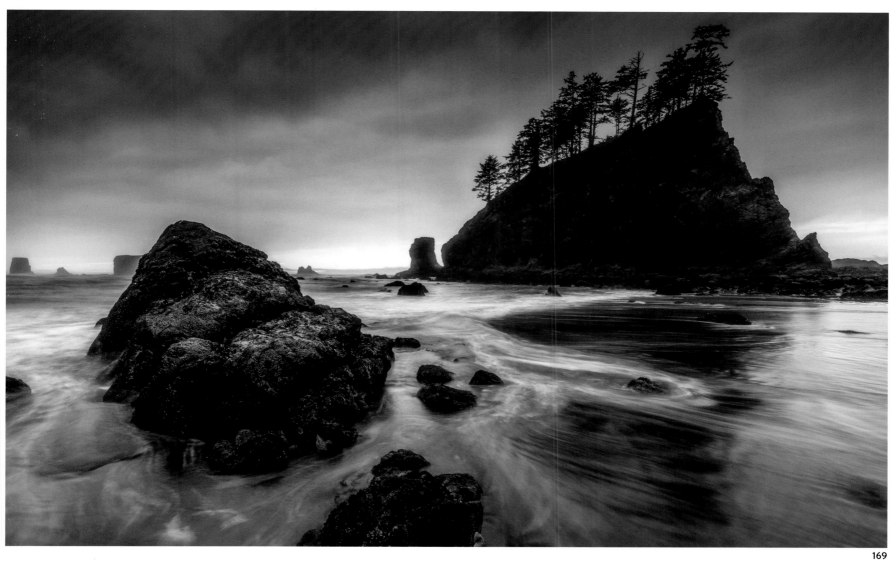

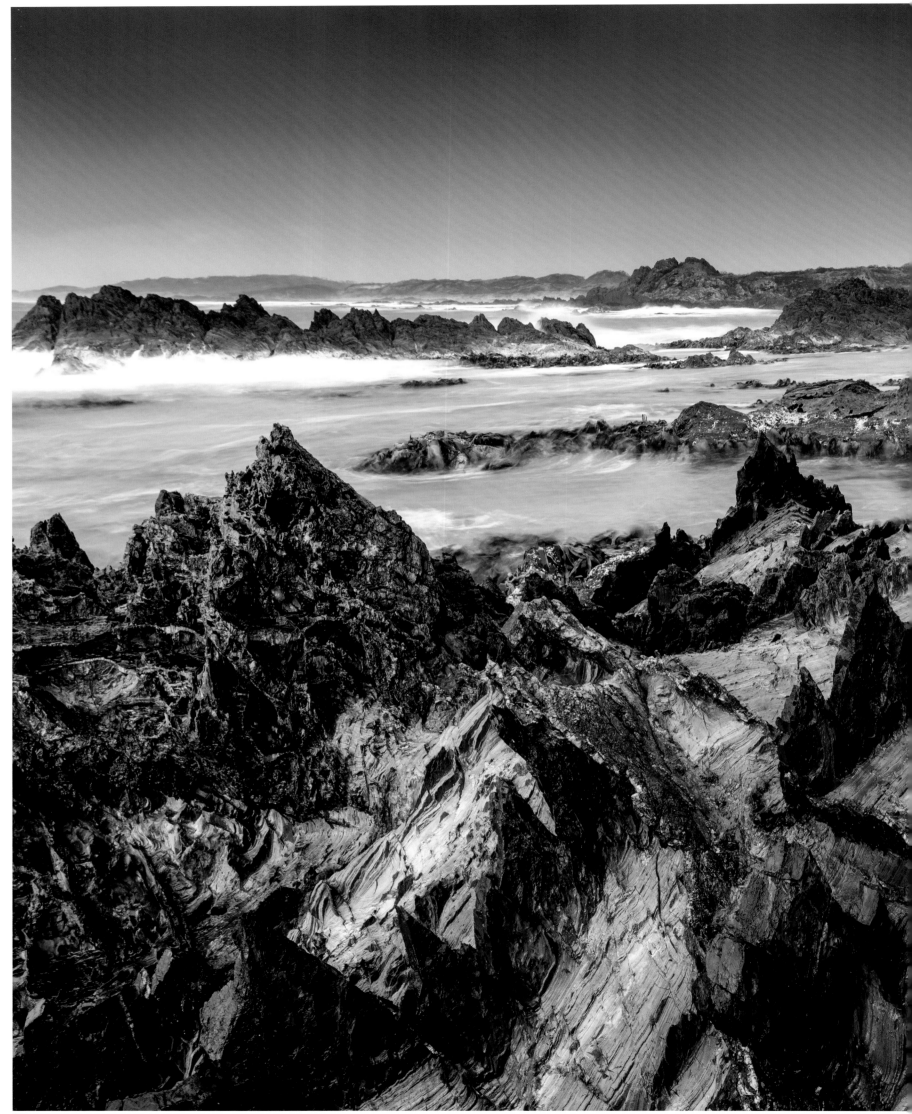

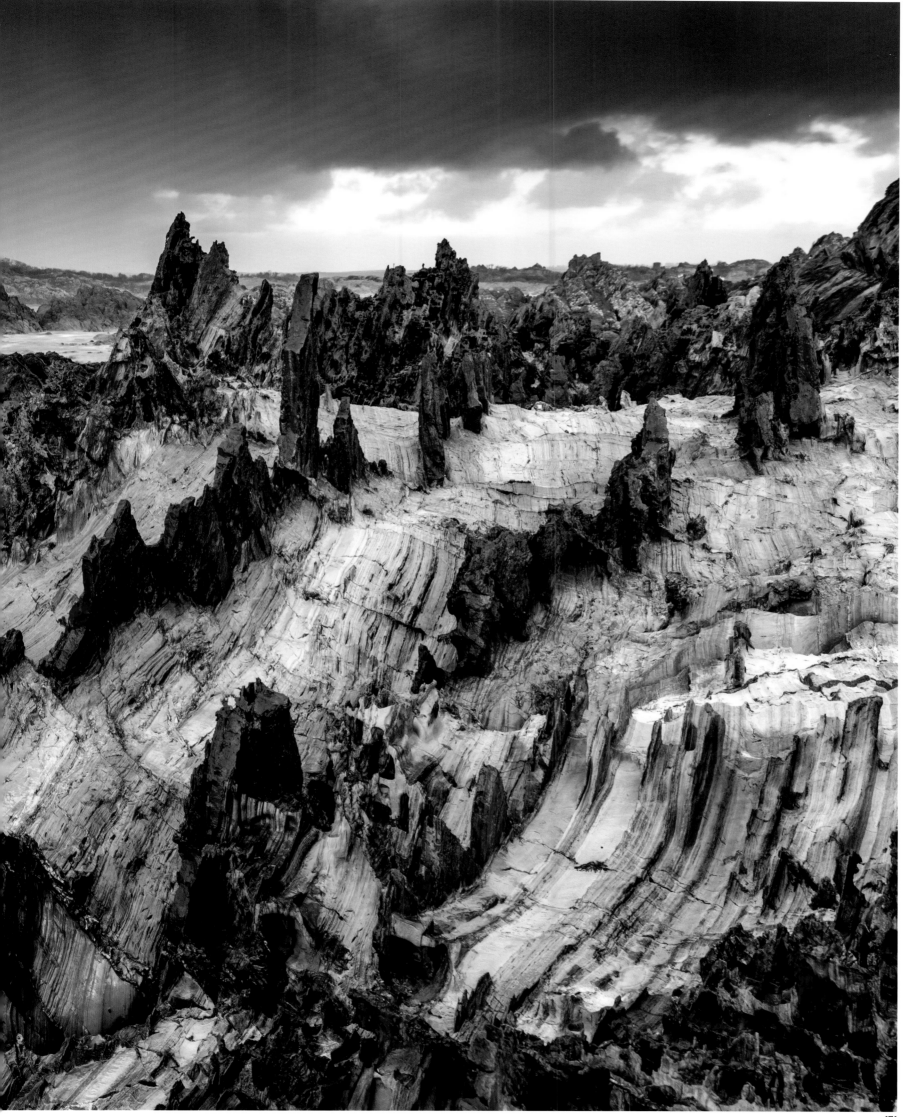

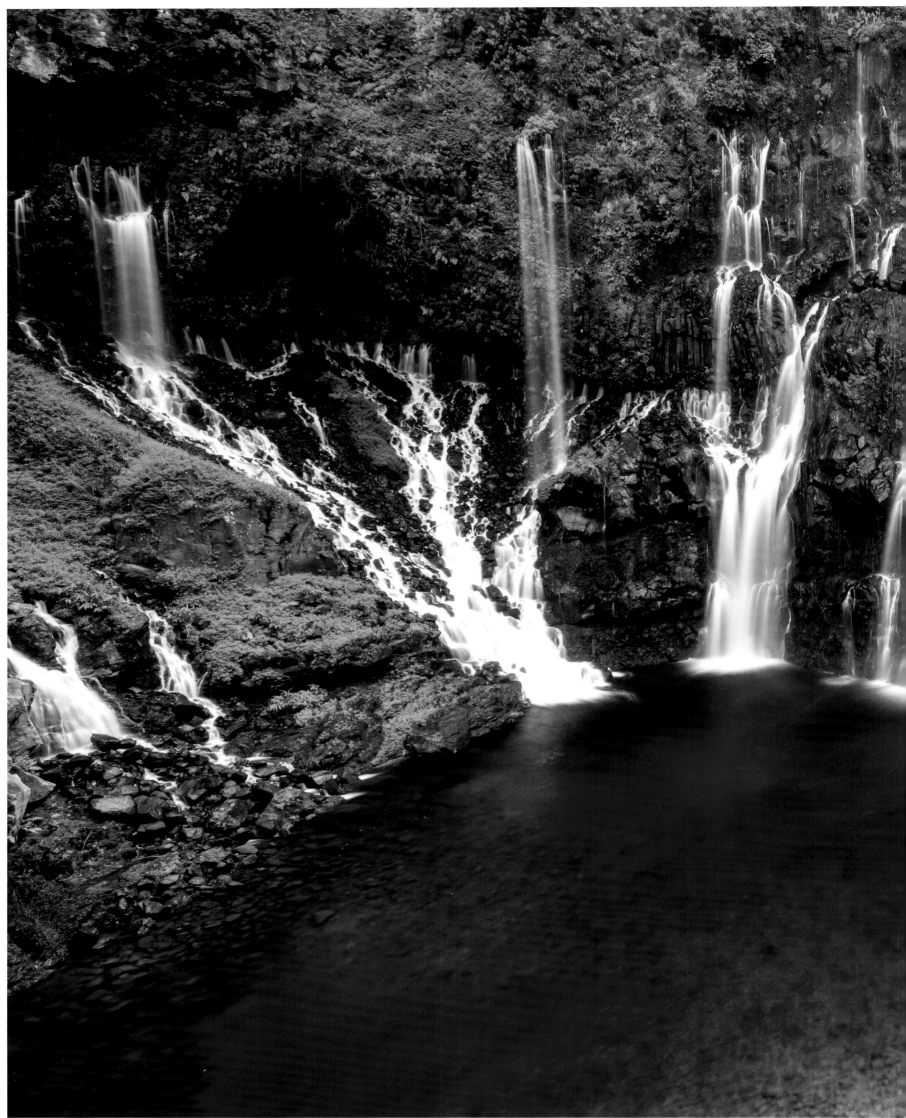

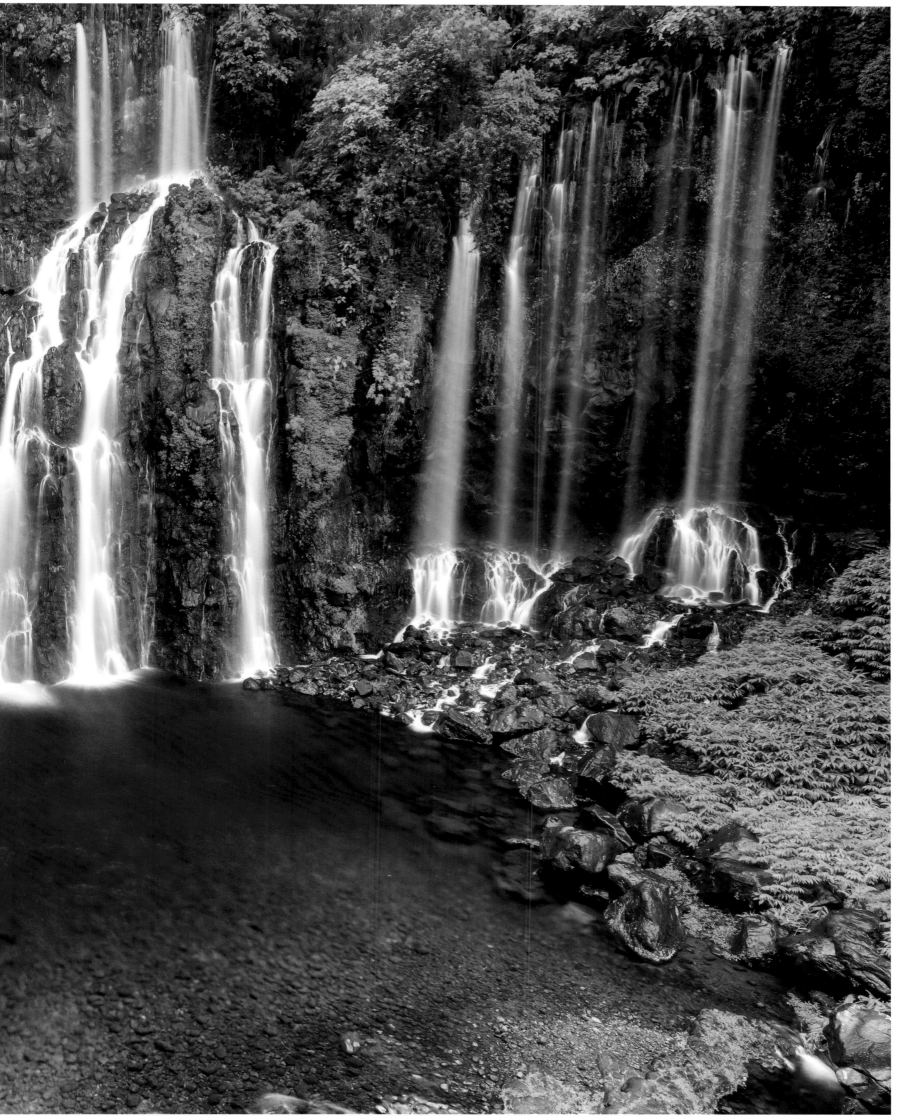

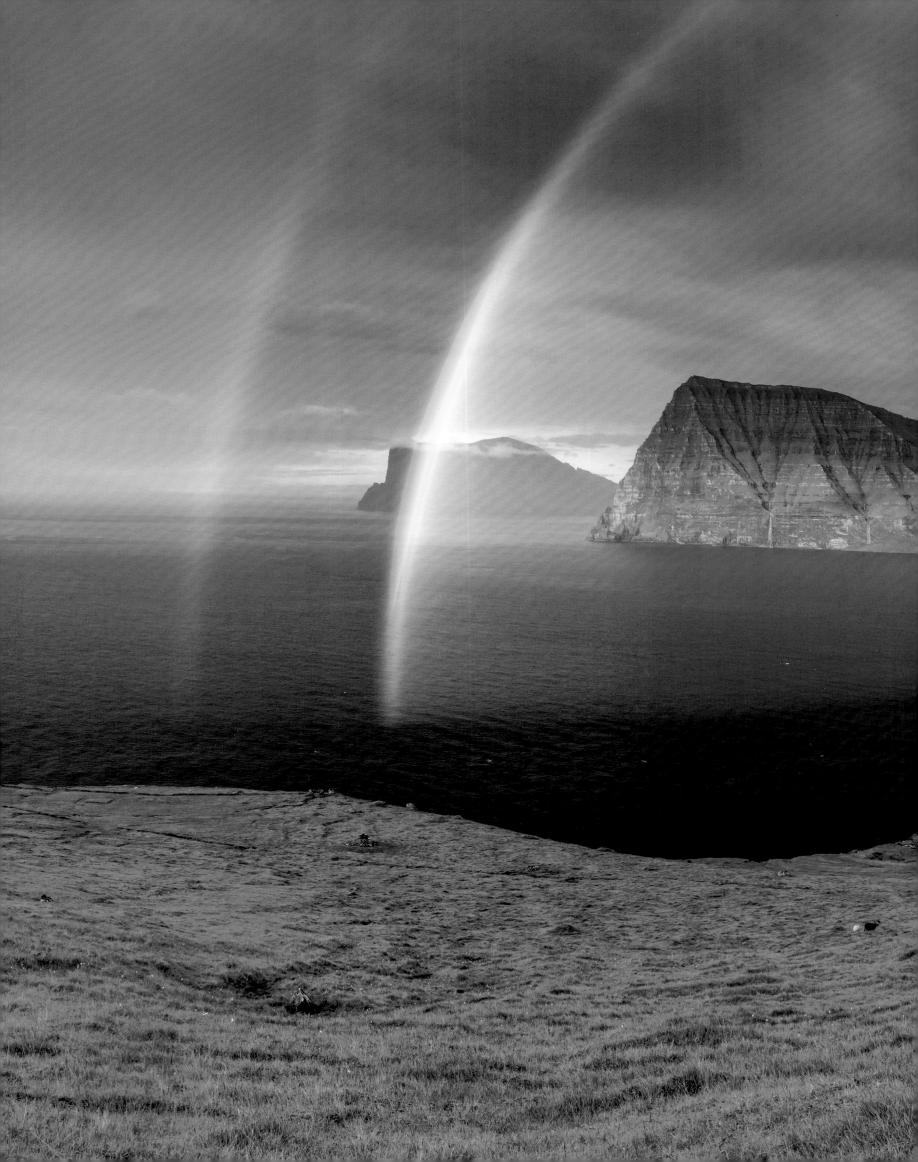

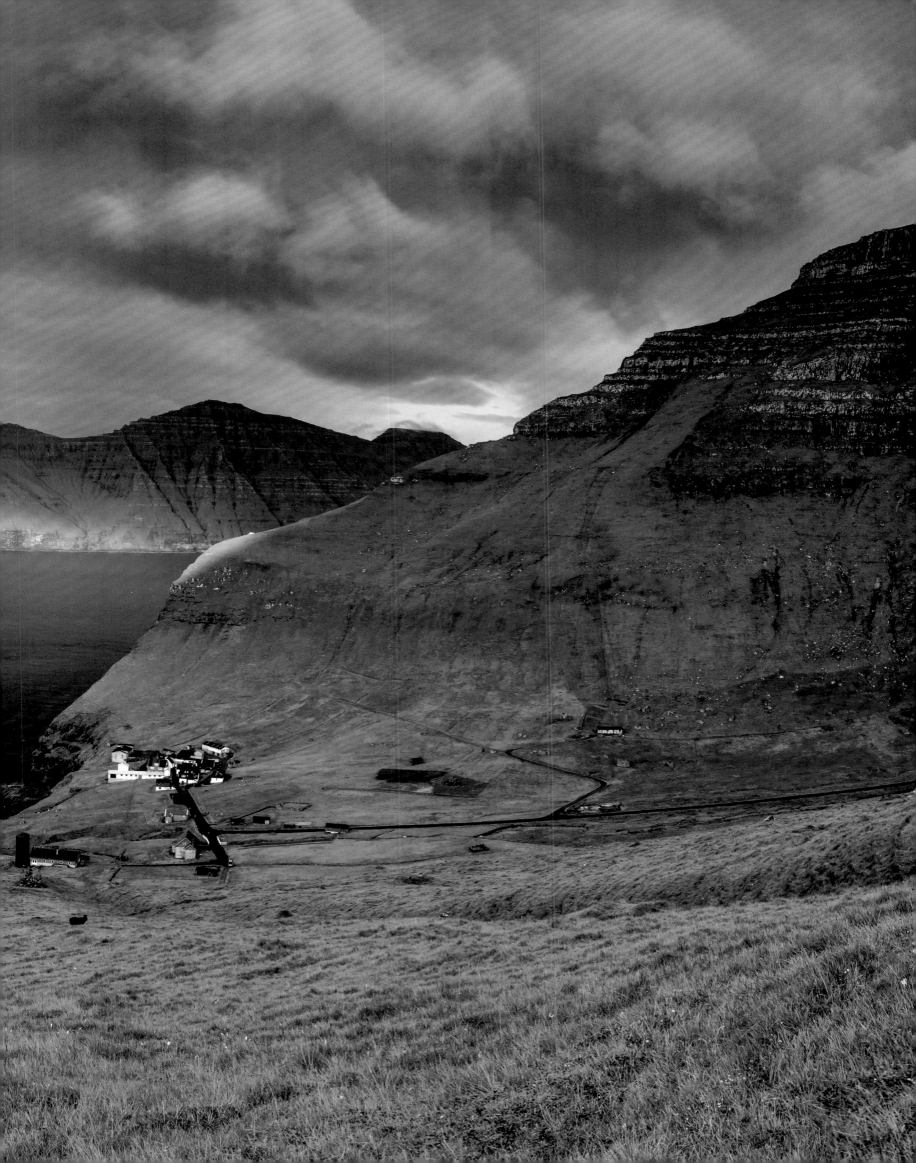

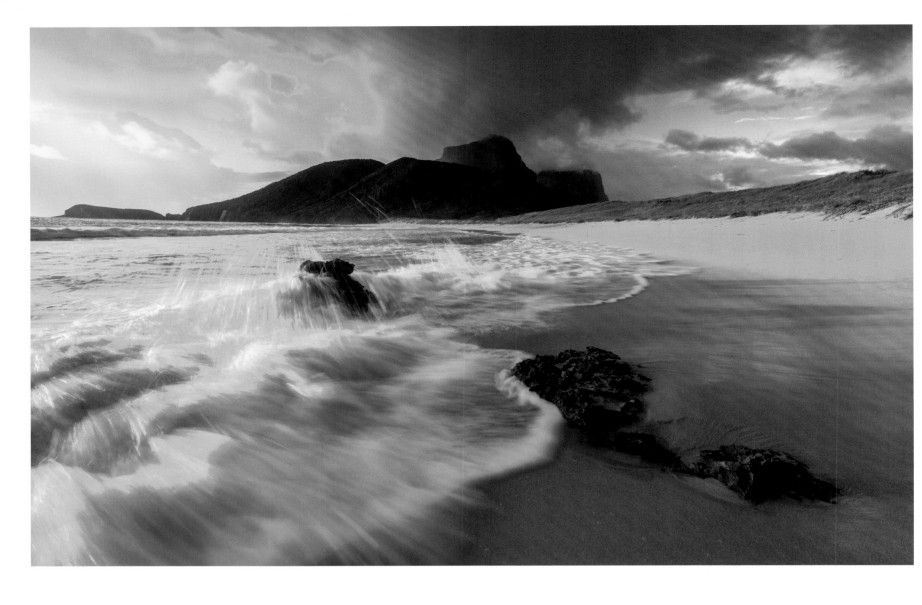

// PREVIOUS PAGE

The cliffs of the Faroes are among the highest on earth. Approaching the islands by boat from Iceland, one can see from far off how they rise vertically out of the sea and extend skyward up to 1,000 m (3,280 ft.). This image, with the hamlet Trøllanes in the foreground, was shot on the island of Kalsoy. Tourism is slowly but surely gaining traction in the Faroes.

// THIS PAGE

It's the first time the sun comes out after nearly a week of nonstop rain on Lord Howe Island. The extreme remoteness and minimal size of the island makes Lord Howe easy prey for major storms. It's no surprise to get stuck at the airport or stranded on the island for up to a week, because the little airport is only approachable in visual flight conditions. Once on the island, however, you never want to leave.

// OPPOSITE PAGE

First there were twelve, but now there are seven. Of course, we mean the Twelve Apostles in southern Australia. As enormous as these stone forts may look, their structure is weak and brittle after thousands of years exposed to wind and sea.

// NEXT PAGE

For me as a photographer the worst possible weather is a clear blue sky. On purpose, I travel to my intended locations for photography in bad weather. On my trip to Australia in February 2017, the Weather Channel reported heavy storms forecast to impact the southern coast, and I changed my plans so I could witness the event at the Twelve Apostles. Over the course of three days, a series of low-pressure systems came onshore and created an outstanding atmosphere for photography.

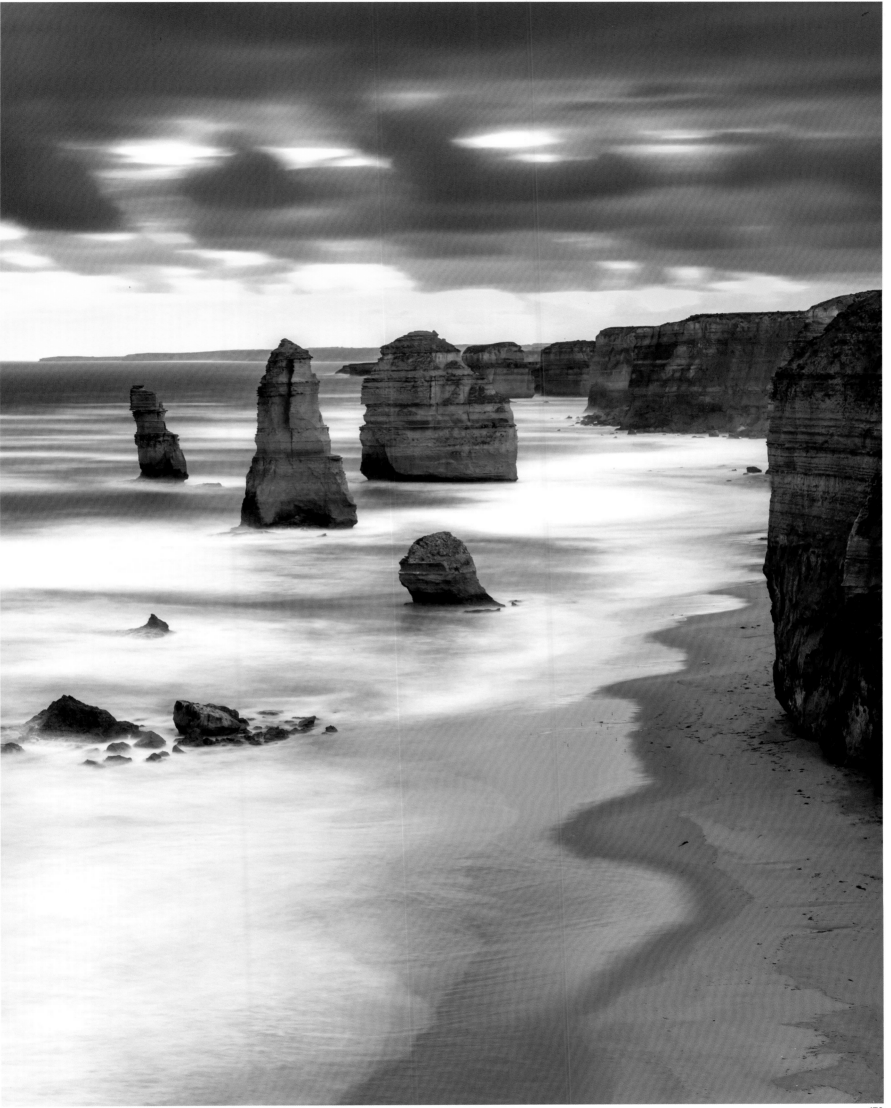

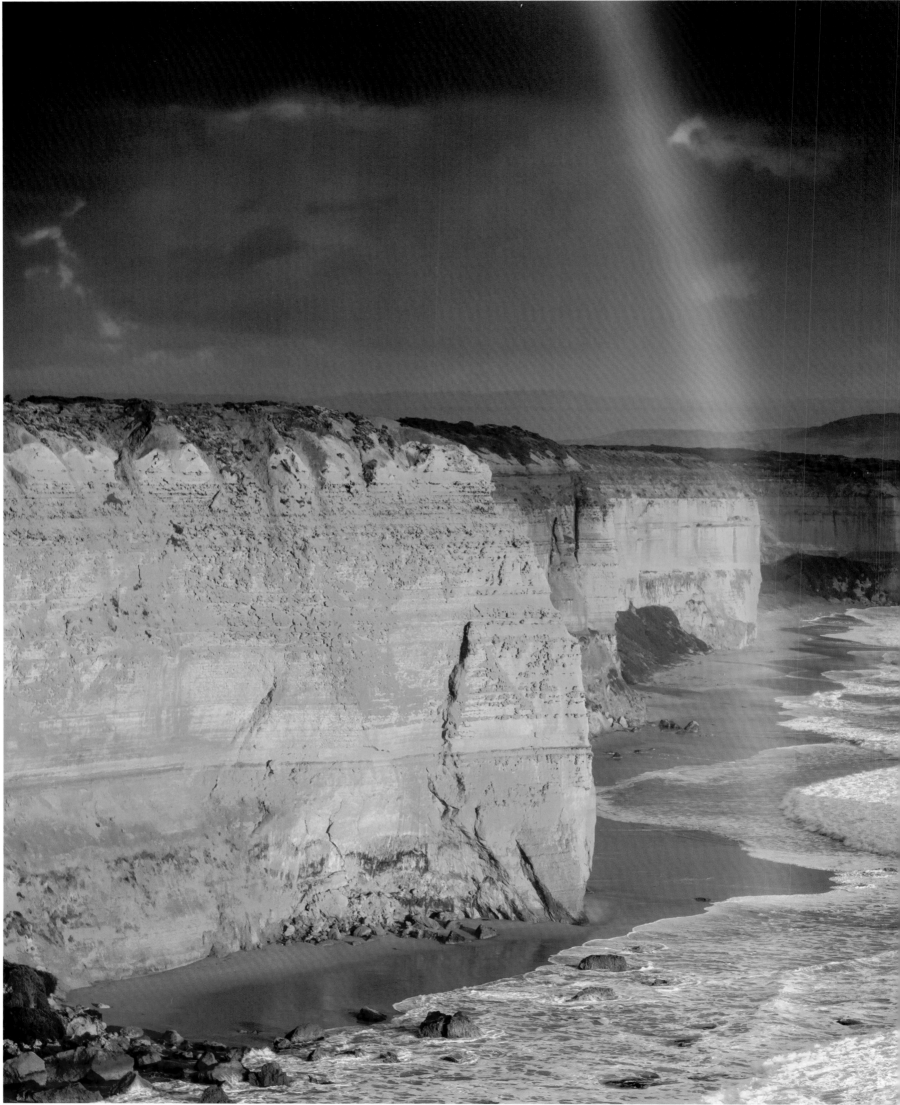

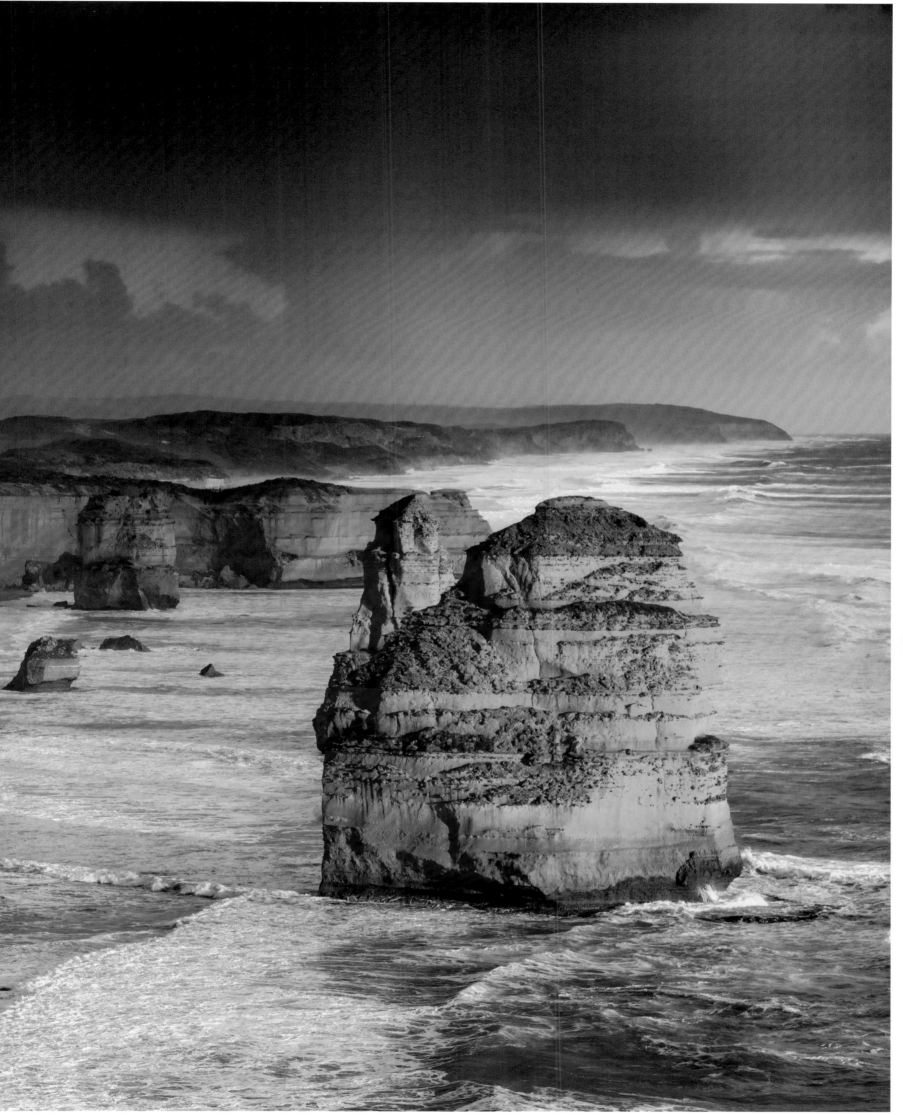

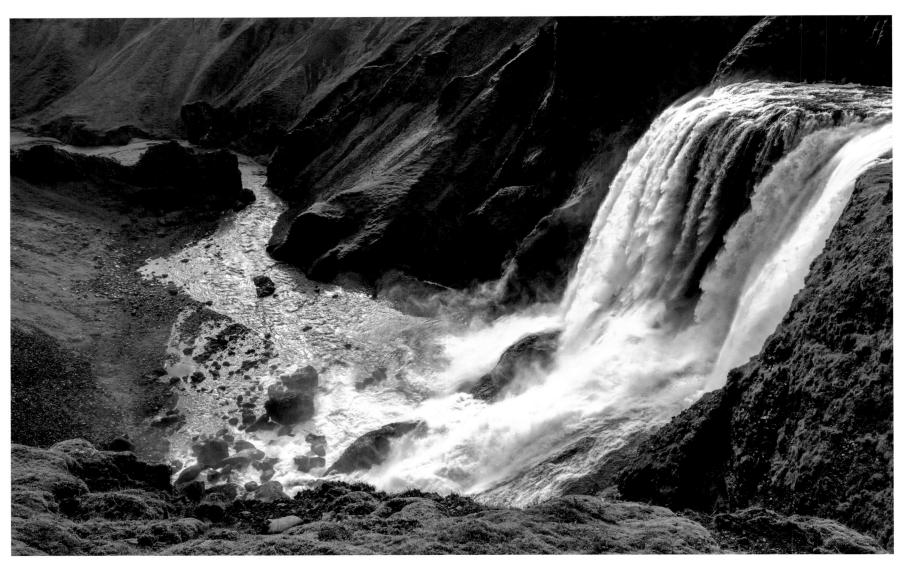

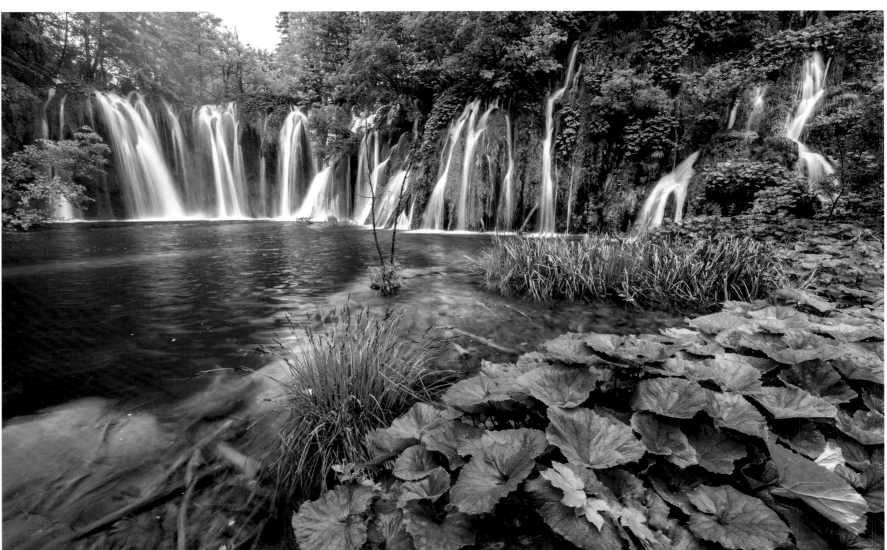

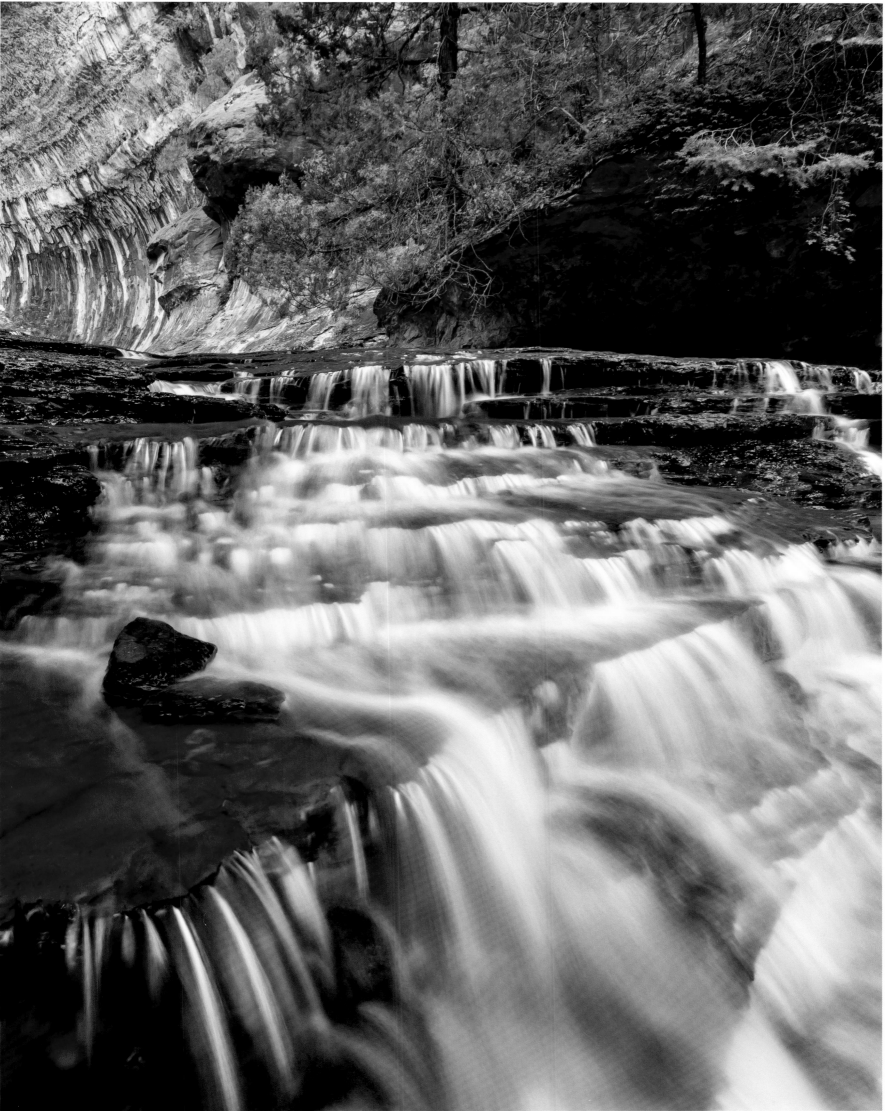

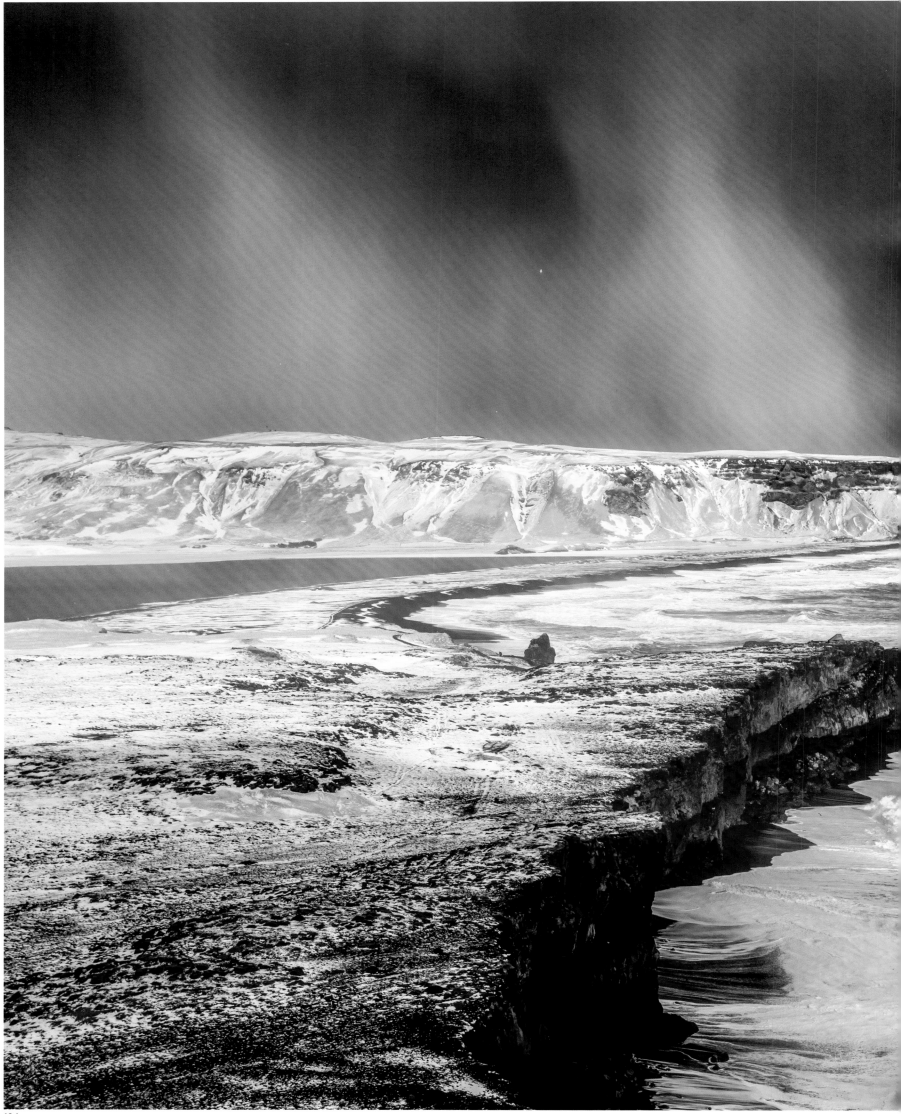

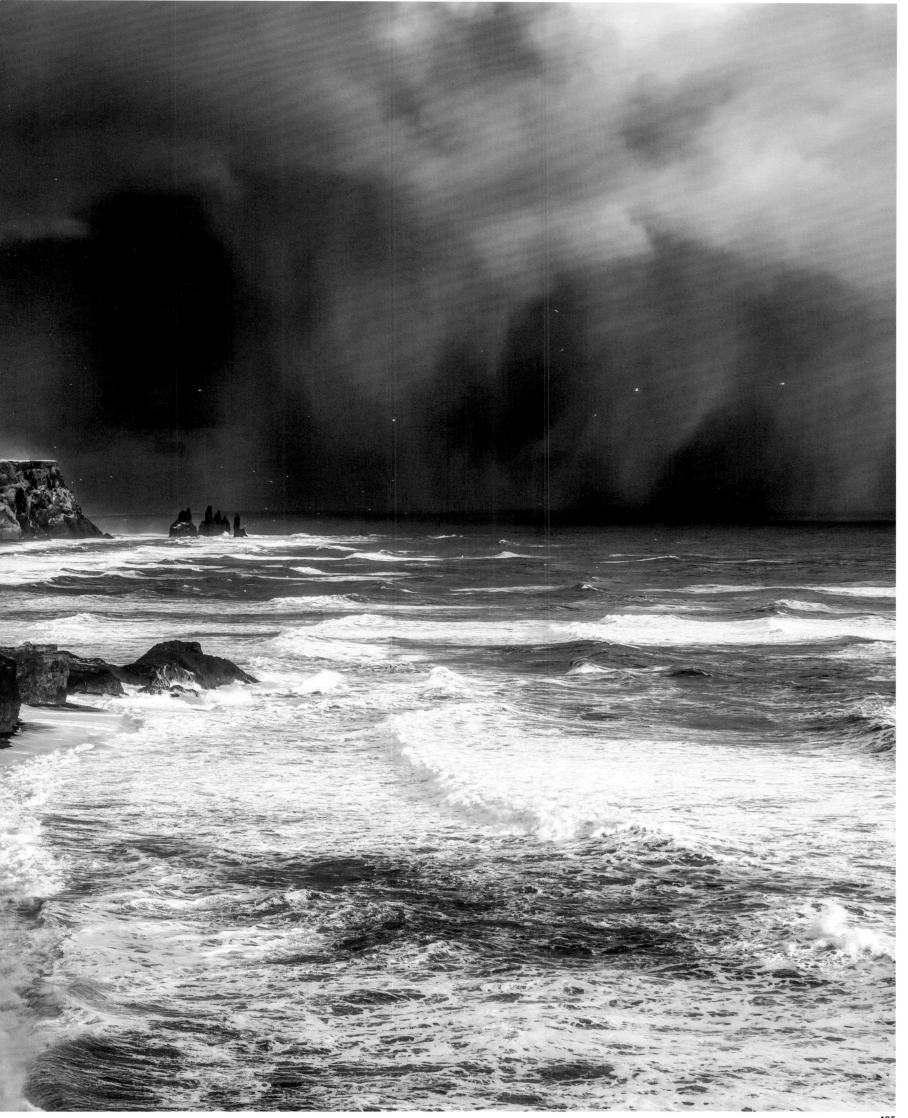

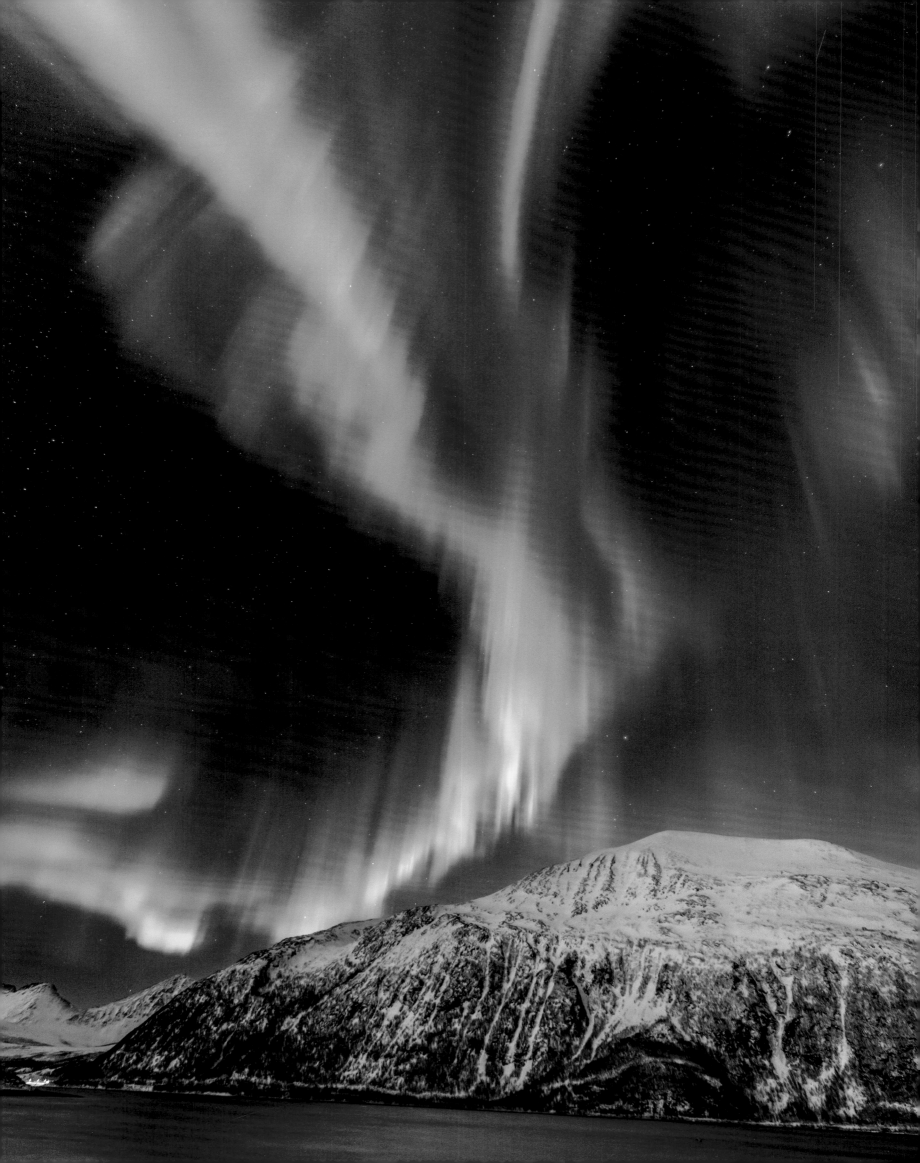

My first northern lights, years ago, were a long time coming. I'd been spending whole nights out in icy temperatures in the deep snow of Iceland without seeing so much as a tiny shimmer. One night I was headed for my vehicle at 3 a.m., when suddenly the snow around me began glowing green. And there it was: the aurora borealis. I immediately recognized that what I had been anticipating for so long was finally taking place. Now and then the sun hurls electrically charged particles into space in what are called coronal mass ejections. Struck by these particles—sometimes also termed solar winds—the oxygen and nitrogen atoms in earth's upper atmosphere become ionized and eventually begin to glow. In the northern hemisphere, the lights are called aurora borealis, in the southern hemisphere aurora australis.

So far, I have under my belt over forty trips to Iceland, Greenland, and Norway—for the most part just to see the northern lights. I have been afforded displays of extremely rare intensity. The lights themselves, which occur no more than every couple of weeks, present no major photographic. Rather, it's the combination of a perfect foreground—say, a transparent iceberg—together with an aurora that makes for a successful photo.

Mein erstes Nordlicht ließ lange auf sich warten, so stand ich vor Jahren nächtelang bei hohen Minustemperaturen im Tiefschnee von Island, ohne auch nur ein kleines Leuchten zu sehen. Dann, als ich mich morgens um 3 auf den Weg zurück zum Auto machte, begann der Schnee um mich herum grün zu glühen und da war sie, die Aurora Borealis. Sofort wurde mir bewusst, dass das, was ich so lange erwartet hatte, endlich geschah. Von Zeit zu Zeit schleudert die Sonne mittels koronaler Massenauswürfe elektronisch geladene Teilchen ins Weltall. Treffen diese Teilchen, auch Sonnenwinde genannt, auf Sauerstoff- und Stickstoffatome in den oberen Schichten der Erdatmosphäre, beginnen diese zu ionisieren und schlussendlich zu leuchten. Im Norden werden die Lichter Aurora Borealis genannt, auf der Südhalbkugel Aurora Australis.

Bei meinen bislang über 40 meist einzig und alleine den Nordlichtern geltenden Fahrten nach Island, Grönland und Norwegen, konnte ich schon Lichter von einer Stärke sehen, wie sie sich nur äußerst selten ereignen. Das nur alle paar Wochen eintretende Nordlicht allein bietet fotografisch keine große Herausforderung. Es ist eher die Kombination aus perfektem Vordergrund, z. B. einem transparenten Eisberg und der Nordlichtaktivität, wodurch ein Foto zum Erfolg wird.

Il m'aura fallu patienter longtemps avant de voir ma première aurore boréale. C'était il y a quatre ans, alors que j'étais aux aguets dans la neige profonde de l'Islande par un froid glacial depuis de nombreuses nuits sans voir la moindre lueur. Il était trois heures du matin quand j'ai décidé de retourner dans mon véhicule et quand la neige a changé de couleur et s'est teintée de vert. J'ai aussitôt compris que le phénomène que je guettais depuis si longtemps était en train de se passer. Car de temps en temps, des tempêtes se forment sur le soleil, lors desquelles des particules chargées électriquement sont propulsées dans l'univers. Lorsque ces vents solaires, ou éjections de masse coronale, rencontrent les composantes de l'air (l'azote et l'oxygène) des couches supérieures de l'atmosphère, il y a collision. Ce qui ensemble, libère une énergie lumineuse qu'on appelle les aurores polaires. Au pôle Sud, on retrouve les aurores australes, au pôle Nord, les aurores boréales.

Lors de la quarantaine de voyages effectués pour la plupart seul en Islande, en Norvège et au Groenland, j'avais déjà eu la chance de voir des aurores polaires d'intensités extraordinaires. Le fait que l'aurore boréale se présente seulement à grands intervalles n'est pas un grand défi, photographiquement parlant. C'est plutôt la concomitance du motif parfait au premier plan, par exemple un iceberg diaphane, et de l'activité boréale qui conditionne la réussite d'une photographie.

// OPPOSITE PAGE

Over the months I spent roaming Scandinavia chasing the Northern Lights, I could never feast my eyes quite enough on the green lights. Most auroras look grayish to the human eye when solar activity is low. When the lights begin to dance, the green really comes through. This image of an aurora was taken near Sommarøy, Norway.

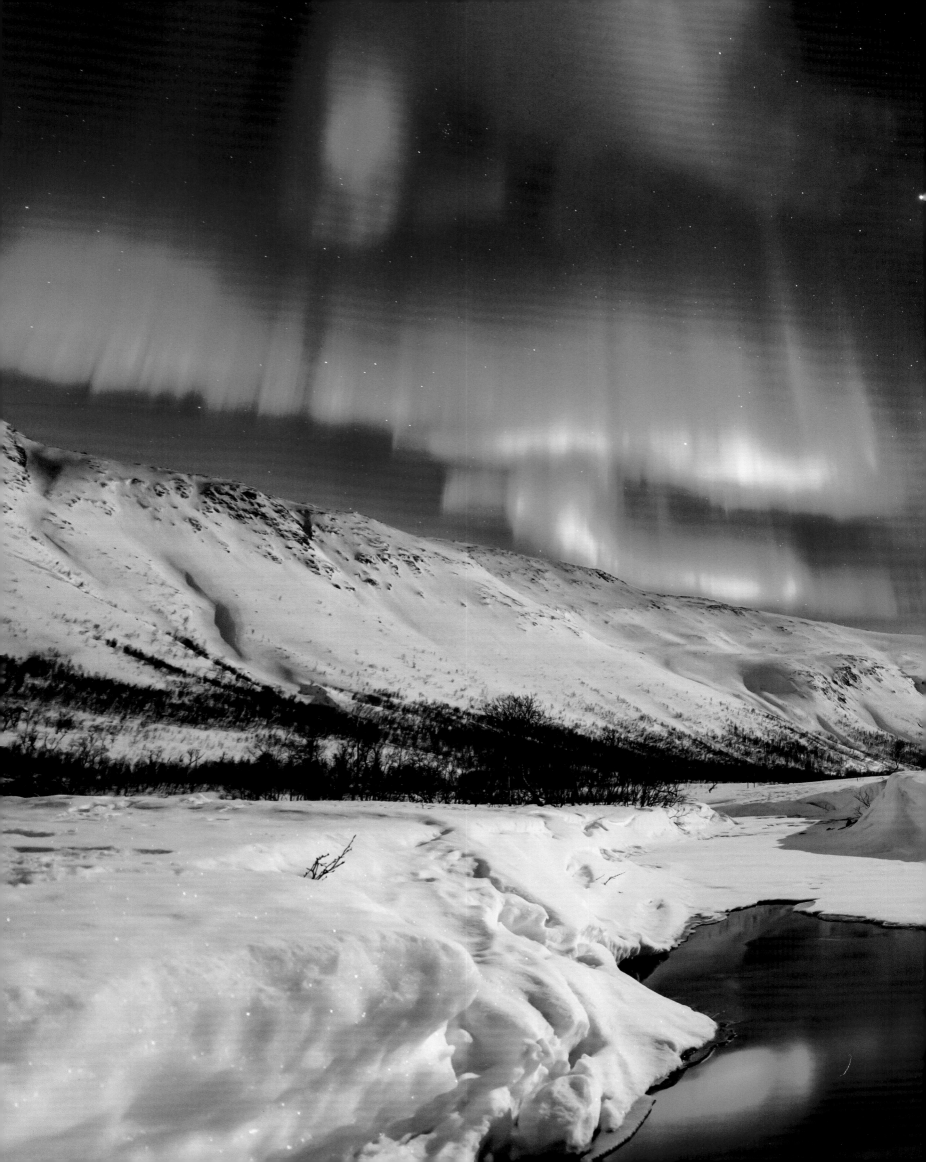

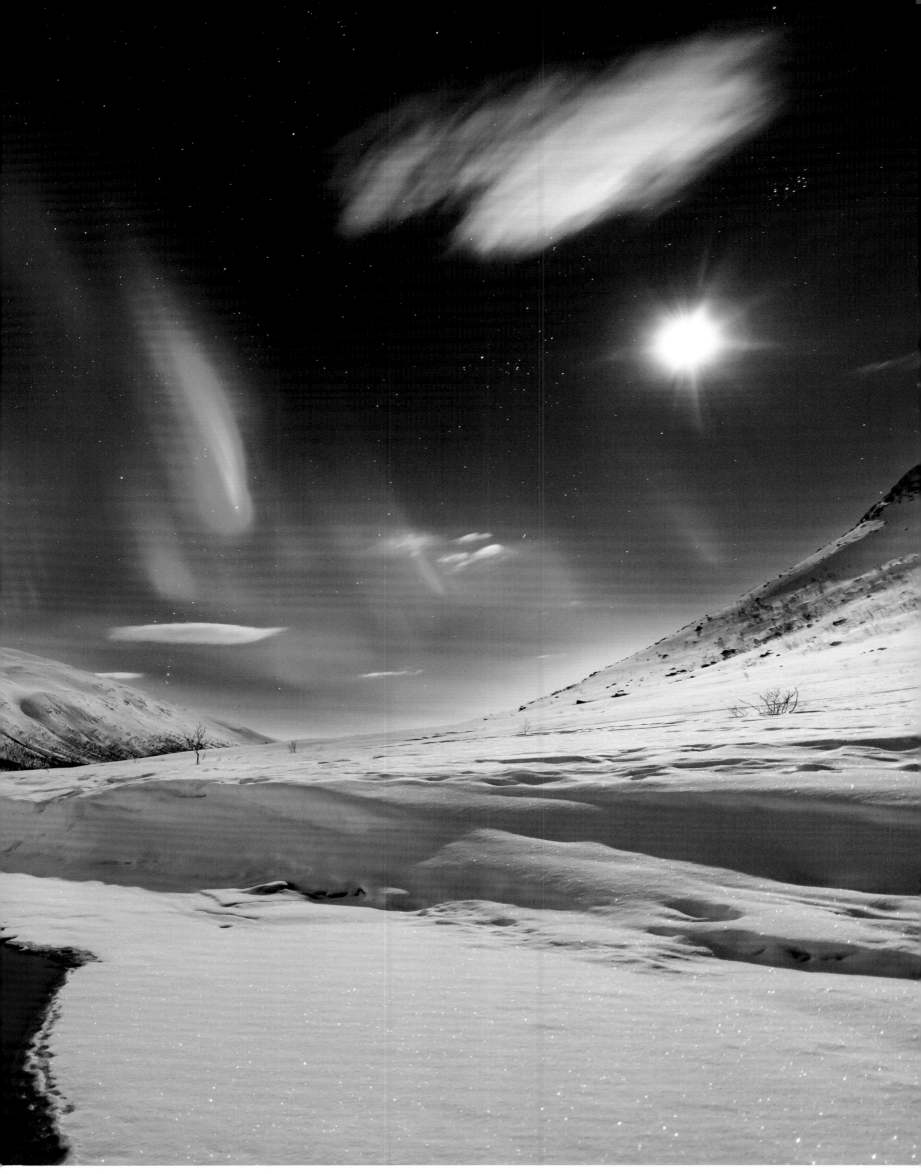

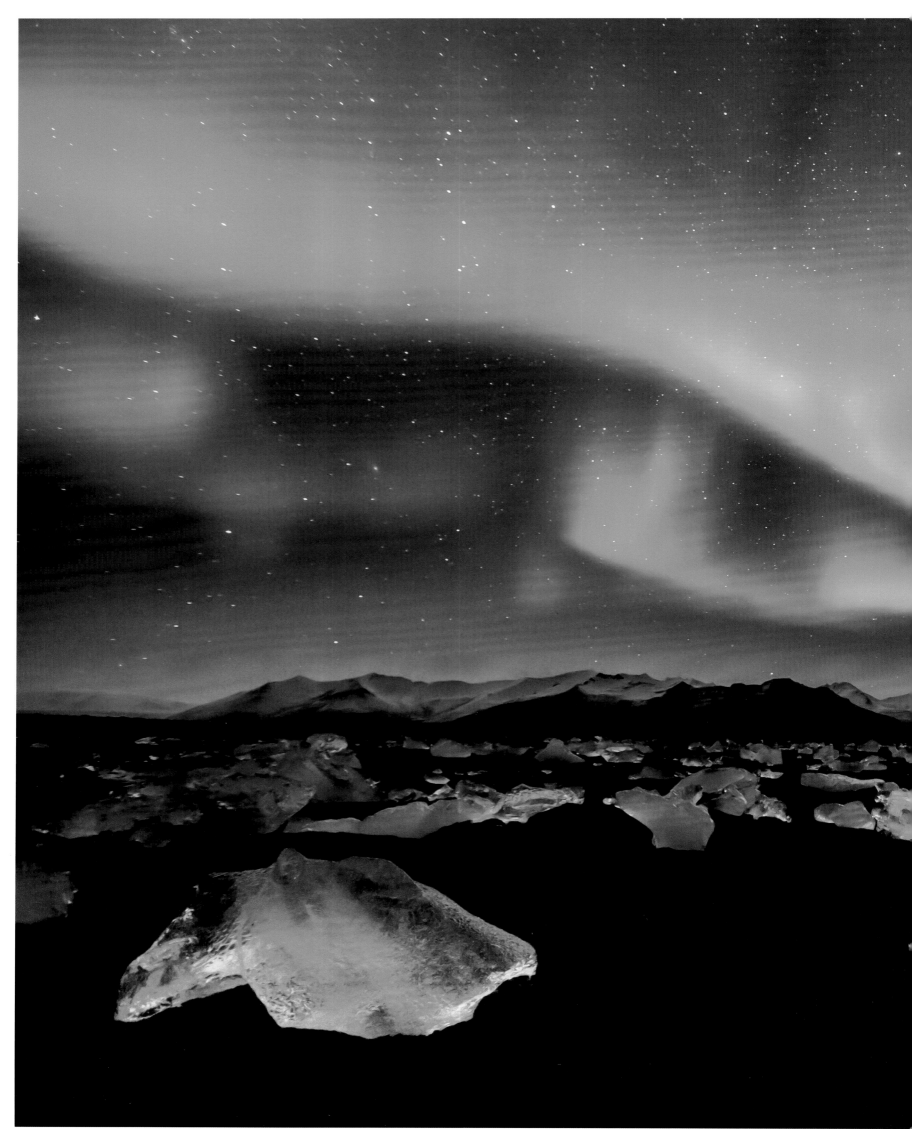

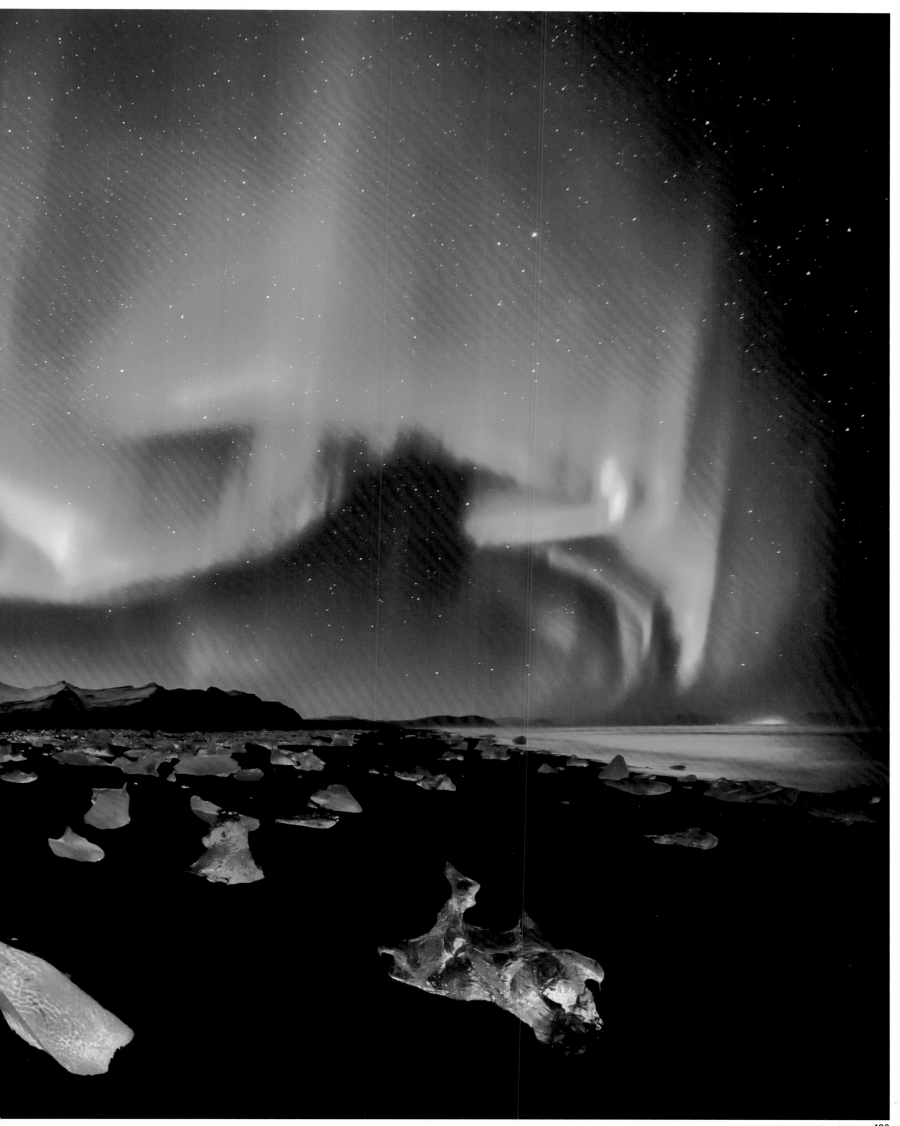

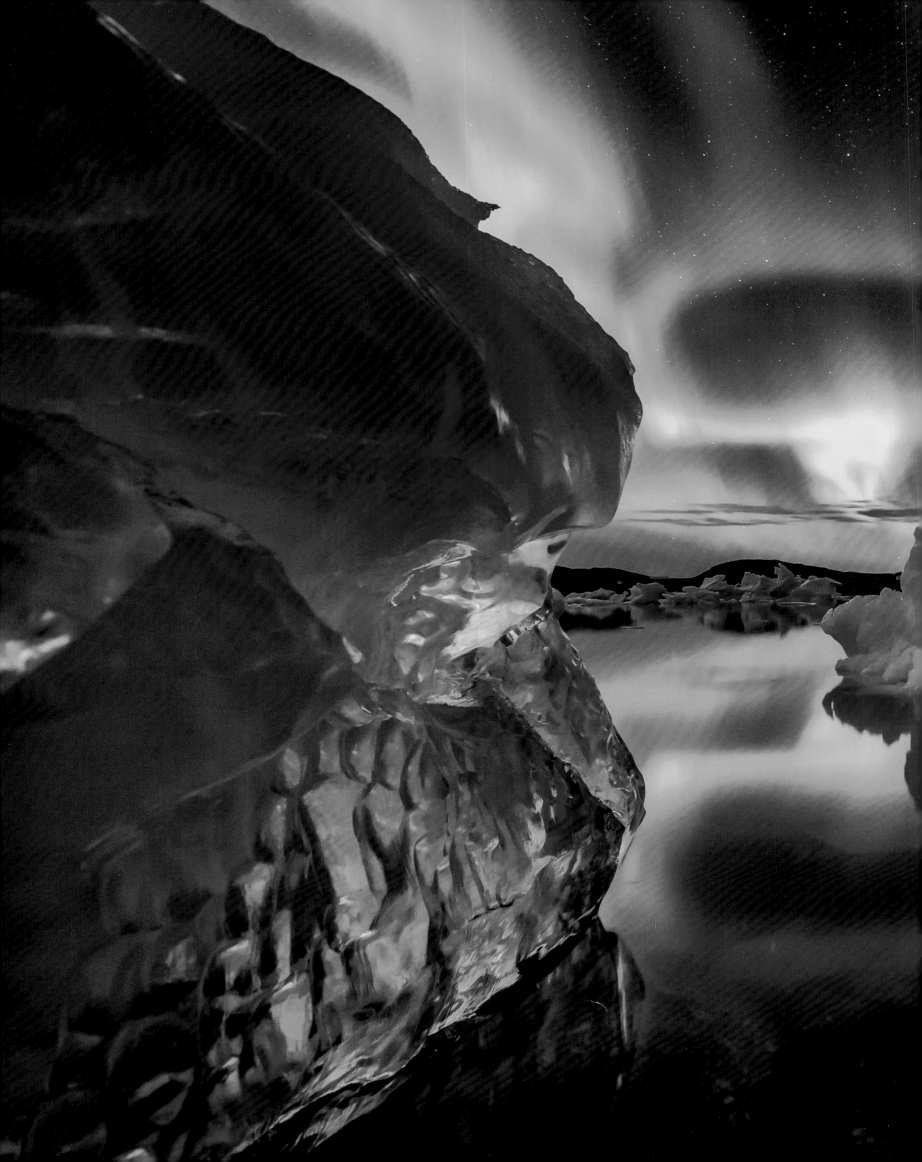

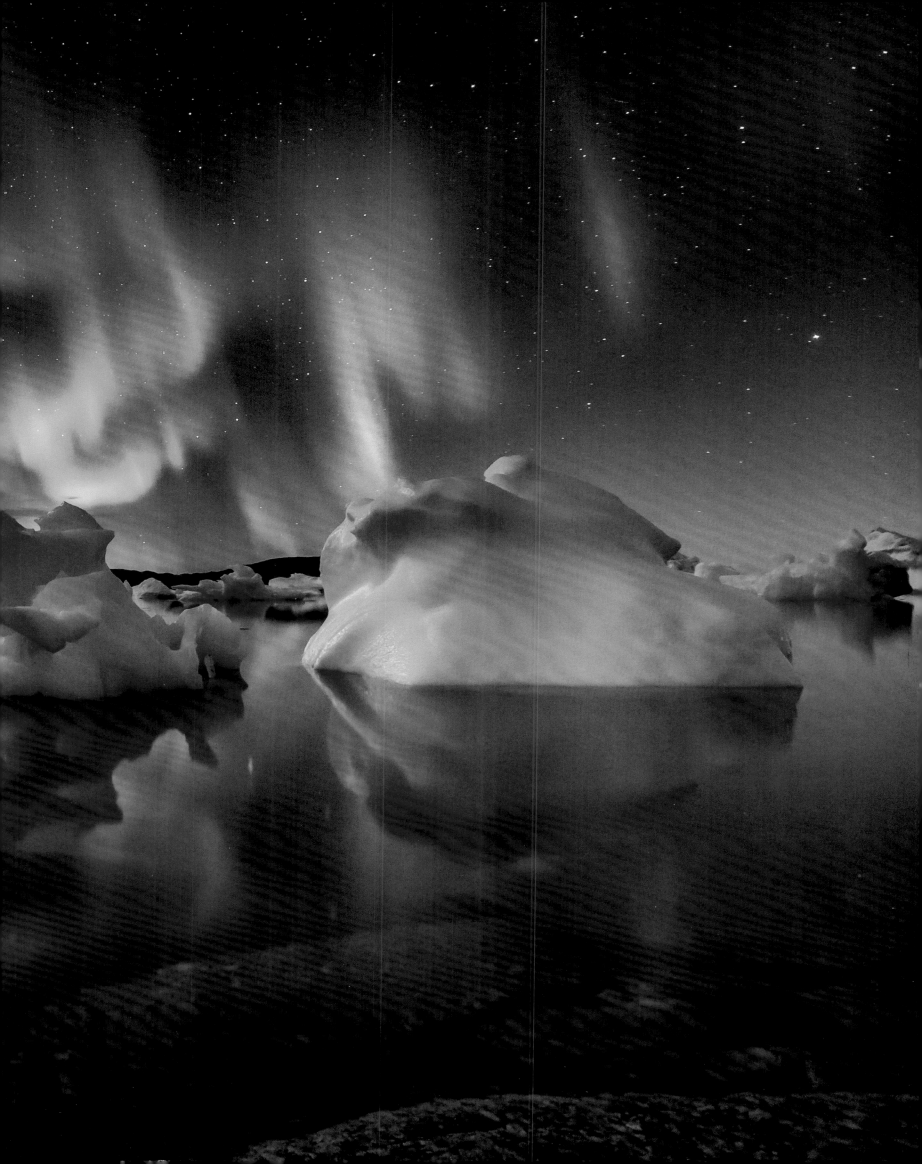

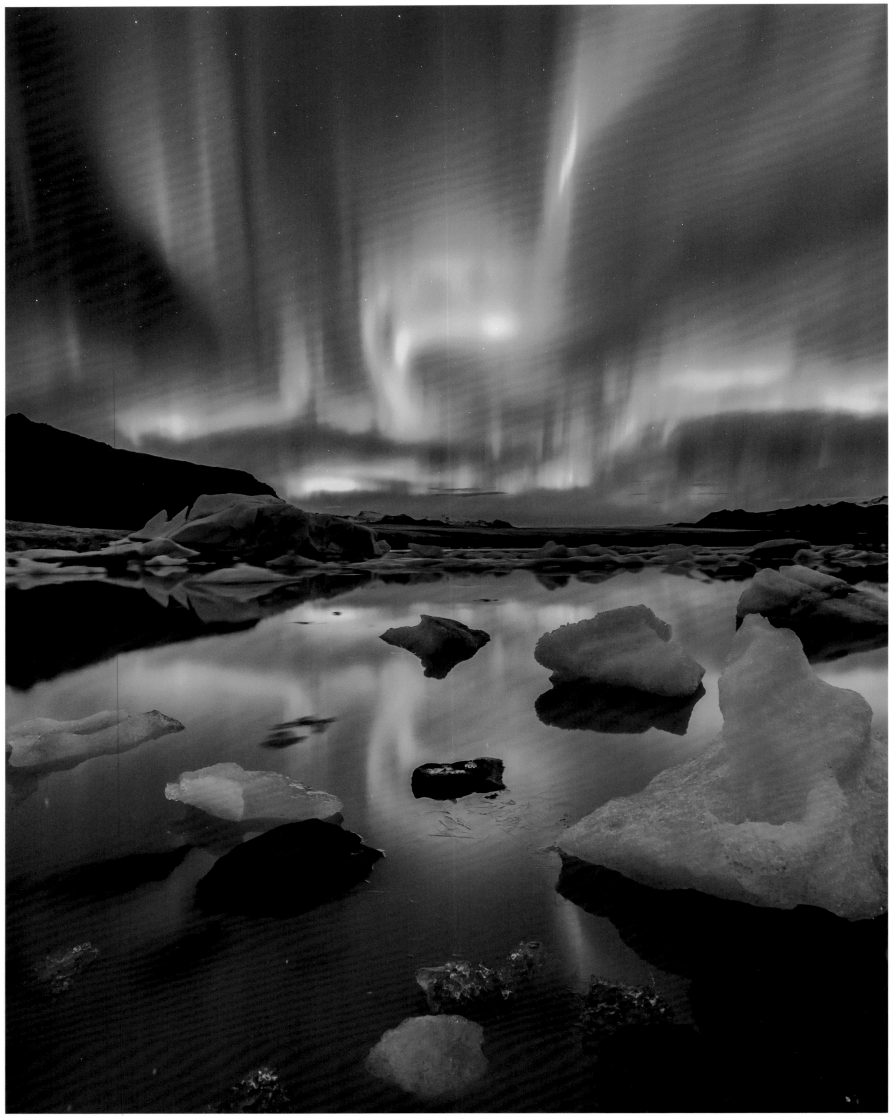

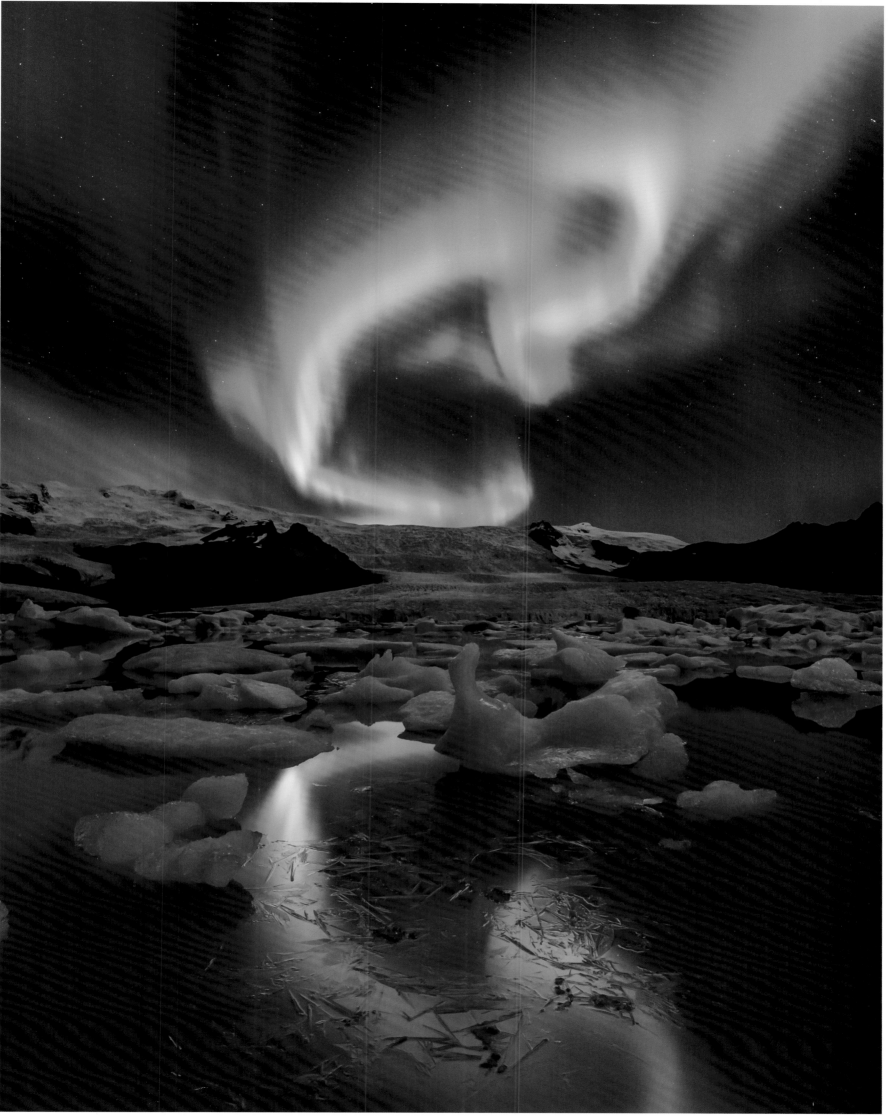

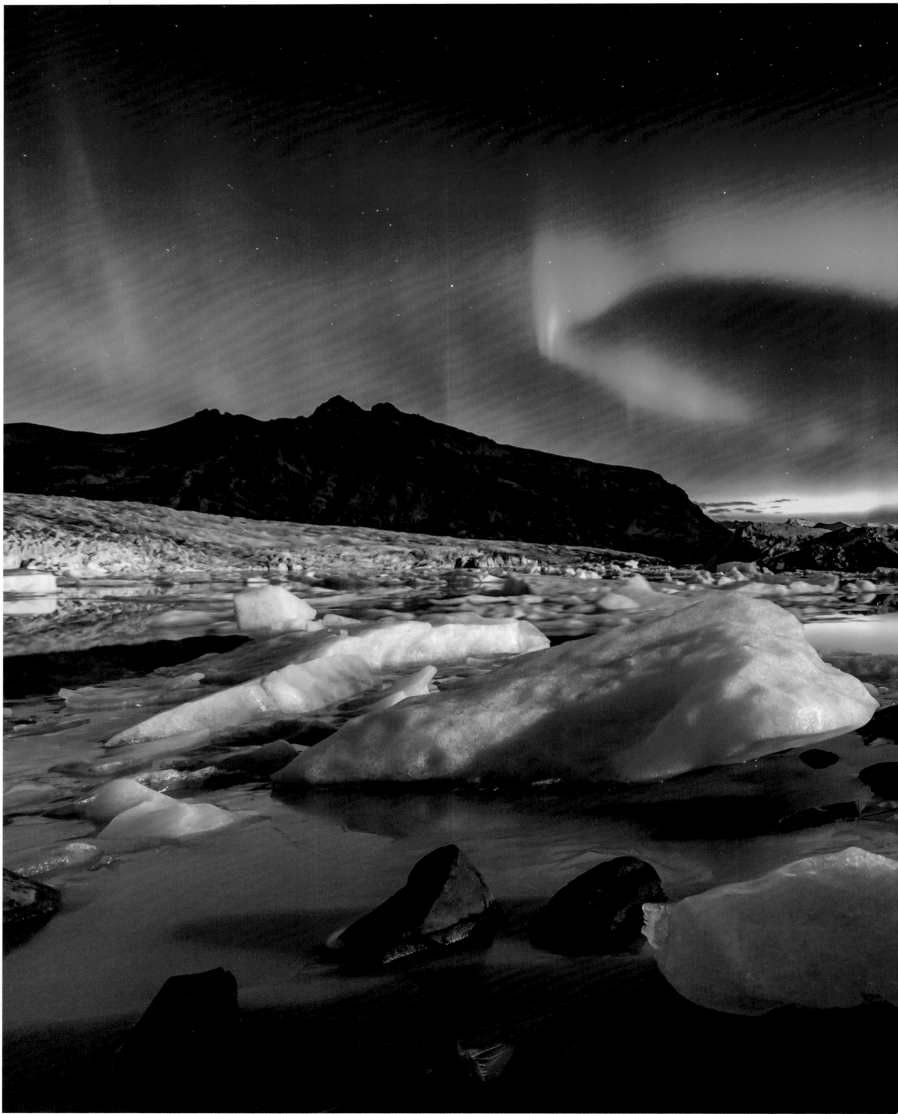

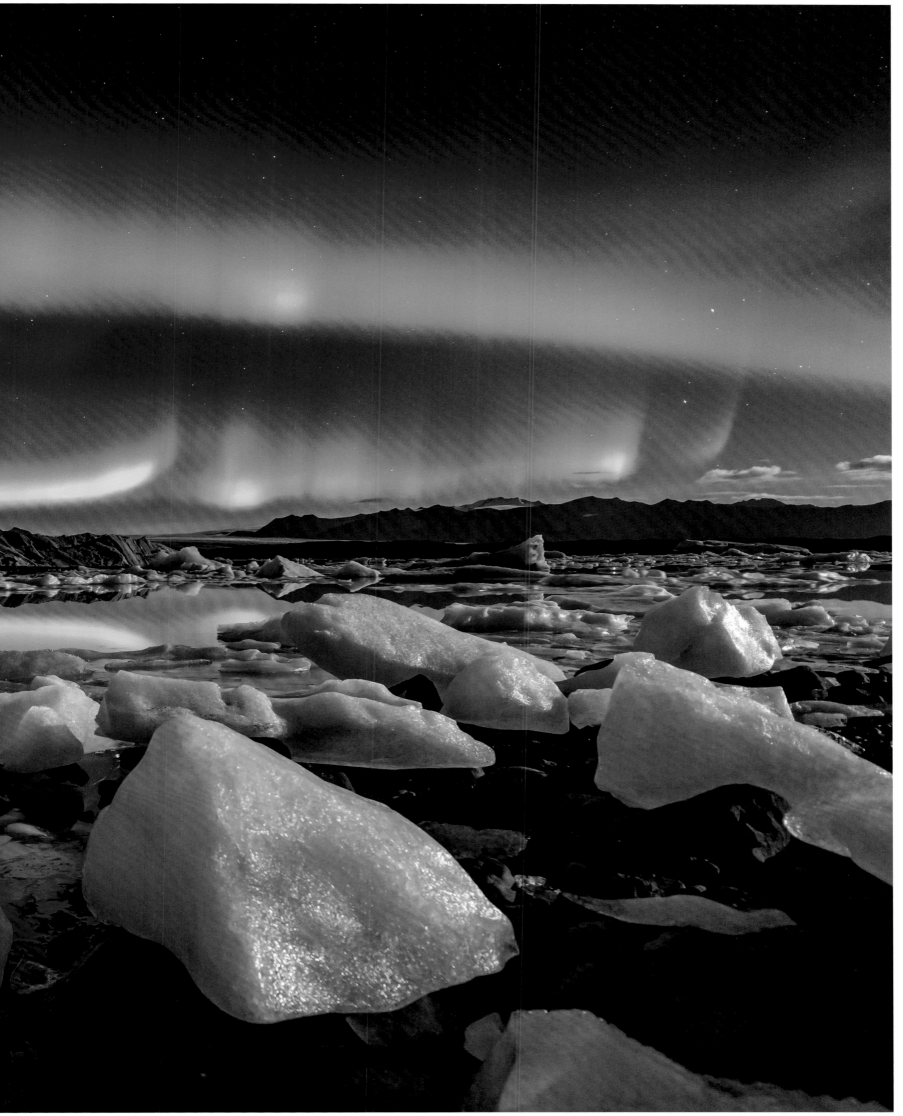

// STEFAN FORSTER

Photographer STEFAN FORSTER, born in Switzerland, spent most of his childhood outdoors. On a three-week solo hike across Iceland's Southern Plateau at age seventeen, he crossed deep rivers and glaciers and found his passion for photography. He began pursuing his passion professionally and opened his own photography academy a few years later. Now thirty-one, the Swiss native spends half the year traveling the world. He offers twelve exclusive workshops every year in which he leads his clients to our planet's most stunning locations.

Der Schweizer Fotograf STEFAN FORSTER verbrachte den größten Teil seiner Kindheit in der Natur. Schon im Alter von 17 Jahren wanderte er alleine drei Wochen lang durch das südliche Hochland Islands, querte tiefe Flüsse und Gletscher und entdeckte dort seine Liebe zur Fotografie. Bereits wenige Jahre später wurde seine Leidenschaft zum Beruf und er eröffnete eine eigene Fotografie-Akademie. Der nun 31-jährige Schweizer bereist während sechs Monaten im Jahr die Welt und führt auf jährlich zwölf exklusiven Workshops seine Kunden zu den schönsten Orten unseres Planeten.

Le photographe suisse STEFAN FORSTER est pour ainsi dire un enfant de la nature. Il n'a que 17 ans quand il entreprend une randonnée en solitaire de trois semaines dans le sud des Hautes Terres d'Islande, traversant rivières profondes et glaciers, et se découvre une passion pour la photographie. En l'espace de quelques années seulement, il fait de sa passion sa profession et ouvre sa propre école de photographie. Chaque année, le trentenaire parcourt le monde pendant six mois et organise pour sa clientèle douze workshops dans les plus beaux sites de la planète.

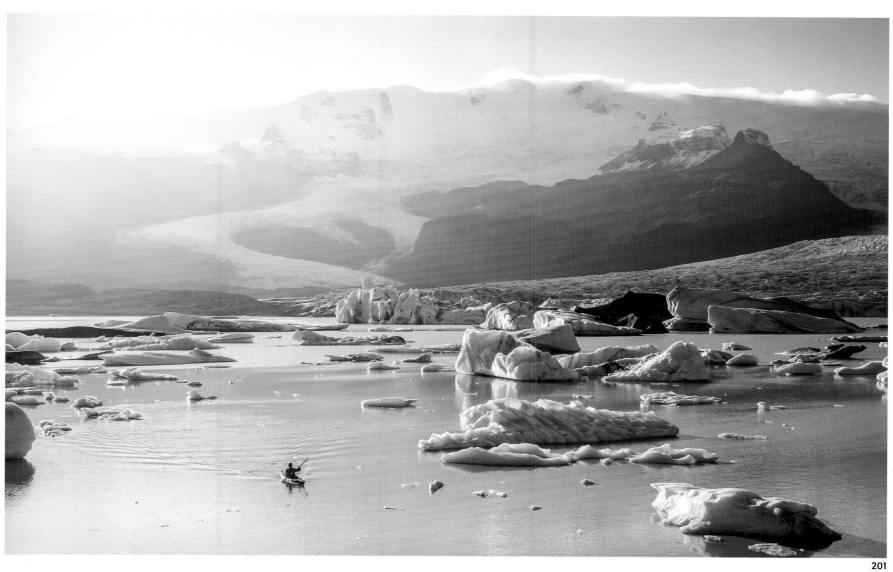

// A FEW WORDS ON IMAGE PROCESSING
WORTE ZUR BILDBEARBEITUNG
QUELQUES MOTS SUR LE TRAITEMENT DES IMAGES

Landscape photography is mainly about being at the chosen location in the right light conditions and then possessing the skill photographically to capture it. The greatest part of image creation has nothing to do with photography itself. In just a few weeks, anyone can acquire the technique necessary to record an image. What really matters in landscape photography is nature itself, weather, time of year, anomalies of climate, etc. Above all, a good landscape photographer is able to read the weather, and developing that sense is what takes a very long time: time getting to know the place, time spent making multiple trips there, time waiting for the right light. When the moment arrives and all the factors are perfectly aligned, the photographer need only frame the shot right, select the appropriate filter, and press the shutter button.

Digital photography has been more influential than many originally anticipated, both on photography overall as well as on people's notions about photographers. In the days of film photography, a drab, boring-looking landscape could not be recast as a colorful paradise, and photographers had to wait for that one-and-only moment. Today, the magic word is Photoshop, and precisely the aforementioned time waiting for that one moment, and the ability to read nature and the freedom to keep returning to the same spot are what have become rare. Many means are now available by which to render a suboptimal image into a photographic masterpiece. The most common techniques are composite images (assembled from various exposures, gathered, for example, on different days or from different spots), blending (building an image out of various other images, the colors of which are coordinated with one another), and HDR (getting a single image composed of several different exposures taken basically at once). These techniques all have in common that they tempt exaggeration, can be unrealistic, and have little to do with classical landscape photography per se. Since the beginning of my career as a photographer, I have pursued a very clear goal: I will never manipulate my images. All of the images printed in this volume are individual shots or individual exposures. None of them is composite, blended, or done in high-dynamic range. Due to my occupation as an organizer and guide on photography expeditions, I am privileged to have been able to travel to the same countries dozens of times over the years, which has allowed me to see them time and again in new, unique light conditions.

This book contains photographs of the most uncommon and unique moods of light I have had the good fortune to witness. Thus, when on your twenty-fifth or so trip to see the Northern Lights, and you find yourself standing before a transparent iceberg in Greenland which the tide has stranded upon a rock while the sky is putting on an ever-intensifying aurora whose light comes through that iceberg, you as photographer need only select the right settings and trigger the shutter. If you experience your first powerful thunderstorm in Namibia on your eighth trip there, if that storm brings rain to a stretch of desert which has done without for decades, and if later a double rainbow appears in the sky, then all it takes is to press the shutter button again. These situations all have in common that they can do without subsequent manipulations of the image in Photoshop, because nature itself rendered a perfect image.

So, none of my pictures have undergone modification of color or content. However, that does not mean that the images were not developed. Modern cameras record images in a basic format known as RAW. A RAW image does not look like what the photographer saw, but rather is comparable to a pad of paper with layered sheets. Developing such an image, I am able to access those layers and adjust the brightness of each pixel after the fact. Everyone knows the feeling of witnessing a unique sunset with a glowing red sky and wanting to capture the experience. But the pupils of our eyes contract on sight of the bright, fire-red sky, ensuring that less light enters our eyes. Focusing on the lovely woods in the foreground, our pupils dilate again, giving a brighter view of the foreground. However, the camera's "pupil"—called the aperture—is not adjustable relative to a single exposure.

That would require one size that captures bright sky and dark foreground equally and acceptably well. It's impossible. Therefore, you obtain images either with a black foreground and beautiful sky or a lovely foreground with the sky overexposed. This conundrum I solve with filters (graduated neutral density filters), a technique I combine with brightness adjustment at the computer. Thanks to the modern RAW format, it is no problem to obtain such results from a single exposure.

Photography is an art form as any other, in which anything goes. Therefore, we—those photographers who make images after the fact at the computer—are artists by the same measure as I am. For my part, however, I have made it a goal to capture nature in its true beauty. Searching for, chasing after such atmospheres or moods of light, is what defines my love for this profession.

In der Landschaftsfotografie geht es in erster Linie darum, den ausgewählten Ort im richtigen Licht vorzufinden und dies gekonnt fotografisch festzuhalten. Der größte Teil der Bildentstehung hat mit der Fotografie selbst nichts zu tun. Innerhalb weniger Wochen kann jeder die Technik, die dafür notwendig ist, ein Bild aufzunehmen, erlernen. Auf was es in der Landschaftsfotografie wirklich ankommt, ist die Natur, das Wetter, die Jahreszeit, klimatische Anomalien, etc. Ein guter Landschaftsfotograf hat in erster Linie die Fähigkeit, das Wetter lesen zu können. Dazu gehört ein immenses Maß an Zeit. Zeit, um den Ort zu erkunden, Zeit, mehrmals an den bestimmten Ort zu fahren, Zeit, auf das richtige Licht zu warten. Wenn der Zeitpunkt, in dem alle Faktoren perfekt aufeinanderpassen, gekommen ist, muss der Fotograf nur noch den Bildausschnitt richtig setzen, den geeigneten Filter wählen und den Auslöser drücken.

Die Digitalfotografie hat die Fotografie als Ganzes und das Renommee der Fotografen stärker beeinflusst als zu Beginn angenommen. Zur Zeit der Analogfotografie konnte eine triste, langweilig wirkende Landschaft nicht zum bunten Paradies umgestaltet werden und Fotografen mussten auf den einen Augenblick warten. Heute heißt das Zauberwort Photoshop, denn genau die vorhin beschriebene Zeit, um auf den einen Moment zu warten, die Fähigkeit, die Natur zu lesen und die Gelegenheit, immer wieder an denselben Ort zurückzukehren, all dies ist rar geworden. Es gibt mittlerweile eine Vielzahl von Mitteln, aus einem nicht optimalen Bild ein fotografisches Meisterwerk zu kreieren. Die häufigsten Techniken sind Composings (Ein Bild wird aus diversen Bildern, unterschiedlicher Tage oder Orte zusammengesetzt), Blendings (das Bild wird aus unterschiedlichen Bildern konstruiert und diese farblich auf einander abgestimmt), HDR (das Bild wird aus mehreren unterschiedlichen Belichtungen komponiert). Alle diese Techniken haben eines gemeinsam; sie sind oft nicht realistisch, verleiten dazu, zu übertreiben und haben mit klassischer Landschaftsfotografie selbst nicht mehr viel zu tun.

Seit dem Beginn meiner fotografischen Karriere habe ich mir etwas ganz klar vorgenommen: Ich werde meine Bilder nie manipulieren. Sämtliche in diesem Buch gedruckten Bilder sind Einzelbelichtungen oder Einzelaufnahmen. Keines der Bilder ist ein Composing, ein Blend oder eine HDR (High Dynamic Range). Aufgrund meines Berufes als Reiseleiter und Veranstalter von Fotoreisen habe ich das Privileg, über Jahre hinweg Dutzende Male in dieselbe Länder reisen zu können und sie immer wieder in einem neuen, einmaligen Licht erleben zu dürfen. Dieses Buch enthält Fotografien der seltensten und einmaligsten Lichtstimmungen, die ich je erleben durfte. Steht man dann nach rund 25 Nordlichtreisen in Grönland vor einem durchsichtigen Eisberg, den die Ebbe auf einem Stein zurückgelassen hat und am Himmel zeichnet sich ein immer stärker werdendes Nordlicht ab, das durch den Eisberg hindurchscheint, muss man als Fotograf nur noch die richtigen Einstellungen wählen und auslösen. Erlebt man nach acht Namibiareisen zum ersten Mal ein gewaltiges Gewitter, dass den Regen in einen Wüstenabschnitt bringt, in dem es seit Jahrzehnten nicht geregnet hat und am Himmel erscheint ein doppelter Regenbogen, muss man ebenfalls nur noch den Auslöser betätigen. All diese Situationen haben eines gemeinsam; sie erfordern keinerlei nachträgliche Manipulation des Bildes in Photoshop, da die Natur die Bilder schon perfekt vorgegeben hat.

Keines meiner Bilder wurde also farblich oder inhaltlich verändert. Das heißt jedoch nicht, dass die Bilder nicht entwickelt worden sind. Moderne Kameras nehmen die Bilder in einem Rohformat, genannt RAW, auf. Das RAW-Bild entspricht nicht dem Gesehenen und ist mit einem Papierblock voller Schichten von Papier zu vergleichen. Beim Entwickeln kann ich dann auf diese Schichten zugreifen und die Helligkeit jedes Pixels im Nachhinein verändern. Wer kennt das nicht: Man erlebt einen einmaligen Sonnenuntergang mit rotem glühenden Himmel und möchte diese Erscheinung fotografieren. Doch unser Auge verkleinert beim Anblick des hellen feuerroten Himmels die Pupille und sorgt dafür, dass weniger Licht ins Auge trifft, beim Fokus auf den schönen Wald im Vordergrund wird unsere Pupille jedoch wieder erweitert, damit der Vordergrund heller gesehen werden kann. Die Pupille der Kamera, genannt Blende, ist jedoch nicht in einem Bild variabel einstellbar und es muss eine Öffnung gefunden werden, welche sowohl den hellen Himmel als auch den dunklen Vordergrund gleichermaßen gut aufnimmt. Da dies nicht möglich ist, entstehen Bilder mit schwarzem Vordergrund

und schönem Himmel, oder schönem Vordergrund und überbelichtetem Himmel. Und genau diese Problematik löse ich mit Filtern (Verlauffilter) in Kombination mit einer Helligkeitsanpassung am Computer. Dank des modernen RAW-Formats ist dies heute problemlos aus einer einzigen Belichtung einer Fotografie machbar.

Die Fotografie ist eine Kunstform, in der wie überall in der Kunst alles erlaubt ist, also sind jene Fotografen, deren Bilder im Nachhinein am Computer entstehen, im gleichen Maße Künstler wie ich es bin. Ich für meinen Teil habe mir jedoch zum Ziel gesetzt, die Natur in ihrer wahren Schönheit festzuhalten. Das Suchen und Jagen solcher Lichtstimmungen ist es letztendlich, was meine Liebe zu diesem Beruf ausmacht.

L'essentiel pour un photographe paysager est de dénicher un endroit singulier, de bénéficier d'une luminosité parfaite et de bien maîtriser les techniques photographiques pour capturer ce paysage. La naissance d'une image n'est pas proprement le résultat des techniques photographiques. Tout le monde est en mesure d'apprendre les techniques nécessaires à la prise d'une photo en l'espace de quelques semaines. Mais pour photographier les paysages, il faut disposer d'un sens aigu de l'observation de la nature, des éléments, des saisons et des anomalies climatiques. Un bon photographe paysager possède avant tout la capacité de lire et d'interpréter les phénomènes météorologiques. Et pour cela il faut du temps, plus que de raison. Du temps pour trouver les bons endroits et pour y retourner souvent. Du temps aussi pour attendre que ces lieux baignent dans la bonne lumière. Quand enfin la conjonction de ces facteurs est idéale, il suffit alors au photographe de cadrer, de choisir un filtre approprié et d'appuyer sur le déclencheur.

La photographie numérique a chamboulé l'univers de la photographie, les qualités qui distinguent un bon photographe ont évolué, et ce dans une mesure qui n'était pas prévisible lors de son apparition. Du temps de l'argentique, un paysage morne et ennuyeux ne pouvait être transformé en paradis bigarré, le photographe n'avait d'autre choix que d'attendre le moment propice. De nos jours, la formule magique s'appelle Photoshop. Toutes les caractéristiques d'une bonne photographie paysagère que j'ai décrites plus haut sont pratiquement devenues obsolètes. Le photographe n'est désormais plus tenu de guetter le bon moment, d'interpréter les phénomènes naturels ou encore de revenir sans cesse sur les mêmes lieux. Il existe aujourd'hui de nombreux procédés pour transformer une photo médiocre en chef-d'œuvre. Parmi les techniques les plus répandues se trouvent le composing, le blending et le HDR. Toutes ces techniques ont une chose en commun : la plupart du temps, elles donnent un résultat peu réaliste, parce qu'elles poussent à l'exagération et sont très éloignées de la photographie paysagère classique.

Depuis le début de ma carrière, j'ai toujours été guidé par un précepte : une photo ne se manipule jamais. Toutes les images imprimées dans ce livre sont des clichés uniques. Aucune d'elles n'est le résultat d'un composing, d'un blending ou le produit d'une HDR (High Dynamic Range ou imagerie à grande gamme dynamique, technique permettant de représenter ou de mémoriser de nombreux niveaux d'intensité lumineuse dans une image). Mon activité d'organisateur de voyages et de stages photo m'accorde le privilège de retourner souvent dans un même pays, ce qui me permet à chaque fois de le voir sous une autre lumière, sous un jour nouveau. Le livre que vous tenez entre vos mains contient des effets de lumières uniques, comme rarement il m'a été donné d'en voir. Quand enfin, au vingt-cinquième voyage au Groenland à l'affût de l'aurore boréale, un iceberg translucide se présente, relégué sur un rocher par le jusant, sous un ciel passant peu à peu à des couleurs extrêmes qui transparaissent à travers la glace, le photographe n'a plus qu'à faire les bonnes mises au point et appuyer sur le déclencheur. Quand au huitième voyage en Namibie, un orage s'abat sur un coin du désert où la pluie n'est pas tombée depuis des décennies et qu'un double arc-en-ciel enjambe le paysage, je me contente également d'appuyer sur le déclencheur. Ces situations ont toutes un point commun : nul n'est besoin de retoucher la prise de vue avec Photoshop, la nature livrant des images déjà parfaites.

Mes photos n'ont donc aucunement été modifiées. Cela vaut tant au niveau des couleurs qu'au niveau du contenu. Mais il va de soi qu'elles ont été développées. Les appareils photo numériques capturent les images dans un fichier au format RAW, c'est-à-dire brut. L'image RAW ne correspond pas à ce que l'on peut voir à l'œil nu. Il faut l'imaginer comme un bloc-notes constitué de multiples couches de papier. Lorsque je développe mes images, je peux intervenir sur ces couches pour modifier a posteriori la luminosité d'un pixel donné. Qui n'a jamais formé le désir de photographier un coucher de soleil extraordinaire sur un ciel en feu ? Or les pupilles se rétractent quand le regard se porte sur un objet lumineux, laissant ainsi entrer moins de lumière dans l'œil, d'où la baisse de luminosité ressentie. Par contre, les pupilles se dilatent devant l'obscurité d'une forêt au premier plan, laissant ainsi passer plus de lumière, ce qui permet à l'œil de distinguer plus clairement les objets. La pupille de l'appareil photo, qui correspond au diaphragme, n'est pas réglable à volonté. Il faut une ouverture qui permette de capturer parfaitement et simultanément un ciel lumineux et un premier plan sombre. Cela étant techniquement impossible, le résultat est soit une image sombre au premier plan avec un ciel éblouissant, soit un beau premier plan avec un ciel surexposé. Je résous ce dilemme grâce à des filtres (filtres de fondu), combinés à un ajustement de la luminosité par ordinateur. Grâce à la technique des fichiers RAW, il est aujourd'hui possible de concilier les deux options en une seule exposition.

La photographie est une forme d'art où tout est permis, comme dans toutes les autres disciplines artistiques d'ailleurs. Les photographes qui manipulent leurs images après coup sont donc des artistes au même titre que moi, avec la différence que mon parti pris est de montrer la nature dans sa véritable beauté. La recherche et la quête de ces effets de lumière sont au cœur de mon amour pour ce métier.

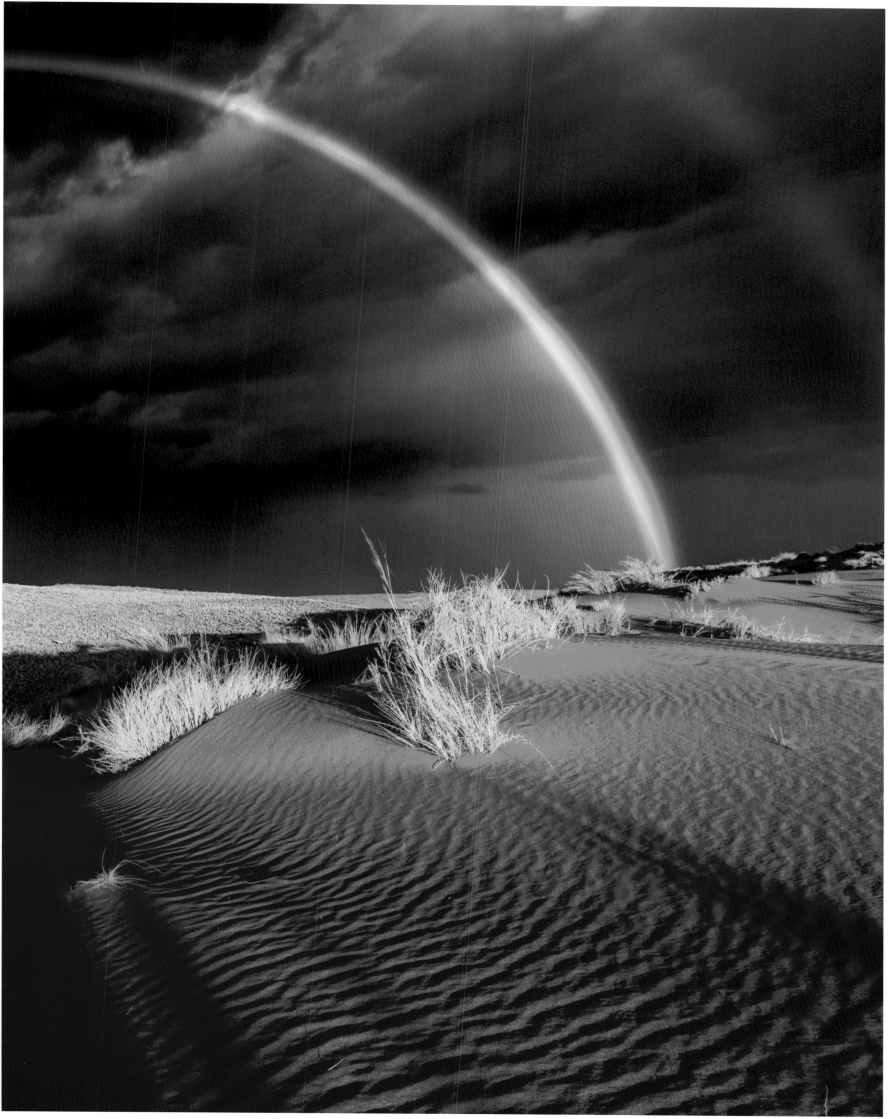

59/60/63(top)/66/83(top)/134/140/141/158/192/196/197/198

63(bottom)/77

122/136/138/182(top)

116

163

72/84

76

130/164

190/194

168

64

176

184

169(top)

70/80/83(bottom)

18

114

160

120 (top)

42

30(top)/118(top)/121/146

28

113

169 (bottom)

86/107(bottom)

38/45/48

23/32

13/98/183

16

26/27

100/102/107(top)

88/92/94/97

78

// Antarctica

54/55

17/36/40/46/154

74(bottom)/75(bottom)

82

120(bottom)

68/147

128/144

186/188/191

126/142/156

10/12
182(bottom)

119

124

30(bottom)/132

172/173

19

22/166

31(top)

174

44/118(bottom)

101

90

56

110

104

34/143/148/178

96/108

43/47/50/51/52/150/152/155

14

179/180

93

170

20

9/24

1. INDEX // FORESTS AND TREES // WÄLDER UND BÄUME // LES FORÊTS ET LES ARBRES

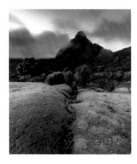

Page 9
Southwest-NP - Tasmania - 08.02.2017 - 6:32 a.m.

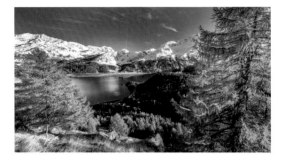

Page 10 / 11
Engadin - Switzerland - 20.10.2015 - 6:27 p.m.

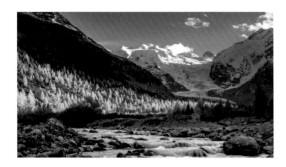

Page 12
Engadin - Switzerland - 09.10.2010 - 4:44 p.m.

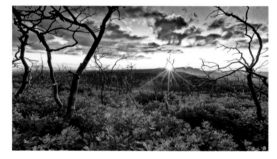

Page 13 top
Utah - USA - 20.01.2010 - 7:32 p.m.

Page 13 bottom
Utah - USA - 11.10.2011 - 3:30 p.m.

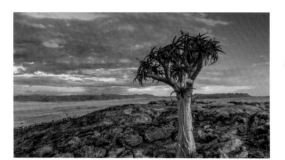

Page 14/15
Klein Aus - Namibia - 01.02.2011 - 7:51 p.m.

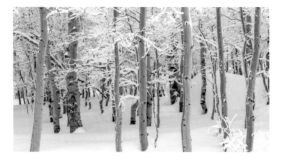

Page 16
Mesa Verde NP - Colorado, USA
19.10.2008 - 6:45 p.m.

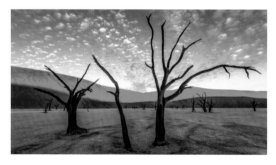

Page 17
Namib Naukluft NP - Namibia
12.04.2013 - 5:37 p.m.

Page 18
Westcoast - Scotland - 21.06.2016 - 5:09 p.m.

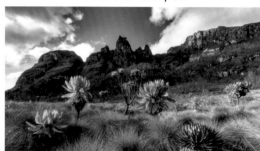

Page 19 top
Rwenzori - Uganda - 28.02.2016 - 8:16 a.m.

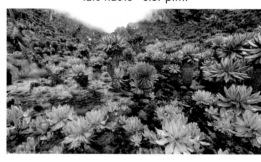

Page 19 bottom
Rwenzori - Uganda - 29.02.2016 - 1:44 p.m.

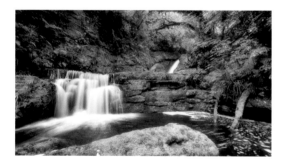

Page 20/21
South Island - New Zealand
08.01.2009 - 2:33 p.m.

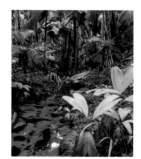

Page 22
Praslin - Seychelles
18.06.2013 - 10:47 a.m.

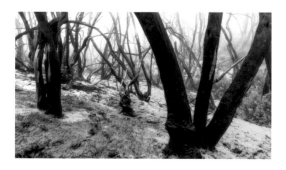

Page 23 top
La Gomera - Canary Islands
04.03.2014 - 11:46 a.m.

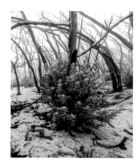

Page 23 bottom
La Gomera - Canary Islands
04.03.2014 - 11:22 a.m.

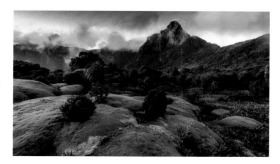

Page 24/25
Southwest-NP - Tasmania - 08.02.2017 - 6:40 a.m.

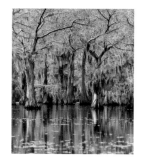

Page 26
Caddo Lake - Louisiana, USA
28.03.2014 - 4:28 p.m.

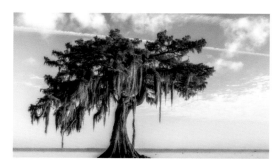

Page 27
Lake Fausse Point - Louisiana, USA
01.04.2014 - 9:10 a.m.

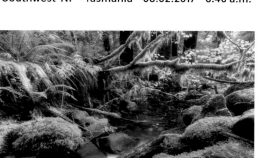

Page 28/29
Olympic NP - Washington, USA
17.10.2012 - 11:76 a.m.

Page 30 top
Thurgau - Switzerland - 20.04.2014 - 1:31 p.m.

Page 30 bottom
Bohol - Philippines - 25.04.2012 - 1:31 p.m.

Page 31 top
Bwindi NP - Uganda - 19.02.2016 - 2:12 p.m.

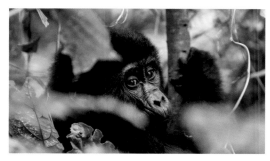

Page 31 bottom
Bwindi NP - Uganda - 21.02.2016 - 10:47 a.m.

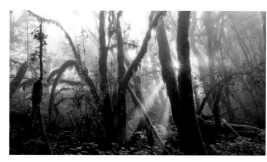

Page 32/33
La Gomera - Canary Islands - 07.03.2014 - 10:02 a.m.

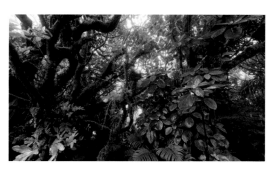

Page 34/35
Lord Howe Island - Australia - 13.03.2017 - 1:59 p.m.

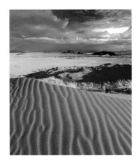

Page 36
Namib Naukluft NP - Namibia
02.02.2011 - 6:42 p.m.

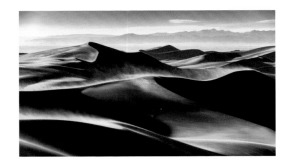

Page 38/39
Great Sand Dunes NP - Colorado, USA
07.10.2012 - 6:33 p.m.

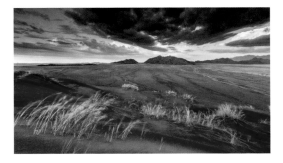

Page 40/41
Namib Naukluft NP - Namibia
02.02.2011 - 7:40 p.m.

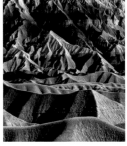

Page 42
Badlands NP - South Dakota, USA
06.10.2011 - 4:42 p.m.

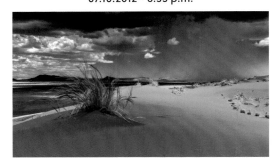

Page 43 top
Namib Naukluft NP - Namibia
03.02.2011 - 2:09 p.m.

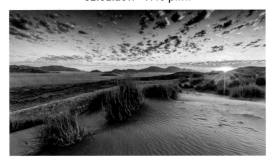

Page 43 bottom
NamibRand - Namibia - 14.06.2011 - 5:11 p.m.

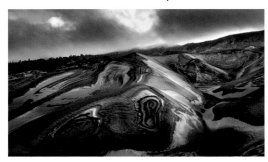

Page 44
Mount Bromo - Indonesia - 01.05.2015 - 5:14 p.m.

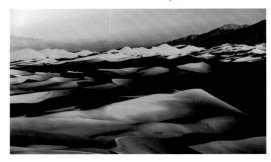

Page 45 top
Great Sand Dunes NP - Colorado, USA
07.10.2012 - 7:31 a.m.

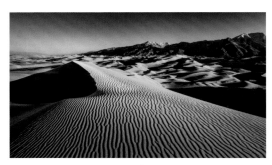

Page 45 bottom
Great Sand Dunes NP - Colorado, USA
07.10.2012 - 7:44 a.m.

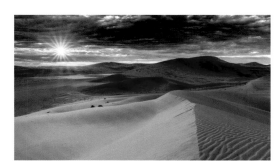

Page 46
Namib Naukluft NP - Namibia
08.04.2015 - 6:18 a.m.

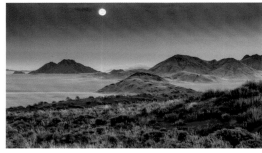

Page 47
NamibRand - Namibia - 16.06.11 - 5:32 p.m.

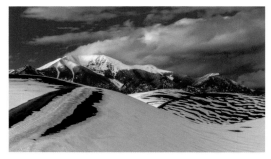

Page 48
Great Sand Dunes NP - Colorado, USA
09.10.2011 - 7:02 p.m.

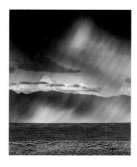

Page 50
NamibRand - Namibia - 09.04.2015 - 0:45 p.m.

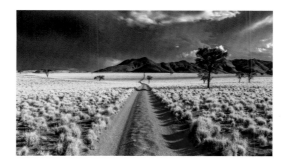

Page 51
NamibRand - Namibia - 09.04.2015 - 3:44 p.m.

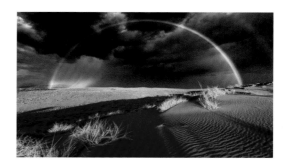

Page 52/53
Namib Naukluft NP- Namibia
09.04.2015 - 5:14 p.m.

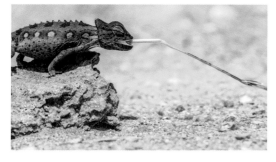

Page 54 top
Swakopmund - Namibia - 03.12.2016 - 10:32 a.m.

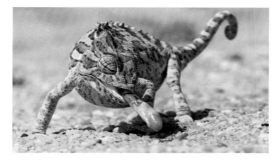

Page 54 bottom
Swakopmund - Namibia - 15.04.2013 - 11:02 a.m.

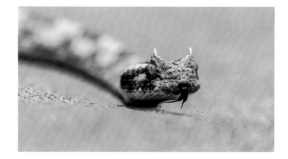

Page 55 bottom
Swakopmund - Namibia - 03.12.2016 - 10:55 a.m.

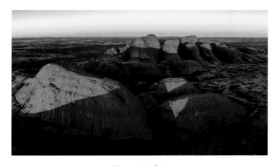

Page 56/57
Kata Tjuta - Northern Territories Australia
26.02.17 - 6:43 a.m.

3. INDEX // ICE AND SNOW // EIS UND SCHNEE // LA GLACE ET LA NEIGE

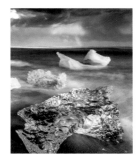

Page 59
Jökulsárlón - Iceland - 04.10.2016 - 5:34 p.m.

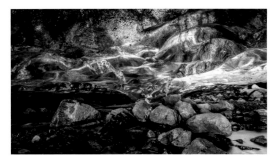

Page 60/61
Vatnajökull - Iceland - 13.03.2012 - 11:22 a.m.

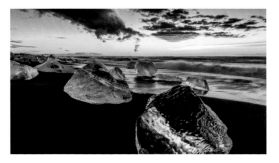

Page 63 top
Jökulsárlón - Iceland - 27.02.2013 - 8:10 a.m.

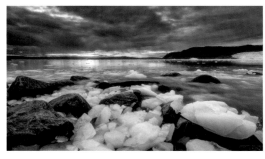

Page 63 bottom
Eqi Glacier - Greenland - 26.08.2014 - 9:22 p.m.

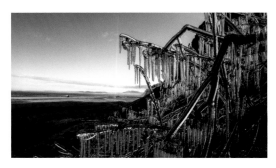

Page 64/65
Seljalandsfoss - Iceland - 06.11.2012 - 11:44 a.m.

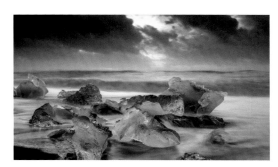

Page 66/67
Jökulsárlón - Iceland - 30.09.2014 - 9:27 a.m.

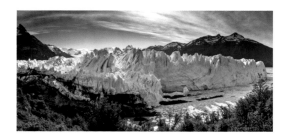

Page 68/69
Perito Moreno - Argentina - 09.12.2008 - 11:20 a.m.

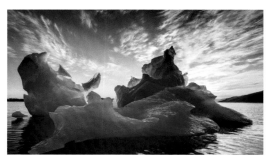

Page 70/71
Narsarsuaq - Greenland - 22.08.2012 - 8:08 p.m.

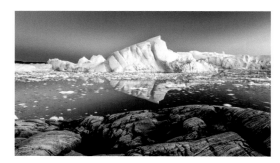

Page 72/73
Disko Bay - Greenland - 27.08.2012 - 10:04 p.m.

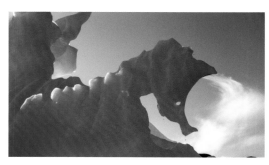

Page 74 top
Narsarsuaq - Greenland - 21.08.2012 - 2:06 p.m.

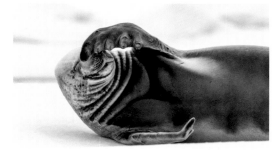

Page 74 bottom
Antarctic Peninsula - 16.01.2015 - 9:10 a.m.

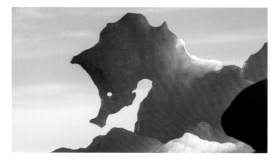

Page 75 top
Narsarsuaq - Greenland - 21.08.2012 - 2:01 p.m.

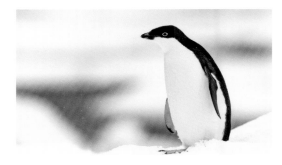

Page 75 bottom
Antarctic Peninsula - 19.01.2015 - 11:25 a.m.

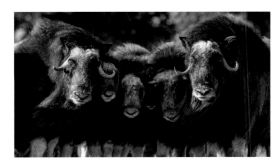

Page 76
Inland Ice Border - Greenland - 31.08.2014 - 5:24 p.m.

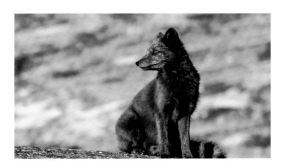

Page 77
Camp Eqi - Greenland - 28.08.2012 - 2:34 p.m.

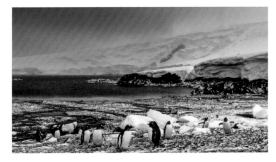

Page 78/79
Antarctic Peninsula - 21.01.2015 - 4:10 p.m.

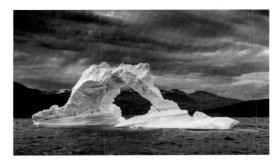

Page 80/81
Narsarsuaq - Greenland -11.08.2015 - 5:54 p.m.

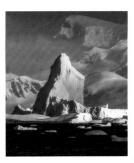

Page 82
Antarctic Peninsula - 15.01.2015 - 11:24 a.m.

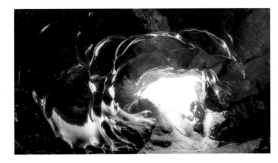

Page 83 top
Vatnajökull - Iceland - 09.03.2015 - 11:22 a.m.

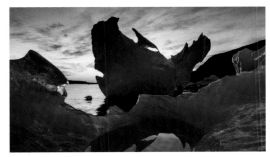

Page 83 bottom
Narsarsuaq - Greenland - 22.08.2012 - 8:38 p.m.

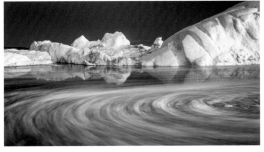

Page 84/85
Disko Bay - Greenland - 27.08.2012 - 10:22 p.m.

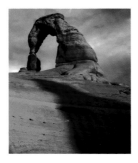

Page 86
Arches NP - Utah, USA - 05.10.2012 - 6:52 p.m.

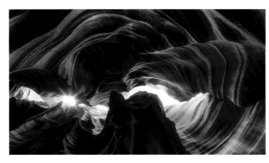

Page 88/89
Upper Antelope Canyon - Arizona, USA
12.06.2012 - 11:45 a.m.

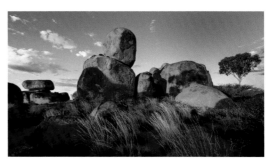

Page 90/91
Devils Marbles - Northern Territories - Australia
03.03.2017 - 8:17 p.m.

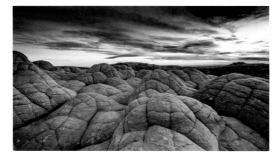

Page 92
Coyote Buttes - Arizona, USA - 09.10.2012 - 6:52 a.m.

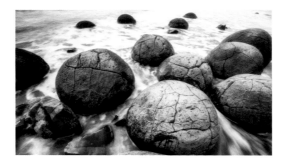

Page 93
New Zealand

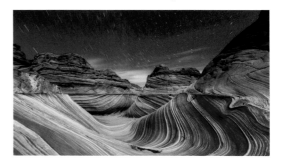

Page 94/95
Coyote Buttes - Arizona, USA

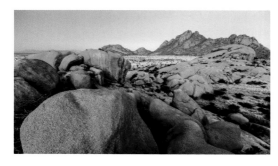

Page 96
Spitzkoppe - Namibia

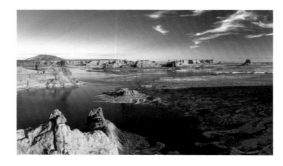

Page 97 top
Alstrom Point - Colorado, USA

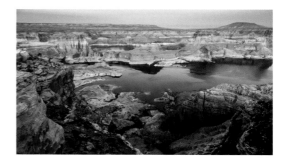

Page 97 bottom
Colorado, USA

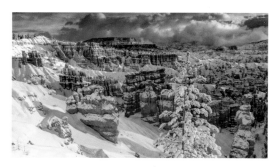

Page 98/99
Bryce Canyon NP - Utah, USA
05.01.2009 - 3:42 p.m.

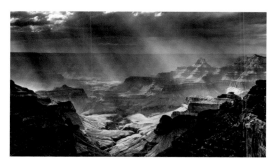

Page 100
Grand Canyon - Arizona, USA
08.10.2012 - 0:10 p.m.

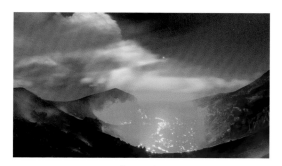

Page 101
Anak Krakatau - Indonesia

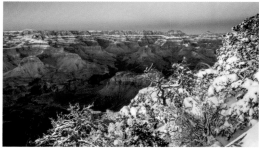

Page 102/103
Grand Canyon - Arizona, USA
20.06.2011 - 5:36 p.m.

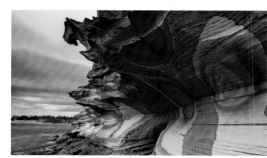

Page 104/105
Maria Island - Tasmania
19.01.2010 - 7:57 a.m.

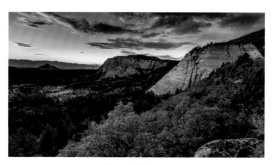

Page 107 top
Zion NP - Utah, USA - 02.10.2011 - 7:19 p.m.

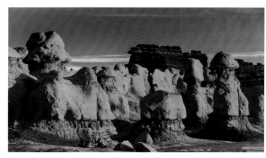

Page 107 bottom
Goblin Valley SP - Utah, USA
04.10.2012 - 8:11 a.m.

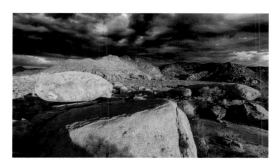

Page 108/109
Ai Aiba - Namibia - 04.12.2016 - 6:58 p.m.

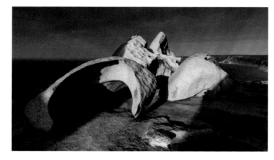

Page 110/111
Kangaroo Island - Australia
21.02.2017 - 7:25 a.m.

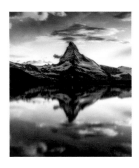

Page 113
Matterhorn - Switzerland - 16.07.2014 - 8:01 p.m.

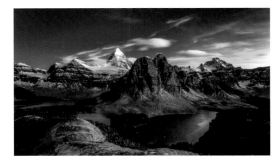

Page 114/115
Mount Assiniboine - Canada
10.09.2015 - 8:55 p.m.

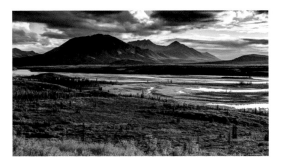

Page 116/117
Denali Highway - Alaska, USA
05.09.2015 - 7:06 p.m.

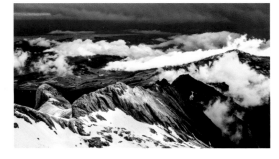

Page 118 top
Appenzellerland - Switzerland
20.05.2013 - 8:38 a.m.

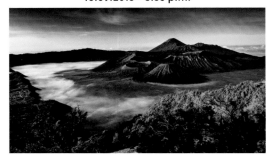

Page 118 bottom
Mount Bromo - Indonesia - 02.05.2012 - 6:29 a.m.

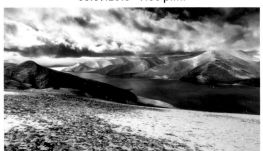

Page 119
Yamzhog Yumco - Tibet - China
31.10.2013 - 4:10 p.m.

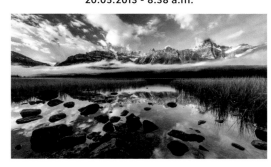

Page 120 top
Waterfowl Lake - Canada - 13.09.2015 - 8:44 a.m.

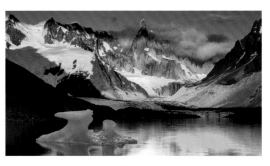

Page 120 bottom
Cerro Torre - Chile, Argentina
12.12.2008 - 5:53 a.m.

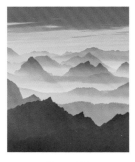

Page 121
The Alps - Switzerland - 11.11.2015 - 4:30 p.m.

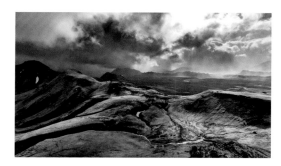

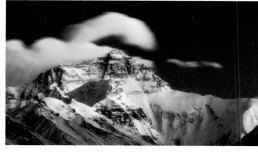

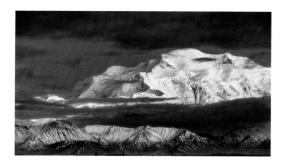

Page 122/123
Southern Highlands - Iceland
23.08.2016 - 9:09 a.m.

Page 124
Mount Everest - China, Nepal
02.11.2013 - 6:03 p.m.

Page 125
Mount Denali - Alaska, USA - 06.09.2015 - 9:10 p.m.

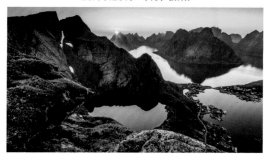

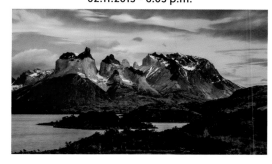

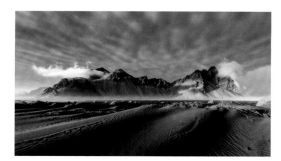

Page 126/127
Reine - Lofoten - Norway - 23.07.2013 - 11:45 p.m.

Page 128/129
Torres de Paine NP - Chile - 18.12.2008 - 5:21 a.m.

Page 130/131
Vestrahorn - Iceland - 28.09.2016 - 6:28 p.m.

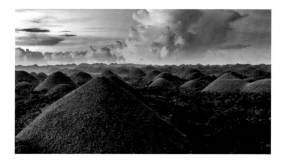

Page 132/133
Chocolate Hills - Philippines - 26.04.2012 - 5:35 a.m.

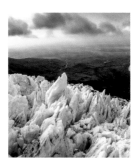

Page 134
Vatnajökull - Iceland - 03.10.2016 - 6:58 p.m.

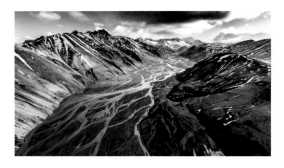

Page 136/137
Landmannalaugar - Iceland 09.10.2014 - 3:55 p.m.

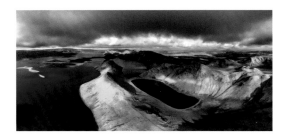

Page 138/139
Lake Langisjór - Iceland - 24.08.2016 - 5:28 p.m.

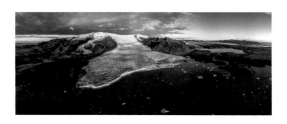

Page 140 top
Vatnajökull - Iceland - 18.10.2016 - 8:24 a.m.

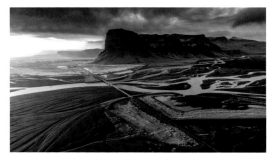

Page 140 bottom
Ringroad N1 - Iceland - 30.09.2014 - 6:43 p.m.

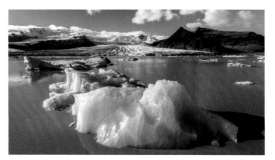

Page 141 bottom
Fjallsárlón - Iceland - 28.09.2014 - 4:11 p.m.

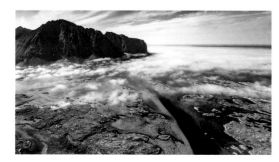

Page 142 top
Lofoten - Norway - 24.07.2013 - 1:23 p.m.

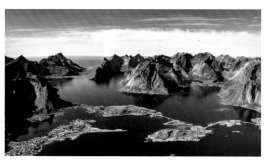

Page 142 bottom
Reine Lofoten - Norway - 26.07.2013 - 3:12 p.m.

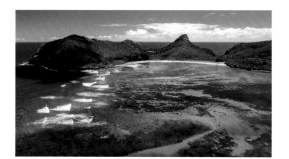

Page 143 top
Lord Howe Island - Australia
12.03.2017 - 2:12 p.m.

Page 143 bottom
Lord Howe Island - Australia
14.03.2017 - 4:33 p.m.

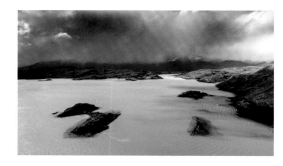

Page 144/145
Lago Pehoe - Patagonia - Chile
10.01.2015 - 3:23 p.m

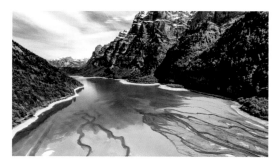

Page 146
Klöntalersee - Switzerland - 21.05.2014 - 11:44 a.m.

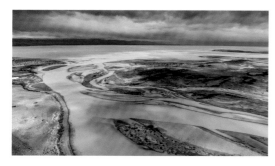

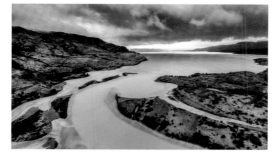

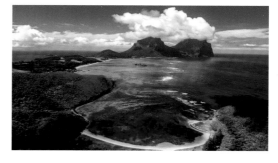

Page 147 top
Lago Argentino - Argentina - 11.01.2015 - 3:45 p.m.

Page 147 bottom
Lago Pehoe - Patagonia - Chile
15.03.2015 - 11:10 a.m.

Page 148/149
Lord Howe Island - Australia
12.03.2017 - 2:28 p.m.

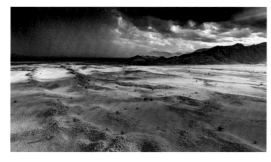

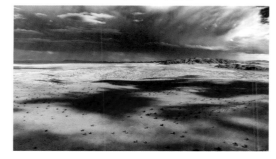

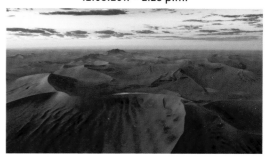

Page 150/151
NamibRand - Namibia - 30.11.2016 - 6:50 a.m.

Page 152/153
NamibRand - Namibia - 10.04.2015 - 3:17 p.m.

Page 154
Namib Naukluft NP - Namibia - 01.12.2016

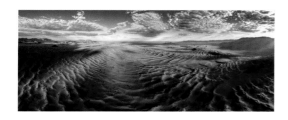

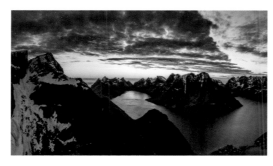

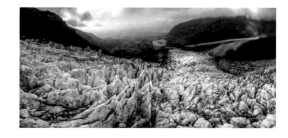

Page 155
NamibRand - Namibia - 10.04.2015 - 5:11 p.m.

Page 156/157
Lofoten - Norway - 21.05.2016 - 0:16 a.m.

Page 158/159
Vatnajökull - Iceland - 03.10.2016 - 4:13 p.m.

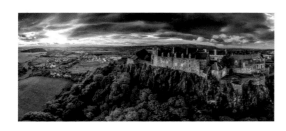

Page 160/161
Stirling Castle - Scotland - 17.06.2016 - 8:42 p.m.

7. INDEX // RIVERS, LAKES AND COASTS // FLÜSSE, SEEN UND KÜSTEN
// LES FLEUVES, LES LACS ET LE LITTORAL

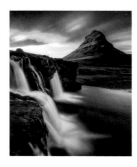

Page 163
Kirkjufell - Iceland - 03.08.2016 - 9:58 p.m.

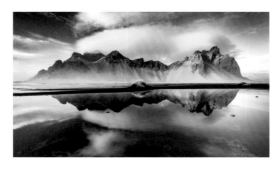

Page 164/165
Stokksnes Beach - Iceland - 07.10.2015 - 6:12 p.m.

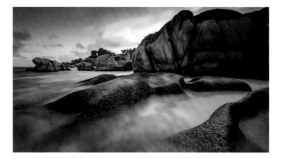

Page 166/167
La Digue - Seychelles - 15.06.2013 - 6:25 p.m.

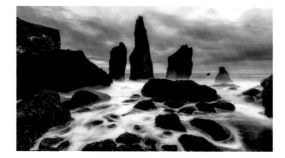

Page 168
Grindavík - Iceland - 24.09.2016 - 6:25 p.m.

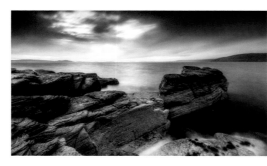

Page 169 top
Ullapool - Scotland - 13.09.2010 - 8:55 p.m.

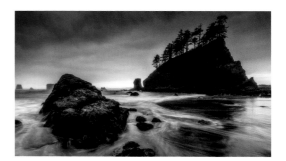

Page 169 bottom
Olympic NP - Washington, USA
15.10.2012 - 6:45 p.m.

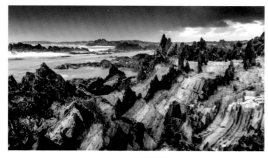

Page 170/171
Westcoast - Tasmania - 12.02.2017 - 8:20 p.m.

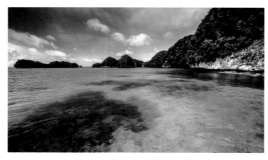

Page 172
Palau - Micronesia - 19.04.2012 - 0:34 p.m.

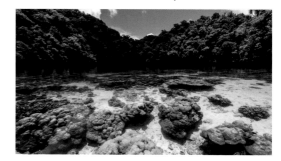

Page 173
Palau - Micronesia - 21.04.2012 - 2:44 p.m.

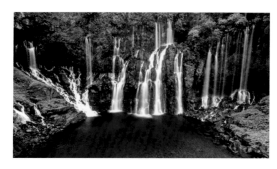

Page 174/175
Cascade Langevin - La Réunion
11.06.2013 - 8:31 a.m.

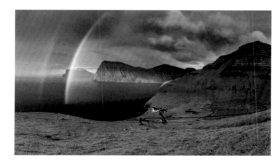

Page 176/177
Trøllanes - Färöer Island - 26.07.2016 - 9:03 p.m.

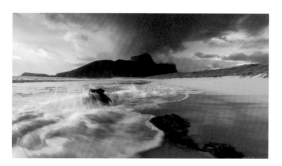

Page 178
Lord Howe Island - Australia
13.03.2017 - 6:33 a.m.

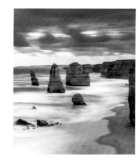

Page 179
Twelve Apostles - Australia - 19.02.2017 - 8:18 p.m.

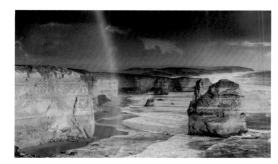

Page 180/181
Twelve Apostles - Australia - 18.02.2017 - 7:48 p.m.

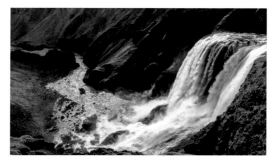

Page 182 top
Fagrifoss - Iceland - 02.10.2014 - 4:10 p.m.

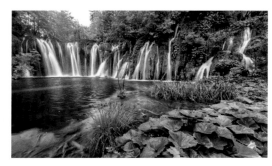

Page 182 bottom
Plitvice Lakes - Croatia - 25.03.2015 - 9:55 a.m.

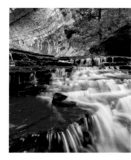

Page 183
Zion NP - Utah, USA - 02.10.2011 - 5:32 p.m.

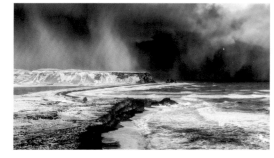

Page 184/185
Dyrhólaey - Iceland - 11.03.2015 - 4:21 p.m.

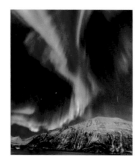

Page 186
Sommarøy - Norway - 07.02.2014 - 2:31 a.m.

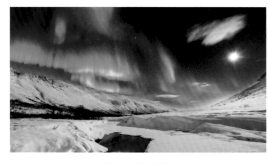

Page 188/189
Tromsø - Norway - 01.03.2012 - 11:45 p.m.

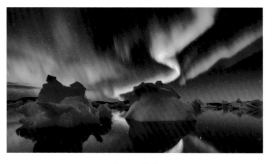

Page 190
Narsarsuaq - Greenland - 13.08.2015 - 0:23 a.m.

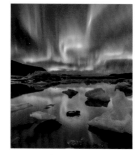

Page 191
Tromsø - Norway - 08.02.2014 - 0:14 a.m.

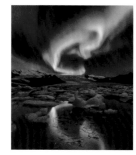

Page 192/193
Jökulsárlón - Iceland - 05.03.2010 - 2:59 a.m.

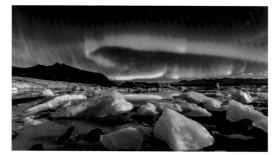

Page 194/195
Narsarsuaq - Greenland - 13.08.2015 - 0:40 a.m.

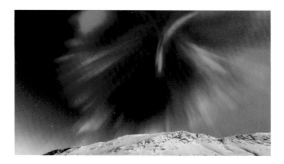

Page 196
Fjallsárlón - Iceland - 28.09.2016 - 2:03 a.m.

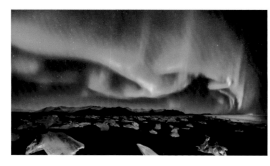

Page 197
Fjallsárlón - Iceland - 28.09.2016 - 1:51 a.m.

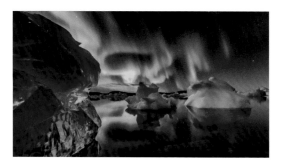

Page 198/199
Fjallsárlón - Iceland - 18.10.2016 - 9:46 p.m.

© 2017 teNeues Media GmbH & Co. KG, Kempen
Photographs and text © Stefan Forster
All rights reserved.
Picture and text rights reserved for all countries.
No part of this publication may be reproduced in
any manner whatsoever.

Art Direction: Martin Graf
Editorial coordination: Stephanie Rebel
Production: Nele Jansen
Image processing and proofing: Jens Grundei
Translation English: John Augustus Foulks,
J.Foulks@gmx.net
Copyediting: Victorine Lamothe-Maurin
Translation French: Mireille Onon
Copyediting: Christèle Jany

Published by teNeues Publishing Group

teNeues Media GmbH & Co. KG
Am Selder 37, 47906 Kempen, Germany
Phone: +49-(0)2152-916-0
Fax: +49-(0)2152-916-111
e-mail: books@teneues.com

Press department: Andrea Rehn
Phone: +49-(0)2152-916-202
e-mail: arehn@teneues.com

teNeues Publishing Company
7 West 18th Street, New York, NY 10011, USA
Phone: +1-212-627-9090
Fax: +1-212-627-9511

teNeues Publishing UK Ltd.
12 Ferndene Road, London SE24 0AQ, UK
Phone: +44-(0)20-3542-8997

teNeues France S.A.R.L.
39, rue des Billets, 18250 Henrichemont, France
Phone: +33-(0)2-4826-9348
Fax: +33-(0)1-7072-3482
www.teneues.com

ISBN 978-3-8327-6916-1
Library of Congress Number: 2016957925

Printed in Italy
While we strive for utmost precision in every detail, we
cannot be held responsible for any inaccuracies, neither for
any subsequent loss or damage arising.

Every effort has been made by the publisher to contact
holders of copyright to obtain permission to reproduce
copyrighted material. However, if any permissions have
been inadvertently overlooked, teNeues Publishing Group
will be pleased to make the necessary and reasonable
arrangements at the first opportunity.

The Deutsche Nationalbibliothek lists this publication in the
Deutsche Nationalbibliografie; detailed bibliographic data
are available on the Internet at http://dnb.dnb.de.

teNeues Publishing Group
Kempen
Berlin
London
Munich
New York
Paris

teNeues